CREOLE SOUL

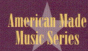
American Made Music Series

Advisory Board

David Evans, General Editor
Barry Jean Ancelet
Edward A. Berlin
Joyce J. Bolden
Rob Bowman
Susan C. Cook
Curtis Ellison
William Ferris
John Edward Hasse
Kip Lornell
Bill Malone
Eddie S. Meadows
Manuel H. Peña
Wayne D. Shirley
Robert Walser

CREOLE SOUL

ZYDECO LIVES

BURT FEINTUCH

Edited by Jeannie Banks Thomas Photographs by Gary Samson

University Press of Mississippi / Jackson

Thanks to the College of Humanities and Social Sciences and the Department of English at Utah State University for their support of the publication of this work.

The University Press of Mississippi is the scholarly publishing agency of the Mississippi Institutions of Higher Learning: Alcorn State University, Delta State University, Jackson State University, Mississippi State University, Mississippi University for Women, Mississippi Valley State University, University of Mississippi, and University of Southern Mississippi.

www.upress.state.ms.us

The University Press of Mississippi is a member of the Association of University Presses.

All photographs by Gary Samson unless otherwise noted.

Text and photographs taken by Burt Feintuch copyright © 2022 by Burt Feintuch
Photographs copyright © 2022 by Gary Samson
All rights reserved
Printed in Korea

First printing 2022
∞

Library of Congress Cataloging-in-Publication Data

Names: Feintuch, Burt, 1949– author. | Thomas, Jeannie B., editor. | Samson, Gary, photographer.
Title: Creole soul : zydeco lives / Burt Feintuch ; edited by Jeannie Banks Thomas ; photographs by Gary Samson.
Other titles: American made music series.
Description: Jackson : University Press of Mississippi, 2022. | Series: American made music series | Includes bibliographical references and index.
Identifiers: LCCN 2022020203 (print) | LCCN 2022020204 (ebook) | ISBN 9781496842466 (hardback) | ISBN 9781496842480 (epub) | ISBN 9781496842510 (epub) | ISBN 9781496842497 (pdf) | ISBN 9781496842503 (pdf)
Subjects: LCSH: Zydeco music—History and criticism. | Cajun music—History and criticism. | Creoles—Louisiana—Music—History and criticism. | Creoles—Texas—Music—History and criticism. | Zydeco musicians—Interviews. | Zydeco musicians—Louisiana. | Zydeco musicians—Texas.
Classification: LCC ML3560.C25 F45 2022 (print) | LCC ML3560.C25 (ebook) | DDC 781.62/410763—dc23/eng/20220516
LC record available at https://lccn.loc.gov/2022020203
LC ebook record available at https://lccn.loc.gov/2022020204

British Cataloging-in-Publication available

CONTENTS

vii Preface

3 Introduction

TEXAS

31 **Ed Poullard**
Creole United

53 **Step Rideau**
Step Rideau and the Zydeco Outlaws

77 **Brian Jack**
Brian Jack and the Zydeco Gamblers

101 **Jerome Batiste**
Jerome Batiste and the ZydeKo Players

117 **Ruben Moreno**
Ruben Moreno and the Zydeco Re-Evolution

LOUISIANA

143 **Lawrence "Black" Ardoin**
Lawrence "Black" Ardoin and His French Band

165 **Leroy Thomas**
Leroy Thomas and the Zydeco Roadrunners

181 **Dwayne Dopsie**
Dwayne Dopsie and the Zydeco Hellraisers

201 **Sean Ardoin**
Sean Ardoin and ZydeKool

223 **Corey Ledet**
Corey Ledet and his Zydeco Band

243 **Nathan Williams Jr.**
Lil' Nathan and the Zydeco Big Timers

261 Acknowledgments

263 Works Cited

265 Index

Creole Soul is meant to provide a stage for the voices, thoughts, and images of some contemporary zydeco musicians. Burt Feintuch set out to interview artists who played live scenes in east Texas and southwest Louisiana, those who worked the road, and some who did both. The primary focus of this book is to document the words of musicians playing live venues at the time Burt did his interviews. Secondarily, Burt wanted the book to capture the words of Texas musicians along with Louisiana musicians. He intended the voices herein to represent some of the traditions, diversity, and current changes in the music. Given the many ways family is important in zydeco music and culture, he also included interviews representative of two generations in one of the first families of zydeco.

This project is not intended to be exhaustive, comprehensive, or to trace an historical arc of the music. It is simply one small slice of zydeco from Creole country in Texas and Louisiana. Burt would've loved to interview many other musicians, but, as is often the case with projects of this nature, pragmatic considerations of musician availability, schedule, and manuscript size also shaped the selection of interviewees.

Zydeco is a male-dominated field, and with his focus on accessible performers in the live trailride, club, and festival scenes, Burt didn't interview any women zydeco musicians. However, their stories are significant. Women such as Queen Ida, Donna Angelle, Miss Ann Goodly, Rosie Ledet, and the many women who assume leadership and supporting roles in trailrides or zydeco club scenes are important to the music and culture. This aspect of the story of zydeco is beyond the scope of what Burt documented. However, it needs to be told; the women of zydeco deserve their own book.

Authored by a cultural outsider, it's not the intent of *Creole Soul* to present an analysis of zydeco music or culture. Indeed, such studies already exist; see for example Ancelet 1996; Bernard 1996; DeWitt 2008; Istre 2018; Le Menestrel 2015; Minton 1995, 1996; Sandmel 1999; Spitzer 1986, 2003; Tisserand 1998; and Wood 2006. Instead, Burt sought simply to create a platform for these zydeco musicians to present their varied and in-depth insiders' views of zydeco. The music and the words of those who make it deserve the main stage in both a literal and a documentary sense, and Burt wanted this book to do one small bit of that good work. His intent was for the book's focus to be on the musicians, with their thoughts about their music represented in their own, uninterrupted words.

The interviews are grouped by the state where the performers lived at the time of their interviews. Louisiana gets a lot of attention for zydeco in both the scholarly literature and the tourism industry, but Texas is a very important part of the zydeco story, too—a fact that is sometimes underappreciated. Burt admired and was influenced

PREFACE

by Roger Wood's *Texas Zydeco* (2006), so I chose to place the Texas interviews first. Of course, while place does have impact on the music, it is not static or bound by state lines. Rather zydeco is an ongoing, dynamic conversation among the musicians who travel in Texas, Louisiana, and the world beyond.

Tragically, Burt died on October 29, 2018, before he could finish this book. He had brain cancer when he died, but it did not kill him. He was at home recovering from chemotherapy and radiation treatment when he felt like playing his fiddle for the first time in months. He went downstairs to retrieve it. Once there, he decided to grab his mandolin as well. While going up the stairs with an instrument case in each hand, he fell over backwards. It was a shocking end to such a vibrant life.

Burt spent a significant part of the summer and fall of 2018 in one hospital or another. In every hospital room he was in, his backpack was by his bed. It contained this book manuscript. He hoped he'd feel well enough to write. He also wanted to be furloughed from hospitals long enough to emcee at the Lowell Folk Festival in July, which he loved doing. It was there, at the festival, that he interviewed one of the musicians in this book. Unfortunately, he was never well enough either to emcee at the Lowell dance tent in July 2018 or to work on this book.

Shortly before he underwent a craniotomy to remove his tumor, he made one request of me as I stood next to his hospital bed: "Please finish my book." During the time he was ill, this was the one and only thing he asked me to do. I would have done it without his asking. I knew that it was important work. I had accompanied him on many zydeco fieldwork trips and knew the places, people, music, and stories. Months after his death, I took out the manuscript and began. My contribution is as an editor; I accompanied him on over half of the fieldwork trips, and I tossed around ideas with him before he got sick. After his death, I edited transcripts and chapters, fact-checked, and contacted musicians and trailriders to clarify aspects of the interviews. I identified the pull-out quotations that begin each chapter and, with Gary's expertise and direction, worked out a final selection of photographs for the book. All photos in this book are Gary's with the exception of a few of Burt's field photographs from the Cleveland, Texas, trailride in 2015. They are included to illustrate the word picture Burt paints of that event in the introduction to this book.

One of the editorial decisions I made was to present "trailrides" as one word. What little literature there is in the press and academe typically and understandably splits it into two words. However, the clubs themselves use "trailride," so theirs was the usage I followed. Here I note that the trailride is an important Creole form, and—like much of Creole culture itself—it has been understudied. I applaud Elisa Istre's (2018) take on Creole culture as a whole and Alexandra Giancarlo's

Sid Williams, owner, El Sido's, Lafayette, Louisiana, 2017

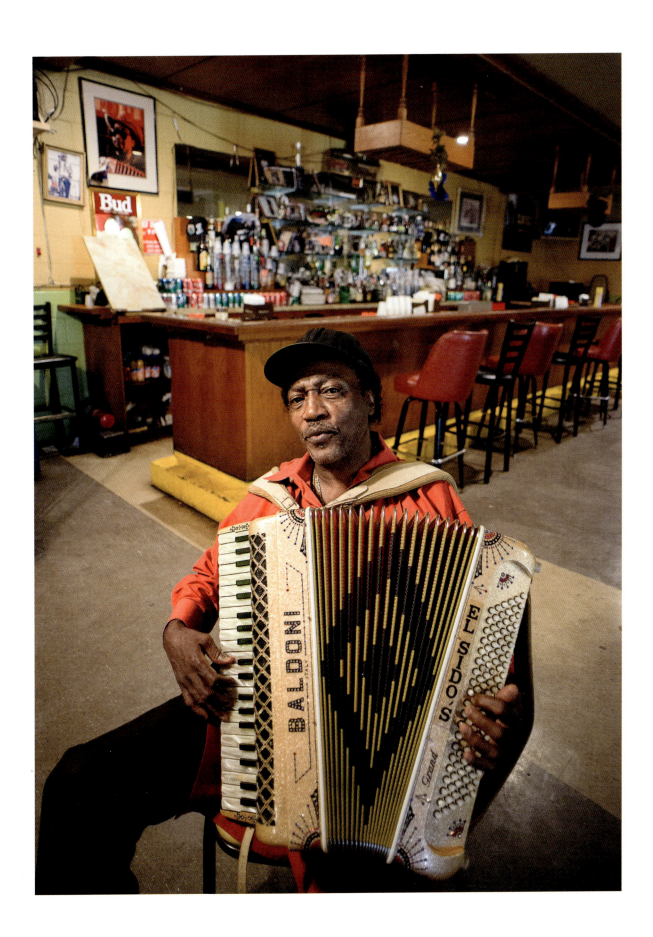

(2016, 2018) look at the racialized policing of the rides and their role in generating aid for their communities, such as school supplies and college scholarships. Also, Jeremiah Ariaz (2018) has beautifully documented the rides with his photographs. More work on the trailrides needs to be done; they also merit their own book-length studies.

As I was in the last stages of editing, I asked Cedrena Tillis some questions. I met Cedrena on a trailride outside of Houston, liked her, kept in touch, and found her knowledgeable about trailrides, the music, and the zydeco scene. She was also patient with my queries. As we messaged back and forth, I realized that five generations of her family had been going to zydecos—contemporary dances powered by the music of the same name—and the earlier "la-las," which were Creole house parties in the first half of the twentieth century featuring "French music," or accordion-based music performed by nonprofessional musicians (Wood 2006, 3).

What brings people like Cedrena's family members to zydeco is both its tradition and its dynamism. Some genres of traditional music could be described as greying. Not zydeco. It's doing the opposite. It's getting younger. It's got millennials and Gen Zers bumping to its beat. The ways that the music has changed to appeal to younger generations have kept it going, and these remakings are also the source of some concern and controversy. With these interviews, Burt documented the musicians thinking through these issues and talking about zydeco during a period of major changes to the music. Therefore, this book makes a significant contribution to our understanding of this traditional—yet dynamic—music at an important time in its evolution during the early part of the twenty-first century.

For me, traveling with Burt through zydeco country was pure joy set to a thumping bass soundtrack. With horses and accordions. I'm grateful that finishing this manuscript allowed me one last trip to the zydeco with Burt.

Now I have completed it: *Adieu, mon amour—avec toi les haricots étaient toujours salés.*

—Jeannie Banks Thomas

CREOLE SOUL

Cory Tucker playing the frottoir at Jax Grill,
Houston, Texas, 2015

INTRODUCTION

Creole people from southwest Louisiana and east Texas created zydeco music in the second half of the twentieth century. They produced a music that is strongly regional and broadly appealing. It has a committed and enthusiastic base of dancers and other local supporters who love the music, admire the musicians, and let the music lift them, dancing their asses off in clubs, at church bazaars, at equestrian events called trailrides, in private parties, and at festivals (Dewan 2011). A few bands play a national, occasionally international, circuit of music festivals, private parties, clubs, and other events. But for the most part, this is a music that has stayed home.

Creole is a complicated word in zydeco's part of the world, and it reflects a complex, fascinating history; see the work of Carl Brasseaux (2005), James Dormon (1996), and Elista Istre (2018) for detailed explorations of that story. Folklorist Maida Owens notes that few outside of the region grasp how truly complex its cultural variation really is (1997, xxix). One of the reasons that the word *Creole* has an intricate history has to do with culture. At least eighteen distinct French-speaking groups settled in the region during the last three centuries (Brasseaux 2005, 2). Also important to the meanings of the term are the various notions of class, caste, power, and ethnicity ascribed to it (for more on zydeco and race, see Sexton 2000; Le Menestrel 2015).

For purposes of this brief introduction, I follow definitions of Creole as outlined by Istre (2018, xiv), Ben Sandmel (1999, 15, 18), and Roger Wood (2006, 61–62). Istre helpfully provides a brief overview of some of the basic ways the word is used in Louisiana: Creole can refer to white, colonial aristocracy in New Orleans. Or it can describe those descended from Louisiana's free people of color (*gens de colour libre*). Or it can reference the descendants of Louisiana's enslaved population (Istre 2018, xiv). The term "Black Creoles" is often associated with the descendants of enslaved people and is the term most commonly employed in the zydeco literature (see Sandmel 1999, 15, 18; Wood 2006, 61–62; Tisserand 1998, 3). Istre tells us that today, "Black Creole" and "Creole" describe people in southwest Louisiana who have African and European heritage and who speak French or who have ancestors who did (2018, 25). As is frequently the practice of folklorists, the term appearing in this book is the word the interviewees most often used for themselves, which is simply "Creole." Not surprisingly, Louisiana is also the home to many versions of the French language. When "French" is referred to in this book, it is Creole French, which was also influenced by several Native, European, and African languages (Istre 2018, 119).

During the nineteenth and twentieth centuries, Creole people tended to view themselves as separate from the African American population, citing ancestors who were Spanish, Native American, white Francophones, and others. Over time, especially as the civil rights movement opened opportunities in education, public accommodation,

and voting, many Creole people began identifying as Black or African American, and the distinctions between Creole and Black began to fade, even while the Francophone component endured (Brasseaux 2005, 111–12).

In the first half of the twentieth century, many Creoles moved from rural areas to work in larger cities (Wood 2006, 66). The prospect of work in the oil industry, the mechanization of farm labor, and World War II led many Creole people to leave southwest Louisiana and move to east Texas. Creole communities developed in many locales, including a Houston Fifth Ward neighborhood known for years as Frenchtown. Houston has a thriving zydeco scene today. Because distances are not far, many Louisiana and Texas musicians move across state borders, bringing their music to sites along that section of the Gulf Coast where their communities lie. Wood, who has chronicled zydeco in Texas, says that Houston was to zydeco what Chicago was to the blues: a place where urban resources and inspirations produced a major stylistic shift from an older rural music to a harder, more assertive, more urban sound (2006, 65). Creole people also moved to California during the 1940s, drawn by wartime industries such as the building of planes and ships. Today, especially around the Bay Area, there is a small but thriving zydeco scene (DeWitt 2008, 67).

Zydeco music is not the same as Cajun music, although they share some features and turf (Istre 2016, 155). Cajuns are primarily descendants of another group of Francophones who settled in south Louisiana: Acadians expelled by the British from the Canadian Maritimes in the mid-eighteenth century. It's clear that Cajun music and zydeco share some roots, but they grew in different directions. You can hear echoes of Africa and the Caribbean in zydeco and in the New World musical forms that are its foundation. Various Black popular music traditions, from blues to rhythm and blues to soul to hip-hop, have influenced modern zydeco. Its tempo tends to be more syncopated and assertive than in Cajun music (Sandmel 1999, 24). Conversely, commercial country music and rock 'n' roll shaped modern Cajun sounds. The tourism industry in Louisiana, along with cultural revival efforts situated in local communities, helped elevate Cajun music to an almost anthemic status in Louisiana and in the larger music industry.

As the music of older French-speaking Black communities, zydeco grew from earlier musical forms. *Juré*, an unaccompanied singing with improvised percussion (clapping, foot stomping, spoons on washboards), was an important step in the development of zydeco, according to Barry Ancelet (1988, 43). Then came "la-la." Some referred to it simply as "French music." "Creole music" is another term for it, and you might hear all three terms in a conversation with an older musician. It was often the music of rural and small-town dance parties (see Istre's overview 2018, 170–93). It typically featured an accordion,

often accompanied by a fiddle, mixing songs in Creole French and instrumental dance pieces. That old music was also a precursor of the music known as Cajun. One feature both bodies of music share is that the accordion often is in front, played by the bandleader who is usually also the lead vocalist. Another feature of both types of music—like much of music in general—is that one can often find exceptions to the common patterns. Both may feature a mix of vocals in English and French, although Creole French is spoken less frequently these days, which means that you hear less of it in the music than you did a generation or so ago. The fiddle is often present in Cajun music; it's largely gone from zydeco (Sandmel 1999, 22–23).

This book is a set of conversations with zydeco musicians, most of them bandleaders. It ranges over Texas and Louisiana, and it moves across generations, too. Some of the interviewees represent the contemporary scene; some are older, more rooted in earlier French music forms, and especially well qualified to talk about zydeco's origins—including the older musical configurations and social settings for the music. All of the interviewees are men, representing an overwhelmingly male world of music. But it is not a world without women. Accidental, but bad, timing meant that as we were doing the research for this book, zydeco's leading woman performer, Rosie Ledet, had taken a break from music. She's back, at least as I write this introduction.

Creole Soul combines text and photographs. As much as I've tried to render these interviews to represent the voices of the speakers, readers can't hear the voices in conversation. But we intend photographer Gary Samson's portraits of the musicians and images of the music in action to add flesh and bones to the words represented on these pages. This is a book about a musical world full of elan, cowboy hats and boots, banging bass, joy, horse trailers, and expert dance moves. We hope that the photographs help you hear it.

SOUND CHECK

Cleveland, Texas, June 26 and 27, 2015

This is in a horse arena. Wooden bleachers running, long and narrow, on one side, a metal shed roof, iron rails, a stage—a flatbed trailer—across from the bleachers, centered. Fine brown earth everywhere. Concessions behind the bleachers are selling boudin, fish, soft drinks, chicken. At one end of the arena, a vendor is selling western hats in many varieties, including some that are a brim with no crown, probably cool in the heat, which is nearly oppressive, although it is way past sunset. You also have your choice of ball caps, some with sparkling letters spelling out "sexy." Centered in front of the bleachers in an area

contained by iron rails, with his laptop and large speakers, wearing gloves, a DJ dominates the soundscape. His friend Poochie is there, having a very good time, his name embroidered on his polo shirt, wearing a tattered straw hat. He's generous with his jar of cold tea blended with moonshine, enhanced by a stick of cinnamon. The band—Leon Chavis and the Zydeco Flames—is setting up on the stage. It's a Friday night in Cleveland, Texas, on the eve of the King City Trailriders annual ride. A website lists more than three hundred of these Creole horse-riding groups, most in Louisiana and Texas. Many sponsor weekend-long trailrides. Tonight and tomorrow night there will be zydeco music on the stage and zydeco dancing on that fine brown dirt.

The sound check takes a good hour or more, as band members try their instruments and vocal mics, alternating with the mostly old-school soul the DJ is playing. Everyone loves Tyrone Davis, it seems. It's not a large crowd; people are sitting in the bleachers, talking, refreshing themselves from coolers, loosening up, walking around. A tall, slim, good-looking man, in his boots and western hat, starts talking to us. He's McDuffie, here with two of his grandchildren. McDuffie's wife died a month ago, he tells us, and he's decided to spend more time with his grandkids. He's had a career of twenty-five years in the police. Now he does contract security work in Afghanistan. His luck has held through his career, but he doesn't think it necessarily will continue. He thinks it's time to stop. He tells us that his two young grandkids might sit in with Brian Jack and the Zydeco Gamblers, who will be on stage tomorrow night after the ride. McDuffie also advises us to stick with zydeco and blues, where the crowds are friendly. Rap, he says, is another story. Another man, older, sitting with friends and a well-stocked cooler, asks if we'd like a beer, handing over a couple of Heinekens. Every time thereafter when I look his way, he offers more. There's a feeling of friendliness and community here, and the fact that we stand out, as the only white people in the small crowd, causes people to want to know more about who we are, where we come from, and why we're there.

This is a kind of sound check for me, too. I'm here, with my partner, folklorist Jeannie Thomas, to scout things out. Having just finished *Talking New Orleans Music*, a book of interviews, collaborating with photographer Gary Samson, I'm thinking about a zydeco book. After reading Roger Wood's fine 2006 *Texas Zydeco*, I want to check out the Lone Star State scene, to see what sort of access I'm likely to have in this world of music. So, we're going to events, taking photographs, getting a feel.

Trika, a young woman, comes to talk to us. She's with the King City riders' association, and she invites us to ride tomorrow on their party wagon, a flatbed with side rails and a roof, towed by a pickup. It joins the horses in the ride itself, carrying people, a sound system, and coolers.

There's a prize for the crunkest wagon. Could she possibly think that our presence might raise the crunk factor? Well, no. But Trika says to ask for her tomorrow; it's clear that her invitation is generous and part of the congenial atmosphere of the event.

This, then, is the eve of the trailride. Tonight is a zydeco—a word that can designate a musical genre, an event featuring that music, or the kind of dancing one does to that music. So, you can go to a zydeco, where you'll hear zydeco music, which will probably make you want to zydeco (Ancelet 1988, 37). Tonight's dance is a good time with friends while the horses and their riders arrive, before the big day begins. The band finally agrees that the sound is right. As he's closing up shop, the DJ tells us that one of his parents is Puerto Rican, so he speaks Spanish. Tomorrow he's spinning at a Tejano event.

Leon Chavis, whose great uncle was Boozoo Chavis, a very influential zydeco figure, is carrying six pieces tonight. He fronts the band, singing, playing the button accordion, in jeans and a grey western shirt, top snaps undone, sleeves rolled, studs in his ears, work boots, a small goatee, tinted glasses. His manner on stage seems affable, and he smiles and nods to me when I approach with camera. His frottoir player is next to him, looking tall in his white pants and shoes and bright blue shirt. He is wearing that distinctive zydeco instrument, a shiny metal rubboard that fits over the shoulders and hangs over chest and stomach. You play it, typically exuberantly and often theatrically, with metal spoons, bottle openers, or other hard scrapers. Next to the rubboard guy is a man on the keyboard, wearing extravagantly large white-framed glasses. In the second row, electric bass, drums, and electric guitar. In some bands, the guitar is a lead instrument; tonight it's more a part of the rhythm section. Leon is terrific, singing a range of old and new material, some of which comes from Boozoo, some of which we know from Smokey Robinson. He's also working the soundboard.

In front of the band, maybe thirty people are talking, dancing, and generally having fun. They are in jeans or cutoff shorts. T-shirts, tank tops, sneakers, western shirts, boots, and cowboy hats are on view as well. Couples can't help but dance to this music. We've been trying to figure out what constitutes a basic zydeco dance step, but tonight the instructional videos on YouTube prove to be less than accurate. I'm not sure there is *a* single basic step. This is couples dancing, sometimes in ballroom position, sometimes with moves that resemble swing or jitterbugging, typically with footwork of small steps keeping time with the music. A lot of it's in the hips (see KQED Arts 2020 for a nice introduction to zydeco dance moves). A teenaged boy in glasses, plaid shirt, jeans, western hat, and boots really knows what he's doing. A younger girl in shorts, tank top, and sneakers, and a pink backpack on her shoulder appears to be very interested in dancing with him. Later on, about eight people start line dancing. They are led by Pat

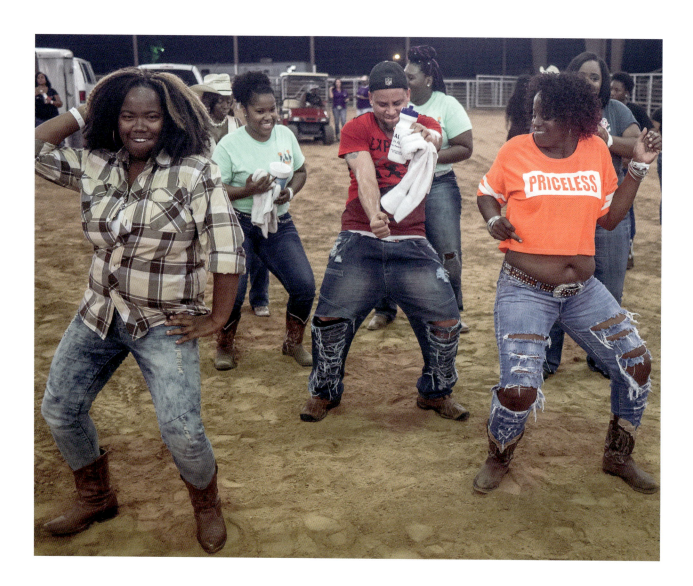

Dance instructor Pat Cel (center) and line dancers, Cleveland, Texas, 2015 (photo by Burt Feintuch)

(top right) Dancing at the Get Money Riders party wagon, Cleveland, Texas, 2015 (photo by Burt Feintuch)

(bottom right) Circle 44 Riding Club party wagon at trailride, Cleveland, Texas, 2015 (photo by Burt Feintuch)

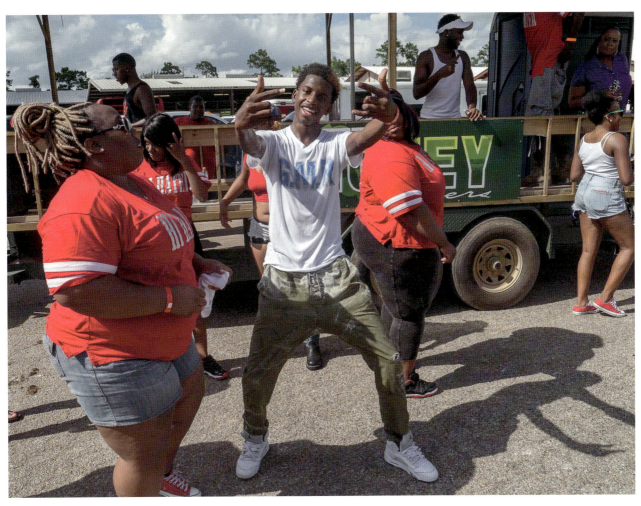
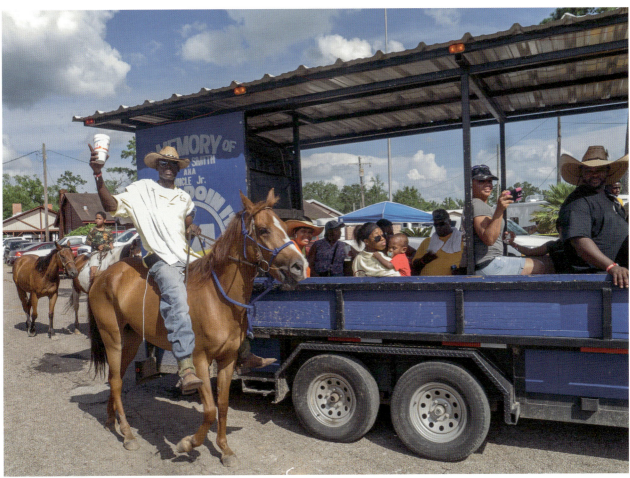

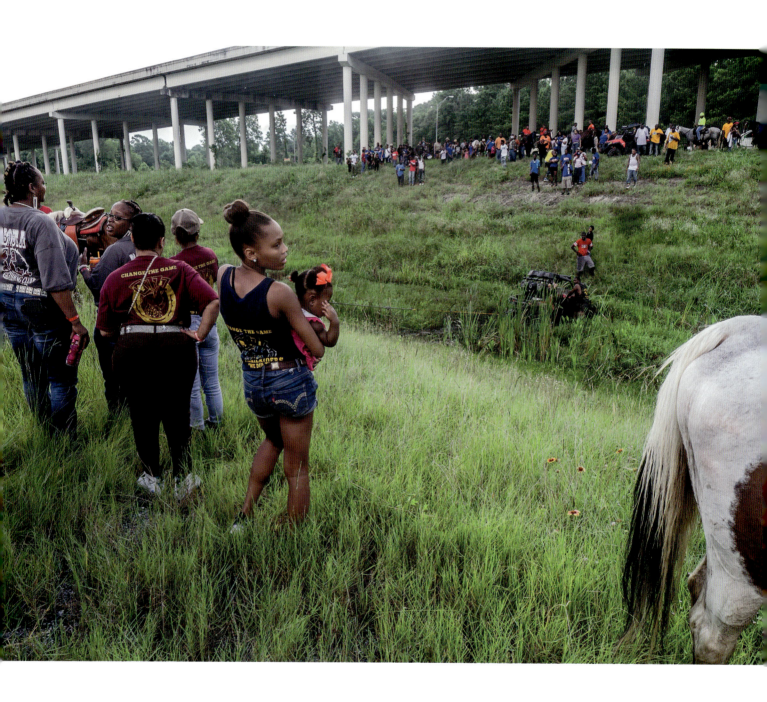

Trailride crowd and OHV stuck in mud, Cleveland, Texas, 2015 (photo by Burt Feintuch)

Cel, a dance instructor whose videos on YouTube capture what we see at live venues in terms of zydeco line dancing. Poochie is making the rounds with his jar of "tea," having an even better time than earlier. I eat a smoked boudin—hot, rich, and delicious.

Saturday's a different story. We arrive around 4:00 p.m., to a congeries of people, horses, horse trailers, pickups and cars, party wagons, loud music, and a good deal of revelry. T-shirts with mottos and emblems testify to the many trailride associations that have come for the day or the weekend. The King City Riders are here in abundance. The Get Money Riders are here. So are the Real Deal. We're Still Doin' It, the WAU, the Drug Store Cowboys, the Texas Sho Steppers, the Nigton Night Riders (out of Nigton, Texas), the Po Boy Ryders ("Texas Bred, Coonazz Raised"), the 4 Horsemen Trailriders, the We All We Got Trailriders, the Backwood Riders, the Change the Game Riders, the Crabb River Riders, the 190 Trailriders, the Triple H (Houston Hard Hitters), and God knows who else. The logos on T-shirts sashay past us. The King City Riders' party wagon looks too crowded, and already the crunkest, so we ask someone who turns out to be her husband to relay our apologies to Trika, deciding instead to follow the ride in the air-conditioned car.

At about five, the procession leaves the grounds. Men, women, boys, and girls are mounted up and in the lead. Party wagons, ATVs, an off-highway vehicle (OHV), a golf cart or two, pickups, and cars follow. We hit the streets moving with the horses; people in the modest neighborhoods wave. The riders process over level crossings, past a cemetery, along a feeder road and up a highway ramp to a large overpass. Riders with flags hold the other traffic back. We take a rest break at the overpass. A large crowd watches the OHV, which is stuck in a boggy ravine near the overpass; the efforts to pull it out are eventually successful. Party wagons are playing their music. People are tending their horses. Others are dancing, talking, partaking in various ways. Jeannie gets invited onto a bouncing party wagon, where she joins a crew of dancing women, seriously crunk. People want their pictures taken; we are given gifts of Coors Light. The riders saddle up and follow the route back to the grounds, where they begin to get ready for the night's zydeco.

We then leave the site to attend a zydeco at a Catholic church in Crosby. It's a longer drive than we anticipated, in heavy rain, with a dinner stop en route. In Crosby, the rain is pouring down, and we slog to the church hall. Looking in, we see a small crowd, many of them older and dressed up, sitting at tables. The music is loud, but it's clearly not inspiring, as no one is dancing. A few people step outside to invite us in, but we demur, hoping for a larger scene with more action. Consequently, we decide to make our way back to Cleveland, and by night's end, we're glad we did.

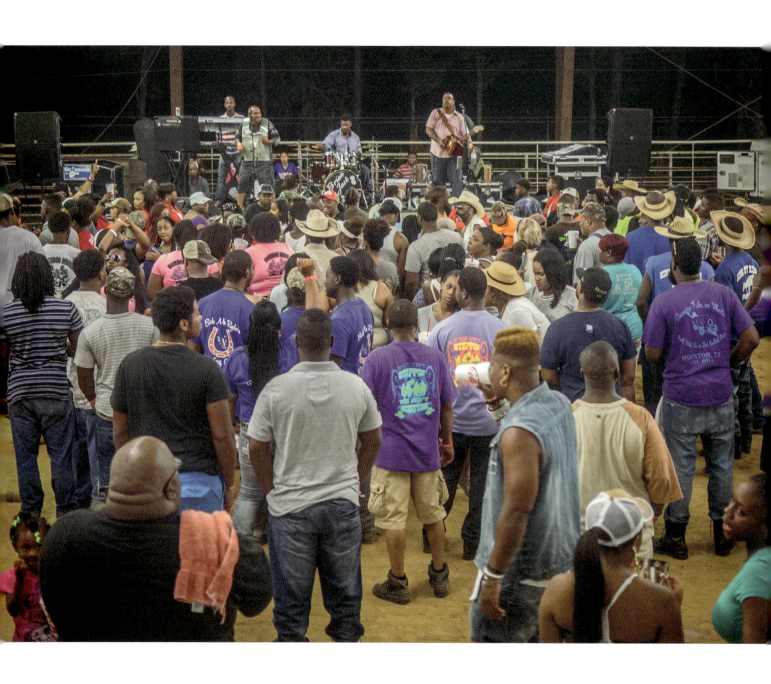

Brian Jack and crowd, King City
Trailride, Cleveland, Texas, 2015
(photo by Burt Feintuch)

In Cleveland, Brian Jack and the Zydeco Gamblers have a big crowd. A thousand people? Fifteen hundred? Most are on their feet in that hard-packed fine brown dirt. Some are dancing; many are in small clusters, talking and having a fine time. The band is scheduled to play from 9:00 p.m. to 1:00 a.m., and they've got the crowd going. People are drinking and eating. We meet a man with Nikon hanging from his neck, who tells us that he's been photographing trailrides for twenty-five years. People also pose for us, calling us over to take a picture. I give out a fair number of cards to people who want to contact me so as to see their photos.

The music is strong. Brian Jack is in a pink button-down shirt, jeans. His rubboard player is in camo shorts and shirt. Behind them: keyboard, drums, and guitar. It's unusual that there's no bass player, but the keyboard has the banging bottom end. Brian Jack is a good singer, and the beat, that propulsive beat, compels dancers to show him what they've got. Some zydeco bands make most of their living playing these trailrides, and people tell us that there's at least one ride in the region every weekend of the year. We are, by the way, only about thirty minutes from Houston's center.

Live music is one way that people make good lives and successful community. Tonight, the music is the center of a huge amount of conviviality. It encourages people to move in synchrony, helps them get close to each other, as it provides a backdrop for a welcoming and caring night. I don't want to romanticize this—after all, at the gate to the event a sign cautions that fighting won't be tolerated. But as we hear over and over again from people that these trailrides are a very big deal in their lives, and as the music transports us all beyond everyday life and concerns, I realize that when it comes to doing a zydeco book, it's time to get going.

HOUSTON

It was good to start this project in the Houston area. Like many people who know zydeco from outside its home grounds, I tended to associate zydeco with Louisiana. At least I wasn't someone who committed the cardinal sin of not distinguishing zydeco from Cajun music. But Houston in particular, and east Texas in general, have a compelling claim when it comes to zydeco. The zydeco scene in that part of the world is hot, yet largely unpromoted to tourists, especially in comparison to Louisiana's marketing of the music. The music in Texas is really banging, hard: propelling people at clubs, on trailrides, in festivals, onto the dance floor. It speaks to an audience that thrives on the way it balances references to country life, cowboys, trailrides, and a sound that reflects contemporary urban Black music influences.

This music, which should be considered a contemporary genre, grew from earlier forms associated with Creole culture in southwestern

Louisiana. Most histories of zydeco describe Clifton Chenier (1925–1987) as zydeco's originator (see Tisserand 1998; Mouton 2015). A Creole-speaking native of Opelousas, Louisiana, and a resident of Houston, Chenier was a musical innovator who convinced the world that the piano accordion is a fine blues instrument. Although he was a native Louisianan, it was in Texas that he refined his music and developed a sound that synthesized la-la with urban Black sounds, especially blues. It was also in Houston that the word *zydeco* became standardized, thanks to influential roots music producer and Arhoolie label owner Chris Strachwitz and intrepid fieldworker and researcher Mack McCormick.

Opelousas, Louisiana, represents itself as the birthplace of zydeco, but Houston has a claim that's at least equal. Houston afforded a set of urban resources and inspirations. It was the place where Clifton and his brother, Cleveland created the *frottoir*—the rubboard or scrubboard—as we know it today. This metal vest is an essential part of any zydeco band. It is also emblematic of zydeco's ability to innovate. The Chenier brothers designed it; a sheet metal worker produced the first one. Now you can buy them on Amazon. As you read this book, note how many bandleaders refer to Clifton Chenier as a fundamental inspiration. Most published histories of this music cite Clifton and then move to the next generation. On the other hand, many of today's bandleaders also talk about Boozoo Chavis (1930–2001), whose infectious music first reached the public in a 1954 release, his song, "Paper in My Shoe." Chavis, from Dog Hill, near Church Point, Louisiana, was very popular in Creole communities. His music, based on the single-row—diatonic—accordion with bass, drums, rubboard, and guitar, anticipated the sound of many of today's younger bands. His rival, Beau Jocque (Andrus Espree, 1953–1999), also cited by many of this book's interviewees, is another one of the founding figures of today's zydeco. Beau Jocque was born in Duralde, Louisiana.

Back to Texas: Because of the large outmigration from south Louisiana, Houston's Fifth Ward had a neighborhood known as Frenchtown. The city's Creole population was large enough that a network of clubs and other venues developed as the older music urbanized and became less of a house-party music, more of a club and public event performance genre. Houston was a hotbed of musical creativity, with blues musicians, jazz, and R&B performers interacting and influencing each other, along with, of course, a very active and innovative Mexican and Mexican American scene. Visit Gabbanelli Accordions, a family business rooted in Italy but established in Houston in 1961, and you'll gain a sense of the intricate cultural connections between Houston and various forms of accordion-based music. And it wasn't only Houston. East Texas had other, smaller, unnamed Frenchtowns—other concentrations of Creole people whose families had left Louisiana for work.

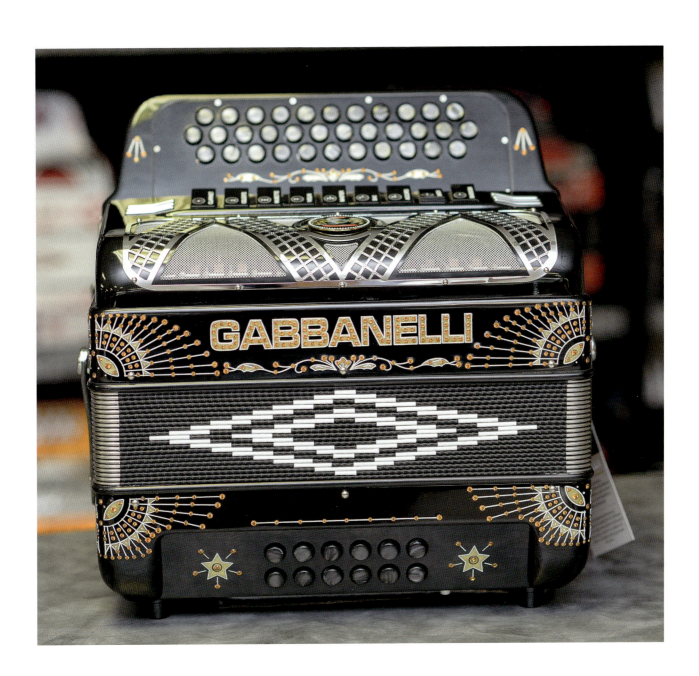

Gabbanelli accordion, Houston, Texas, 2015

In fact, the word *zydeco* is a Texas standardization of words such as *zarico* and *zodico* that were current in Frenchtown. They referred to accordion-based music and to the events where it was featured (Wood 2006, 96). The dominant origin story is that it derives from the expression, "*Les haricots ne sont pas salés*," which translates as "the beans aren't salty." This is a line from a Creole song; it can also be a comment on hard times. For some, it's understood to have a sexual connotation. Other commentators have suggested that the term has an African or Caribbean origin (Spitzer 1986; Ancelet 1996). Regardless of the varied spellings, the word became standardized thanks to Mack McCormick, who chose to use today's spelling on a series of field-recorded LPs he produced and released (Wood 2006, 118–19). Arhoolie Records owner and producer Chris Strachwitz also employed that spelling on some releases of Clifton Chenier. Arhoolie Records brought Chenier's music to a public beyond the region. And Louisiana tourism development efforts moved the music's early Texas associations to south Louisiana.

Tyina L. Steptoe's 2015 book, *Houston Bound: Culture and Color in a Jim Crow City*, offers a very helpful perspective on the growth and decline of Frenchtown as well as on Houston as a place where vibrant but marginalized cultures heard each other and incorporated new sounds into their own musical creativity. Tourism, she and others say, captured—or created—the association between zydeco and Louisiana:

> The marketing of zydeco, however, downplayed the influence of Texas music and the experience of migration on Chenier's music by spatially rooting him in the place he left. Strachwitz titled his [Chenier's] first album *Louisiana Blues*. He did not sell the new genre through an association with Houston or Frenchtown. Yet for Mack McCormick, the man who first used the word zydeco, the name referred to music from Fifth Ward. Over the years, McCormick began to resent efforts by the state of Louisiana to apply *zydeco* to music that developed east of the Sabine River. He created the modern spelling of "zydeco" in Frenchtown, and he intended the name to refer to that place. "When I'm talking about zydeco," he wrote, "I'm talking about the music of Frenchtown . . . and the people who usurped that . . . were the Louisiana tourist commissions. . . . Louisiana's very big on tourists, so when they put out a map that says rice country, zydeco country, jazz country, and they send three million copies of the map, it's over." (42)

"SOMEBODY PLEASE SLAP THE SHIT OUTTA ME WITH SOME ZYDECO"

So writes one of my new zydeco Facebook friends on October 21, 2015. Some people *really* like zydeco. I keep thinking about my university

Introduction

colleagues, and how unlikely it is that a member of that crowd would say something like, "Somebody please slap the shit outta me with some Chaucer." First of all, academics rarely say "please."

After Jeannie and I went to our first trailride in June 2015, we wanted to get copies of our photos to the riders, many of whom had asked us to take their pictures. One way we did that was to post photos on Facebook and to make contact with two of the organizers—Teresa and Trika—whom we'd met at the ride. The Facebook photos began traveling around the internet. Trailriders friended us. Some used our photos of them as their Facebook cover photos. We scanned their pages to get some a sense of those people who were now linked to our pages. They are medical assistants, admins, construction workers, home healthcare workers. Some went to college. Some live in Louisiana, although the ride was in Cleveland, Texas. Some are very into the life, displaying photos of horses and trailrides, and posters for zydeco events, trailrides, clubs, other musical occasions. One lists among his interests "female anatomy." Many are proud of their families. Many are religious. And a lot are playful in their responses. One reply to the "slap the shit" post reads, "Slap yourself, then pull out your accordion. Lol. Man you crazy."

The upbeat energy at many zydeco events is intoxicating, which is perhaps not surprising given the amount of intoxicants involved. People bring coolers to the trailrides, seemingly favoring Coors Light and Bud Light, at least at the rides we attended. There's moonshine, too. And if it's not a trailride, a zydeco venue is likely to be a club or a sports bar, the band drawing the crowd, and the crowd supporting the bar. The Houston clubs we've visited range from Jax Grill, with its Friday zydeco bands to Prospect Park, a sports bar with contemporary décor, a dress code, and an elegantly dressed older Black crowd, to Club ICU—a place surrounded by razor wire where most people were wanded as they entered. Hundreds of trailriders celebrated at their annual dinner to the music of J. Paul Jr. and the Zydeco Nubreeds at this club. It's all good. It's also all notably hospitable—Creole *hospitalité* in action—with people in the venues extending lovely acts of kindness to us. They've bought our drinks. They've found seats for us when there seemed to be none. At the razor wire place, they made sure we ate some of the food they'd set up in chafing dishes, warning us that it was pretty spicy, explaining that this was because they'd made it for drunk people. Leaving that place—Club ICU on Mesa, in Houston—a man we'd met and photographed at the first trailride said to us, "We love you guys." That's a sentiment we heard again when we were talking to some of the organizers of the second trailride we went to, especially Malex Wilson.

At the Tri-City Riders' ride in September 2015, Malex and his brother Nathanial were among the principals who welcomed us. The poster online had said the ride would begin at 1:00 p.m. We arrived at

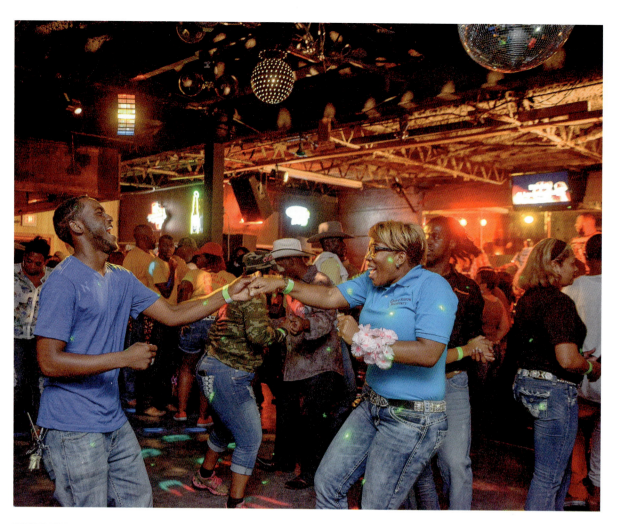

Introduction

noon, this time with Gary, thinking there would be some good photo ops. Attendance was sparse; as we approached, we were welcomed and told to make ourselves at home. The ride, people said, would probably start around 3:00 p.m. The sun was beating down, and there was little shade. After a preliminary walk around the site, we decided to get in the car and go buy some hats. Concerned that we'd be perceived to be leaving, we announced our intentions to the people who were taking tickets. It ended up that Kenneth, who is president of another trailride association, jumped into our car, in his socks, western boots in hand, saying he'd take us to a feedstore where we could get hats.

This was still technically in Houston, but the feedstore felt like deep country, complete with a wooden front porch and cages of chickens. They also had only expensive hats, whereas we wanted disposable chapeaus. Jeannie found a visor; Gary and I didn't find anything. Kenneth then directed us to a gas station convenience store, where Gary and I invested about $3 each in two elegant ball caps.

Malex and Nathanial invited us to ride on their club's party wagon, which would be the first one in the procession. They were concerned that we be comfortable, and they introduced us to various family members who were also onboard. At one point, late in the ride, a couple of young women on the wagon had an angry exchange of words that, from what little I could tell, could become something that might escalate into more than words. Malex was very upset by this, and he put one of the women off the wagon. He was shaken by what happened, and he told us probably three or four times how sorry he was about the drama. Trailrides do seem to be events that are good at self-monitoring, although you may note in some of this book's interviews that people worry about violence at trailrides.

From my all-too-limited experience, it seems that the trailriders do a good job of regulating their events, sometimes with the assistance of hired security. Everyone seems to be a celebrant; everyone seems to be embraceable and a dance partner, and body image seems to be the last of anyone's concern. I don't want to idealize this, but I will reiterate that these are comfortably inclusive events where people revel in the company of other revelers. Jeannie described it as like a New Orleans second line—but with horses.

They're also really loud. I used to think that the loudest musical event I'd ever attended was one night at the Maple Leaf Bar in uptown New Orleans. The great Rebirth Brass Band was playing, and standing in the room, I could feel my pants flapping as those loping bass sound waves hit. Feeling old and embarrassed, we retreated to the garden at the back of the club, where we could hear but not see the band. At the Tri-City ride, the Saturday night dance was in a very large picnic pavilion: concrete floor, roofed, open on four sides. Lil' Nathan and the Zydeco Big Timers were playing. They use massive woofers stacked

(top) Zydecoing, Club ICU, Houston, Texas, 2015

(bottom) Nathaniel Wilson (right) and friends, Tri-City Trailride, Houston, Texas, 2015

Celebrants, Club ICU, Houston, Texas, 2015

two-high, a pair on either side of the stage, with large sets of horns above. When I was near the stage, not only did my pants flap—an inelegant-sounding phrase, I know—but I could feel that bass in my chest. This is what zydeco people describe as *banging*. At the back of the pavilion, a good fifty or seventy-five yards from the stage, I could still feel it. A lighting fixture, hanging over the stage, came loose early in the set, dangling over Lil' Nathan. I can only wonder if that was because of the sheer volume of the music. Sean Ardoin told me that he's resisted the huge investment those woofers require—not only the cabinets themselves but the sizeable trailers to pull them in, and then, presumably, something to pull with. But zydeco fans, Sean said, really love that bottom end. As an observer, I'd say that this seems to help dancers move their bottom ends.

A couple of days ago—I'm writing this in June 2018—the fellow who wanted to be slapped posted on Facebook that the problem with Wednesday nights is that there's no live zydeco.

MILLER'S ZYDECO HALL OF FAME, EL SIDO'S, AND OTHER CLUBS

It's early March 2017, and we're staying in Opelousas. On a cold New England day, Gary and I boarded a flight for New Orleans. Jeannie did the same in Salt Lake City, and we met in New Orleans, oriented ourselves by eating considerable quantities of seafood, and headed to Opelousas. That was Thursday. The goal is to wrap up the interviews and photography for the book.

Now it's Saturday morning, after a late night at Miller's Zydeco Hall of Fame in Lawtell, Louisiana, a few miles from Opelousas. Miller's is the former Richard's Club, which opened in 1947 and became one of the major venues for zydeco. We were welcomed by Dustin Miller, co-owner of the club. Jeremy Frugé and the Zydeco Hotboyz opened, and then came J. Paul Jr. and the Zydeco Nubreeds. I hadn't heard Jeremy, who is young but seasoned, and who seems very much, at least currently, in tune with the Lil' Nathan style, with elements of neo soul and other contemporary sounds. J. Paul Jr., one of my favorites, is passionate and powerful. Dustin is warm, enthusiastic, and welcoming, making sure we have beer. Earlier that evening, we'd gone to a very different venue—Feed and Seed in Lafayette. There we heard Chubby Carrier and the Bayou Swamp Band.

The audience at Miller's was Black; at Feed and Seed it was largely white. Feed and Seed has an intentionally rural look about it, and it's one of the main venues for zydeco and other local musics in Lafayette. Miller's is redolent of its 1947 origins, a sagging, low-ceilinged place, with a prominent photo of Amédé Ardoin near the entrance to the

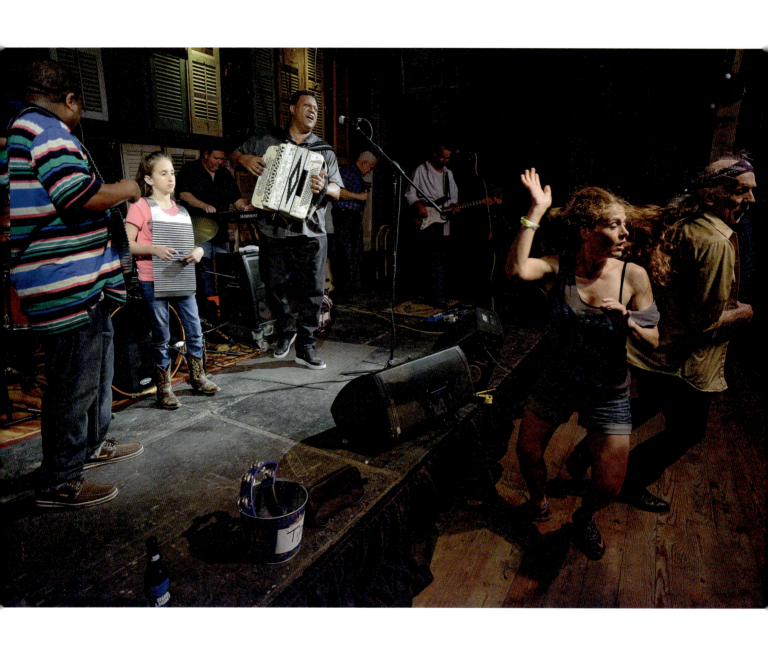

Chubby Carrier and the Bayou Swamp Band
at Feed and Seed, Lafayette, Louisiana, 2017

huge dance floor and photos of zydeco luminaries on the walls. It's a funky rural roadhouse. Feed and Seed is a designer's idea of such a place, so it's entirely different. Beer, if I recall, at Miller's was a buck, and it was by Anheuser Busch. Craft beers dominate Feed and Seed.

Now it is the morning after, and we're not booked for anything until tomorrow. I suggest that we take a drive toward St. Martinville and Loreauville, just to look around. While we're at it, I'm thinking we should have a look at the Clifton Chenier Club in Loreauville. Maybe, too, we can find another old club to photograph. I'm thinking here of Philip Gould and Herman Fuselier's excellent book *Ghosts of Good Times*, which documents now-abandoned clubs—including Chenier's—that were once plentiful and are currently supplanted by trailrides, casinos, and restaurants (2016, 2). To get to Loreauville from Opelousas takes you through, or around, Lafayette. We decide on through. At one point, I realize that we're not far from El Sido's, another famous zydeco venue. Gary and I had photographed Lil' Nathan and his band there a couple of Halloweens earlier. And it turns out that Jeannie and I had both been there, almost certainly on the same several nights, in the mid-1990s, before we knew each other, thanks to our having attended the same conference. So, I suggest we have a look, especially because we had no photos of the exterior of the building, it having been dark on that Halloween. We park on the street, start taking some photos, and a low-slung, obviously cared-for old truck arrives. Out comes Sid Williams, proprietor, musician, entrepreneur, manager, raconteur, businessman. A neighbor had called, he said, telling him that there were white people taking photos of his club. I reintroduced myself and Gary and mentioned Jeannie's connection. Within moments, Sid is graciously sitting for photos on the low rail outside the club.

He likes the camera, and the camera likes him. Today, he goes into the back and comes out offering us shirts emblazoned with the club's name. He offers us drinks. He shows us photos of various zydeco dignitaries on the wall. Buckwheat Zydeco, a good friend, who died September 24, 2016, is there. A large painting of Canray Fontenot (1922–1995), the celebrated Creole fiddler, occupies a wall. Sid has been at the center of many enterprises, including his younger brother Nathan's career as the leader of Nathan and the Zydeco Cha Chas. He pretty much raised Nathan after their father died young.

The club is often described as the epicenter of zydeco in Lafayette. It still caters to the traditional zydeco audience, unlike the Feed and Seed and other clubs that bring the music to white fans. Sid's energy and enthusiasm seem unbounded. Come to the store, he urges.

We follow him a few blocks around the corner to Sid's One Stop on Martin Luther King Jr. Drive. We meet Susanna, his wife, who is behind the counter. His brother, Andrew, walks in. Moments later, in comes Dennis Paul Williams, another brother. I'd met Dennis Paul

a few years back. He's the guitarist for Nathan and the Zydeco Cha Chas, and I'd emceed for them at a festival in Lowell, Massachusetts. Dennis Paul is a painter. You can see his work in *Soul Exchange: The Paintings of Dennis Paul Williams,* which the University of Louisiana at Lafayette Press published in 2013. He shares Sid's gift of gab. We pass a very pleasant couple of hours with the extended family. The club scene is not as robust as it used to be, Sid tells us. The audience is getting younger, but they tend to want to go to trailrides over clubs.

Then we head out, looking for Clifton Chenier's old club. To get there, we pass through St. Martinville, where we pass the legendary Evangeline Oak on Bayou Teche. It's a small town in good shape, unlike some of the other small places we've passed. Dennis Paul's home and studio are here, and he's involved in local government. From St. Martinville, we head into the country, looking for the club at 2116 Fernand Crochet Lane. The GPS tell us that's in New Iberia, but local knowledge has it in Loreauville. There are storm clouds in the distance, and the light is spectacular on March fields of sugar cane. We find the club, a low metal building hugging the ground. Clifton opened it in the 1970s, although I gather that he rarely performed there. Now it's in someone else's hands, open occasionally for performances and events. Clifton and his wife, Margaret, are buried nearby in All Saint's Cemetery on Harold Landry Road.

Heartened by our having found Clifton's club, I suggest that we escalate and look for another one. So we set our sights on PB Dee's Classic Club Valentine in nearby Parks. Or maybe it's Promised Land—it depends on your source and your map. And sometimes it's Promised Land; other times it's Promiseland. At times, Promiseland is described as a neighborhood in Parks whose residents are the descendants of enslaved people. Closed for renovations, the club itself sits on the corner of Resweber Highway and Promise Land Drive. We motor a few yards down Promise Land Drive to get off the main road, then exit the car to take photos. Moments later, a car stops, and a very friendly young Black woman asks us what we're doing, saying that she's just curious. We tell her, and she invites us to continue down the road to her family's house, from which she can show us the bayou. And she mentions a crawfish boil.

It's an invitation too alluring to pass up. So we finish our photography and drive down the road where we eventually find Tramaine Payne and some of her extended family in front of her mother Mary's house. They walk us to the verdant bayou through damp high grass. Mary tells us that Corey Ledet, whom we will visit tomorrow, played for a family event for her, and that his family owns property on that road. Gary shoots portraits of Tramaine, who will start graduate school in marketing in the fall. Crawfish are roiling in a huge pot on a propane-fueled burner in front of the house, children and adults having

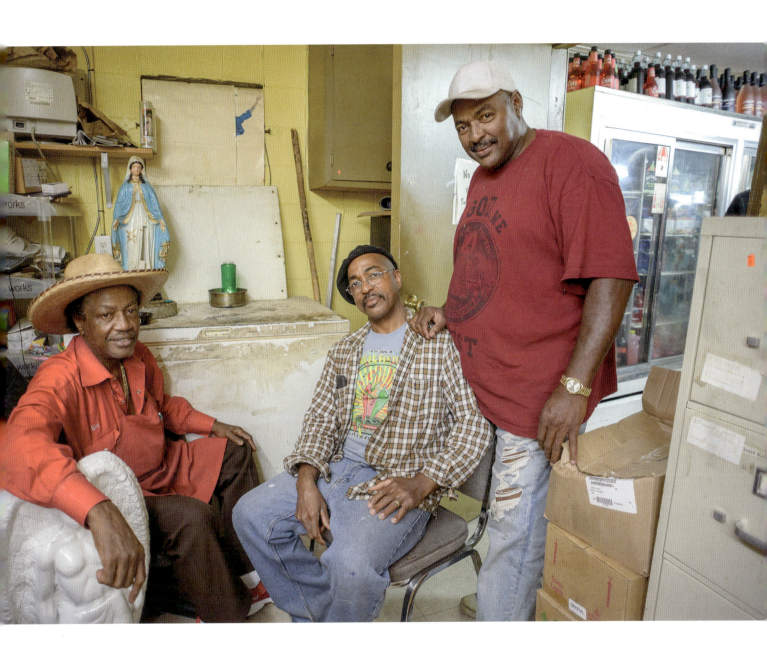

Sid, Dennis Paul, and Andrew:
Williams brothers at Sid's One-Stop
grocery, Lafayette, Louisiana, 2017

a quiet good time. It has been a long time, someone tells us, since they've seen white folks drive down their road. This, like our unanticipated visit with Sid and his family, like the previous night's short encounter with Dustin Miller, is one of those instances of kindness that I'll carry with me long after the book is published.

Before Dustin and Nichole Miller bought and renamed Richard's club, the hall was a major component of the world of zydeco music. It was a stop on a circuit of Black clubs that featured R&B artists touring the region; B.B. King and John Lee Hooker played there, along with Clifton Chenier, Boozoo Chavis, and other regional favorites. When we were there, it was an aging wood-frame building with a small bar, an expansive dance floor, a low ceiling, and a compact stage. A few weeks after our visit, the building burned; it was a total loss. Eventually, the police arrested the owner of another club, accusing him of torching two rival establishments—Miller's and the Charcoal Club.

BIG ACCORDION, LITTLE ACCORDION

Two lineages dominate today's world of zydeco. Call them big accordion and little accordion. On the big-accordion end of the spectrum, Clifton Chenier played the biggest—the piano accordion, forty pounds worth, or at least that's what people claim it weighed. Likewise, Rockin' Sydney, whose "Don't Mess with my Toot Toot" did very well, featured that "stomach Steinway," the piano accordion. These big instruments have a right-hand keyboard modeled on a piano, typically with many basses on the other side. They're chromatic, like a piano, utilizing black and white keys to play all the notes Western music tends to utilize. The first accordion with a keyboard dates to the 1850s, where, in Germany, it became a serious competitor to older forms of the instrument. Vaudevillian Count Guido Pietro Deiro christened it the piano accordion in 1910.

Clifton's influence can still be seen on stage; a number of zydeco musicians, probably inspired by him, use the piano accordion as their main instrument. In zydeco circles, people call it the piano-key accordion. They're typically produced industrially. Corey Ledet, interviewed here, a leading exponent and an especially fine player of any accordion, was heavily influenced by Clifton, and he talks about the instrument's versatility over the smaller accordions more common on zydeco stages these days. The late Buckwheat Zydeco, an alumnus of Clifton's band, played the piano-key. Although we ran into the instrument occasionally on our zydeco travels—Chubby Carrier and the Bayou Swamp Band at the Feed and Seed in Lafayette comes to mind—it's not the preferred squeezebox for any of the other leaders I interviewed for this book. C. J. Chenier, one of Clifton's sons, who continues his father's legacy, touring

with the Red Hot Louisiana Band, plays the piano-note accordion. His father, plagued by illness toward the end of his performing career, eventually became too weak to stand and play the big instrument; in his last shows, he sat, until C. J. eventually took over the accordion.

The small accordion in zydeco is the button accordion. It's a diatonic instrument, meaning that each button produces two notes, depending on whether you're pulling or pushing the bellows. People liken this to a harmonica, where inhaling and exhaling does the same. On the zydeco circuit, people tend to prefer the single-row accordion, ten buttons on one side and a few bass notes, typically not played, on the other. This is an older form of accordion, rooted in mid-nineteenth-century Europe. They reached Louisiana and other places in the Americas in the nineteenth century. Today, craftspeople in Louisiana, Texas, and elsewhere make these instruments, generally employing reeds and bellows produced in Italy. Ed Poullard, featured in this book, is probably the first Creole person to make button accordions.

Some musicians split the difference, as in the case of Rockin' Dopsie. Dopsie played the triple row, still a large, complex machine for making music. So does his son, Dwayne, one of this book's interviewees. And many of the players who use the single-row will also occasionally play the more flexible triple-row. What we saw at the trailrides and in clubs along the Creole Corridor nearly always featured the smaller, gutsier single-row accordion—more compact, lighter weight, more limited in its range. Because they have so few notes, it's common for an accordion player to have a few boxes on stage, each in a different key, adding flexibility for singing. Boozoo and Beau Jocque mostly played the single row. The big-accordion guys seem to center Clifton on the family tree. The little-accordion guys put Boozoo and Beau Jocque there, with Clifton present but not in direct lineage. In the world of zydeco, accordion size is an indicator of influence and lineage. But whatever the instrument, in the hands of a master it can growl, sound bluesy, and lift people off of their seats onto the dance floor.

At this time in the music's development, the audience is trending younger. It's a music that has willfully experienced a great deal of innovation, sweeping contemporary sounds into its core while holding hard to its cultural associations. A dance music first and foremost, it became for some, as in the case of Dwayne Dopsie (see his interview) more of a concert music. In fact, as Clifton Chenier's popularity grew and he and the band moved from playing dance halls to playing festivals and concerts, one change he had to cope with was playing for seated audiences. These days, as several of my interviewees commented, there's tension between older followers of the music and the newer, younger, more energetic fans, whose dancing, some say, is wilder and less dignified. Or, worse, they may have Creole forebears, but that doesn't mean they know how to dance. At trailrides and clubs, people

also do line dances, some of which are recent creations. They're a way for people who don't know how to zydeco to move on the dance floor—or it's a way to participate without needing a partner. You can also take zydeco dance lessons in Creole country, if you're interested.

On the map, the world of zydeco music is fairly small. But on its home turf, the music has a big presence. People love it and organize their lives around it by supporting trailrides, going to clubs, festivals, and church bazaars. In this fashion, they help musicians feed themselves and their families. Fans post innumerable videos, wear riding association T-shirts, and support the food vendors who haul their trucks and trailers from place to place. A generation ago, you had to have a day job if you wanted to play zydeco for money at night or on the weekends. Now, the zydeco economy is big enough that it supports a good number of musicians, and it has something of an infrastructure underneath it. Some of the interviewees here talk about radio play and selling sound recordings—even as those industries change and mostly become less pluralistic, less financially rewarding.

No one who speaks on these pages is on a national record label. But while there was a time when that might have been important—and Rounder, one of the major independent labels, released a lot of zydeco recordings—today, that hardly matters. The Maison de Soul label, established in the mid-seventies in Ville Platte, Louisiana, continues to feature zydeco. But most musicians think of sound recordings as secondary sources of income; it's live shows that support them. So, it's a fairly small, or regional, world of music that calls forth a big response from its fans. It gives young people an opportunity that's increasingly rare in the United States—dancing to live music. It gives people who care deeply about their culture and their heritage a boost. In fact, zydeco both induces people to feel the music in their bodies and reminds many of them of the ties that connect them to friends, family, ancestors, and meaningful places.

TEXAS

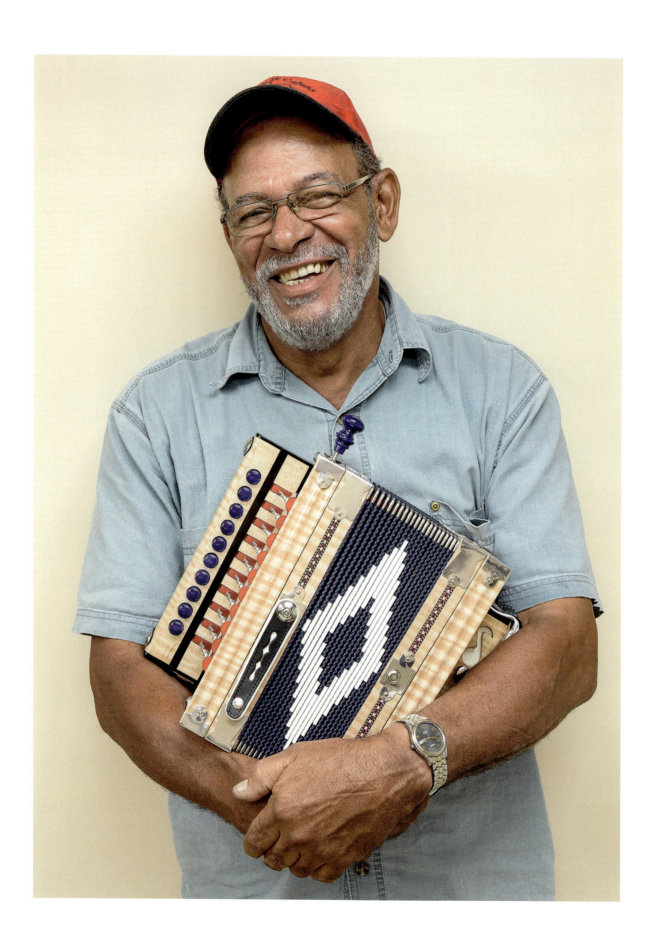

ED POULLARD

Creole United

In his affable way, Ed Poullard tells me that he's not a zydeco musician. He plays *French music*, zydeco's precursor. The music that moves him most comes from an era before Francophone music in Louisiana hit a fork in the road, branching in the two directions of Creole and Cajun. He has become a standard-bearer for that old music. He loves it.

Late one August night, we're in a closed restaurant just outside the bar, which is hopping, at the Holiday Inn in Bangor, Maine. It's the weekend of Bangor's annual American Folk Festival. Ed is here as a member of Creole United, a loose aggregation assembled by Sean Ardoin and Andre Thierry. Representing at least three generations of Creole musicians, the band plays across the history Creole music, from its early days to its contemporary zydeco sounds. Ed is there in part to play the fiddle, an instrument that has almost entirely vanished from Creole music. He plays the accordion, too. And he's also a maker of excellent diatonic accordions—reportedly the only one who bears Creole heritage.

He's thought a lot about this music. First and foremost, he puts it in the context of his life. It's "family music," he says. His father played the accordion, and his grandfather played the fiddle in a time and place where that sort of engagement was not out of the ordinary. "It's the continuance of a birthright," he says at one point. Later, he describes the music as the "continuance of a culture." Talking with him about his family history is a reminder that modern zydeco is not all that old. And its roots, in the tradition of musicians such as Amédé Ardoin, who are at the foundation of both zydeco music and Cajun music, remain close (Savoy 1984). Ed's grandfather played fiddle with Dennis McGee (1893–1989). McGee, a legendary musician of Irish, French, and Seminole descent, had played with Amédé Ardoin and other musicians back when the music was French—neither, or both, Creole and Cajun. One of its trajectories was to move through families, across generations. That's what happened in Ed's family.

"You've got little accordions running through your veins; you ought to be able to do this."

Interviewed August 30, 2015, in the lounge in the Holiday Inn in Bangor, Maine, during the American Folk Festival. Ed was at the festival as a member of Creole United. Ed grew up in and lives in Beaumont, Texas. Beaumont is home to the historic 1901 Spindletop Oil Gusher, which brought many job seekers to the area. Today, Ed lives about a mile from the original well.

Ed Poullard, Beaumont, Texas, 2015

Ed was born just outside of Eunice, Louisiana, in a small place called Richey. Before he was a year old, the family moved to Beaumont, Texas. They were "seeking a better life," as Ed puts it. His father, John Poullard, ended up working for the county, driving trucks and operating equipment. He had put the accordion aside while raising his family. He eventually went back to it, and for Ed, that was inspirational. He describes recording his father's playing and listening to it. Within a year of picking up the accordion, Ed could play a four-hour dance. His late brother, Danny, fourteen years his senior, was an important and revered accordion player and teacher in the northern California zydeco community (DeWitt 2008, 80). But unlike Ed, Danny left home before their father came back to the instrument. So Ed had firsthand exposure while Danny worked from tapes. Thanks to their father's influence, they both had the gift of an older model and style. They weren't fusty musical antiquarians, though. The family loved Clifton Chenier's music.

Ed began playing the fiddle after a freak accident damaged a right-hand finger, putting an end, for quite some time, to his ability to play the accordion. His grandfather's fiddle had passed to his father, John Poullard Sr. Ed took it up. He got some assistance from the very influential Cajun fiddler, Dewey Balfa (1927–1992). Creole fiddler Calvin Carriére (1921–2002), sometimes known as the "King of Zydeco fiddle," also helped out. Ed wrote a proposal for a traditional arts internship that gave him time with Canray Fontenot (1922–1995), probably the most influential fiddler in the Louisiana Creole tradition. Fontenot played, as a teenager, with Amédé Ardoin, although they did not record together. That was the start of a long relationship with the extended Ardoin family. For many years he partnered with Alphonse "Bois Sec" Ardoin. Bois Sec was Amédé's cousin. Canray and Bois Sec performed widely in Louisiana and, having been "discovered" by the folk revival, farther afield, including the Newport Folk Festival and at Carnegie Hall. Canray went on to play with the Ardoin Brothers, a band led by two of Bois Sec's sons. When Canray was indisposed, Ed took his place. Ed Poullard thus represents a stream of tradition deeply rooted in south Louisiana Creole culture. These days he plays with others whose interest or experience takes them to the same sources. He partners with Preston Frank, whose son, Keith, is enormously popular in contemporary zydeco. He got to know Cedric Watson, whom he met when Cedric was a young Texan learning to play Creole music. He teaches at music gatherings such as Augusta Heritage Center's Cajun and Creole Week at Davis and Elkins College in West Virginia. It's tempting to describe Ed Poullard as an elder statesman of an older tradition. But that doesn't do justice to the joy, enthusiasm, and mastery he brings to his music. Watch him perform. You can't help but appreciate that the old music is in good hands.

BF: Tell me something about the music you play. How would you describe it? How would you define it?

EP: Well, my best definition is something that I would call—I always did think this—it's family music. It's learned in the home, as all traditional music, or at least most of it, is learned. That's the way I've always seen most traditional musicians come up in the ranks, so far as their learning capabilities and skills. It's a music that's an expression of an individual. But it's also a continuance of a culture that's long preceded me.

And I would mention the people I got it from. My dad was an accordion player. He was my biggest influence in learning the accordion. And my grandpa was a fiddle player. So naturally the influence was there. And now I play both those instruments. So I got it from both sides of the fence, I guess.

It's a continuance of a birthright, first of all, being born in Louisiana and living in another state. And a continuance of a culture. Look at it from a cultural aspect—when I started this I didn't think that way. I was just having fun playing music. But now I represent a culture, and I'm doing the best that I can possibly do to be a good representative.

It's a music with a really good groove. It's transitioned considerably since the time I learned to what the younger people are playing now. Which is cool. It's not my preference. But I'm kind of old-fashioned anyway. I like what I do, and I'm proud to share it with others.

BF: That's great. You said it's connected to a culture, along with your personal family background. Can you say something about that culture?

EP: My dad was like a sharecropper. Raised a big family. And during those times, when he was coming up, even before he got married, he'd learned how to play the accordion—ever since he was a child. Twelve years old, he was playing the house dances. I always did hear about that. I never got a chance to witness any.

But that part of the culture is what I'm trying to deliver and represent. Back when those house dances were being given and even the positions that they sat in, the instruments they played—I try to keep that as original as possible. Right now. When I play with my trio, we play sitting because they always did play sitting. There wasn't that much room, anyway. We play sitting. We play the older style. Which is a little bit more syncopated than what they're playing now, or versus Cajun music. It's a real rapid pace, like double time almost. When I play I prefer to play that way because that's the way I got it.

And now I'm representing that form. Because nobody else is doing it. Everybody's attracted to today's band atmosphere. But they forget about where the music came from. I'm trying to keep the music thing alive. The band is secondary to me. But I do play in the bands, too. It's a lot of fun.

Zydecoing, Jax Grill, Houston, Texas, 2017

The groove is real important. Like I say, I play a very old style that's eventually going to fade away. Because none of the younger—very few; I say "very few" because "none" is not the word. Very few are learning that style. Andre Thierry is an accordion player. He's one of the few that can sit and play in that same tradition. You can recognize the style that he plays immediately versus what the other people his age are doing. All it takes is one person, one young person, to make it attractive to a whole lot of others, and that's the way you keep the tradition from dying. That's what I'm trying to do.

BF: Would you call it Creole music? Is that good term for it?

EP: I've always called it French music.

BF: French music.

EP: Yeah. I never lived in Louisiana that long, but we made frequent trips to Louisiana when I was kid. I lived in Texas most of my life. And the music that I'm playing now was always referred to as French music. It never was called Cajun music or Creole. The labels came, I think, about when the music started becoming commercial. That's when the identities started showing up. It's always been French music to me, and it still is today.

A lot of people call me a Creole fiddler. I can play in any music situation. I don't consider myself strictly a Creole music fiddler. I play in Cajun configurations. I play in country configurations. Creole, too. But these labels appeared much later.

BF: So you were born in Louisiana.

EP: I was born just outside of Eunice, Louisiana. My family came from an area called Richey, Louisiana.

BF: How do you spell that?

EP: R-I-C-H-E-Y. Like "Richey." But you know, the French pronunciation puts the emphasis on the backside.

I come from a family of eleven children, six girls and five boys. I can't remember what number child was born before they moved to another location right on the south side of Eunice. I was the last child born in Louisiana; I was number nine out of eleven. There's two younger than me, one brother and one sister. We moved to Texas when I was nine months old. I've been living Texas ever since.

BF: And what year were you born?

EP: 1952.

BF: You said your father was essentially a sharecropper. Your mother—probably working in the house?

EP: She didn't have time to work anywhere else, with kids. Yeah, she didn't have time for a full-time job. The family was a full-time job. And she stayed pretty busy.

BF: What took the family to Texas?

EP: Seeking a better life. You know, my dad had a bunch of kids. He just didn't feel that life, or the style of life they were leading, was

enough to provide for big family. So, he moved to Texas. It was back in the oil-boom days, where jobs were plentiful over in that area. So he just moved over there to better living conditions. Especially with the kids.

BF: And did he move to Beaumont?

EP: Moved to Beaumont. Beaumont was not large; it was bigger than Eunice, where they originally came from. But there was a lot of work. There were a lot of oil businesses. Petrochemical plants. My dad got a job there and finished raising a family right there in Beaumont.

BF: And he was an accordion player.

EP: Yeah. He started playing when he was twelve years old. When he turned, I want to say thirteen, fourteen, he was playing house dances. Those were in the former communities where they lived around Richey, which is slightly west of Eunice. Slightly south of Eunice. In between Eunice and Iota is where it is. He learned from his uncle, my grandmother's brother. He learned from him and learned how to play what they call double notes, which is harmony, as you know. And he became a real good accordion player really fast. Because he had an instrument and had the time to do it, I guess.

He was always my idol. I never knew he could play accordion. I was always told he was an accordion player but never saw him play. He played the house dances and then a little bit later in life he got married, started raising a family. And the accordion kind of got put to the side. He sold it; he needed the money. The kids were popping up faster than the accordion was worth.

He concentrated on making a living and raising his family, and just kind of put the accordion-playing on the back burner. Finally, he sold it; he got rid of it. He stopped playing for like twenty-one years.

During that time I guess was when the decision was made to move to Texas, to better living conditions. They used to go up town every Saturday. And that's the expression they used. To go shopping, to get groceries, and everything. Well, when I was nine or ten years old, one day he comes back with this little box that I came to find out he had been paying on, like a layaway deal, but he never said anything, never told anybody. He brought his little box, placed it on the sofa very gently. And he sat down, opened up, and took it out. It was a little Hohner HA-114 accordion. Back then they were made in Germany. He took that thing out and unwrapped it, stuck his thumb in the thumb strap, opened it up. And he started playing.

That was my first exposure to it—my immediate family member playing music. I could not believe that. I thought that was the coolest thing I'd ever seen. But I guess the inspiration set in right there, after watching him play.

My grandfather used to sit and play fiddle with Dennis McGee. I never got a chance to hear my grandfather play. For many years. My parents told me that; I never witnessed it. That was a big inspiration, too. Really,

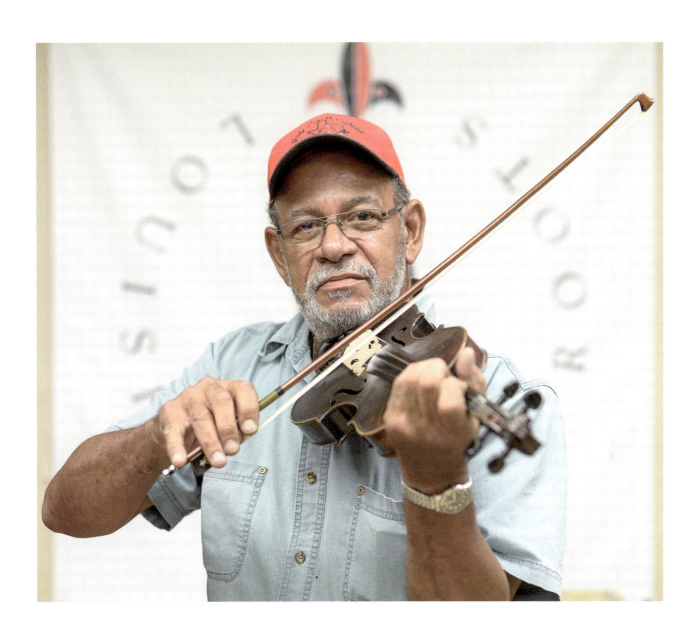

Ed Poullard and fiddle, Beaumont, Texas, 2015

when I first started playing music, I wanted to play the fiddle. I wound up playing the accordion. Then I had an accident with my right hand; I couldn't play anymore. That's the reason I'm playing the fiddle now.

BF: I guess you recovered enough from the accident that you're playing the accordion, too; you're back on the accordion.

EP: It took a long time. I was out of it for like, I don't know, ten years. I almost lost my finger. I was a truck driver and jumped out of a truck and got hung by my ring.

BF: I don't want to hear that.

EP: Yeah, I know. Makes me cringe every time I think of it. That's how—it took—you know, it never was the same. I still play. And at times, depending on the time of year, depending on me, you know, I still play fairly well, but nowhere near where I did before. It's frustrating. So I kind of put it aside, left it alone.

When my daughter and my son started playing—after I got married and had kids and they grew up and were interested in learning—I started playing again. Trying, but maybe not a real good attempt, to get back to what I had before. It's not there, but I'm satisfied with what I can do now. It took a long time.

BF: So you were nine or ten, and your father brings home the accordion. And you're inspired to start playing. Were you hearing that kind of music at all around, in Texas?

EP: Oh, yeah.

BF: It was in the community?

EP: There were programs, radio programs, that had French music broadcast that we could catch.

BF: Were they coming from Louisiana?

EP: Coming from Louisiana. There was also a local television station that broadcast live music, French music, Cajun music, Creole music, whatever you want to call it. So it was televised, way back then. I used to watch that and watch how people responded to the music. Andrew Cormier was one of the people that was frequently a guest on that TV program, and several others back then that were pretty popular. I used to watch all that stuff.

I guess that was the beginning of my method of absorbing the music and trying to retain what I could. I didn't realize it at the time. But I remember a whole lot more than I thought I would about the music.

It was shock for me to sit there and watch my dad play. And I didn't want that to happen when my kids were around. I didn't want them to hear about me playing from somebody else. So I got them exposed to it at real young ages. Now they both play.

BF: Exposed to it in that you played for them?

EP: Oh yeah. In the house. All the time. And my dad was still around when they were little. He would come over, and we'd play together. So that was, that really got my son—my son is older than

my daughter—that really got him inspired. He learned pretty much on his own. Just sitting there, listening, chiming in on sessions when we'd play, and stuff like that. That's how he got started.

BF: So it sounds like, at that point, anyway, it was kind of a home music that you're describing. It wasn't that people were going out to clubs to hear that music or anything like that. And I guess it sounds, too, like when you were young and getting started in Beaumont, people weren't dancing in people's houses, or you weren't aware of it.

EP: There were church functions, like bazaars. They'd give church dances, like maybe—if it was very often it would be once a month. Sometimes it wasn't that often. But that's where we played most of time, when we played out, away from home. Church functions and private parties.

BF: Would people dance to the music then?

EP: Oh yeah—at the church functions they would. And a lot of times at the parties they would, too. I wouldn't consider that a house dance, like they were speaking of long ago. But people would feel the music and start dancing. I guess it would turn into one.

BF: And it would it be mostly one accordion player, or would it be more than that?

EP: No, it would just be one accordion player—they weren't as plentiful as they are now. Fiddle players were even less plentiful. There weren't very many fiddle players in that area where I lived in Beaumont. One guy, but he wasn't—he was an infrequent player. And when he played it kind of showed. He wasn't one I wanted to sit with and learn.

BF: So, you're a kid and you're learning to play, and you're starting to play a little a bit at parties and church and so forth. Did you feel—I'm thinking about what your friends in school would have thought about a kid playing accordion. Was that a cool thing?

EP: No. They made fun of me. Laughed and said I was playing that old la-la music, and all that. You know, they had a good time with it.

Now I'm having a good time with it.

BF: And you're going to outlive them, too—right?

EP: I already have, some of them.

Back then people always kept their doors open. Front doors, for sure. Kids were in and out of the houses, across the street to somebody else's house. And it was just a small neighborhood community, where we lived. Some people from Louisiana, some people just never been out of Texas before. People in that area used to hear my daddy playing and say how good he sounded. None of them, I guess only a few, went over a little bit closer where they could listen.

But both my neighbors at my mama's house, they were from Louisiana. They were right at home listening to us when we played acoustically, say like in the bedroom or on the back porch or wherever it was. It was a mixed community but everybody liked it. So that kind of response,

people don't think about. But when you go back and think about it, it you get that kind of response from people that have, I guess, been exposed to but witnessed people playing live, and they enjoy it. So why not give it a shot? And see how far you can carry that. See how many more people you can get interested.

That's what really carried me farther than I think I would have gone, had I not seen how people responded. That means a lot when you're learning. A lot of people, when you're not that good a player, they're pretty brutal. They'll tell you, "You need a lot of work," or—my daddy's favorite saying was, "That's not for everybody."

So, in retrospect, I gave a lot of time, on my own, listening to my daddy play. And I recorded him on tapes. I rode around, cutting grass, riding bicycles, with some headphones on, with a tape machine on, so that I could learn the melodies the correct way, note for note. And when I sat down to try to learn how to play a song, everything was up here, in my head.

I was playing what could have been considered professionally in a year. Playing accordion.

BF: What do you mean by "considered professionally"?

EP: I was at the point where I could go play a dance, a four-hour dance, and not play the same song twice. I'd learned a lot in a year just by trying to absorb that music any kind of way I could. From watching, listening, and everything. And trying to pick up more repertoire in that process. I moved pretty fast on it.

That might have been a little bit too fast for my daddy, I think. I used to let him listen to tapes that I recorded, of me playing. He would think it was him. Because I emulated his style so close. My mama used to tell me that all the time. "You sound exactly like your daddy." Couple of times I fooled him pretty good. That's how I knew I was doing okay.

BF: You had at least one brother who played, too. Right?

EP: Yes. One brother only that played.

BF: That was Danny.

EP: Yes. Out of the five brothers, there were just two of us that picked up the music and carried it on.

BF: And was he older or younger?

EP: Older. He was fourteen years older than me.

BF: Did he start about the same time?

EP: He started before I did. Yeah. He was living in California. Queen Ida and a guy named John Simien lived out in the same area where he was, in the Bay area. He got involved in the music, playing guitar. But he always wanted to play the accordion. So he was playing with John Simien. He played guitar, bass guitar. Queen Ida picked him up, and he played bass with her for a while.

During that time, when he was playing guitar with those two, primarily with those two, he bought an accordion and started learning.

He'd get tapes from my dad, and whenever he'd come to visit he'd record a bunch of stuff and take it back with him. That kind of thing. He pretty much learned on his own, compared to me. I was living in the house with my daddy, so if I ran into a snag and needed something demonstrated, I could go get him, say, "Hey, play this for me so I can see how you do it." Or listen to it; try to get it. He didn't have that advantage. He was gone. That's why I play so much like my dad because I was there with him.

But Danny was a good accordion player. He learned a lot, just from recordings, which he did a really good job of doing. And he always looked back and said, "I wish I'd had the opportunity to sit with daddy the way you did."

BF: Any of your sisters . . . ?

EP: None of them played accordion. I had one sister played the guitar. She played acoustic guitar. She didn't carry it very far. She did it whenever she had time. She played a lot in church, primarily. As far as playing in public, she wasn't interested.

BF: Did your parents speak French?

EP: Oh yeah. They spoke French all day, every day, all day.

BF: And what about you? Did you speak it at all?

EP: I didn't speak it because nobody around but my parents, and my older brothers and sisters, spoke it. Being normal kids, and hanging out with people our age—nobody else spoke it. Because we lived in an African American neighborhood where there were mixed French people, Texas people, and everything else.

So they didn't spend much time teaching us because they would always talk French when they didn't want you to understand. But, man, we used to go see my grandma. My grandmother didn't speak English all. She spoke French until she died. Whenever she said something, she spoke to us in French—knowing that we didn't speak much. But she had a real particular way of encouraging you to learn French. Because if she told you not to do something, and you did it anyway, you might not have understood the first time, but I guarantee that second time, you're going to know what those French words mean the next time. It would get a little bit physical there—you know what I mean?

That's how I learned, really—listening more to the grownups talk. And I'd ask questions. My mother would tell me, but a lot of the other grownups wouldn't tell you much. They wanted to keep it hidden.

BF: When did you start hearing the more modern music? I'm talking about Clifton Chenier. . . .

EP: I've been listening to Clifton Chenier ever since I was a kid.

BF: Yeah, I would think you would have.

EP: Both my dad and my mother was crazy about his style of music. And they had a few records. Not very many. But they used to play some of his stuff on the radio, too. And I loved it. There were

several nightclubs in the area where I lived that Cliff used to frequent and play there regularly. I mean, I couldn't go—I was too little. But my older sisters and older brothers had a chance to go listen to him on occasion. For me, it was mostly recordings where I got to listen to him. And I liked that because it was more bluesy sounding. Which was a drastic change from the old, what was called "la-la music," which was what I was playing.

You're limited on the style of accordion that I play, which is called a diatonic accordion, compared to the type of accordion that Cliff played, which was a chromatic accordion. It had a full twelve-note scale. You could do just about anything on that because of the wide range. And Cliff felt very limited on the older accordions, and I'm picking this up from my older family members; they heard interviews where he was talking. He said the reason why he learned to play the bigger accordion, there were so many limitations on the little one. He couldn't do the expressions that he wanted to do—the blues and the other things that he did. And the little things; they just didn't sound right. So the chromatic was the way to go. And he was awesome at playing it. He used to play a single-row accordion, when he started. Sure did.

I like what a lot of the younger guys are doing. But there are some out there that are just playing. Some of them are representing. Some of them are just playing in a band. The ones that are representing, they're really, really serious about what they're doing. That shows in their recordings and their live appearances also. The others, they're just out there playing in a band. I'm not going to call any names. I've got my preferences. People like—and I keep using Andre Thierry—there's another guy named Corey Ledet. He's a fantastic accordion player.

Chris Ardoin is an awesome accordion player. Nathan Williams Jr. I can go on and on with people from Louisiana. But Andre does not live in Louisiana. And Corey Ledet is not from Louisiana. He lives in Louisiana now. But they took it upon themselves to go that extra mile to learn the repertoire as it was played originally and then take that ball and carry it further. I can't say enough about him. That means a lot to me. And if they come back and want to learn some of the older tunes, man, I flip over backwards to try to help them out and get them headed in the right direction. I spend a lot of time with Corey and Andre, when he came.

BF: So, you think it's important that this older approach to the music, older understanding of the music, older style of the music, continues.

EP: A lot of people nowadays learn three songs on the accordion, and they get a band together, and start playing commercially. They don't take the time and do what it takes to learn the history of the music. You can sit them down in a situation and ask them questions

and find that out quick. I think they should at least find out where it comes from before they try to carry it forward.

BF: Do you think it's important that the people who do carry the music, or even come to it to learn it, have that French ancestry, that Creole ancestry, the same cultural background?

EP: I think it's important for them to progress faster. Being in that environment helps out tremendously. Like I was. I don't think I would have progressed as fast as I did had I not been in that situation. Just playing the music? There are a lot of talented people out there. They can come back and do everything you do, note for note. But they're not coming from here, from the heart. They're just playing notes. That's it. They don't have the groove, a lot of times. And they sure as hell don't have the heartfelt feeling that was with it, too. I think. That's my own approach to it.

BF: So, to change gears, talk about when you started to play the fiddle after the accident. How old were you, and how did you connect with Canray?

EP: I had just gotten married. I was working for United Parcel Service. I was a package car driver, and I was on my route one day. I pulled up to a place called Mid-County Hospital, of all places. And we had a pretty hectic schedule daily, as you know. You've seen those guys running. And I jumped out of the package car to make a delivery and got hung by my ring. At the hospital, thank goodness. I couldn't get off the hook. Anyway, I got bailed out and had to have the ring cut off. It was—when I finally got my head back in order, I guess it was a couple, three years, after that, I didn't want to stop playing music. I liked the music so much that I wanted to do something. I couldn't play the accordion. I could play the guitar, but that wasn't my cup of tea.

During that time, that transition between when I got hurt and when I so-called recuperated from the injury, my grandfather passed away. My dad, being the oldest kid in the family, he got my grandfather's fiddle. The rest of the family thought he ought to have it because he was the oldest member. So he gets the fiddle and brings it home, just about the time that I want to play—getting my head straight and trying to focus on it. I asked my dad, "Do you mind if I try to learn something on that thing?"

He said, "Yeah. Just be real careful."

I started scratching. I was making everybody miserable. Including myself. That's how I got started, really. And then my wife bought me a fiddle, I guess about a year after that. Because I was limited to the time I could spend on the one my dad had; I couldn't take that fiddle home. It had to stay at his house. So she bought me one so I could have it at home.

I started making a little bit more progress. But I was working shift work, working in a plant and all this, didn't have a great amount

of time to spend doing it. When I did get the time I'd really knuckle under and get after it. I started making more progress because I had time. Then I started listening to more people, and I was trying to jam and get into music situations with other people. And I really started sounding halfway decent—this is coming from my mother—compared to when I started.

Anyway, I started getting out more, going over to Louisiana, trying to learn from other people. I went to see Dewey Balfa, and he helped me out a little bit. I showed him what I could do. And I went to see a guy named Calvin Carrière and sat with him and had a real nice long conversation. He demonstrated a few things. He said go home and work on this kind of thing. And I started going back and forth. We were still going to see my grandparents. Then I started making a little bit more progress.

Finally, a guy named Nolton Simien needed a fiddle player. Calvin Carrière used to play the fiddle with him. So they wanted another Creole guy to play with them—he was playing without a fiddle player. I told him, I said, "I'd love to play, and try to play, if you'd teach me the songs." He played awesome accordion. Badass accordion player. So I got a chance to meet him and go over to visit with him, jam with him. And, finally, he was the first one that let me play out in public, you know, commercially, in his band.

So, I started that way. And we played like once, twice a month, maybe. I'd have to drive over to Louisiana and meet him; he played over in Texas some, too. That's how I got the ball rolling with playing the fiddle.

BF: Playing for what kind of events?

EP: Church. It's basically the same situation. We didn't play in hardly any clubs. It was mostly just church dances and bazaars, stuff like that.

BF: These churches, presumably they were Catholic; were they mostly for people of French ancestry?

EP: Oh, right. They were. Sometimes they were in rural communities, and sometimes they were in the heart of Houston or someplace like that. But it's still the same atmosphere. Once you get inside those four walls. The same type people. The same beliefs. Same heritage. You know, come together to enjoy each other's company and dance a little bit, listening to music. But I started playing with Nolton, and then it took off.

I used to listen to the Ardoins play when I was coming up. I never got a chance to listen to them play live. I used to go to Slim's Y-Ki-Ki; that's when the Ardoin Brothers were playing. Gustave Ardoin was still living—Black's older brother. Got killed in an automobile accident. I'd listen to him playing. He was a really good accordion player. Then after his accident—he passed away—Lawrence came up and started

taking over the band situation. I got a chance to go listen to them, too, at Slim's. Then they got Canray to start playing the fiddle.

I know you know his history of alcohol abuse. He had a real bad drinking problem. He couldn't stay awake the whole dance. That happened a lot of times. I got a chance to go listen to him in Opelousas, and the same thing happened. Then I got a chance to go listen to him in Texas. It was the same situation. They asked me to come sit in and play the fiddle with them a little bit. And I did. I didn't like to do that, playing on Canray's fiddle. But I did. And got away with it.

The third time that actually happened was in Lake Charles. They were playing at a place called Walker's Recreation Center on Interstate 10. I walked in—same situation. Went up and sat in. And then after I got done playing with them, they asked me to stay until after the gig, the Ardoin Brothers did. And I followed them home after all the equipment was loaded. We all sat around the table and had a little meeting, and they asked me to join the band. That's when I really started taking off with the fiddle because I was playing a whole lot more. That's how I got started back then.

BF: How old would you have been when they asked you to start in the band?

EP: Man, I want to say it was in the early—late seventies, early eighties. Yeah. Early eighties. Because Black and I recorded our first album together somewhere around '84. And I had played with him for several years before.

BF: Was that for Chris Strachwitz and his Arhoolie label?

EP: Yes. Sure was. And that was the first recording that I ever played on.

BF: At some point you got an apprenticeship.

EP: Yes. Later on, while I was playing with those guys. I was approached, actually, by the Texas Folklife people, to be a master artist on the accordion. It was Kay Turner and Pat Jasper—we talked about it, and then I kind of turned that conversation around, when I found out what my options were. I told them I would love to do the apprenticeship but be the apprentice myself. And learn fiddle. They said, "Oh, that's a great idea." I told them what I was shooting for and the people I was interested in—Dewey Balfa and Canray. So I applied for the grant and eventually got the grant to study with Canray. That ordeal lasted nine or ten months, traveling back and forth from Texas to Canray's house, trying to get it when I could because I was working shift work. I was working twelve-hour shifts, and every twenty-two days I had a seven-day period of being off work. So I'd try to get as much done during that week as I could.

I got the grant to do that, and I was set. I learned a lot from him. And I thank him and God every day for being able to do that. I was,

I think, the first formal apprentice. And D'Jalma Garnier was the only other one, after me.

BF: It interests me that you talk about going to see Dewey Balfa and Canray, whose music, to me, is very different. And I think, too, about how I've read about how some of the young zydeco guys get really angry when people call their music Cajun music. I'm not sure what my question is here, but I'm just thinking—do you think of the older music as being more closely related to Cajun than most people say, or in that earlier era that they weren't as much two separate streams?

EP: Sure. That's what I said earlier about it being called French music. In the early days, like when my dad came along—anywhere from 1910, which was when he was born, and there were a lot of those older gentleman that was born along that same time period. All the way up to the forties, fifties, sixties. You could listen to those old guys—I don't care what background they were. You could listen to them play the accordion, and you couldn't tell who it was. They played the same songs, and they played them the same way. It wasn't Cajun; it wasn't Creole. It was French.

Later, much later, when the distinction really started to show up, the real polished guys that would play all the time started playing real notey—lots of notes. You could tell who those people were. But with the old timers that kept the music original—the way it was played, the way they learned it—you couldn't tell who it was.

If somebody calls what I do Cajun, I don't care. Because I know better. I'm playing music that was here before that term was ever used.

BF: That makes perfect sense. Yeah. So, who's your audience these days?

EP: What kind of situations are you talking about?

BF: All of them, I guess. I know you play a fair number of festivals and do some teaching. Do you know Leroy Thomas? I was talking to him at the Lowell Folk Festival a few weeks ago, and he was talking about how happy he is that he has enough gigs around Louisiana that he doesn't travel very much. And he said, "I play for almost entirely white audiences there." Are you playing mostly for festivals and white audiences these days?

EP: Yes. I would think so. There's not much demand in the younger Black community for the music I play. There are a few that appreciate it. None of them, I don't think, will be in a position to, say, hire me to play at one of their establishments. But there are a few that like it. Most of the people that I play for are people that are out of Louisiana, away from Louisiana, that are big fans of the music and avid participants in it. They even go to the extreme of coming down to Louisiana and learning the music, and then go back to their states, wherever they're from, and form their own bands. And do a good job.

I never thought about that. I really haven't. But I still—I play with Preston Frank; Lawrence Ardoin and I still play together. I play in several different band configurations. I guess that would be a good depiction of it, primarily white, yeah.

BF: When did you start building accordions? You starting building for your daughter?

EP: Well, one year I was going to Augusta, West Virginia, and my daughter was always interested in coming. So I brought her with me. But I told her she just couldn't go—she wanted to go there and hang out and see what was happening. She didn't know this, but I had arranged for her to have a scholarship to take a class. But I didn't know what she wanted to take, and I wasn't going to make that decision until we got there. So we get there, and I introduced her to Margot Blevins, director of Augusta Heritage Center at the time. I explained to her what the conditions were for that week. Strangely enough, she picked accordion. The beginning accordion class then was a guy, originally from Mamou, he lives in Lafayette. His name is John Vidrine.

BF: I know that name.

EP: Yeah. He's got recordings. I didn't want to teach her, a beginner; I would rather somebody else started her off. Because I would have the attitude of, well, "You've got little accordions running through your veins; you ought to be able to do this." I would have run her off. I didn't want to break her spirit or change her attitude about it. John is a real sweet guy. He has a real nice approach to newcomers and does everything he can to encourage them. I thought that that would be a good start.

She was in there two days, and John couldn't believe her. She was pretty much taking over the class. She would learn so fast that at the end, during the showcase, she was the music director. He didn't have to do nothing.

BF: She's going to elbow you aside.

EP: Yeah. She blew me away, doing that. So I figured, well, "You don't have an accordion. . . ." I went to a friend of mine. His name is Jude Moreau. Asked him to build an accordion for her. For my daughter. I saw what she was capable of doing. If she's going to need an accordion, I want somebody—get her one built.

Well, Jude knew I was interested in building accordions. So, he said, "I'm not going to build that accordion. Unless you help me." He wanted me to get more involved in the building. So I started doing that. I helped him—didn't have a clue what was happening. He took the time to explain every little detail, step by step, of everything. Even the tuning. Right down to putting it in her hands. I really was impressed at his method. He made it look a whole lot simpler than Marc Savoy and Larry Miller did years before when I had gone to them for advice, anything they could help me with.

Anyway, I thought about it. Said, "Man, if I'm going to do this, I need to get a means of paying for the equipment and getting the guy that I'm going to do the apprenticeship with paid for his time." So I wrote to Nancy Bless, the Texas Folklife Resources director. She told me to go ahead apply for a grant. She thought it was a great idea. So I did. And I wrote my own grant for the apprenticeship. And I got it. That was in 2001? No. That was in 2003.

That's how I started. It was after my brother passed away. He's the one that always tried to get me to start building accordions because I'd been a woodworker for a hundred years. After he saw what I could do—cabinet work and desks and all kinds of other furniture that I was building, he said, "You ought to be able to build one of these. It's made out of wood." And he pushed it and pushed it and pushed it. Finally—it wasn't until after he passed away that the opportunity came along. And the reason, I guess, other than just him pushing, saying, "You can build this." When my daughter got interested in learning and my son was already playing, I said, "I need to get this done so I can take off with this and at least build their instruments, and maintain them and my own."

But I didn't know I was going to do it commercially. So that's how I got started, and I've been doing it ever since.

BF: How many have you made?

EP: I'm putting together 48 and 49 right now. And that's along with playing music—and back then I was working full time, playing music, and taking care of all my other duties. That's a large number of accordions. Every spare moment I had I was out there, trying to cut them out and put some together.

BF: Do you do the reeds, too?

EP: Reed blocks, yes. I make the blocks. But I order the reeds from Italy. And the bellows. But all of the woodwork—the framework, the end plates, the bass box, the keyboard, the internal slide plates and the stops inside, the reed blocks themselves, both sides—I do all of that myself.

BF: Is that one of yours that you were playing on stage?

EP: Yes.

BF: Beautiful. Beautiful. Beautiful figured wood.

EP: Thank you. That wood came from West Virginia.

BF: I didn't see it close up. Was it maple?

EP: Curly maple.

BF: Like a fiddle back.

EP: It didn't really contrast and enhance the wood; it kind of hid it. You can't really see it until you get close to it. It's a pretty color; it just didn't blend well with that wood grain. In spots where you thought it would have shown the dye, and absorbed in in other places, it did exactly the reverse.

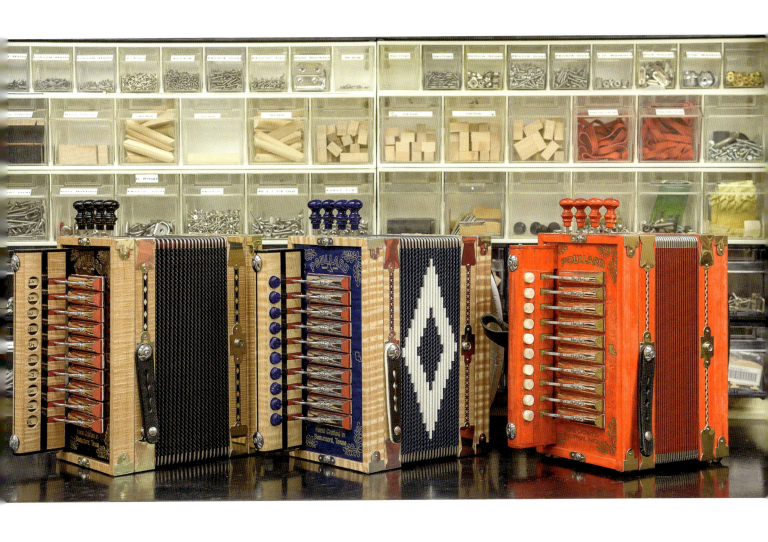

Single-row accordions made by Ed Poullard, Beaumont, Texas, 2015

BF: I don't think wood gets much prettier than curly maple. Beautiful wood.

EP: There are several variations of curly maple that are just ungodly pretty. I got a cut of wood from a guy named Peter Lynch, who's a violin-maker in Michigan. I've never in my life seen curly maple like that. It was real tight. And it looked like it was stamped; it was so perfect. It was gorgeous. Really. I've got enough for one more accordion.

BF: Another question about accordions. This is based, actually, on something that Leroy Thomas said to me. He said that most zydeco musicians—he was comparing this to Cajun players, to modern, contemporary Cajun players—the Cajun guys attach the microphone on the outside, and the zydeco guys like to put it inside the cabinet of the instrument. I see you're clipping on a microphone. Is that because you like that sound better?

EP: Yes. It sounds more natural. You don't have all that growly sound with the bass—every time you change directions with that accordion, and the pickup is internal, unless you have some kind of special windscreen—and it can't be a regular windscreen, it has to be something special. Every time you change direction, it makes a sound. You can hear it in that PA.

BF: I wonder if that's one of the things that characterizes some of that modern playing.

EP: I never did like that sound. I play with a bass. You get a cleaner sound if you put microphones in front. It defines the music to me a whole lot more so than having that old growly sound. It's constant; it's irritating to me. And I don't like it. But I don't think it's a Cajun-zydeco thing. Most of the zydeco players prefer to have the pickup internal because it's loud.

BF: Yeah. Some of those guys are playing at really high volumes. Less feedback, probably, too.

EP: It's less of a hassle. The thing is already built in the accordion. You plug the wire in and go. I use clip-ons because you cannot get a natural sound out of those internal pickups. There's a few on the market that you can, but they feed back like nobody's business. A lot of those guys, most of them, are in a hurry because they're running late. They just plug and go, you know. There are a few, I guess, I don't know of any—none of the Cajun players that I know have internal pickups. But I think that's the sound they're looking for. There are other people that play Cajun music around the United States that have internal pickups, but the people in Louisiana don't.

BF: So who is making accordions? I know that Marc Savoy is still making accordions.

EP: Marc is still making them. Junior Martin. Leland Colligan. Randy Falcon. A guy named Rusty Sanner. A guy named Bryan Lafleur. Guy named Guillory from Lake Charles; he still makes them. Larry

Miller doesn't make them anymore. He was making them out of Lake Charles. There's a new guy, two new guys, one named Toby Cormier, New Iberia, and there's a guy named Richard—don't know his full name. But he builds them, and one other guy in Ville Platte.

BF: So quite a few.

EP: Quite a few. Oh, Michot, not Tommy, but his son, Andrew. He builds accordions.

BF: And are you mostly playing with the trio when you're doing gigs?

EP: Depends on the venue. I would prefer that it be the trio most of the time. Because when I play with Preston Frank we usually have a band that backs us up. With Lawrence Ardoin it could be the trio or a band, depending on the venue. The other group I play with, called Cajun Harmony, it's a full band. When I play with Jesse Lége, most of the time it's a full band. Just depends on where we play. I prefer playing three-piece.

BF: Who is in the trio?

EP: Mine?

BF: Yeah.

EP: It's myself; sometimes it's my son [Ryan] on accordion. And me on fiddle and a guy named J. B. Adams, from Houston, plays guitar with us. In that same configuration, when Ryan, my son, can't be there, Lawrence Ardoin is there. He plays with us. We just did a job in Houston at the Rothko Chapel. My son couldn't be there. So Lawrence came with us and played. When I play with Jesse, he's on accordion, I'm on fiddle, and we have a guitar player.

BF: Thinking about the old-style music that you play, which is your first love, obviously, what do you think will happen when you stop playing? Do think there are going to be many other people playing it?

EP: I think it will still be played, but there won't be many people playing it. It's a difficult style to learn. One thing I will say, that a lot of the guys that went the zydeco route—these were the younger guys— they chose that route for, I would say, two reasons. One reason is to be able to deliver what they have to an audience, pretty much their own age. Another reason is it's easier to play that style of music than it is to play that older style. So, if that attitude continues in that respect, it's going to die. But there are a few—I say that honestly, just a few—that search for the older styles. And as long as those kind of people are around, it's not going to ever go away.

BF: This is a hard question to ask; if it did die, what would be lost?

EP: That would have been a whole lifestyle gone. Because back then, that's what it was. A perfect example of that is Amédé Ardoin. That's the style that, what I call the older style. This guy used to roam around and play music, and write songs and tell stories about what he witnessed that day. When he'd get invited to the dances to play, a lot of those songs were about individuals that he could have seen that

day. And probably that led to his demise, singing about situations and people that he had seen, that were really, I guess, shocked and upset by him putting that into a song.

I wouldn't call him a minstrel, but he was a traveling guy that witnessed a lot of things and incorporated a whole style just from that. If that ever dies, there could be other styles that pop up, but there will never be another one like that. That's it. So, that's pretty valuable to me. It's valuable to people like me, that search out that older style. I'd hate to see that happen. I guess eventually it could. It could.

BF: Although I hear some of the younger players who started with not a lot of interest in the old tradition starting to sing in French and are at least, I think, getting more interested in where the music comes from.

EP: Yeah. That's a positive sign. Very few of those younger zydeco guys bother to even learn songs in French. They just sing them in English. And I think they should be singing them in French. Or at least half and half. You know—meet me halfway, baby.

BF: Well, this has been great. Is there anything else I should be asking you about? Am I missing anything?

EP: That's a good question. When I say that's a lifestyle lost, it incorporates that whole era, back then. That's what I'm really trying to put a finger on. Because this guy played for house dances which were in rural communities—it incorporates a whole era, I guess, is a better way to put it. And to me that's a whole lifestyle gone. That should not be, just because someone might find it a little difficult.

STEP RiDEAU

Step Rideau and the Zydeco Outlaws

knew I wanted to talk to Step (Stephen) Rideau. His name crops up whenever you read about the contemporary zydeco scene in Texas. Lacking any "friend of a friend" or other sort of way to reach him, I tried via his website. No response. Other opportunities intervened, and I let that task slide down my list of priorities. Then Gary, Jeannie, and I were in Houston, doing some interviewing and photographing, zydecoing—each in our own way—at clubs, a trailride, and a couple of church bazaars. I saw that Step was playing at a bazaar, and we went over. There he was, with a handful of young rubboard players off to the side. We were outside. People were dancing, socializing. We started making photographs, and Step and I made eye contact. I took that to be a kind of welcome, a kind of permission. At one point, I walked up and handed him my business card. He responded to all of this with warmth and hospitality. We had a good time, loving the music; eventually, another commitment led us away. That evening, we went to the Big Easy, a club that hosts Sunday night zydeco sessions in Houston. Step was there, hanging out, talking with people. We talked then about an interview, and we agreed that the next time we were around Houston we'd set something up. And we did, via text message.

Step Rideau has real presence and a lot of personal warmth. He's not unusually tall, but he gives the appearance of physical strength, which mixes with the warmth I noted above. His strong voice can have a growl or some roughness. His website bio tells us he has more of a singer's sensibility than many other zydeco leads. A 2003 album review in the *Houston Press* says, "Unlike many zydeco bandleaders, Rideau is truly a singer, not just a shouter." He's a fine accordionist, too, and his band, the Zydeco Outlaws, is tight and kicking. Jean-Paul Jolivette, his drummer, has played an important role in helping the band develop its sound. And the music reflects the complexities of

"I've always been impressed by the attention that it gets from young kids. It shows them the craft of live music; they have a big interest in live music. Actually playing a guitar. Drums. Because everything is so produced and sampled today."

Interviewed October 29, 2015, in his living room in Pearland, Texas; an accordion was nearby, which he eventually played. Step's wife, Monique, and Gary Samson were also present.

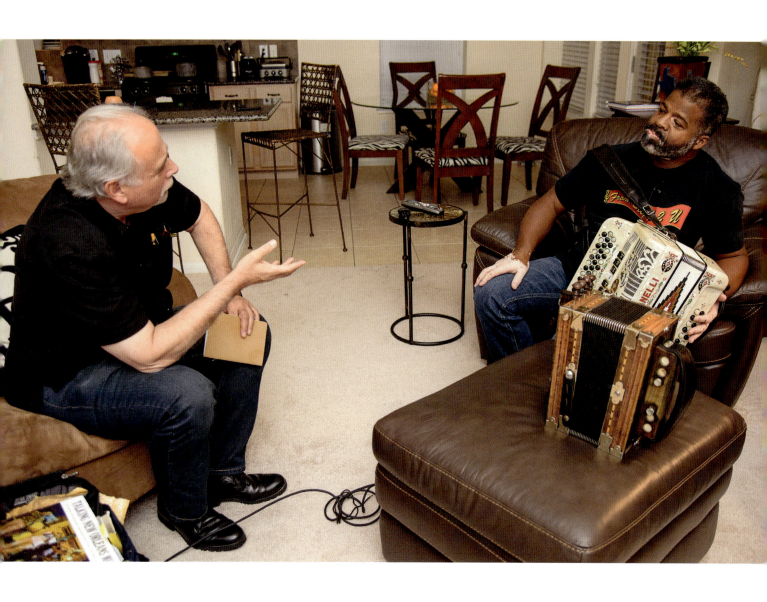

Step Rideau in his home being interviewed by
Burt Feintuch, Pearland, Texas, 2015

being a Louisiana-born Creole man who took up zydeco in Houston, balancing affection and advocacy for old rural ways with an urban existence and a primary audience that has struck the same balance.

> She likes it the Creole way.
> Everything's got to be the Creole way.
> [break]
> Ah, file gumbo!
> —Step Rideau, "Creole Way"

It's a long way from Lebeau, Louisiana, to Step and Monique's home in the Houston area. Step's parents farmed, and he and his brothers worked about 300 acres, mostly corn and soybeans, after school. His first memory of music is his grandfather playing blues on the porch of the house in Lebeau. Every July 4, on his parents' wedding anniversary, there'd be a zydeco band. Like many other Creole people from Louisiana, he moved to Houston. This was around 1987, and he made good money working construction. In Houston, he went to zydecos, just as he had at home. Boozoo Chavis frequently played gigs in the Houston area then, coming over from his Louisiana home. Step credits Boozoo, and the sound of his single-row accordion, with inspiring him to learn to play in Houston. Step says that in those days most of the zydeco players were playing the piano accordion. He describes the single-row as the "French accordion," and that was the sound that grabbed him hardest. In 1991 Wilfred Chevis, originally from Church Point, Louisiana, but well established in the Houston area with his Texas Zydeco Band, invited him to sit in at a church zydeco at St. Monica's in Houston. Later, that was the site of Step's first professional gig. He got his band together. For three years or so, J. Paul Jr., who is now one of the biggest draws in the zydeco world, was his drummer. Things began to take off. In the mid-nineties, Step and the band began playing back in Louisiana. For him, that was a landmark accomplishment, being invited to play back home. But Houston is his turf, and he reigns there as a senior figure in an ever-changing community of musicians and fans.

An October 14, 1999, *Houston Press* article by zydeco scholar Roger Wood says, "These days, Houston's Step Rideau is cooking up zydeco that is staunchly traditional and turn-of-the-millennium progressive at the same time." Wood cites his use of electronic voice effects. Titled "Zydeco Rap?" the piece also mentions "the pleasantly shocking special ingredient of rap." Two Houston-area MCs do guest spots on Step's 1999 album, *I'm So Glad*. These days, I suspect that Step would describe himself as more of a traditionalist. He plays clubs, church bazaars, and other events within his community. He's also a go-to guy when people book festivals in Houston, where his audience is broad and diverse.

When we did the interview, he was looking forward to playing the Houston Margarita Festival, expecting an audience of about 15,000.

Step Rideau was 49 years old when I talked with him. That's young to be an elder statesman in a genre. But that's what he is—a seasoned, committed musician whose influence has made a difference. His music is forceful, danceable, very much of the tradition. He's committed to his culture and aware of his status as an enthusiastic representative. Gary and I were on our way to Louisiana the day after the interview. Step told us where to stop, near the Texas-Louisiana state line, for the best boudin balls.

BF: How would you describe the music you play?

SR: Well, very energetic. I guess the biggest description would be really energetic, close to tradition. With a little new wave flavor to it. But close to tradition. Yeah.

BF: By "close to tradition," what do you mean?

SR: Well, I don't get too deep off into the new sound of today, of maybe the hip-hop type, you know, the sounds on the radio today. And keeping it—the guitar with the rhythm playing, and the washboard and the drumbeat—the style of the beat. And making sure that it's danceable music. That's kind of the genre that I fall in. I got songs with a lot of storytelling, but the main thing, the appeal, is that it's dance music. That's pretty much where I fall. That's what keeps me eating.

BF: And where does that fit in today's world of zydeco?

SR: That's interesting. Because the thing with zydeco—I want to say a few years back, I would hear people say they were worried about where it's going or if it's dying out or whatever. I've never seen it dying out. I've always been impressed by the attention that it gets from young kids. It shows them the craft of live music; they have a big interest in live music. Actually playing a guitar. Drums. Because everything is so produced and sampled today. It's just good to see.

Zydeco does that, we notice, with a lot of young people. And there's a lot of dancing going on. Nowadays there's a lot of line dancing going on. Because the ladies outnumber the guys that like to dance. Versus back in the day, the tradition was couple up and dance. It was very seldom you'd see a shuffle until the Harlem shuffle came around. I remember the days when that came around, and it invaded its way into zydeco. Because in the middle of the show, they would ask the band, "Can anybody play the Harlem Shuffle?" That's the same kind of era we're dealing with right now, when the line dances came back. Like the Cupid Shuffle, those type of songs. The Cha-Cha Slide, and all that stuff like that.

And it's connecting globally. So that's where I see the dancers come in at. Now you have guys that put on clinics, teaching people how to dance. Like I said, it's incorporating new people all the time. And I

guess with the world we live in today, back in the day if you didn't hear it, you didn't believe it. You didn't know about it. But now you don't have to be at a dance to—you know what I mean—to come across a screen somewhere. You got all your media outlets.

People gravitate to it, and it's very, very fascinating to them—they want to know about it. And that's where, like I say, I come in, and I try to keep it where there's always a feel to the beat. Every now and then we throw in some little ballad, but for the most part zydeco is about dancing.

BF: It's probably the only live music a lot of the young people dance to.

SR: Yeah. Especially a couple-up dance. And then like I said, nowadays, with the new wave, the nouveau type of style, there's a lot of breakaway dancing. But at the end of the gig, they end up coupling up.

BF: And you're originally from Louisiana, right?

SR: Yes. My home is Lebeau, Louisiana.

BF: You were born in . . .

SR: 1966. Yeah. Lebeau, Louisiana. I was born and raised there, to my parents, Dalton and Merline Rideau. We were farmers. All through when I was growing up, we were farmers. Came to Houston, I want to say, 1987.

BF: What were you growing?

SR: We were growing soybeans and corn. And I want to say I caught the tail end of the cotton farming. And that was—my dad, he didn't do much for himself of cotton farming. That was kind of going out, and the corn thing was coming it. Most of the corn we were doing for our own animals. We were raising cattle, hogs, chickens—everything you could think about out on the farm. Right now he still raises cattle. But my brother and I, both my brothers, we were farming about three hundred and some acres. My dad was working his job. My mom was working her job. Get up and going to school, get done, hit the fields. And at the same time, a couple of acres over were my grandparents, my mom's parents, the late Wallace Chamber and Irene Chambers.

My grandfather, that's where the music came from. The Chambers side. My grandfather was a guitarist and a drummer. And plus he worked a regular job as well. But it was in his family as well. They were known to play guitars and drums and sing the blues and rock 'n' roll.

BF: Is that your first memory of music?

SR: My first memory of music, hearing him play his Fender amplifier and his Gibson guitar on the front porch. And I'll tell you, now I appreciate it even more. You know what I mean? When those things are gone, you just—the connection back, you just can hear it. And the weather like this right now, that's what I was telling my wife a while back and another friend. I was like, "Man, this time of year right here, you know, for a farmer—the type farming we was doing—it brings back

so many memories. Harvest time." He would get on the porch with that guitar and play, and of course, most families had a lot of kids. My grandfather would play, and the kids would dance.

But I didn't have an interest in playing any instrument, up until I was an adult. My grandfather, he gave me a guitar. It was a acoustic guitar. He gave my older brother one, and he gave me one. My older brother had a little talent on it. He was learning scales and stuff. But he didn't have interest in it. I didn't have interest in it. I left mine outside, and it got wet.

On my parents' anniversary, every Fourth of July, they would celebrate; they had a wedding anniversary. And we had a zydeco group and R&B group called Flashback Zydeco, which was our second cousins on the Bush family side. That was my dad's dad's grandkids. They would come and perform on our patio at home. And every Fourth of July when my parents would celebrate their anniversary—a big cookout and you name it. Family and friends from everywhere would come. It was like the whole neighborhood would come, everybody that knew them. It was one of those type of things. These guys had a group, like I say—it was called Flashback Zydeco. And you probably never heard that style before. It was just a certain sound they had.

Anyway, my cousin, the lead accordionist, he would always pass the accordion, "Hey Step, come on man, try this thing." I would pick that thing up; I could never make no sense out of it.

Like, "Man, I can't play this thing." So I left it at home; it just wouldn't fall in place for me.

I was a line mechanic at Service Chevrolet in Lafayette. Later on, after I ended up getting laid off, my cousins that I was raised with were down for Fourth of July. They had moved on to Houston; they were older than I am. And they were working construction in the high rises here, all downtown Houston, in the commercial side of construction. They told me, "Man, why don't you just come down and hang out for a week or two?" Because I was laid off at that time. My mom was against it: "You don't need to go to Houston." Because all her brothers were already here. She was like the only one that stayed back home. Everybody else had moved away. She was like, "You'll end up like everybody else. All end up in Texas. Ain't going to be anybody home here."

I ended up going just to see them and stay a couple weeks with them. Lo and behold, I saw the kind of money they were making, and I'm like, "Oh, I like mechanic work, but this money here look like it's better now." Because this was in the eighties—it was driven by oil. Still is. That's how I ended up staying here.

So I started working construction, interior construction, and, of course, my cousin and them, they were steady going to the zydecos around here. All the Catholic church halls would host a zydeco dance because the Creole culture is real, real strong here in the Houston, Beaumont, Port Arthur, the Golden Triangle area. When people migrated

from Louisiana they either came here to Houston, Golden Triangle area, or they went straight to California.

We would go to the dances on Saturday nights, which I did when I was back home. But here, that's where everybody would meet. Boozoo Chavis would come out here a lot. He was burning up hot then, and that's where I really, really got the turn-on to say, "Man, I really want to do this now. I want to learn."

Because watching him play; he'd play the single-row, the French accordion, like my accordion right here; this is the one he would play. At that time Boozoo, I don't know how old he was, but he was up in years. I want to say probably sixty-some. But to see somebody grace the stage and get the response, pulling in the crowd, the diverse crowd—young, old. It was amazing to me. So I'm watching him, I'm just checking him out. Finally, one day, I was going back home, I think to visit, and one of my little cousins; I was going to get him a toy for his birthday. So I picked up a toy accordion. I open the thing up and just check it out before I bring it to this kid, and lo and behold, I started messing around with this thing. And for the first time ever, some notes came together that made sense on the accordion. And it was, "Oh Bye," by Boozoo. So I'm like, "Wow. Wait a minute here." So I ended up with that thing.

That's when I said, "Well, if I can really learn how to do this real good, I'll get a band." But at that time I'm like, "I'm not going to spend a lot of money." Because those accordions were expensive. Back then they were expensive. This one here was only, I want to say a thousand, but I only paid eight hundred for that other one because someone had ordered it brand new, and he didn't like the feel of it. And I'm like, "Okay, it feels good to me."

I ended up going around to the pawn shops, and I found this little Hohner accordion, all taped up and like it had been in a war. I had to piece this thing up to make it—it was losing air everywhere. I paid $45 for that thing. I don't know if you know this, when you see bands playing—in zydeco music we put the microphone inside the accordion. That way we pick up the bass side and the treble side. So there was no microphone; clearly it hadn't been on the professional stage of zydeco.

So anyway, I fiddled around, learned a few songs, and I took the thing over to a church bazaar, where Wilfred Chevis, Texas Zydeco Band, was playing. At St. Monica's Catholic church, over on Acres Homes, Texas. He let me sit in. I had a microphone on the outside of it. Of course, he played the piano accordion. He said he played the single-row accordion, like this one, when he was young. But he lost interest in it. They wanted to play the big piano accordion because Cliff had that fad going on, Clifton Chenier. And they were hooked on the blues turnaround stuff. You can do all that on the piano; while you're limited what you can do on the single notes. So, later on, I finally purchased my professional accordion.

And also, Little Willie Davis, I don't know if you ever heard of him, Little Willie Davis and His Zydeco Hitchhikers. He's from Louisiana, but he lived here most of his life. He just passed away, I want to say three, four years ago, maybe. Matter of fact, Clifton Chenier's drummer, Robert St. Julien, he lives here in Pearland. I see him all the time. After he finished on the road with Cliff, and Cliff had passed on, he started playing with Little Willie Davis. He would play a lot of church dances. So, anyway, he would let me sit in. Until finally I put a band together and ended up getting hired. My first professional show was at St. Monica's, where I first sat in with the little accordion.

And I've been rolling ever since.

BF: When would that have been?

SR: That was '91.

BF: To go back to Louisiana for a minute, did your family speak any French?

SR: My grandfather spoke it; my mom's dad spoke it. And my dad's dad spoke a little bit of it. But in the area of Lebeau where we lived, very, very, very few people spoke French there. A lot of them knew it, but they wouldn't—back then, you know how that thing was. The English was—you were outnumbered, and a lot of people, I think they just, it was like they felt like, "I don't want my kids going through what I've gone through." You know, that scenario that they had then because things were real tough back in those days. I think that's where a lot of it went out. But there was very little speaking of French in my neighborhood.

BF: The people in your neighborhood would say they had Creole heritage?

SR: Oh yeah. Oh yeah. They definitely Creole. Oh yeah. Oh yeah. Oh, definitely. Total Creole. Oh yeah—the whole community. Yeah. And the thing about our community—it's Lebeau, Palmetto, Bolden, and the Rideau Settlement. Rideau Settlement is my ancestors. That whole community they founded. I forget what year it is. There's a whole book on the Rideau Settlement. It's a lot of history there. Deep, deep, deep history.

BF: So you heard the music, eventually got interested in the accordion, and . . .

SR: Well, yeah, I'd hear it every day around home. Because there were zydeco programs that would play it on the radio stations around—the Opelousas station, we would pick it up in Lebeau. Which is fifteen miles, maybe. Yeah. And that was like going to town.

Opelousas was the nearest big city, basically. That's where you had Richard's Club, on the outskirts—Lawtell and Opelousas are adjoining towns. Slim's Y-Ki-Ki in Opelousas. They were probably five miles apart. And they hosted zydeco dances. Zydeco came first there. Very seldom would any other type band play any other type of music there.

There was a radio station called KSLO, "king-sized radio" was their slogan, out of Opelousas. They would play zydeco programs. We would hear—that was kind of our Saturday morning ritual. You know, that thing coming on at five o'clock in the morning. They'd play zydeco all day on Saturdays, Sundays. So whatever activity we had going on, there was always music around. Yeah. You couldn't escape it. You might not have liked it, being a kid, you know what I mean?

That's the thing—different times right now that we're dealing with. We have a lot of young players involved in the music now, and it makes it appealing. The young kids see it and want to do it. But the style that was being played when I was a kid, it was more the bluesy, you know, the blues turnaround–type sounds. Very little bit of the rock beat was in it. Very little. There were not that many songs, but the majority of it was the blues turnaround. And that wasn't too appealing to youngsters. But more like the Boozoo style, and the style I'm playing right now, the straightforward style, the one-four—you know, those type, real snappy type beat, it gives the energy. That's what's so appealing now and at the time, twenty-five, thirty years ago.

BF: I guess when you're talking about twenty-five, thirty years ago it's mostly Clifton Chenier's influence.

SR: Cliff's influence was shadowed kind of then with the Boozoo style. I want to say thirty years ago. Yeah. Because you had Rockin' Sidney came out with "Don't Mess with My Toot Toot." And he's from Lebeau as well, the same little parish. His parents were farmers just like my parents were. Anyway, he played the piano; he played rock 'n' roll in the beginning. And then he switched over to zydeco.

But the piano accordion, I want to say '84, '85, '86, around in there, around the Opelousas, Lafayette area, that's when Boozoo came back into play and shocked the whole—he turned everything upside down around there. Him and John Delafose. That button accordion; the single-row, French accordion—that really, really got people riled up again. Because when Boozoo came back in, everything was smoking fast, hopping, snapping. That's when the button accordion came in with all the influence. Then at that point a lot of people, a lot of the piano accordion players, they had to travel a lot to stay busy. That's basically how it all came to the circle, where we are right now.

BF: So, eventually, after doing some sitting in, you said you put your own band together. Are any of those guys still with you?

SR: No. The original band member that started with me was the rubboard player, Welton Celestine. He stayed with me for many years. He was driving truck for a freight company and playing with me at the same time. And it was kind of like, "Man, I'm kind of like burned out on it." He got out of the band.

Right now my longest player I have with me right now is my drummer, Jean-Paul Jolivette. It will make twenty years he's been with me in

February. But when I first started the band, the first show I had—have you heard of Little Brian Terry and the Zydeco Travelers? I had his brother, Rick Terry. Rick was playing with Brian. Early on, he was a member of Brian's band. And then he had gone to work, and things were kind of like too much for him. I was just getting started, so he came in and helped me out, to get me started until I would find a permanent bass player. So I had Rick Terry on the bass, and I had another guy, a cousin of mine, on drums. He only played that one show, my very first show. And he told me, he said, "I can't commit to it." Because he was into the top-forty stuff. Real great musician. He's, I want to say, in Colorado somewhere now, playing. And I had a guitarist, was one of my cousins, as well. He was like a Jimi Hendrix type of player. That's all he was about, Jimi Hendrix. His name was Reginald Chambers; he was living out of Barrett Station, Crosby. And Welton. That was the band; there were five pieces.

Later on I ended up getting a permanent drummer, after a couple of other guys that came, sat in, to get me through some shows. But later on, J. Paul Jr. came along when I was looking for a drummer, a steady drummer. We met one another at a drum shop. I had pulled up in my pickup truck, and I had the music playing. I had a habit, I would open the door before I would turn the engine off. The truck had speakers in the door. So he heard that music, and he's like, "What is that?"

I said, "Zydeco. Zydeco."

Never heard of it, and he was living in Houston. He was eighteen years old. And his dad, he was coming to get drumsticks to play in the church for his dad. So I said, "Man, I got a show on that Thursday night; I got a show down the street, on that Thursday." I said, "If you want to come check it out." He was real enthusiastic about it. He wanted to know. I said, "Just come out, and the drummer I got there, he'll let you sit in if you want."

"Oh, he will? Man, I don't know if I can do that. I don't know if I can play that."

"Just come and see."

So he came. Brian Terry's drummer was playing with me that night. They call him "Little Rev." So I told Rev, I said, "This young guy I met, man, you want let him play a number?" Because he sat there and watched. And he came up there; he was shy.

He said, "Man, I don't know if I can do that."

Rev told him, "Just relax. Just look for the cue to come in, follow the drive."

And he jumped back there, and he hit it, man. Man, he fell in the groove. He ended up joining the band, and he stayed with me for three-and-a-half years, until he formed his own band. So that was his first time being introduced to zydeco, basically. And like I say, he stayed with me three-and-a-half years. Then he wanted to do some things,

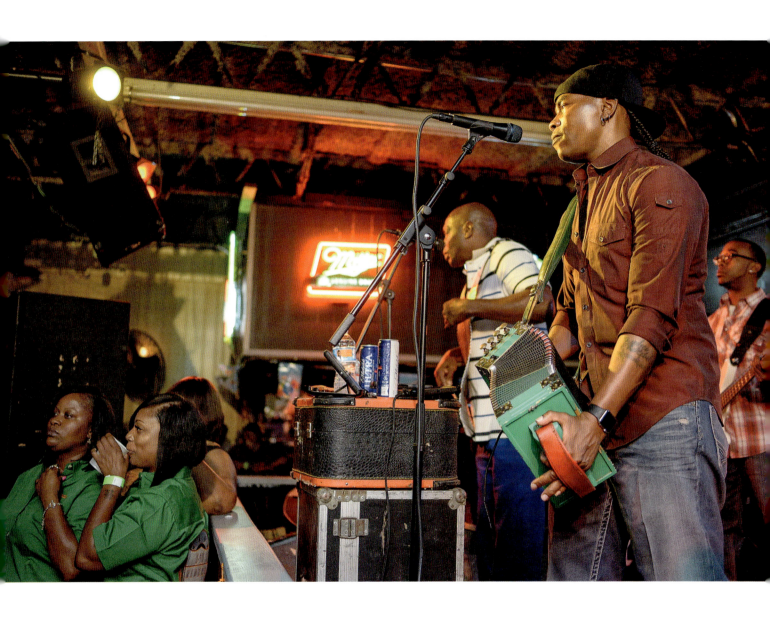

J Paul Jr., a popular zydeco musician who began his career playing drums with Step Rideau, Club ICU, Houston, Texas, 2015

try to do it for himself, do the style more of the hip-hop lyrics, and I was like, "I don't want to do that type stuff right now. I don't know if I'll ever do it." So he went off on his own; started his own deal. And that's how all that got going.

BF: And he's doing pretty well.

SR: Yeah. He's doing damn good. Yeah. Yeah.

BF: Were you the Zydeco Outlaws from the start?

SR: Yeah. It's always been the name. Step Rideau and the Zydeco Outlaws, yeah.

BF: Why Outlaws?

SR: I don't know. I wanted to come across as, well, when everybody would see me play, they say, "You play with so much passion, so much energy. You don't let nothing stop you." I don't know it was just, it was something bold. You know what I mean? And I think we lived up to it, in a good way. Because we came in, we answered the call; we set trends. When I got the band really solid, I had a lot of support, a lot of friends and family, people that was really supporting me, coming out to the shows. So people seeing the crowds I'm drawing, and it's making the band better the same time. The more shows you get the better you play.

I ended up getting a break and getting a Sunday evening, like a house gig, at a place on I-10. Man, this thing would bring in people from Beaumont, Raywood, all these little areas, little country towns. That thing ended up taking off on a Sunday. The house was full every Sunday. And of course we picked up others; we were doing the Continental Lounge sometimes on Friday nights. Then another club owner came to me and said, "I want y'all's guys every Friday." Which was the Ebony Club, which is on Langley Road. Started playing there every Friday.

Things were just spreading like wildfire. I said, "Well, it's time to record." So we put together the first album. I went down to Louisiana, and I ended up going to Rockin' Sidney. I think I'd seen him somewhere, and he told me to stop by whenever I wanted to stop by. So I ended up stopping by. He gave me a lecture that's the lecture of a lifetime because Rockin' Sidney, he was a poet. If you listen to any of his songs, everything is just fluent with the lyrics all the way through, with storytelling. I mean he was teaching me about writing songs. He was just lecturing me about writing songs. So we went in, and we cut the first album. And of course we're still adding shows to the roster.

Then we picked up a Thursday night show. That lasted about three years. This place called the River Lounge. Then the club on I-10, we kind of outgrew it, and it was the perfect time. The guy that owned it came into some legal issues with the place, and the next thing you know they wanted to—the lease was up, and they wanted to bring in some doctors' office or something. So anyway, another club down the street that had been trying to get me, with a bigger venue, called

Zydecoing, Miller's Zydeco Hall of Fame (formerly Richard's Club), Lawtell, Louisiana, 2017

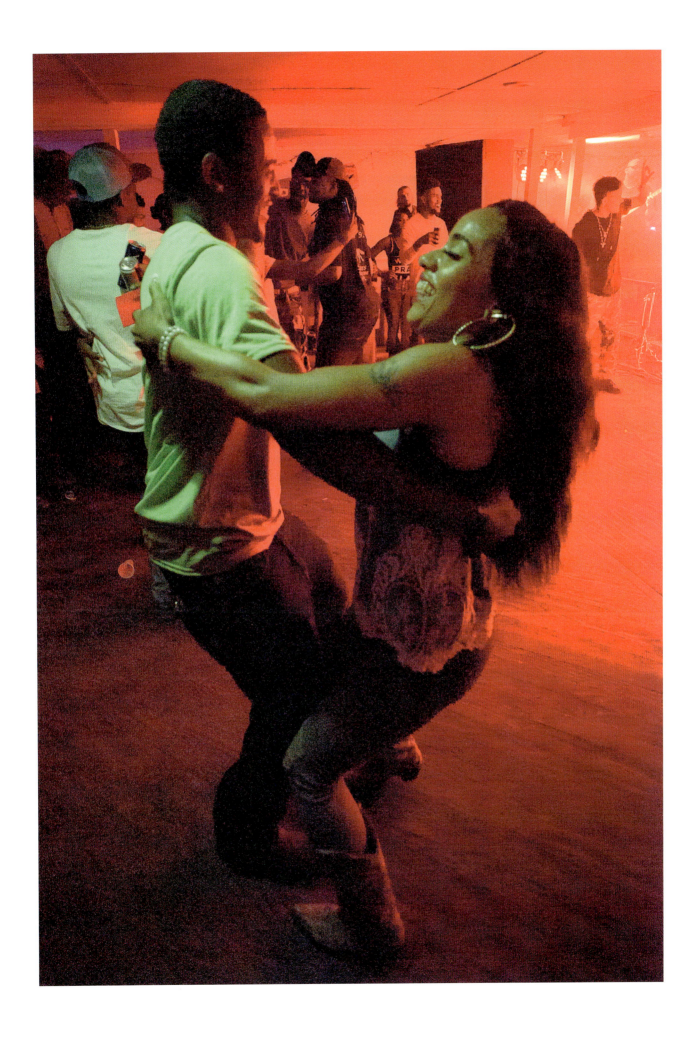

the Talk of the Town. It was almost twice the size of that first place. Real nice, elegant place. And that was rare for zydeco around there because we used to do the church halls or, you know—the Continental Lounge was a wooden building. Talk of the Town was putting people in these settings, and it was mixed drinks. It was kind of different. But the people went for it. We were putting four hundred, five hundred people in it every week. That went on for years. Then that owner went into some issues, and we went to another club called Sugar's Hideaway. That went on for years.

And at the same time all that's going on, the wildfire's spreading. Now we're into Louisiana because I've recorded now. Unlike some of the guys that had already been playing—they'd never recorded, and they didn't realize at that time you got to record something. Because once you leave a dance, all you have is memory from that night. You know what I mean? And there were radio stations there in Louisiana that were playing music. So we started putting songs together. So we were traveling back and forth; I mean every weekend we were playing probably five, six shows between here and Louisiana. I was the first guy to be able to get a band started in Houston, in Texas, and go to Southwest Louisiana, my home of it, and gain respect and draw record crowds. And play amongst the guys that were running things in that area. I was the only one that was able to do that.

BF: This would have been about what year?

SR: This was when I started going to Louisiana, Richard's and Slim's, I want to say that was probably '94, '95 we started. Yeah.

BF: Were things especially busy back then? Are they still busy? I'm not talking so much about you as about the world of zydeco.

SR: There was a time when I would say it wasn't as busy. It got a little slow at one time. After I got into it, at one period things slowed up a little bit. That's at the time that we lost Beau Jocque, around '99. There was a lot of weird things going on around '99, 2000. There was the millennium stuff coming. That's the only time I can remember things really started getting kind of dim. But we maintained, stayed busy enough.

But probably around 2000 things began to be like, "Okay, what is it going to do? What's going to happen?" And then all of a sudden, new guys come in. You know, the younger generation. Younger people getting involved. We're still recording. Other people, recording. Keith Frank is doing his thing. Buckwheat is still doing his thing. And I think around that time Buck got a break on BET (Black Entertainment Television). He cut a couple of songs, and they were being played on BET.

So every now and then it was a little spark thrown in somewhere to make people realize, "Hey, this thing ain't never going anywhere." And of course, the next thing comes along, like I say; we got all the

social things, with the websites and all that stuff. The visibility came a little easier to the music.

It's always been backshelved and underground. Even with the Grammys we had to get our own category, and then we lost it, and now we have to share it with something or other. Yeah, there were times when it was a little dim, but I was never in fear that it would ever go away. Because I know what I see when I see the crowds and see the young people that's getting involved. Not only young people, but the tourists from everywhere, as well.

I even did Lincoln Center, did the Kennedy Center. There are dance groups out there. There are a lot of bands that just basically tour, just drive it. A lot of those bands, they couldn't get enough work around home to stay busy enough. The styles, I guess, there wasn't enough room for that same style.

Some people say zydeco is here to stay. And I believe it. You know, Cliff said it long time ago. Boozoo and them said it. Dopsie and them, they always said, "Zydeco is here to stay." Some of the things I'm seeing, they had seen it already. Yeah.

BF: What about your audience? Has it changed?

SR: No, not really. Not really. I've been maintaining pretty much; I still get a lot of the youngsters. I still get my older crowd that loves their waltzes. Still love to get a quick two-step in, as well. Yeah. I think I'm changing with them, getting a little older.

BF: Are a lot of the people in the audience people who would say they have Creole ancestry?

SR: No. These days, there's a lot of non-Creoles. Like I said because of the attention that it's getting. The exposure. There's a lot of non-Creoles.

BF: In the Houston area is it still mostly an African American audience?

SR: For the weekly gigs, I would say, the majority, yeah. Except for your special events. Like coming up in a couple weeks, I have the Houston Margarita Festival. That's so diverse. You're talking about 15,000 people. And I'm the only zydeco act that they use for it. We share the stage with all the other genres—the Latin, brass bands. You see that crowd, and you see the response that we get, and it's like, "Wow." It's real appealing to a diverse audience.

But the die-hard followers from week to week, it's going to be majority African American. Yeah. But you got Mardi Gras time coming around, crawfish season coming around, all that changes. Festivals and the culture thing. Crawfish comes in, it connects with the zydeco. Then we see more diverse crowds, different, diverse events. They're there, but they're just not following it every week. It's seasonal for them. But if they stumble up on it, trust me, they're going to embrace it. That's

what zydeco does. There's something that's—you know what I mean? It's something special.

BF: Well, I'm here, you know.

SR: Yeah. Yeah. Yeah. You guys made two trips back here.

BF: This is my third trip.

SR: Third? Really? Yeah, yeah, yeah.

BF: We need to spend more time in Louisiana.

SR: I bet y'all been eating a lot of boudin.

BF: Well, I need to keep at that.

SR: You need to. Well, it's a good time now. A lot of people doing gumbo right now. You know, fall weather coming in.

BF: When you were talking about going back to Louisiana, and being accepted in the tradition, do you see those two scenes as different? Louisiana vs. Houston?

SR: For my crowd, not too different. There's not much difference there. No.

BF: Houston is a much more urban environment.

SR: Right, right. And the thing is the western side of this thing, that brings a lot of young people in, young and middle-aged people in now, which had been going on years and years, is the trailride scene. Now you got a lot of families involved, their kids following them, going everywhere. A lot of families doing it because of the kids doing it. They want to be with them, make sure, and guide them through. And some of the bands, and some of the riding clubs, they travel in Houston, the Texas area and back, vice versa, the Texas people traveling here. The difference is going to be, I'm pretty sure, your menu—your food menu. The difference in Louisiana and Texas, you know. With a lot of the Creoles here, like I say, a lot of the riding clubs, I know they won't do much of the traditions that they do in Louisiana as far as menu-wise here. But other than that, you know, it's pretty much, I think it's tit for tat. Yeah.

BF: Do you play a lot of trailrides?

SR: Not that many. I don't do a lot of trailrides. No. I used to do more; I can't say I did a lot of them, ever did a lot of them. It was always a special event ride I would do. Like the Step N Strut Ride—that's one of the main rides now. Actually, I started a ride with them, and that's how they got the name, from one my songs, the "Step N Strut" song, off the *Standing Room Only* album. I started that with them. I do probably about five, six riding clubs a year.

BF: It seems like it's a mainstay for some bands.

SR: For some bands. I think that I'm fortunate and blessed, the appeal that I have. It's kind of diverse, and I like that. I really do. I get to see other parts of the spectrum, basically. Yeah, I feel like I'm in a good place.

BF: I've been to a couple of trailrides. It could be hard work to play for those things.

SR: Yeah, yeah, yeah, yeah. Yeah, hard work, and just sometimes it's one of those types of scenes that you probably could get burned out on. You know what I mean? Yeah. But you end up coming back to it. You know what I mean?

BF: Is it bigger now than it used to be?

SR: It is. Oh yeah. It is. It's much bigger now than it used to be. More people into it, but there's a lot of people break off from the clubs, "I'm going to start my club; I'm going to do it my way." Then the next thing you know—because I hear this from the trailriders, from some organizations, I hear this from them. So it ain't just me. You know what I'm saying? And some of them feel like, "Man, there's a ride every weekend."

I'm like, "Well, y'all must be doing some good. People like it. They coming out." You know?

BF: I read someplace that among the influences you've mentioned are Bobby Bland and Howlin' Wolf. You must have grown up listening to that music.

SR: Yeah. My grandfather, like I say, he played that. The radio, I'd hear it. And my mom, she used to sing in the choir. And my baby sister, she used to sing in the choir as well. So that music thing, that soulful sound, soulful music, that's in my blood. I love that sound, man. Yeah, it gets you going.

BF: And would you say you brought some of that into your . . . ?

SR: Oh yeah. Yeah. Yeah. Yeah, the album I have right now, I covered one of Bobby Womack, one of his songs I got covered on the album that's coming out now. And there's a lot in the other stuff. You can probably get a feel of some of my passions coming through. Yeah.

BF: But you also are trying to stay true to an idea; it sounds, too, that you don't want to go too far.

SR: No. No. And that part of it—I try to be careful for a couple of reasons. One, I'm a type of guy, I know once I record and whatever I put out, I know I have to live with that. That's my work; that's my representation. That's my reflection of me. And I'm the type of guy, I'm conscientious about stuff like that. I just want to make sure it's something I can stand behind and be proud of it. If I turn my back on it, I ain't worried about it.

I did a few songs on that '99, *I'm So Glad*, album. I did a couple of the rap tracks, hip-hop tracks. But it was more poetry. The thing about it is when we put the album together I knew, when you're coming out with the rap, the phrase, the title of it, the few bad things in it, which is not a few anymore, you know the bad parts of the rap. It's a good thing; it's sad when you sending the wrong messages out. And it's kind of hard when you say the word *rap*, it's harsh. You know what I mean. And it's too bad it has to be that way because it just goes to show you, now you got country-western guys rapping. And I'm saying, "Oh, wow. Really?" That's what my style was. It was more country.

There's one song out right now; I'm not going to say the name, artist out right now. If you turn his song on, ain't nothing but country, and you turn on mine, called, "Bayou Swamp Thing," if you know anything about music, you'd be like "Wait a minute. Oh, wow!" And when I heard it, I'm like, "I did that album back in '99." This guy just did this about three years ago, maybe. And I'm like, "Okay." And a lot of people—I get requests for that album right now. A guy sent me a text the other day; he said, "Man, I'm jamming that album right here. This thing's ahead of its time." But when I did the album I changed up a whole lot of the style. I changed up the arrangement; it was real lyrically loaded. There was a lot of lyrics, you know—storytelling. And I changed studios. Changed the whole production of everything. What happened, well, I know they over-compressed the mix on it, and somehow at the end of the project, the quality wasn't good at the very end. When you play it on the radio next to another zydeco song, that was in rotation, it's like the quality didn't match up. But the quality of the work in it, it was there. Plus, I did the whole album—the whole album was different. You know what I mean? It was like, "Oh, that's you, but it's different." Right now, hearing a lot of the young guys that's recording, I'm like, "I did that already." You know?

A lot of people come up to me, "Man, you did that style already." Yeah, I did it, but it is what it is. It just wasn't for me at that time, to have that album to be—it was a sleeper. I'll probably go back in and just remix a few songs from it.

BF: Yeah, I was thinking you could probably remix it.

SR: Yeah, I'll go in and remix. And probably throw some videos, a couple of songs on there. Because, yeah, we got some on there that's so lyrically loaded, with good lyrics, good storytelling of the Creole living, the Creole way, just the way of life every day we live it.

BF: Do you write most of your own songs?

SR: Most of it, most of it, yeah. On that particular album I had a co-writer, on it. But mostly all the rest of them.

BF: How important are the CDs? For a career now?

SR: Nowadays it's important, but the returns are not as big, not near what it used to be. Because right now everything is digital download. Right now we're dealing with this. It's not a fad; it's here to stay. The way people do everything every day now; the attention span is short. Everybody looking for what's next, in the majority. If everybody got songs on their handheld devices and the freedom of musicians now—you don't need a record label; you don't need a studio. You can record it or sample it, whatever. If you're not in front of the audience, it's kind of hard, as far as full CDs. But you have to have it because it's all about what you record, what's the latest. So it's not returns from it, but you still have to write songs.

BF: Is it mostly you selling them yourself off the stage?

SR: Yeah. In zydeco, I think every artist, the majority, is selling off the stage. That's the most sales because there are no storefronts. But people, they still want it. The audience that's there, they'll support it.

BF: What about radio play?

SR: Radio play—right now we're getting, well, like I was telling you, KCOH, they have a program on Tuesdays. Don Sam, the disc jockey, he's been on there doing that program a little over twenty years. He does it from two to five p.m. on Tuesdays, once a week. That's on AM. Majic 102, which is the granddaddy station here, soul station—Houston and all the out-of-town cities connecting, about a hundred-mile radius. They do a "Zydeco Meets the Blues" show on Sunday right now. Walter D. and Larry Jones. Well, Walter D., back in the Sugar's Hideaway days, he came on board with me. He was with 97.9; he's still with 97.9 and 102. Clear Channel, both of them, in the same building, same studios. But back in the day, when we got to the Sugar's Hideaway on the Sundays, at that time he heard about the zydeco. He had never heard it. He's a hip-hop DJ. And he came in with me, and he started playing; he was trying to get the station to let him play zydeco.

Everything is formatted over there, on those type stations. That took the freedom away, in those years, from everybody just doing what they wanted to do. So he came on board with me. He started playing zydeco for fifteen minutes daily. They gave him fifteen minutes on the hip-hop station in 1997. They gave him fifteen minutes. He was a mix DJ: he was used to mixing songs. They wouldn't play the whole song. You know how they mix them in and cut and paste here. So it was hard for him to do zydeco because of all the bands that were recording had live drummers, with no sequencing. So if you're used to doing this sample stuff. One, two, three, you know, all those beats. Nothing is going to be off time nowhere. So zydeco, he had to catch on to that. Anyway, he was doing fifteen minutes. And he came onboard with me. So he would DJ when we would take a break, on Sunday. He brought the crowds up. I want to say we went from probably five, six hundred people to some Sundays seven hundred, eight hundred people.

BF: That's a big house.

SR: Yeah. We did that for a few years together, he and I. He's still with the station, but he's probably—I'm 49—Walter's probably around my age, 49, 48. You know, the hip-hop stuff right now, he's old school. So they're using him more on the Majic station. He's done a lot of mixing on there. So, the ratings went down. Changed the program director there. They're searching around. And Walter said, "Well, I got this zydeco show. Let me do it. It's still here."

"All right, let's give it a try."

They did it. They've been running that show now for probably like six months. They do two hours—one hour of blues, R&B blues, and the other of zydeco.

So we have those in town. And we have 90.1, KPFT. Public radio station. Early, early in the morning, around four and five in the morning, with PT and this other guy that does the zydeco portion of it. Those three.

And we have KTSU, a college station. They do a little bit on Fridays. A few songs here and there. But not full format.

So we're getting a little radio action here. But not mainstream. Like country has its own stations, and, you know, blues and whatnot. I think if they would do that, at some point because this city is big enough, steady growing, I think it's big enough now, and it's diverse enough. I'm sure they will. Because this Sunday program is holding its own. Yeah.

BF: So do you see things growing?

SR: Yeah.

BF: At least in Houston?

SR: Yeah. Yeah. I don't see it going anywhere. Because there's a lot of young kids now that really want to get into it, too. A lot of them inquiring, trying to learn to play accordions and stuff. And I'm seeing younger ones—guitar players, drummers. So that's telling me a lot. Yeah, it's going to be around.

BF: And what about things like—I'm trying to think what else there is here that supports the music. Like, for instance, I know that at the Big Easy club one night a month they have this thing . . .

SR: The jam session.

BF: That they say is sponsored by the National Zydeco Foundation. And that's something here?

SR: That organization. Yeah. What it was, it was Clifton Chenier's sister, Mary Thomas. She the one formed that little organization called National Zydeco Foundation. She was just trying to unionize everybody. I'm sure she had bigger plans to do with this. But she's got kind of up in age right now, and her health is kind of getting in the way of a few things. But that's her that formed that. It's kind of like just a commemorating-type thing. Once a month, just having something annual to look forward to. The Big Easy does bands every Sunday, but that last Sunday every month, it's like a jam session. You'll probably get most of the same guys who play on Sundays there.

BF: And there are some Houston-based zydeco music awards, too?

SR: Yeah. There's one award now. This is the second year—last year they did it. Called Zydeco Blues Award, ZBT. That's coming up in December. They're working the kinks out of it, trying to—I think they've seen the Grammys, and saw the categories get split up, they were like, "You know what? Let's try to do our own one here." But with award ceremonies, you know, that's a delicate thing. You can't please everybody. That's a deep, deep issue. Yeah.

BF: Just switching gears. That triple-row accordion sitting there. Talk about the triple-row. When did you start playing?

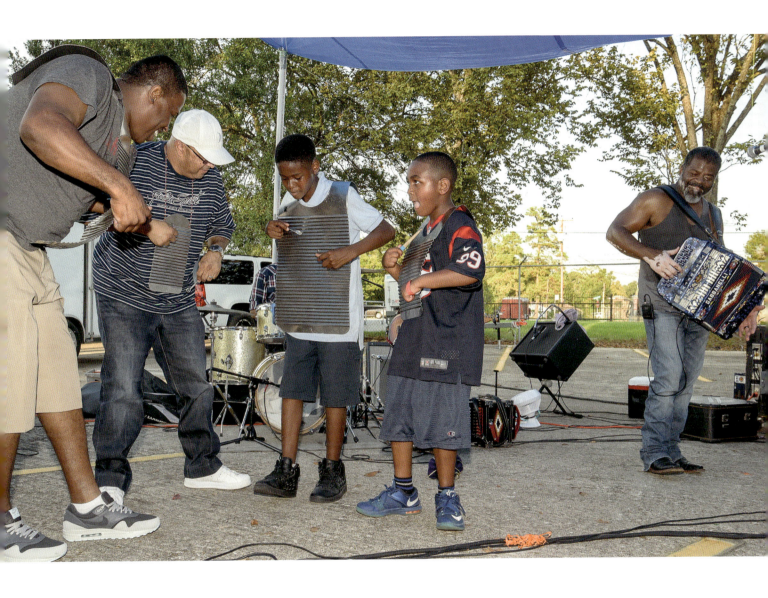

Learning the rubboard with Step Rideau
on accordion, St. Gregory the Great
Catholic Church, Houston, Texas, 2015

SR: I started the triple-row probably six months after I started my band. I'd seen that I was going to have to incorporate another accordion with different sounds. And the piano wasn't appealing to me. So the triple-row: I'd seen Boozoo had success with that as well, Rockin' Dopsie was doing it. John Delafose was doing it with it. You get more music out of it. It has the same scales and everything, just about, as a single-row, but you can get a lot more music out of it. Yeah. This one right here has, my wife was just asking, she said, "If you had to pick one accordion?"

I said, "It would be, the French accordion; it's one of those things that you gravitate to. It looks more artistic. The sound of it is more rough. You know, you think Louisiana when you see that. And when you hear it as well." Versus the triple-row, it's shared with, you got a lot of Tex-Mex and Tejano music played with it. You got to really come down; they got to hear you play it first. When they see that, they know what they're going to hear. That one, you got to play it because everyone knows what to expect. You know what I mean?

BF: One thing I really don't understand about the single-row is, though, you've got, what, ten buttons, right?

SR: Yes.

BF: I don't know what key this one is in.

SR: This is a C.

BF: So it's in C. So, how many keys can you actually play on it? Can you play in more than C?

SR: Yeah. You can play in more than in C. You can play probably C and G on this thing. Yeah, yeah. And that's the thing. You can play some others on it, but you can't get the dynamics out of it. It's hard to get dynamics out. For me it is, anyway. Yeah. And that's the thing with my style of music. My style of playing—everything is real dynamic. Yeah. But I tell everybody, it's easy once you learn it.

BF: Do you ever sing in French?

SR: French. Yeah.

BF: But you don't speak it.

SR: I don't speak it fluent, but I sing in it. I know quite a bit; enough to get me in trouble and out of trouble. Yeah.

At this point, Step sings "Oh Bye Mon Neg" with accordion.

SR: I got another; in English it's "Can't Keep a Good Man Down." My wife's dad was a French teacher. He gave me the lyrics, in French, to this song.

> You can't keep
> A good man down.
> No, you can't keep
> A good man down.

He's going to find a way
To make it another day.
He's going to push on through
With or without you.

Step then sings the lyrics again, but this time in French.

BF: That's great.

SR: Thank you, thank you, thank you. There's always room for improvement.

BF: How important do you think the French part of it is? How important do you think it is that the French influence stays?

SR: It has to stay. Because that's zydeco. That's zydeco. It has to stay. That's the ingredients from birth. And it's real watered down. I'm guilty of watering it down. But I always find a way to try to come back to put some of it in it. You know what I mean? I understand the part of getting away from it, and not just singing French all night long because if we did that, we wouldn't have an audience. We would have audience, but we couldn't step outside; we couldn't bring people in.

That's what happened—can you imagine going to a show, and you don't know what anybody is saying? It sounds good for a minute, but after a while, you'd be like, "Man, I feel left out." And with a lot of today's music, I think that's what brings a lot of people in. Once you get them in, okay—you know, this is where you play your waltzes, and play some of your songs in French, and let people recognize and remember this is where it came from, this is why we're here. So let's not forget it.

BRIAN JACK

Brian Jack and the Zydeco Gamblers

Brian Jack successfully navigates urban life, zydeco's early rural roots, and an audience representing the wide spectrum in between. He's a commanding performer, and he is also an embodiment of Houston zydeco, joining others including Step Rideau and J. Paul Jr. as someone who bridges those realms. He knows his audience. A musician, recording engineer and producer, and a dynamic performer, he describes himself as a businessman, and he runs his career accordingly. Speaking of audience, J. Paul Jr. and his band, the Zydeco Nubreeds, is very popular; originally from Texas but also loved in Louisiana, he has YouTube videos with numbers that are enormous for regional music. His song, "She Like That Wood," has over half a million views. "Pipefitta," is Brian Jack's response to J. Paul's song. "Pipefitta," has more than a hundred thousand views: "She screaming my name all through the night; Don't stop, Brian Jack. Just lay that pipe."

As I write this, the Houston R&B artist Speedy, aka Icewater Speedy Wheel, has just dropped a video titled, "How to be a Cowboy." According to the YouTube video, Speedy "links up with Zydeco superstar Brian Jack to tell the world how to be a cowboy." In his western hat, jeans, and boots, Speedy raps about cowboy life. We see rural backdrops and trailride scenes. Brian sings the chorus and adds harmony, helping create this ode to cowboy life:

> How to be a cowboy
> Is all I know . . .
> Ain't a city in the world
> Where I want to go.

"I've got songs that older folks be like, 'Oh, hell no. What is he playing?!'"

Interviewed, with Jeannie Banks Thomas and Gary Samson, September 21, 2015, in his recording studio, Humble, Texas.

Brian Jack in his studio, Humble, Texas, 2015

In his 2006 book *Texas Zydeco*, Roger Wood describes Brian Jack as one of the young progressive Houston-area zydeco musicians, influenced by hip-hop and other urban sounds. For a time, people used the phrase *nouveau zydeco* to describe the mélange of old sounds and contemporary Black popular music styles. Brian says he doesn't "know what the hell that means." Scheduling an interview and a photo shoot was complex because he gives priority to driving his kids to school, sports practices, and other events. Brian Jack is a highly regarded performer of music rooted in old Creole ways, someone whose music reflects the popular music of his era, a dedicated father, and a friend to many of his audience members. There's some French in his music. There's some hip-hop in his music. There's country. There's reggae. He's thinking about Latino music, an especially wise move in Houston.

We saw him play twice one June Saturday. That afternoon, he was part of a thirty-dollar ticketed event at an agricultural exposition center outside Houston. Brian Jack and the Zydeco Gamblers and Lil' Nathan and the Zydeco Big Timers headlined. Big Ass Fans moved the heat-heavy air in the large venue, which was a little empty. But it was early. Brian and band came on stage first, and many in the small crowd were immediately on their feet, dancing. Couples went through their moves. A group of women began line dancing. Zydeco line dancing is a thing these days, and choreographers and instructors come up with new routines, often teaching them in classes. Brian's young son was on stage, too. It was a good set—robust, percussive, visually engaging, the low end banging. On stage he seems in control, but you also have the sense that this is a good guy. The set ended, and he came off the stage into the crowd, greeting people, shaking hands, hugging.

Although he's originally from Dayton, Texas, and his father was from Barrett Station, Texas, many of his people, Stoots on his mother's side, Jacks on his father's, were from Louisiana—from Elton, Lebeau, Washington. His grandparents spoke French. He liked music, but early on he didn't think he liked zydeco especially because he wasn't drawn to the piano accordion. Then his parents brought home a Boozoo Chavis recording. He got interested. Beau Jocque came next, and Brian became hooked on the sound. The single-row accordion did it for him; he loved what he describes as its grungy sound. He still does.

He describes himself as a "gadget fan," and he's interested in sound and its technology. He owns and operates a recording studio, which he had moved to, and was setting up in, a space in a commercial area just outside of Houston when we interviewed and photographed him. He produces his own CD recordings, and he's engineered and produced for others, including Jerome Batiste. The first time I heard him on stage, I was taken with the harmony singing. Then I was puzzled—the second voice was audible, but no one else seemed to be singing. It turns out that he uses a vocal effects box that helps shape his sound.

His interest in gear takes him to music industry electronics shows to check out the new stuff.

From country to city, from trailride to church bazaar to club, Brian Jack has made a career of zydeco in greater Houston. He's happy not to be on the road, to have all the work he wants near home. He values his Creole heritage, and he balances that with his own interest in innovation and his broad musical tastes. He usually plays for an audience that knows him well. In and around Houston, that audience keeps him busy enough to have made a good life and career close to home.

BJ: I enjoy not just performing and playing music: I really love all the details. I love the engineering part. I love all the background stuff, behind-the-scenes stuff. That's why when I do festivals and stuff, I always say, "Give the sound engineer a good hand." Even if they did a horrible job. There's a lot of musicians who are good musicians; they understand how sound works. And there are musicians out there that they don't know nothing but just put a guitar amp on ten. And it gives the engineer one hell of a day.

BF: All right. So let me just say we're in Brian's studio. We're in Humble?

BJ: Humble, Texas. Actually it's pronounced *Umble*, like *Be umble*.

BF: Well, we'll try to be *umble*. Can you start by describing your music? Where do you fit in the world of zydeco?

BJ: I get in where I get in. Honestly, I'm a fan of all kinds of music. I try to stay within the zydeco format. Because zydeco, it's not just a music; it's a dance. So when you listen to my music you can get something from zydeco with a country feel to it. You can get something—I love reggae. Reggae is like one of my favorite musics. You can get that. You can get rap. You can get an R&B sound. I'm not too familiar with Latin music, but I don't know what I'll discover. I hear a song one day, and I say, "I like that." And then I want to do something to kind of bring it in. I don't know really where to put myself in an actual zydeco format. You will hear people say, "Nouveau zydeco." I don't know what the hell that is. You know, people have different ways of describing it. Brian Jack zydeco—that's what it is, to me.

BF: Why did you decide zydeco was the route you were going to go?

BJ: Zydeco is deep in my family, my roots. Rockin' Sidney was mom's first cousin. Rockin' Sidney was in a rock 'n' roll band with mom's uncles. My grandmother played fiddle. They all played la-la at house parties, stuff like that. So music goes way back. On my dad's side—gospel musicians. My mom's side is where the zydeco and rhythm and blues come from. But I was introduced to zydeco—I was like most kids, you hear it and you'd be like, "What is that? I don't want to hear that."

My parents had some kind of zydeco CD, and I don't really remember who it was. But I remember not liking it. I was like, "What is this?"

I remember it being in a piano-row style of zydeco, the piano-note accordion style. Then, one day they came home with a Boozoo cassette. And I was like, "That's not zydeco. Listen to that accordion sound. That's not accordion; that's not the same thing." That's when I discovered there was a difference between the piano-note accordion and the single-note accordion. But that tone; that's what made me start liking zydeco. And I just really was into it.

I was young. My momma's brothers, they had a zydeco band; it was more like a big band style. There was a keyboard player, trumpets, piano-note style of accordion. I liked being around it. But when I heard that Boozoo tone, I was hooked. Yeah.

And then when Beau Jocque came along, it was like—everyone who's playing zydeco, I'm sorry, but nobody's going to beat Beau Joque's sound. That's just what it was to me.

BF: How old do you think you were then?

BJ: Oh man, I think back when the whole Rockin' Sidney thing was going on, I had to be probably about 8 years old. And then I started really getting off into zydeco probably by the time I was about 12 or so. I remember playing little league football and listening to zydeco music and loving it. And that was like my sixth-grade year.

BF: And where was this?

BJ: I'm from Dayton, Texas. Yeah, Dayton, Texas. They used to have a lot of church dances in Raywood, and other than my uncles' band, the first live zydeco music I heard that wasn't family was Willis Prudhomme. He would come to Sacred Heart church in Raywood all the time. Play dances over there. He was one of the first bands that actually let me play on stage with them. I was probably about 11, 12.

I had an uncle in Lebeau, Louisiana, he was a zydeco guitarist, played guitar with a lot of zydeco bands. By the time I was 13, going on 14, I told him, "I want to learn how to play guitar. I just want to learn to play something." You know, the guitar's not expensive; drums were expensive, horns were expensive. So I was like, "Give me a guitar; just give me an acoustic guitar or something." And I ended up getting one. A neighbor of mine had one. Got it from him. And I got with my uncle in Louisiana. But before that, my mom, I told her—I struggled a whole week. Didn't know how to tune a guitar; didn't know nothing about it, really. Just banging on it, trying to get some sounds out of it.

She said, "Maybe this will help out."

I was like, "What are you doing? Give me my guitar back. You're joking around; I don't have time to joke. I'm practicing."

She said, "Let me see it." She played the song from the *Peter Gunn* television show. That "Dum dum dum dum . . ."

I looked at her, like, "You let me kill myself for a whole week, and now you're showing me something?"

Then my daddy said, "Well maybe this will you help out." Then he grabs the guitar, and he plays like an old slow blues, "Ba dum, ba dum," like a walking bass line.

I'm looking at them, like, "You got to be shitting me, man. You give me a whole week of hell, and now you want to show me something."

But it led to me knowing, "Okay, this is what I need to do."

It was just two strings I was beating on. But it worked. Yeah, then I went to Louisiana, and after that it was all over. Between my uncle in Louisiana that played zydeco and my uncle in Texas that played gospel, I had the best of both worlds.

BF: What were your uncles' names?

BJ: James Stoot. James Elton Stoot. That's my mama's side in Lebeau. Right there—Immaculate Conception Church on the right side, that's the house my mama grew up in. And my uncle from Houston is Lionel Jack. Lionel Jack.

BF: And what year were you born?

BJ: 1979.

BF: And would you say your family has Creole heritage?

BJ: Oh, yeah. My mama was from Lebeau, Louisiana. And my dad was raised in Barrett Station, Texas, but his mama was from Washington, Louisiana. On my dad's side, the Jacks, the Ledets, and I'm trying to think of the other side; there's so many of them out there, man. But mainly the Ledet side. They were from Washington, Louisiana. I'm kin from the Jacks in Ville Platte. I don't know too many Jacks from Ville Platte; we're from Elton, Louisiana. So all the Jacks in Elton, Louisiana—that's all my people.

BF: Did any of your people speak French when you were growing up?

BJ: Not really. My grandparents did. My grandmother that lived here—my dad's mom—she did. But she didn't have anybody out here to speak it with. But her sisters would probably mumble something. But I wasn't around them most of time. I was real small at that time. But they definitely spoke it.

I would ask my grandmother, once I started playing I was like, "Can you teach me some French?"

She was like, "I don't even remember half the stuff."

But when she'd get around somebody that spoke it, it would just come right back again. Yup.

BF: So, you're a young teenager, playing guitar, listening to zydeco. Were other kids your age listening to zydeco?

BJ: Oh, no. It all goes like this: I was an athlete in school; back when I was younger, and I wanted to play music when I was playing little league football. When I got up to sixth grade you could actually play the instruments in band. But it was either join PE or join band. You couldn't do both. And I wanted both. When I was in third, fourth, fifth grade,

you had to learn how to play the recorder. And my music teacher was always telling my mom, "He can really play that. Anything I show him, he catches it right away." I was good at sight-reading things and also doing things by ear. Anyway, get to sixth grade, all my buddies, they're athletes. I'm an athlete. I love football. So, it was like either get teased for going to band, or be with your buddies because it's cool to be playing dodgeball and stuff like that. So I chose that. But by the time I was in seventh grade, going to the eighth grade, I was already playing guitar. Just starting out. But by the time I was in eighth grade, I was playing accordion.

One year, to kind of backtrack, I was going to Lebeau, Louisiana; I went for two summers to learn how to play guitar, just hang with my family, and stuff like that. And then one time, that next summer I was going to go out there, stay—my uncle thought I was going to play the guitar. I had been practicing; you know those toy accordions—you can see them at Toys "R" Us? I had one I was fooling around with. And I went down there, and I said, "I want an accordion." And I saved my money up, and I wanted the real thing instead of playing on a little toy one. He took me to Savoy Music Center: Marc Savoy, who makes some of my accordions now. I had gone to him to buy a guitar amp when I first started playing guitar. This time I wanted to go buy an accordion.

I bought the accordion. And that was the thing that really got everything going. By the time I was in the eighth grade, I had like sixty or seventy songs I wrote in a shoebox of accordion songs, accordion lines that I knew. Within like four months of playing. And I don't know, man. A light bulb went off in my head. I was already making money at a young age, playing guitar for my uncle's zydeco band. His son ended up deciding he didn't want to play anymore. He ended up quitting the band and leaving all these gigs behind. And he was like, "Well, Brian knows enough songs to play." So that's how I ended up getting thrown into playing.

The original band was Pierre Stoot and the Zydeco Two Step. Then they changed to Brian Jack and the Zydeco Two Step, for like one month. I was like, "I don't want that name." That's when the casinos were being built in Louisiana. And my cousin was like, you know, "There's going to be a lot of gambling out there. Maybe from these casinos we can get some gigs. Hey, 'The Gamblers'; we can be The Gamblers."

I said, "I like it. Sounds good."

But then, shortly after I started getting a real taste of what it's like to be in the music business, it turned into, instead of just trying to get attracted as a gambler, this music business became a gamble. Like you're rolling dice. So, when people say, "What's the meaning behind the band name now?" Even from years ago, it's not about the fun of gambling and Louisiana; no, this business is construction work. It's a gamble, just not knowing—I won't say living paycheck to paycheck, but it can be that way. If you don't manage your money right, I've seen

a lot of musicians out there that don't manage their money right. By the time they're 50, 60, it's like they having fundraisers for them. It's not the way to go. But that's what happens.

BF: Did you pick up the accordion yourself?

BJ: Oh yeah. Everything I did was self-taught. Nobody around me played squeezebox. I say *squeezebox*—that's a term for accordions. But nobody played a single-row accordion. That was the style I was in love with. Nobody played that. I just picked it up. My way of teaching myself was I played guitar. You have accordion lines. I would figure out what the accordion player played on the guitar. I knew my notes. So you had, for example, a Boozoo song, "Da da, da da." So I would get my accordion, match up the notes, say, okay, this is what the hands are doing. After you get used to doing it for so long, it becomes second nature to you, and you don't even pick up the guitar. You start hearing what they're doing.

Yeah. No instruction. Even when I would go to zydecos, and I was kind of like, "Hey man, can you show me something?"

Guys are like, "Yeah, stick around, stick around."

And I stayed. But they're too busy loading up to show you anything. It was like, okay, I got it from an early age. It's like, "Okay, I get this. You don't want to show me nothing. No problem." But I knew I had a pretty sharp ear. So, I was like, "You don't want to show me. But if you play it, I got it." All I'd have to do is hear it. That's how I learned things. It ends up developing to, "Okay. I know how to play other people's stuff. Now it's time to get creative and make my own stuff." And that's kind of what separates this artist from that artist—get your own stuff.

BF: Do you think you ever said to yourself, "I need to create my own sound?"

BJ: Oh yeah. You can play a whole bunch of cover songs, or get known for your own songs. It's like, okay, how do you get on festival and play? Nobody's going to watch you on a festival if you're going to play all of another band's songs. It's like, "We hire them to play their songs." You know, you can be the soundcheck band. That's what I always call it—when you're the first band, that's the soundcheck band. That's always just what it is. I definitely knew that I had to get some kind of something going on. Even if it wasn't liked. I didn't know how people would take it. But by the time I had played for about two years, I knew every—this band's songs, or this band's songs, or we knew how to play this song; if this band comes out with a CD we can learn it. But it's like being a wedding band. You're going to always pray to God that, you know, Lenny Kravitz comes out with another hit, or whoever comes out with a party hit. You know what I'm saying? So we can play it at the party. That works for some people. But not for me.

BF: And do you think you had, as you were moving toward your own sound, did you have a sound in mind? Did you know what you were trying to do, or is it just sort of what happened?

BJ: Just keep it in a zydeco format. And just make something that feels good.

Anyway, yeah, I just knew I needed my own sound, but just whatever feels good. That's how it is even today. Back then I was trying to write—you didn't want an accordion line that sounded like somebody else's accordion line because accordion is the lead instrument in zydeco. Now I write off of melodies. I don't even pick up my accordion. That's the last thing I record. I'll make a whole song off of guitar. And bass. I play bass, also. And once that feels I good I add words to it, and then, when it's time to lay down the accordion, in the demo process, I'll say, "Okay, let me figure out what I'm going to do with the accordion now," to where it doesn't sound like somebody else's music.

BF: You're doing this mostly in Texas, right? You're doing this in Texas because that's where you're from. The band is developing in Texas.

BJ: My whole band has always been from Texas. I've had to use musicians from Louisiana, if I'm passing through, doing shows out there. You know, we're all connected. We all know each other. Louisiana musicians come down here and they play, and they need—"Hey man, a guitar player. I don't have one tonight. You know anybody who can come play?" Or whatever. Oh yeah. So we're all connected, as one big business, I guess you can call it.

BF: Do people here have the idea that Louisiana is sort of the homeland, or that things are different here from Louisiana, musically? Is zydeco in the Houston area different, would you say, from Louisiana?

BJ: Yeah. It's not that big a difference. It's all on the person. Because I know some musicians from Texas—even myself, if I wanted to mimic how a Louisiana artist sounds, yeah, I could do that. But like I say, it's on that person. I don't really say, "I want to have that Louisiana sound for this CD." You know, I could. The only difference I tend to find is they play slower than us. The tempos are slower. Texas people like faster, upbeat music. They like it a little bit faster. Louisiana likes to groove. I like to be in between. I like to be fast sometime; I like to groove. To me, it's two different styles, but it's not like a big difference. To me, if a Louisiana artist wants to sound like a Texas artist, play faster; you sound like a Texas artist. I don't really see a big difference.

Of course, a lot of those Louisiana guys, by them having the Creole influence, they have people out there that speak French. A lot of people in Texas, we don't have that; a lot of our songs are probably going to be written in English. At least mine are going to be. If I have to figure out—I don't speak French or Creole, so if I want to learn something I know older people that I can go to that live here, that still speak French. I can say, "How you say this? How you say that?" Make sure I'm saying it properly. Then I can go and record it.

You know, it's a younger audience in zydeco now. There's still a lot of older folks that are still here, but it's a younger audience. And the

Brian Jack, St. Peter the Apostle Catholic Church, Houston, Texas, 2015

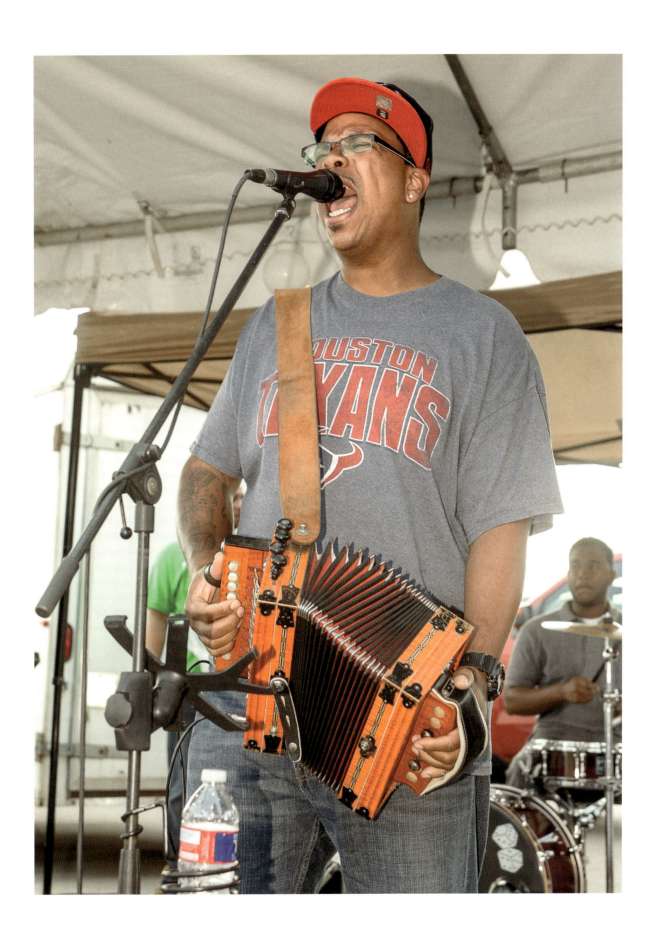

younger folks that are here now, they don't speak the language. So why would you write in language that nobody understands?

But you want to keep the tradition alive, too. You don't want to lose that. So it's still good to write songs in French. Nothing will ever be wrong with that. Yeah.

BF: So you have some interest in helping keep the tradition alive.

BJ: Oh, yeah.

BF: Can you say more about that?

BJ: The tradition, it's just—it's the roots. Everything comes from a root of something. The plant dies if it's uprooted. So you want to definitely keep where it comes from alive. Even if zydeco changes so much that it doesn't sound like what some people call zydeco anymore, I would still say every artist should at least put out one song that sounds like that zydeco, that people will remember. Like a lady told me yesterday, actually she's the widow of Wilbert Thibodeaux—he was an artist, actually one of the guys that gave me a chance when I was real young. She said, "I don't know who that band was last night, but, man, he sounded good. He played some good zydeco." Now, for somebody in that age range to say "some good zydeco," I knew what she meant. You get people that play the stuff from the nineties, the eighties, stuff like that. Because that was the style that they danced to back then.

Nowadays, you want a broader audience, so you're going to mix in R&B, rap, and stuff like that. You don't have to because there are people who don't want to hear that. It's kind of like country music; I listen to country music all the time. It's another favorite music. Listening to that, you hear people say traditional country versus, you know, "That's not country. Doesn't sound like country." Or I watched an interview with Florida Georgia Line; they were talking about they get labeled as "bro country," because it sounds like that kind of upbeat, mixed with hip-hop. But that's what the audience is wanting, and you want to give them what they want. But you also want to give them what you want—to see if they're going to want that, too. People don't know what they want until you give it them.

BF: And who is your audience? Who do you play for?

BJ: My audience? Everybody. Everybody. Yesterday we were at a church bazaar. It was a fifty-fifty crowd. It was some older, some younger. More older people in the beginning—y'all were there early. So you play a lot of traditional songs. You know, "Dog Hill," Boozoo; "Oh Bye Bye," another Boozoo song. "Cornbread," Beau Jocque. Or Willis Prudhomme; a lot of people don't know that Willis Prudhomme made "Cornbread" first, and not Beau Jocque. You play stuff like that because the older crowd, they're always there early.

BF: It would make sense that we were there then.

BJ: They have those early bedtimes. You know, it is what it is. They leave at intermission. So that's just one of those things. But you watch

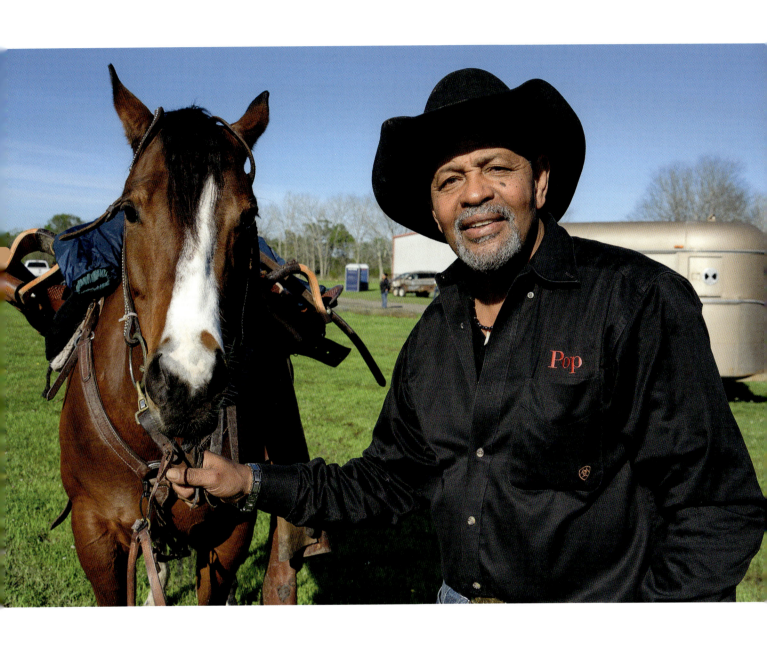

Trailrider, Opelousas, Louisiana, 2017

the crowd. That's what I do. I don't diss them. I've got songs that older folks be like, "Oh, *hell no*. What is he playing?!" They may say that's not zydeco; they may say, "I don't want to hear that." They want to hear the Clifton Chenier style, stuff like that.

And then you get a younger crowd there, there's a crowd shift. Or if it's all just young folks. That's just what you play for. You play for what you see.

BF: You do church bazaars. Do you do a lot of trailrides?

BJ: Oh yeah. We do everything, man. I do everything from church bazaars to festivals on the road, festivals here, trailrides. Trailrides are real big right now. Just about every weekend this year I was doing a trailride.

BF: We saw you doing a trailride.

BJ: Yeah, in Cleveland. Most of our schedule is booked up by trailrides. I do anything, man. Do family reunions. Do weddings. I haven't done a wedding in a long time. Actually, I did a wedding like two years ago.

BF: It seems like around Houston, the zydeco audience is mostly African American. Is that true, or is that just what we've seen?

BJ: Probably so. It depends on what you go to. Because if you go to a festival or something—depends on how it's advertised. If you have somebody that's giving a trailride and the majority of the people are African American, they go to where they know people that listen to the artists. So that's how it comes out. But if you to places like Jax Grill, more the restaurant-style places—some people don't even know. I'll tell people that have lived in Houston for years, "Yeah, we play a lot of trailrides."

They like, "What's a trailride?"

You know, they don't even know what it is. So, I won't say that zydeco has an all-Black audience or a majority Black audience; it's just that you happened to see that now because that's the venues, you know. Everybody is not into trailrides, but they love zydeco. I know a lot of people; I meet people at Walmart, they're like, "Are you Brian Jack?"

And they're white or Hispanic, or whatever.

I'm like, "Yeah."

They're like, "Hey man, I have your CDs." I was in Subway one day, and it was a lady that had my ringtone. And she wasn't Black. So I'm like, okay; somebody's listening to the music other than Black folks. It's definitely not a one-race music.

But it is a cultural music. So by being cultural—you know, that's what I try to tell some people. They ask me all the time, "Do you think zydeco will be as big as R&B or country?" Those musics are worldwide. Zydeco is known throughout the world, too. But it's just more of a cultural music. You know, people that like soul music hear a zydeco song, just because soul, R&B, or whatever, the Motown type of sound,

was Black folks—vs. zydeco being Black—don't mean they're going to like it because, "Hey this is Black music." It doesn't work like that. It's what you like. Do you like zydeco music?

BF: I'm here.

BJ: Hey. There you go. So, you can't say that it's all just one-race music. In my opinion.

BF: I was talking to Leroy Thomas at a festival in Massachusetts . . .

BJ: Another guy that used to—I used to be a kid hanging around those guys. Not too many of them you can put by me that I haven't hung around or been around or knew here.

BF: Leroy said his audience in Louisiana has really shifted. He's playing mostly in front of white audiences these days. So I wonder if, given that it was Creole and African American musicians who created this music, it seems again that in Houston that audience has stayed more true to the music's origins. Maybe because more tourists go to Louisiana to hear music.

BJ: Yeah. That, too. It's kind of like I tell people I play zydeco, they say, "Oh yeah, that New Orleans music." No.

It could be a battle or discussion all day about what's what with the zydeco music. I can tell you what I know. But you can get somebody that's in Louisiana that's deeply rooted and can tell you how it all began, that's an older person. I only can tell you what I've been exposed to. And some of my details—I might think—like some people might think, some people say Beau Jocque made "Cornbread." I could be one of those guys say, "Yeah, man, Beau Jocque made 'Cornbread.'" And if you go to Louisiana, they be like, "No." You know, an older person can educate you on that. I like to be very careful with what I say with what has happened with zydeco. Because I don't know it all. I only can tell you what I know and what I experienced.

BF: Have you always been a full-time musician?

BJ: I worked one job, one job. This goes back to the whole knowing what I wanted to do thing. To answer that question, I worked for Central Freight Lines; I worked for a freight line company. They had this thing called a belt that went around the whole dock; I worked from a dock. And the freight would be on buggies. My station would be station fifty to station eighty; the trucks backed up, and you would pull the freight off the line. It was on these big buggies. The forklift driver would bring the freight, and you'd load it into the trucks. I worked there for about a year.

But I guess I always tell this story because it's proud moment for me. When I first started playing guitar, I was roughly about thirteen or so, and started playing in my uncle's band. And I got a taste of making money. I made like fifty dollars a show; they would give me like fifty bucks a show. And I was actually the second guitar player. He had a guitar player already. But it was just something; you know,

he kept me out of trouble, stuff like that. I made money; I made about $150 a week. They were gigging all the time. Some gigs I couldn't even make because school came on Mondays and stuff like that. So I started making some regular money, and I became the full-time guitar player, making $150, $200 a week. And I'm saying to myself, I'm going to make this money for the summer. I've always been known for being tight. I don't spend money. Man, if I make it, I set it to the side. Unless it's going to make money. I definitely will invest into a bunch of stuff if I can flip it.

So, I did that and I realized, like, my parents, they never had like six-figure jobs, nothing like that. Mom was a custodian for a school district. My dad laid asphalt all his life, working for the county. And I said to myself, "You know what? I'm going to take a little load off of them. I'm going to start buying my own lunch at school." When the summer came, I said to my mom, "You know what? I've got enough money saved, let me buy my own school clothes." I did that from roughly my eighth-grade year until the person you see today. Never had to ask my parents for money again. That was my thing. My daddy used to tell me, "Save your money. Save your money. Save your money. Don't mess up your credit. Save your money."

That's what I did. I tried my best to keep my nose clean. I never was a kid that was in trouble. I saved my money and ended up—going back to the sport things, I was in eighth-grade football, going to the ninth grade, and I was, I guess, considered to be a star, eighth grade. I was playing defensive nose guard and sometimes linebacker, and the coach asked everybody, he said, "If you're moving or not coming back, raise your hand; we're trying to get a headcount to make sure our starters are coming back. Let us know."

I raised my hand up, and he said, "Hey, Jack, I don't have time to play right now. Now look here, we're trying to get this going."

I said, "No, I'm not coming back."

And he said, "Well, what's wrong? Are you moving or something?"

I said, "No." And I stood up in front of everybody; it was like a brave moment for me.

Everybody said, "What's wrong?"

I said, "I'm going to start a zydeco band."

And they busted out laughing. Man, they just laughed.

Not to rub it or nothing, the same guys that I know that were my friends, they were still cool with me. They laughed; they say, "Man, you remember when you told coach you were going to start a zydeco band?" They're like, "Man, we hear you on the radio all the time. We can't believe you actually . . ." They always say, "Man, I apologize for that. Because you knew what you wanted to do."

And that led to me making money, but I was like, "Okay, I'm not making a lot of money." But by the time I stopped going to school, I

Zydecoing at Jax Grill, Houston, Texas, 2015

was like, "You know what, I'm going to get a job. I can play zydeco and get a job."

That's when Central Freight Lines came in. I worked that job for a year. And they pissed me off good one day. They gave me two different loads of work. One guy didn't make it in. My boss's boss came, and he was like evaluating this guy, and he was like, "Why is it taking so long for all this freight to get out?" I heard the guy say, "Jack, what's taking you so long?"

I said, "Man, I got a double shift; I'm doing this man's load and my load. What you want me to do?"

And he just made a big scene in front of his boss; he wanted to look like a boss himself. I was pissed off. And I said, at the end of the day, "See y'all on Monday." When I was walking down that dock, I said, "Shit, I'm not coming back to this job no more. I'm not working for nobody ever again." Haven't worked a job since.

I said I was going to make music work for me that day. That's what I did. Yes sir.

BF: And what did you have to do to make the music work for you?

BJ: Live it. Got to live it. Breathe it. Every day. You got to think. What's the new thing to do? What can I do? It's a business. It became a business for me. It wasn't no more, "I like to do this for fun." It became a business. It was just like what you guys do for work, it's a business. You got to go out there; I started making my own flyers. I was known, but I wasn't like known-known. People weren't paying ten dollars to come see me in nightclubs and just waiting outside the door, like, "I can't wait to get into this club." It never was that. So, I just—hey, if I had a gig, I was at other people's gigs, putting flyers on cars. You know, I don't play at Jax anymore, but I was like the second band that ever played at Jax. I opened the doors for Jax. Jax, you know, opened the doors for other bands, but I was the one out there, when the other bands that was actually doing good saying, "I would never go play at the place," I was like, "Come see me play; it's free. You don't have to pay any money. Just come see me." And then once I started luring them in with that, I had it. I was rolling.

I don't know if y'all got that history, but there was a manager at Jax named P. C. He was the first guy to bring zydeco there. P. C., what was P. C.'s name? It was Preston something. But anyway, P. C. had my cousin's band there. My cousin's band couldn't make it. He started calling my band. Because you see when my cousin left he went to the Zydeco Dots. He was the accordion player for the Zydeco Dots. And there was a Pierre before him; Pierre from Louisiana, the Zydeco Angels, I think. I don't know if you're familiar with them. Pierre Blanchard, that's his name. Pierre Blanchard. Somebody you can probably look up; I don't know if he's still playing. He left the Zydeco Dots—my cousin's name just happened to be Pierre also. So

it was still Pierre and the Zydeco Dots. They called me for a few sub gigs to fill in for him. Because they were there at Jax every Friday. So then P. C. started saying, "Hey, let's rotate some bands. We're getting different faces here." And I pushed the hell out of Jax. I was pushing and pushing and pushing. And that's how it kind of snowballed into, "Hey," P. C. said. "You know any other bands?"

"Yeah; you ever have Nooney?"

Nooney was playing. I gave him the people that I knew. That's how Jax ended up really taking off like it did. I was there, and I played Jax for years. For years and years and years. Long story happened with that; I won't get off into that. I don't play Jax anymore. But, hey, it was good while it lasted. Which was many, many years.

BF: And you were out there putting out flyers and . . .

BJ: Yeah. Man, you put out a flyer. You do it like any other business. You advertise yourself. Sell yourself, as they say. That's what you do. That's what I did. Had to record a CD. Did two CDs.

BF: When did you do your first one?

BJ: I did my first CD tenth grade, eleventh grade, maybe. Tenth or eleventh grade.

BF: How many have you done?

BJ: I don't even know. Because after I made my own studio I just sort of started spinning them out. My first studio was small, the size of this room. It was a bedroom, actual bedroom, in my mama's house. I had to convince her, "Hey, I know how to do recording." Not recording; I knew how to do live engineering a little bit. And if you don't know, you think it's the same thing. But it's not. It's a totally different atmosphere. So I convinced her, and that's how that came about.

BF: I'm really interested, the couple of times we've seen you, it took me a little while to realize that when I'm hearing the harmonies, it's that you're using effects.

BJ: I don't really tell people; I never really say it, I'm not a trendsetter in zydeco. I'm not the first one to actually do stuff, but I'm always finding ways to do it for the first time for zydeco. The products that they make that's been out there in the R&B field—I'm a gadget fan. I like finding stuff that can work for me. If you catch me this time next year, you're going to see something that's going to be really different. I'm just always thinking ahead. That just is what it is. I used to have musicians that play with me in the past, and they did back-up singing and stuff. One of my main guys—he plays bass with J. Paul now—he was my drummer. He's the drummer on my CD, *You Don't Know Jack*.

BF: He sounds really strong on that.

BJ: Between me and him—I did the background vocals too on that. When that CD was getting ready for release he told me, "Hey, I'm going to go play bass with J. Paul."

"Okay."

I'm saying to myself, "Shit."

He sang all the low harmonies, and he was strong. He could sing all around. He's a great singer; he taught me how to sing. I don't consider myself a great strong singer, but you know, I get by. He's the all-around musician. He was like a drummer; his timing was like, I tell people all the time—if you want to know who the best drummer in zydeco was, it was him. He was just that good. Been playing since he was like four years old. Just that good. But anyway, I lost him. And that was like my main guy. I had one guy that was singing the high parts, you know, together put out that low harmony; just something missing. I would always say, "Man if I could find something to just help me sing." I started researching. I would see all these little harmonizing vocal boxes and stuff. I had one of them that was made by Digitech or something. It was crappy. It was in the early stages of the company developing that type of stuff. And then I found one that TC-Helicon made. It was called Voice Play or something. It was something. It can do three, four harmonies.

It was a really difficult but eye-opening piece of equipment to learn how to work. So I bought it. It was two or three hundred bucks; something like that. I tried it out. I didn't really know how to set it. But when I would get it, it was like, man, this shit sounds great. I really love it. I used it for a while, but it just really wouldn't do what I wanted. I go to the NAMM (National Association of Music Merchants) show every year. I don't know if you're familiar with NAMM show.

BF: Yeah.

BJ: In California, Anaheim. So I went, and I went to TC-Helicon booth, and they say they have a new pedal coming, this and that. And I was like, "Oh! There it is." They were doing these demos, and I was like, that's what I've been waiting for. I called the company—"When is it coming out? When is it shipping?"

"Hey, we working on it; we working on it." Time passed, and I just forgot about it.

I went into Guitar Center one day, "Oh shit, there it is!" And I was like, "Give it to me." Bought it. Brought it back, kind of fooled with it. And man, that thing is great. Actually on my last CD, that's not even me singing at home; that's the actual box doing all the harmony. And it's become kind of like a backbone. If I'm doing a new song, and I'm not sure what the harmonies are going to be, I plug up the box and listen to it. Because it's still good to hear actual people singing your harmonies, not a digital box. But it helps. It's a great tool to have. But yeah, it's a digital harmonizer.

Now, like I said, with that, you've got other people—Chris Ardoin has one. I get people calling me, "Man, how do you set the box? I can't get it to set." If you don't know your keys, what key you're singing or playing in, if you don't understand that stuff, you'll be lost. But I got it from the day I saw the demo. I was like, "That's it."

BF: It's fun to watch you work it.

BJ: Oh yeah, man. I remember the first time, I played at Festival International. That was one of the first times I went to Louisiana and played with it. J. Paul's band happened to be there. I think they had a show that night. I had an early slot at the festival. They were out there looking, and they kept looking, like, "Who in the hell is singing with you, man?" They just kept looking. And the stage, the monitors on the floor were kind of big, so they couldn't see my foot. To this day, people are still like, "Who's singing, man? You got some great singers in your band."

I'm just tapping my feet to the music. But it's not a secret. They didn't make that one pedal just for Brian Jack; you know what I'm saying? So, there's people out there that definitely use the product. Hey, that's one of my own sounds. People see it, you know, and they try to get it. I don't know; I can say it's made for everybody; if that's what you want to use, this will definitely help. But I know I've inspired a bunch of zydeco musicians to go get one. I tell them, "Go get one. Shit, why not?"

BF: You need to make a deal with the company. Signature model.

BJ: I've been trying. I've talked to PreSonus; I'm trying to get some endorsements. I've got an endorsement deal right now from the speakers that you've seen, Yorkville.

BF: They're Canadian, right?

BJ: They're out of Canada. The rep that I deal with, he hooked up a nice little deal for me. It's not a full-ride scholarship with them, you know. To me, the sound of those speakers, they can't be beat. Not box for box. Like they say, pound for pound.

They got some bands out there with some massive sound systems. Lil' Nate has a great sound system. It's really big. Keith Frank has a big sound system. Chris Ardoin, actually Chris's speakers—have y'all seen Chris play since you've been here? If you go see Chris play, his JBLs are my JBLs that I sold him, J. Paul, there's a few guys that bought them. I had eight dual eighteen-inch subwoofers, and eight dual twelve boxes. Tops. Yeah. I had a pretty big sound system, but I had to downsize. Man, it was like power is the new age. It's been out there for a while. I was like, "Why keep lugging this heavy stuff around?" And that trailer that I had—that's what I consider my big trailer. I have a smaller trailer that I actually put stuff in if I don't feel like carrying a big load. I know I got some shows coming up that's outdoors, and I got to pack a pretty big punch to reach a big crowd. That's when I bring my big trailer.

BF: Do you see yourself at seventy years old hauling that stuff around?

BJ: Oh, no. At seventy, no. Fifty, maybe so.

BF: I'm trying to think how to ask this. When I was talking to Leroy, one of the things surprised me was that he talked about how happy he

is to stay home. Basically he says that they play fifteen to seventeen gigs a month, and he doesn't have to travel very much. He sort of seems to be all in favor of a local scene.

BJ: Yes, sir.

BF: And a local career. How do you feel about that?

BJ: How can I say this? It's a blessing. I've always played around home. Don't get me wrong—I've done road work. I've gone to California, Florida; I did the Seattle stuff, all the stuff they do in Philly and all that. I did that run. The same run that Leroy used to do all the time. That's why he's saying he's happy to be home. Well, I've been home for a long time. I always say, man, why do they do all that damn driving? It's like, by the time they do all that driving and that, they making money, but they can make the same damn money right here. But on the same note, you're exposed to a broader audience.

I'm playing right here. For example, my audience, Texas and Louisiana, just a thousand people. You on the road, you hitting a hundred new people per city in all these different cities. You know, you come out with a CD and the way the towns are now, you don't have to order stuff, the actual hard copies of the CDs for the record stores. You just, boom, instantly got it. So the advantage of that is, you have people that you actually reach; you just never know who is going to know somebody. And just playing for multiple people on different nights, you're seeing different people. That's always a great thing. Now here, I can guarantee you that he's like me: you're going to play right here, you're making good money, you don't have to travel, you can go and sleep in your own bed every night. But the downside to that, to me, is you're not expanding.

There's ways of expanding yourself, social media and stuff like that. But still, you're—how can I put it? For example, we play here—I could tell you half the people that were at that show last night. Because I see them every weekend. They support me like crazy. I love that. But on the same note, it's like, how do you make a hit record if other people in the world don't hear it? Unless it just blows that big, like "Cupid Shuffle" did. "Cupid Shuffle" was right here. It just kind of took off. You know what I'm saying? So unless you get one of those type of situations, it's like, you never know if you got another audience. Like I say, I've got songs out here—you ask me about my style or whatever. If I make a CD and nobody likes it out here, who's to say somebody in Nebraska might not like it? Who's to say somebody in DC might not like it? You will never know unless you're out there doing it. I can guarantee that people in DC, they may go to a roots type of festival or something. I can guarantee you they're not, at home, shopping for zydeco music on iTunes. But if they see a zydeco band at a festival in their community, it's like, "I like this music. What is this?" Or whatever. That's how you capture an audience. But it's hard, like me and you, we talked; I told

you I have school schedule, dropping kids off in the morning. It's really hard to get out on the road and do that.

You know, people call me for the road all the time, but I'm like, "If I'm not flying, I'm not going." That's just what it is. If I can't fly in and out. My last few experiences with flying—these damn airports broke my accordion two times in a row. Twice. They just throw the hell out of the luggage. And my stuff is in flight cases, and still; I don't know if you're familiar with how accordions are on the inside. All the reeds are mounted onto a reed block; it's just a wood block in there, different slots. It's a reed instrument. Well, that block is glued real tight, and it's glued very well, onto the actual plate. When you see the paddle slapping, it's glued onto that; that's why they have holes, and the air is going in and out. Completely snapped off. Snapped off, and no air is getting to the reeds. And I have to go, and my accordion is down for like three weeks because they have to scrape all this stuff off and try to make it like new again. Accordions are very expensive now. Too expensive, if you ask me. But I'm not the one to say what the price point should be. I hear why they're going up. My last accordion, I paid fifteen hundred dollars for it. And now they're like three thousand. I'm like, "Shit."

BF: It seems like there are more people making them now than used to be.

BJ: Maybe. I got my number one people that I deal with; I don't go to nobody else. I don't want nobody experimenting on me.

BF: You play a triple-row sometimes.

BJ: Yeah. I played it yesterday. I just normally play it midways through my show. Yeah.

BF: What do you get from playing that that you don't get on the single-row?

BJ: Well, like I say, I had an infatuation with the single-row from the first time I heard it. But then as zydeco progressed, with different, with people coming out—Boozoo played triple-row. But like I say, I didn't really know that sound in his songs at that time. Then Beau Jocque came and Keith Frank was playing, and those guys. They started whipping out the triple-note. It's like, okay, people started asking me to play songs that I couldn't play because it was required that they be played on the triple-note. So I kind of got thrown into the whole triple-note thing. But I prefer a single-note. I just like the feel of it. You can really get up and just be aggressive with playing it. Because it's small. Don't get me wrong. I know some triple-note players, you got the Dopsie brothers and all those guys, Andre Thierry, Cory Ledet—those guys play the hell out of a triple-note accordion. And make it look easy. Very easy. I just can't wrap my head around it like they can. But I like it. I like the tones of it. If it's played right, it can be a very, very beautiful-sounding instrument. But at the end of the day, I just like the single-note. It's more of a grungy-sounding accordion. But the fans, you know, a lot of

great songs have been made on triple-row accordions. So that's why I've got to roll with it. If they start playing piano-note style again, I guess you'll probably see me in the corner, practicing on the piano-note style until I get it down. I don't play piano-note style. I know a little about it but not enough to say anything about it.

BF: Andre plays it.

BJ: Andre plays the hell out of it. Andre is an all-around musician. He just, you know—good person and accordionist. From him to, even Chris Ardoin, or Cory Ledet, Dwayne Dopsie—they're out there. Lil' Nate plays the triple-note well, also. There's a lot of them out there. And Keith Frank; Keith Frank plays the hell out of it. Not to miss anybody. I don't put myself in the triple-note category. I just don't.

BF: Well, is there anything I should be asking you that I'm not asking you?

BJ: How's my family?

BF: They're playing football. I know that.

BJ: Oh, man, my kids are doing great. My daughter's three. My middle son is five and my older son is seven. The two boys have birthdays this year, so they'll be six years old in October and eight years old in December. I'm having fun; I'm doing the whole football thing. We were against it at first, like, no, man. My wife, her brother was a coach, and he still is a coach. And it was a whole lot. We would see his schedule and think, "No, we're not going to get into football."

"No. It would be fun."

But she was a little bit worried about injuries and stuff like that. And now she is like, my wife is like, she's all for it: "We got football; get them there on time." And this and that. It's like, "We can't be late." We got this chant that we do before the games with our team. Actually some of the team members and the coach, we all did a song in the studio. I told them, I said, "You ought to come into the studio, the whole team's lineup, and make it like, get an announcer." This is little league, but I'm thinking overboard. We came out with this big lineup announcement and this chant that they do. It was like, the other team was like—we scared the shit out of them before we even started playing.

BF: That's great. Well, I want to thank you. I'll turn this off.

JT: Can I ask one question?

BF: Yeah, sure.

JT: Think about your best moments in zydeco—could you describe to me where you are when you're thinking, "Yeah, this is why I play zydeco"? What's happening to you? Where are you?

BJ: In my career is what you're saying? Right now?

JT: Yeah, you're really feeling you're in the flow, and you really feel it, and you're like, "This is it. This is why I got into this."

BJ: At this moment, I'm nowhere where I want to be. When I got into this, it was rock-star level, if you will. Not the rock-star lifestyle,

but just the sky is the limit. I'm never satisfied, just like the whole vocal box thing. You know, even if I had singers in my band, I probably would be using the vocal box. Because it's that perfect for me, and it just—I'm always looking. Like I said, a year from now, you're going to see me with something totally different from what I'm doing now. At least that's the plan. I'm just looking for the next big outlet to boost myself to the next level. I've started off, as they say, from the bottom, and worked my way up to, from spending $4,000 to record a CD to owning my own recording studio. To going from having musicians to doing certain things to, "I got this now." Like in the early days, my band played with me, my CDs. Now the majority of the CDs is me playing guitar and bass, and background vocals and stuff like that. I don't know where I'm really headed, if you will. I never have an agenda on what I want, on this is what I'm going to do next. I always have a timeline I want to try to keep myself on, "Okay, by next year I want to be doing this and that."

I guess to really answer your question, the next move is to play more shows—and I'm always playing—I love playing. I want to start playing more festival-type of events. Like I say, to reach out to that crowd. Broadening my horizons, if you will, just reach more people. I know how to reach people in Texas and Louisiana. But there's more to music than one area. You'll always be loved in the area you're in. But there's more love in other places that you can go. I just think that that's mainly just to grow. As to where I'm at right now; I'm happy where I'm at right now.

Right now, I'm doing something that, Chris said he did it back in the past. I don't know if you noticed; I don't have a bass guitar player. My keyboard player was playing bass. I'm going to do some different things. You know, you deal with musicians that, "I can't make it to the . . ." My drummer yesterday; that wasn't my drummer. My drummer was on the road with Ruben Moreno. They had some vehicle issues. He was supposed to come back Saturday, and they were still on the road trying to drive in. So, I'm working on solving those problems in the next year. Of dealing with—I'm not saying my drummer is a headache because he's not—but with the headaches of, "I can't show up right now, Ma. I'm sick." I'm always thinking ahead. What does Beyoncé do if her guitar player is sick? Or what does this person do? Does the show stop? I never heard of Beyoncé canceling a show because her tambourine player got the flu. You know what I'm saying? The show goes on.

Well, with zydeco, if your drummer doesn't show up; you know, if you can't call nobody until the last minute, what do you do? I got a few solutions I'm working on. I used the drummer—that's bad example because I never would want to see a zydeco band without a drummer, live. Unless somebody just says, "Hey man, can you play me three songs at a bar mitzvah?" Hey, let's go for it; if that's what you want.

GS: Did your wife understand what she was getting into marrying a musician?

BJ: Can I say this into the mic? Hell, no. I was that guy that—well, she knew what I was going to do. She said, "Yeah. The sky's the limit. It's going to be great. I'm going to do this; I'm going to do that." I was playing gigs when—it's not like she was introduced into anything new. It was more the longevity of it. It was kind of like, "Okay, you're going to play music, blah, blah, blah."

"Hey, no. I'm going to play music. I'm going to do great things. I'm going to be known. I'm going to be big. I'm going to be playing here, there, everywhere."

We dated for like seven years before I popped the question, as they say, because I wanted her to know—really, I'm being very serious—to know what she was getting into. How serious I was about playing music and what comes with being married to a musician and all that other good stuff.

About three, four years after being married, she said, "Shit. Are you ever going to have a weekend off?"

"No. Musicians—we are the party. We don't go to the party on the weekends."

We're the entertainment for the people who do work regular nine-to-five. They want to let their hair down on the weekends and say, "Man, I really can go and see a good band this weekend. I can't wait."

That's why Monday through Friday, I'm sitting, and I'm taking the kids to school. I'm up here in the studio—this is work for me, too. I'm up here doing stuff or whatever. So our schedule, it works out, just if we want weekends or whatever, it's kind of like, "Okay, we're going to have to put in for vacation or something like that." But most of the time I don't see too many; like this weekend, Friday, Saturday. Next week, Friday and Saturday I'm off. Sometime I do something I call—I force gigs. You know, I could call a nightclub right now, say, "Hey, I'm going to come over and play; I'll take the door." And I'll do the whole advertising thing, like I told you. I could pull in 150, 200 people and make something happen.

This weekend coming, I'm just not feeling it. Just going to sit and relax; just so happens it works out. My kids are playing football an hour or something away. I've been blessed for the majority of the year to where if I don't play for the rest of the year, I'll be good financially. It won't be a problem. But that's not what you want to see; you want to stack as much money as you can because you never know. Our fear is you know, my mama always goes to the extreme: "What if your fingers get cut off or something like that? What you going to—?"

"That's what you have insurance for."

But that's the fear. What if you can't play no more at a young age? Everything is day by day. For the most part.

JEROME BATISTE

Jerome Batiste and the ZydeKo Players

"I want to stick to zydeco that is family oriented. Kids and everybody else—they always want to come to zydecos and the trailrides."

Interviewed November 2, 2015, at home in Barrett Station, Texas; Gary Samson was also present. Barrett Station has an interesting history. Harrison Barrett, who was an enslaved person, founded the town. Upon emancipation in 1865, he spent years tracking down and reuniting his family; he was able to locate four of his five siblings. They then settled in what became Barrett Station, which is the place Jerome calls home today.

We just some Creole country boys.
We just some Creole country boys.
We just some Creole country boys.

Not long after our interview, Jerome Batiste dropped this song, "Creole Country Boy," which is a celebration of life, and especially of hunting, as he wants to live it. The song joins others in the zydeco repertoire, telling listeners what's good—and there's much that is—about Creole life. It makes me think of Step Rideau's "The Creole Way." Riffing on the accordion, Step calls out a menu of Creole dishes—file gumbo, étouffée, and more. The Grammy nominee's song talks about hunting, his one-eyed dog, and his four-wheel drive. Given that both Step and Jerome live in the environs of the fourth-largest city in United States, it's worth thinking about the enduring power of what began as a rural identity. When it's at home, in Texas or Louisiana, zydeco is a music that represents community, an affirmation of shared identity.

We pulled up to the Batiste family home, near Crosby, half an hour (if the traffic cooperates) from Houston. In the bed of the pickup truck outside, big coolers held the bounty of the hunting trip from which Jerome and the family had just returned. Jerome opened the door in a camo shirt. He lives the life he sings about in his songs. And he was more than ready for this interview. One question from me, and he was rolling.

There's a nice photo of Jerome from 2004 in Roger Wood's book *Texas Zydeco*. He's on stage somewhere, playing a triple-row accordion from Houston's accordion dynasty, Gabbanelli. And he's wearing a western-style hat. Wood writes about this, contrasting the hat's older, more rural look with the more urban, hip-hop-inflected style of J. Paul Jr.,

one of zydeco's best-known bandleaders. These days, Jerome seems to prefer ball caps, bill-forward (while J. Paul wears them backwards), but that contrast holds. Jerome is that Creole country boy he sings about. Family matters a great deal, and his father and other family members come to visit as the interview is winding down. He and his family hunt for their food, and Cheri, his wife, made sure we were well fed, including some deer sausage, before we left. Extended family members came by as we were finishing up, and, as some Creole people say, we passed a good time together. The Batiste house displays many trophy heads, testifying to Jerome's competence in the rural ways he celebrates. Jerome runs a family business, repairing small engines. He seems very content with his life. It's surprising he's also not a little breathless, given how busy he must be.

BF: Why don't I start by asking you where you were born? Talk a little bit, too, about your family.

JB: Well, actually my mom and dad are from Louisiana, but all the kids are from Houston. We grew up on the south side of Houston, Sunnyside area, attended St. Francis Catholic Church. My daddy made his home in Sunnyside, and I grew up there. I attended Worthing High School, where I obtained a track scholarship, ran track four years at Texas Southern University, qualified for the Olympic trials in '92, but I didn't make it past the trials—400-meter hurdles. From there just kind of was into everything.

I've also been country. I fish and hunt—I live that. That was my number one before anything—fishing and hunting. So I got into riding bulls. So I rode bulls for a couple of years until my dad persuaded me to give it up because we lost one of my brothers in a freak accident playing street football. And he was afraid he was going to lose me, too. So he convinced me to quit the bull riding. Some of my friends I was riding with went on to become professional bull riders, Gary Richards and James White. Tea-Spoon. That's who I rode with. I was pretty darn good at it.

So after I gave it up, I picked up the accordion. I went to a zydeco, and I went to see J. Paul Jr.; that's when he first got started. I really liked what he was doing, and I was kind like, I kept saying to myself, "I know I can do this."

So I went and bought me an accordion. And it was crazy. I didn't know much about accordions, so I was going around to the pawn shop. And they ended up cheating me. I went and bought a toy accordion for 150 bucks. I bought a little old—it's called a Hero—and took it to Gabbanelli Accordions to get it tuned, to get it fixed. And he was like, "What are you doing with this? Hey, I got stuff like this for sale for twenty bucks if you want a new one."

I went through a lot. I started out getting a toy accordion. Finally I got a chance to get my first real accordion on my birthday. I think I was

Jerome Batiste and his wife Cheri at home, Barrett Station, Texas, 2015

Jerome Batiste and his son Jeremiah,
Barrett Station, Texas, 2015

turning 26. And I'll never forget that day. I was coming from work, and I was so excited about going to get my first accordion from Gabbanelli. And I got a traffic ticket on my birthday. I ran a red light. I ran a red light and got a traffic ticket. So from then on I got the accordion.

I nearly ran my parents crazy with it. Because I was staying at their house at the time, and my daddy was like, "Man, you need to go to a park. You need to go somewhere, whatever. You're not getting it." I ran him crazy. I kept on and kept on, and eventually, about six months later, I was going to sit in at a couple of places like the Big Easy and Shakespeare's, places like that, where they had a jam session. I would sit in. I was getting pretty durned good at it.

Mary Thomas, she was the first one to give me my first zydeco gig. Y'all know Mary Thomas. That's Clifton Chenier's sister. So she gave me my first gig, and the rest is history. I'll never forget. The first time I ever played was with Dwayne Dopsie. He was doing a little tour with Geno Delafose's brother, Tony, the one who plays bass guitar. And they'd play Shakespeare's, and I was shocked to see how he played Clifton Chenier's music better than Clifton. Dwayne Dopsie, he's probably the most talented zydeco accordion player there is. Watching him, I got my chance to perform, and did my little thing. People said I did a good job. I was asked to play, Pierre Stoot was having some problems; there was a guy named Pierre Stoot back in the day. The Stoot family here in Barrett Station, they were very popular. They brought a lot of zydeco here. Matter of fact, was one of the first ones, before Step Rideau and Bon Ton Mickey and those guys, they were around in that era. But I know they started before Step Rideau. Because I remember Step Rideau used to come and learn from them, also. So Pierre Stoot was going through some things in his life, and his band asked me to help because they had some gigs lined up, and they needed some commitment. So I joined the band or whatever. They didn't think it was going to work. They were just trying to finish out the gig.

So they asked me, "What are we going to name the band?"

I said, "We're going to name the band Jerome Batiste and the ZydeKo Players."

They said, "Okay, that's fine."

We were Jerome Batiste and the ZydeKo Players. So we started playing, and next thing you know we were playing everywhere. We were gigging. We were probably playing four nights a week at all these different places. And we were a good band. Walter Chenier was also in the band; Clifton was his uncle. And Gerard Chenier was in the band; he was the scrubboard player, actually. He and I was pretty tight at the time. So we was really moving up.

So they came to me one day, "Jerome, mister; let's change the name of this band."

"What do you mean? All the bands I know, the accordion player's name's out front. That's what makes zydeco."

You know, we kind of had discrepancy; we ended up parting our ways. I ended up starting my own band.

At the time, Step Rideau was going through a transition; he had lost a guitar player by the name of Kevin Navy. Kevin Navy, we talked, he said, "Well, I play guitar." I found another guy who had played with Sherman Robinson; he played with J. Paul, with a lot people. He helped me get started. That's how I got started; he played bass. I had another guy named Derrick Murphy, which is Weasel's cousin; Weasel played the bass with J. Paul. He also had his band. Derrick Murphy played drums. And a real good friend of mine named Eli James. Me and him was the ones that said, "We're going to start a zydeco band." Because we were watching Beau Jocque. I said, "I got an accordion. I'm learning to play it."

He said, "Man, I got a scrubboard."

He's a lot older than me; our families came from the same Catholic church, and we'd always see each other. He was a fireman at the time.

So finally we got a chance. I had him on scrubboard, and everybody else, and we started a band, Jerome Batiste and the ZydeKo Players. I'll never forget it. The first gig I had, I was on TV. Channel 26. I was playing for the United Way. They were having like a nonprofit deal or whatever. So I ended up making the news the first time with my new band.

Pretty much the rest was history. I went from there. I recorded my first CD in 2000. My second CD recorded was named for my little girl. And I just finished my third CD. It was released in December. It's doing well. It could do better, but I'm really getting a lot of good reviews on it.

Actually, I gave it up for a while; we've been through a lot of tragedy. A lot of close people in my family. My little nephew that I was raising. About twelve years old until seventeen. Ended up getting himself killed. Gun violence. And then my nephew that I was really, really close to—I mean, I spent a lot of time with him. His name was Gregory Anderson. His dad was a professional basketball player, Cadillac Anderson. He went to the Navy to try to better himself. He got promoted to an officer. Went to celebrate in Seattle, Washington—got shot and killed leaving a club. It just, it really just knocked the wind out of me. I actually stopped playing for about almost three years.

Everybody was saying, "Jerome, you got a lot of talent. It's in you to play. We really enjoy your music." Because back then we didn't have the internet too strong. Everything was by word of mouth. And I started paying attention. I would still go and check out a couple of bands, whatever. But all these young kids, they knew me. They knew me by name and they were playing music, my songs. Like Koray Broussard: he actually recorded one of my songs. He did a better job than I did.

I really applaud him on it. And Lil' Wayne recorded one of my songs, and he put his own twist to it, and he actually did a hell of a job with it, also. They really made me feel good because that's what it's all about. Because that's how we all learn to play, from listening.

Boozoo is my favorite. He's actually kin to us, like on the in-law side. My auntie—I think that was Boozoo's first cousin. Every time we had a family function, he was out playing for us. Him and my Uncle Charlie, they used to race horses back in the day in Lake Charles, Louisiana. So, I have a strong family tie to the zydeco community and Creole culture. It's embedded in my blood. And a lot of Native American—later on, we found out that my dad's pretty much a hundred percent Native American. His parents were off the reservation; it's the Avoyel Indian tribe in Marksville, Louisiana. They're now just getting noticed, and they're trying to get things together.

BF: So you were born in Texas or . . . ?

JB: I was born in Texas. My family is from Marksville, Louisiana. Every summer I was down there, little kid. I was staying every summer, places in Marksville with my auntie.

BF: And do you have early memories of zydeco music? Did you hear much of it when you were growing up? You mentioned hearing J. Paul Jr. here. Before that?

JB: I was going to get to that, and I'm glad you brought it up. When I was young, I couldn't stand zydeco. I didn't like it at all. I used to make fun of my daddy. Me and my brother used to talk about, "Look at him—he thinks he can dance." He'd get out there, and Geno's daddy was popular then. John Delafose. He ended up playing a benefit for my brother at St. Philip Neri Catholic Church. That's on Martin Luther King Boulevard. So we pretty much have been between St. Philip Catholic Church—St. Francis is our home church. And that's who I remember hearing. John Delafose. Geno was probably a teenager at the time. I remember seeing him playing the scrubboard, you know, playing in the band with his dad. And that kind of got my attention. But other than that, I really didn't care for zydeco at all.

So like I said, I ended up going back to my roots later on. And it seems like I'm paying the price. Because my kids really don't care for the zydeco. I made a song after my daughter; every time I play it, she's like, "Dad, please don't play that song. Don't play that song; you're embarrassing me."

BF: So you didn't like it that much when you were growing up. Was it around? I mean did you hear much of it as a kid?

JB: Yeah. I heard a lot of it. I really didn't start paying attention to zydeco until, like I said, I heard Beau Jocque. Beau Jocque came out hard on the scene. That's when I started to pay attention to zydeco. And then when I started getting older, when we was going to the dances, and I learned how to dance to the music and stuff like that. We used to

go out—that's when the Rawhide was popular. There was a club called Rawhide; it was country. . . .

BF: In Texas or Louisiana?

JB: Here in Texas. It was probably one of the first country western and zydeco clubs here. It was called Rawhide, and I kind of knew the people that owned the place. They took a liking to me, so we would be there every week, played Friday and Saturday; they'd have live zydeco bands playing. Actually, J. J. Caillier was one of the first guys that I got a chance to sit in with. When I first started playing, even before Mary saw me playing, I got a chance to play with J. J. Caillier. And it's crazy how everything's going. First person I played with was Dwayne Dopsie; now my CD is rated along with him. So that's really a big thing to me. This weekend, this Friday, me and J. J. Caillier are playing a step and strut for the big trailrides here, in Plaisance, Louisiana. So that's a big thing.

So, like I say, I have no complaints. This is a hard road, really to get your people to support you. There's a lot of things that's changing. You know, the Creole way is changing. But it's having to change, so the kids—you know, all the old people going to eventually die out—so they're doing a lot of different things to zydeco music to make the kids get involved.

BF: So, when were you born?

JB: 1970.

BF: Did people speak French in your family?

JB: My dad speaks French fluently, and my mom speaks it a little bit.

BF: Do you speak any?

JB: Very little. My dad was real tough on us, and we really didn't ask him to help us do anything. But now he's really trying to teach me how to speak French. It's hard to teach an old dog new tricks. But I learn words here and there, and I pick up on it. And when he's speaking it, I understand.

BF: You were saying that you're related distantly to the blues harp player, Little Walter. Can you talk about that?

JB: Yeah. Little Walter, he came up with my daddy in Marksville, Louisiana. They are first cousins. Walter is a Jacobs, and my dad is a Batiste. The Batistes and the Jacobses are double kin. I really don't know all the history on it, but I know that they are double kin, like double first cousins. And they always played music; my dad played the guitar.

My daddy's actually a musician. He played with a popular band back in the day—the guy's name is Clarence Jones, out of Arnaudville, Louisiana. He was real hot. They'd play like honkytonk, kind of like rock 'n' roll-type music. Back in the day my daddy played bass guitar for years with him. My daddy sat in with Clifton, often. He played with Boozoo, Ashton Savoy. Ashton Savoy, my dad played with him. We had music in the family. But my daddy, he really didn't take interest in us—he didn't want us to play music when we were young because he

gave music to my older brother, and it didn't turn out good for him. The outcome wasn't a good thing, you know, far as music. He always said he didn't want to be an alcoholic or a druggie, and if you're playing music—he didn't want us to do it. So, pretty much, I picked it up on my own, and I just taught myself. And now, every day he tells me how proud he is of me. Now he's my number-one fan.

BF: Is your father still in Houston, in Sunnyside?

JB: Yes.

BF: Growing up in Sunnyside, was it a community where there were a lot of people of Creole background?

JB: We had a lot of Creole people. Because of the Catholic church, St. Francis. Everybody from Louisiana, basically, was at that church. They built that church. Most of your people from Louisiana are concrete finishers, bricklayers, whatever. They actually built that church. A lot of the Creole people. Me and Jean-Paul Jolivette, Step Rideau's drummer, we grew up in the same church together. His mom and my mom and dad, they were competing in the church—who was going to have the most kids. We had the two largest families at St. Francis. But my daddy and mom, they had to throw in the towel. Step Rideau's drummer, Jean-Paul Jolivette, his mom and daddy, there's ten in their family. And it's eight in our family, four boys and four girls. Like I say, we were real tight families there—the Jolivettes, the Batistes, the Savoy family. That's just to mention a few.

BF: So there were probably a lot of people going back and forth to Louisiana.

JB: That's right. Exactly.

BF: And there were zydecos in the church?

JB: Yeah. Most definitely. Actually, I'm grateful that I'm able every year to play for the church bazaar. Me and Step Rideau normally play our church bazaar every year at St. Francis.

BF: About what year was it when you heard J. Paul and decided you wanted to buy that toy accordion?

JB: You know, I had to be about 25 years old when I heard J. Paul play. Because I bought my first accordion when I was 26, on my 26th birthday. And I started my own band in 2000, but actually it was around '99—that's when I was playing with the Stoot zydeco. We changed the names. It ended up being the ZydeKo Players—that's what they called themselves. Because they kept on playing for a while.

BF: I know Brian Jack has some Stoot family in his . . .

JB: Yeah, exactly. Brian is first cousins with a Stoot. And they're all first cousins. Like I say, Brian, he and I, we were good friends. He's the one who got me back out here. When he got into doing the studio, recording stuff. He actually produced my last CD. And like I mentioned before, we up for a Grammy. And if I win one, he'll get one. It's a blessing just to be a part of, you know, top people. But like I said, he

produced the CD. He put his heart and soul in it. He didn't hold back because he was a musician or anything else. I mean, he actually—I call him the zydeco coach. That's his nickname, Brian Jack. He's going to make sure it's right. You know, "Stop, man, hold on." Some people get offended by it, but he's a really stickler at what he do, and he don't want to release nothing unless it's A-1.

BF: Yeah, we've been to his studio. His new studio. You probably did it in his house.

JB: Yeah I did it in his house. He just moved a couple months ago. It's a blessing to be a part of it. He didn't have to do it, but he opened his house up. And really, you know, took his time with me. I had some good music that I needed to put out, and he made sure that he got every bit of it out.

BF: How would you describe your sound? Well, how would you describe your band sound? The sound you're after.

JB: I'm kind of sticking to an old-school type of zydeco. I don't do a whole bunch of singing. I do more playing than I sing. I try to—I'm telling my life story. I'm singing about life, kids, something like that. A cultural thing. That's one thing I want to do. I want to stick to zydeco that is family-oriented. Kids and everybody else—they always want to come to zydecos and the trailrides. Now the way that they doing it, some of the language and stuff, the way they present the music and stuff is kind of almost rated R. But my music is clean. You can understand what I'm doing, understand what I'm playing.

I just say I'm old school, with a new school twist. That's basically it. That French magazine review I showed you, they compared me to Beau Jocque and Boozoo. When they heard my music, in the magazine that's what they were saying. My musical influences also were Jeffery Broussard, love that guy to death, and his two brothers. One of my first times in Louisiana, I had to do a radio interview; he called in and gave me some words of encouragement that still stick with me now, today. And like I say, a combination of his style, the old Boozoo and Beau Jocque styles—the closest to old that you can get. Only a couple of us still doing it. Step Rideau is sticking to it. Keith Frank is sticking to it. Lil' Wayne is pretty much sticking to it. Still you have to do what you have to do to make your music sell. So it's all about being an artist, but it's all zydeco. Like Harold Guillory said the other day, some of the people upstate, they get hip-hop zydeco and stuff. Well, zydeco is zydeco. It's all a cultural thing. Just people doing different things to make it work and to get the attention of other people. Older people; I have the older people. Some people like Lil' Nathan—they've got all the young crowd and everybody else. They're playing a lot of times a week. They're popular, doing well.

BF: So do you play mostly in Texas or do you play as much in Louisiana?

Young trailrider, Opelousas, Louisiana, 2017

JB: I play a lot in northern Louisiana. I really don't play a lot in southern Louisiana. But I've been all over the United States playing, touring California, up on the East Coast, the West Coast. I've been all the way from Atlanta up to Rhode Island. And all up in California, Frisco, San Diego, Los Angeles.

BF: When you play locally, where do you play?

JB: Locally? I've been doing a lot of trailrides lately. A lot of trailrides. When you make the big trailrides, that's when you make the better money. So that's what I've been doing a lot. I've been playing a little bit at Jax Grill in Houston every now and again; when it gets slow, I'll play a couple gigs at Jax. At like the Silver Eagle, different places like that. Trailrides and festivals is what keep it going for me. And I try not to play a lot of clubs. I love playing at the church bazaars, festivals, and the trailrides. The club, I'll do it, but it's really not my thing, my main focus.

BF: And who's your audience in this part of the world?

JB: The audience? Like I said, it's mainly the older people, from the mid-forties up. Because I play an old-school type of music that they really enjoy. It's dance music.

BF: Do a lot of those people have Creole heritage, too?

JB: Oh, yeah. Most of the people that listen to my music have a strong tie to the Creole heritage. And a lot of them don't. The people in California, they love my music. The people up on the East Coast, they love my music. Everybody, they love it. And it's getting bigger, because like I said, I hadn't put a CD out since 2005. I'm back. I'm back, strong as I've ever been. I think about it every day. I was like "Lord," I'd talk to the Lord, "Why wasn't I popular back then, when I was younger?" Now I'm getting old and grouchy.

BF: And you've got all those heavy bass cabinets to haul around.

JB: Actually, I downsized to some new stuff. Brian Jack helped me get that from Starr Sound. It's lighter; it's more efficient. Smaller.

You just never know where you will end up in life, you know? I'm happy at this point with my zydeco.

BF: It's great that it's going well. Talk a little more about Creole culture.

JB: The culture? The concern is mainly with food. Creole culture is really known for the food. Like the boudin, the cracklings, your gumbo, your sauces, you know, sauce piquant, different dishes—fricassee. That's another thing. A lot of people don't know, but I'm pretty much like a five-star chef when it comes down to Creole cuisine. My mama showed me how to cook as I was coming up. But now you can ask anybody in my family, and I've got a big family. Every time we have a function, I have to do the gumbo. I have to do the crawfish. I have to do everything.

And like I say, we do a lot of hunting. I'm mainly the one at the camp doing the cooking. Everybody wants to eat good when they're

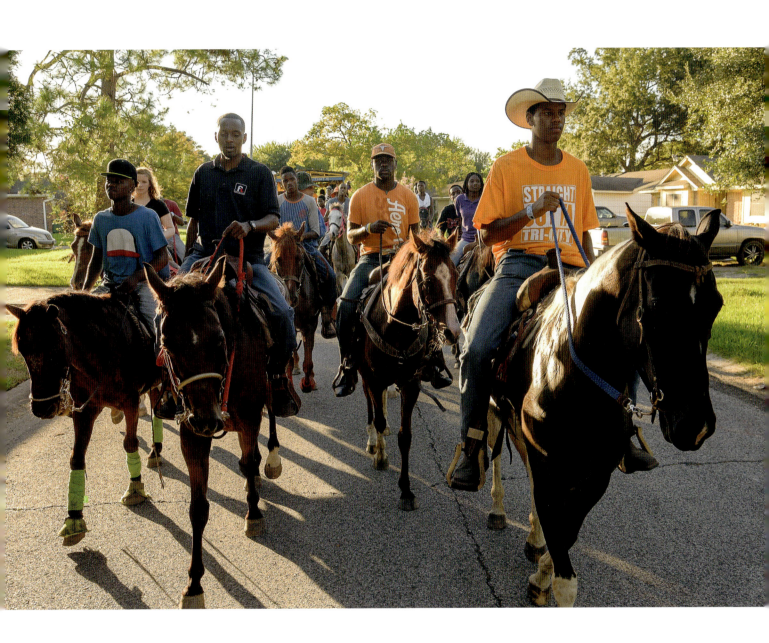

Tri-City Trailriders, Houston, Texas, 2015

away from home. So we don't miss our wives when we're away—far as the cooking goes.

BF: So you have all these Creole people living in the city but still pretty connected to the country.

JB: Yeah. Exactly. That's the only thing that separates us. We just have our own culture. You know Louisiana is like one of the only places in the United States that people speak a different language. So that's unique in itself right there.

BF: And do you have any sense that your dedication to zydeco is also a dedication to the culture?

JB: Yeah. Most definitely. I didn't realize it until I started playing, how important that was to the culture.

BF: Why is it important?

JB: It's important because a lot of us are losing the culture. A lot of people from Louisiana, they don't like zydeco music. They can't stand it; they want to hear something else. But if you're making music that they're enjoying, you're bringing your culture back together. It's very important.

BF: Do you ever get asked to go into schools or anything like that to represent the culture?

JB: Oh yeah. I do. I went to Texas Southern University, so every year I go back there. I play at Texas Southern. And I also do another school, T. H. Rogers. It's a magnet school with handicapped. I got involved in that through my wife because that's what my wife does. She worked at that school for thirteen years, working with the handicapped. She went back to school to become an occupational therapist to help them. So she's still working with the handicapped kids. She does a great job at it. Like I say, every year I go back and play for them for Black History [Month]. I do a lot of community service. I've played for drug rehabs. I play for old folks' homes. A lot of different things. To give back to the community.

BF: And you have your own business besides that?

JB: Yes. I took over the family business. It's Batiste Small Engine Repair. You know, from generators to weed eaters, whatever. Pressure washers; you name it. Four wheelers; we work on it all. It's right in the Sunnyside area, where I grew up. Right across the street from St. Francis Church is where our shop is. My brother, Vincent, he's pretty much running the shop now because I've been trying to pursue my music and my hunting. I really want to combine them together. Hopefully, it will come together. Maybe a reality show or something. Because that's another thing I do—my hunting, I take it serious. I got five-star accommodation, basically. I mean when we go out to hunt, it's not what you going to see; it's what you're going to shoot. Basically, that's the way it is. I do bow hunting; I was the number three archer in the Houston area, and I don't even shoot competition. I just went one day,

me and my son, and I ended up getting third place in the city. I've won a couple of bow tournaments.

BF: I need to ask you about bull riding. I come from New England. Tell me about bull riding. Is this rodeos or . . . ?

JB: Yes. It's rodeos. We'd practice on a lot of bulls. Used to go out to Santa Fe. This guy used to buy bulls and want us to buck them. That way he could see which ones were good. And we'd go ride. We'd go out there and ride them. Get kicked around and beat up pretty good. I made my debut—that's where I rode my first bull. I ended up being pretty good. I rode some pretty good bulls. Like I say, it was just unfortunate I didn't get a chance to stick to it. Because like I say, everybody in that group that we were riding with went on to be professionals and being pretty good at it. So that's why they call me the real Creole cowboy.

BF: And do you play any piano-note accordion, or is it all button?

JB: I started off with piano-note; that's when I bought the wrong accordion. I ended up playing a button accordion. I play the single-note; I also play the triple-note. Getting pretty good at it. Like I say; you never stop learning. You can always—I spend a lot of time with my wife and the kids.

BF: How many kids to you have?

JB: I got five. Five kids.

BF: So you've been on the scene and based in Texas for quite a while now. What's the scene like today? Has it changed much?

JB: You see so many people come and go in the zydeco scene; it's a whole new crowd out there now from when I first started playing. Now that I'm back out there, there's a lot of new people. They never heard of me; they say, "There's a new guy, Jerome Batiste. He sounds good. Where'd he come from?" There's a whole new crowd. But I mean it's all good. It's all good.

RUBEN MORENO

Ruben Moreno and the Zydeco Re-Evolution

On his website, Ruben Moreno describes himself as a "proud young Chicano-Creole artist from Houston, Texas." In highlighting identity and place, he goes directly to heart of who he is and what his music is. Creole people, in Texas and Louisiana, often talk about their varied family heritages and roots. Ruben embodies the diversity many Creoles assert and embrace. And as a young zydeco artist from Texas, he fits squarely into a world where diversity and various styles make their way into a dynamic set of musics, always finding a balance between the contemporary and the historical. He adds a strong commitment to social and economic justice to his music. He's a passionate man, which is evident in our conversation, in his performances, and in his activism. Even his band's name testifies to his expansive view of the zydeco tradition.

Ruben thought about where to do this interview, and he settled on meeting us in Houston's Second Ward at a bar, the D&W Lounge. He grew up in the neighborhood, and he performs here sometimes; the choice was intentional. The D&W is a funky place, with a mix of taxidermy and paintings on the wall. It's not far from the site of the now-gone Henry's Lounge, which Ruben's grandmother owned and operated. In this interview, Ruben talks about his grandmother and her place in relation to key aspects of his life—she opened the door to music, community, and mentorship for him. Hanging around the bar led him to zydeco. It was how he met Leroy Thomas, who was in Texas in those days. Leroy, as Ruben says here, helped open doors for him and taught him how to think of music as a profession. The diversity of music he experienced as a young kid, especially at Henry's, may underlie his interest in broadening zydeco, in bringing in more

"We're not the elitists. We don't have billions of dollars in the bank. It's about respect and having compassion. So I got this tattoo on my arm; it's the word 'compassion.'"

Interviewed September 17, 2015, at the D&W Lounge, 911 Milby Street, Houston, Texas. Gary Samson and a friend of Ruben's were also present.

Ruben Moreno at D&W Lounge, Houston, Texas, 2017

contemporary sounds. Again, this is a personal commitment that's fully consistent with Houston's role in zydeco history. It's his continuation of what Houston gave to zydeco.

During our interview, Ruben spoke at length about wanting to use his music for social justice. He's especially concerned about the way gentrification affects residents of some of Houston's neighborhoods, making local life unaffordable for long-term residents. Speaking of neighborhood, he had also scouted locations for a photo shoot—we had told him we'd want to make a portrait of him. His recommendation was an abandoned house that for him evoked his childhood and where he came up. So, Gary shot portraits at the D&W Lounge and around the house; the photos give a good visual sense of Ruben's roots. Ruben also speaks here of difficult encounters, of not always being welcomed by zydeco audiences. In thinking about whether to interview him, I wondered if this was something he'd experienced. I consulted a couple of people whom I'd met at a trailride, receiving only very positive recommendations. One of them messaged me, "He's good and I think he would be a great person to interview. I would like to know his story." It turns out to be a story of a deep commitment, based on considerable reflection, strong will, and driving musicality.

BF: You wanted to meet in Second Ward; we're at the D&W Lounge on Milby Street. Why was the location important to you?

RM: Why this community? I was raised in this community. I was born a few miles down Lockwood at LBJ Hospital in Houston's Fifth Ward. My grandmother had a house and a bar, a business here, on Milby Street, where I came and I lived for the first eight years of my life—right on the other side of these tracks, next to Maxwell House Coffee plant. It was called Henry's Lounge, and it was, again, right here on Milby Street. There's so much history in this community with my family, and with my culture, with my people. Specifically, this street, Milby Street.

I remember every Sunday my grandmother would—I don't have much shame, dude—my grandmother would bootleg. On Sundays. You can't find alcohol here on Sundays until after 12 in Houston. She'd bootleg in her backyard. She had a high wooden fence, and our house faced another block, but our business faced Milby Street. So they'd come in in the backyard, and she'd have tables, chairs, domino tables. Everybody's jamming. A live band outside. All that type of stuff going on. It would be great.

And we'd call in. It would be Sunday morning, seven o'clock in the morning, and we'd call; our Pacifica radio on Sundays plays nothing but blues. Nothing but blues, from midnight, starting with the *Zydeco Pas Salé* show, to 11:45 at night. I mean nothing but the blues. Okay, after ten it gets a little weird, but . . .

Ruben Moreno in the Milby Street
neighborhood, Houston, Texas, 2017

So I'd call in 90.1 and talk to the blues broad. I was five, six, seven, eight years old for those years. I'd say, "Hey, this is Little Ruben and the Milby Street gang." The guys would be behind me. I'd have the phone on speaker phone, and they'd be playing the guitars and screaming. It's nine o'clock in the morning, and we're bugging the blues broad. She'd say, "All right, Ruben, what do you want to hear?" This was every Sunday. So she'd always send a shout-out to the Milby Street guys.

Those were Sundays in Second Ward for me. The name of this community—this is Second Ward, the east end of Houston. It consists of a lot of predominantly Latino communities from east of downtown all the way to the Ship Channel.

So, yeah, this is home. This is why I picked that location.

BF: Okay. Good. It's not where you live now, right?

RM: No, I live a few miles out, a few miles north of Second Ward. I live in Fifth Ward.

BF: Your grandmother's place was called Henry's? Henry's Lounge?

RM: Henry's Lounge.

BF: Is it still around?

RM: No, it's closed. A few bars closed that were in this area.

BF: What was her name?

RM: Her name was Julia. Julia, Julie. A lot of people called her "Mom."

BF: And lots of live music in the bar?

RM: Lots of music in the bar. There was a lot of DJs, a lot of different type of acts. We'd have Mexican trios; mariachis would come if the occasion was for it. A lot of conjunto, Tejano, blues. House party stuff. I'd say more DJs, more electronic stuff than live bands. But we'd get the live bands in there. And that jukebox played all day, all night, man. My grandma would leave a beer crate, plastic one, right next to it. I'd pull it in front of the jukebox. It was an old jukebox; she taught me how to use that thing. So I'd sit up there and put like a dollar bill—it would be like five songs played. Now you can't get but two for a dollar. But we're not here to talk about that.

BF: Let me start by asking you to describe the music that you've ended up playing in your life. How do you think of your music, and how do you think of yourself as a musician?

RM: My music, that I play? I like it, apparently.

BF: That's good.

RM: I was always pushed and inspired to do original music. There's no one in the world who creates something that someone else hasn't done. So I can't say that I've done that. But I've taken all my influences and pretty much used that as a foundation. All my favorite genres and my favorite artists. And to create something kind of new. It's zydeco music. Some people would actually argue with me and say it's not. But overall, yeah, it's zydeco music. I play zydeco festivals across

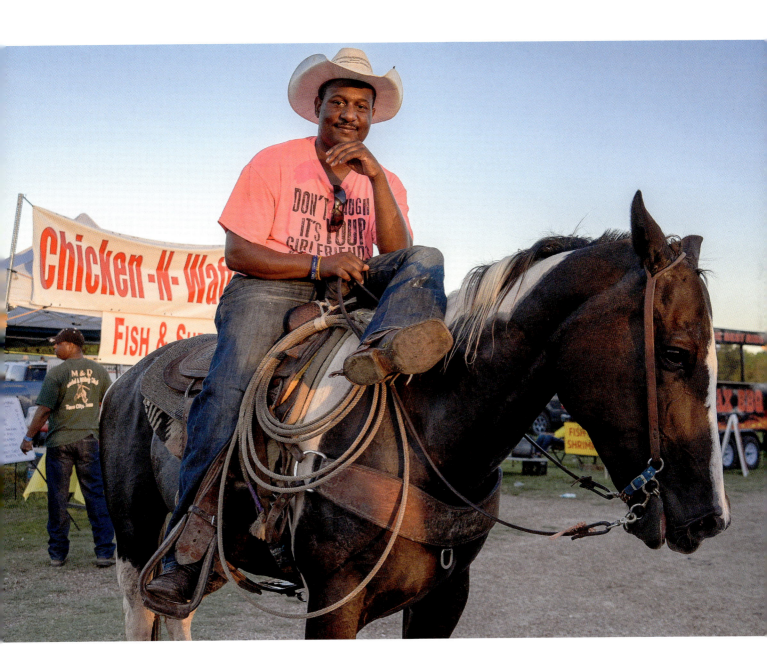

Tri-City Trailrider, Houston, Texas, 2015

the nation, across the globe. So, it's definitely zydeco music. But it's something different. I think I've added something that's needed to be added. Something refreshing. Something organic.

I don't know how to explain it. I'm happy with what I do. I'm happy with what I've turned it into, also. It's kind of my perspective on the art, on the genre. I try to reach out and give people a really different experience when it comes to my shows. Here especially, this D&W Lounge; I think my crowds are very diverse. A lot of different types of people that come to the show here. We have cowboys, trailriders. We've got the neighborhood guys, people all over the neighborhood. People from out of town. People from the inner city. And all type of groups from the alternative midtown area and the hipsters. And everybody's welcome. Everybody comes from all over. And that's mainly what I want to attract and capture in my music.

Like Terrence Simien has a worldly sound in his music. And that's cool; I'm not comparing my style to his. But it's the same concept—of being worldly. Except my angle is a little more modern, pop. Not pop like bubblegum pop, but I'm going to give you some popular sounds. Something you're familiar with. We're doing intros to Dolly Parton and Jimi Hendrix and Drake. That's what you hear on the radio now. Rappers and R&B artists, and country artists from the sixties. They have so much to offer and so much to admire. And we play it across the board. We take a little bit of this and a little bit of that. People love it. So if that helps answer your question; I tried my best.

BF: Yes. Why the zydeco route into all of this?

RM: Of all the genres that I was exposed to, all the genres I grew up listening to, zydeco music has moved me the most. Plain and simple. I've been asked this question a lot. And this is the best I can answer. It moves me; it takes me somewhere that again is familiar to me, and it feels like home. I grew up listening to it. I grew up listening to zydeco, blues, rock 'n' roll—I say "rock 'n' roll," I mean 1960 and before. Conjunto and Tejano. Being from this community, you're going to hear that. Especially in the early nineties. Tejano ruled half of the state of Texas. Tejano was hot. That style of folk music here. It's like Tejano was to Texas what zydeco is to Louisiana. You know what I mean? All southwest Louisiana rocks Cajun and zydeco. It's everywhere. It's on the radio. Tejano was once that in Houston. It's that in many other cities. But it's not that in Houston anymore.

So I grew up listening to a lot of that. The accordion always interested me. The crowd—the feeling you get when you're on stage. I was always a dancer. I danced, danced, danced to zydeco and Tejano music, and blues. Always. But being on stage, it gives you a completely different feeling. And, yeah, once I got into actually actively going to the zydecos, then I was like this is exactly what I want to do.

I was first put on the stage around 2 years old. I was probably almost 3. At the Houston Miller Outdoor Theatre. It's a huge pavilion. It fits about 4,000 people. There's a big hill that fits about another two, three thousand people. The conjunto festival was going on. Next month will be the conjunto festival for this year. It's an annual event. There were thousands of people out there. My aunt's friends were playing on stage, old family friends. They asked me to come up. My aunt grabbed me, put me on stage with some maracas or some bongos or something, and that was it. I was like, "Ooh, I like this feeling." It was an addiction. I stayed on stage after that.

But zydeco music didn't come into play until I was around 7 or 8 years old. I started going to the zydecos. Back then it was a weekly thing. Every weekend I was at the zydeco; I was at the church bazaar. I was at the restaurant, everywhere. Everywhere I could possibly get into. I was 11 years old at Leroy Thomas's birthday party, December 14th week. My son, my Junior, that's his birthday, too, on Leroy's birthday. Leroy and his dad were playing at the Houston Continental Club; it had been open one year. I walked in there; I had my washboard that my aunt surprised me with, on my back, and the doorman didn't give me no shit. I walked in there, got straight on stage. Yeah. Leo Thomas's (Leroy's dad) hand engulfed my hand. It was awesome. It was a great experience, man. And that's when the zydeco started. I was like, "Oh, yeah. I want to do this."

I'd played before, but I didn't have my own washboard. I'd played with Leroy a few times when I was little, and I played washboard for Tony Delafose. For Dwayne Dopsie. That was back when they came to Houston all the time. Them cats don't come to Houston much. Leroy hardly comes to Houston. That's when he was living here. He was playing every weekend in Texas. Every weekend. If he wasn't on the East Coast or in Louisiana, he was here.

So that's how that happened, with the zydeco. Pretty much that's what hooked me. And ever since then I've strived; I'd been waiting. I can confidently say that at 6, 7, years old I'd been waiting for a genre to grab me. Because I knew I wanted to play music since I was, like, one year old, probably. I have a 2-year-old that sings. And my 8-year-old sings. All my family's musical. I've been singing since I was a baby. But actually wanting to jump in a band or actually pursue, "Okay, this is what I want to do—zydeco," I was around 8 years old. That experience is what triggered it. So ever since then I've been striving, working hard, trying my absolute best to make a difference. And using my music as a tool.

BF: So at that young age, that experience—did that lead to the accordion?

RM: I didn't play accordion until I was about 12. That was a few years later. Yeah. My grandmother's friend would come over, Tony, and he'd

have his friends and his crew—the Milby Street gang. It consisted of a bunch of old people. It was me, my grandmother, and about five of her friends. They all had nicknames. They all played an instrument. Tony played accordion. He was in his sixties—in the nineties he was in his sixties. He passed away like in 2006, the year after my grandmother passed. But he'd been playing accordion since he was around 5. And I liked it. I always respected all styles of music; I loved it. I don't know; I got interested, and, again, they surprised me. My grandmother and Tony went half on an old one-row Hohner. Not the Cajun accordion. I forget the model; ten buttons with four reeds, four bass side. It wasn't four-reed. It was two-reed. That accordion was ancient. It had to be from the forties. Had to be. It was old—very, very old.

They surprised me with that after school. I got home from school, and it's there. Then my lessons started. They weren't lessons, but I'd watch Tony play. And what they usually use around here is a three-row Hohner accordion. That's popular in conjunto and Tejano music. What they were doing with forty-something buttons, Tony was doing on a ten-button accordion, the accordion they bought me. He was showing me how it works. Playing all these traditional conjunto songs and all these blues songs and all this really cool stuff, this jazz and swing, and loving it.

I didn't want to play anything but zydeco. I already knew what I wanted. I ran to my grandmother's stereo system area, and I looked for cassette tapes because that's what we had. And I grabbed *Beau Jocque Live*. I forget where. But I remember that album like it was yesterday, man; that was a really good album. I had the cassette tape, and I got the CD later. And I put that cassette tape on—every single song there was to learn. I didn't care what key it was. I had one key, and I didn't give a shit. I tried my best. Figured out—he taught me how to operate that thing. And I figured out the songs.

BF: Was this Tony Delafose?

RM: It wasn't Tony Delafose. It was one of her friends. It was another Tony. Tony Delafose plays bass. I don't know if he plays accordion. I know Tony Delafose well; Tony and Geno. I lived out there with the Delafoses for a while.

BF: Am I right—I read someplace that you had a grandfather that had some Creole heritage?

RM: Yeah. But he didn't play zydeco music.

BF: Okay. Was he this grandmother's husband?

RM: Yeah. But last time I saw him I was probably around four. So he wasn't much of a musical influence. He drove trucks, raced cars, and he was just a crazy man. In a good way. He was cool. Yeah, that's the only ties I have.

I was raised right here, between Fifth Ward and Second Ward. You go to Frenchtown; I lived in the Fifth Ward a little bit growing up. My dad's side of the family came from the Fifth Ward. Frenchtown,

off Quitman and Liberty, those streets around that area, there was a huge Creole community. When I was little, and I'd go over there, and I'd sneak around the Silver Slipper and the Zydeco Continental Club. Not the Continental Club Leroy played at—that's the main one, from Austin, connected with that one. But this one here was another Continental Club, a little hole in the wall. The ceiling was like a foot lower than this ceiling, and the stage was like two feet high. And it was hilarious because—you can imagine, right?

BF: Well, it was good you were a little kid.

RM: Roy Carrier walked into that place and got on stage; he had to sit down the whole night. It was—yeah, I got to see Roy there, too. I played with Roy. This lady out of Houston, Clifton Chenier's sister, Mary Thomas, she set up a big tour. She said, "Ruben, I got a tour for you." I was about 13. I was happy. Very, very excited. She said, "I got a tour for you."

I was like "Lay it on me."

She was like "Houston, Texas."

I was like, "Okay, Thomas."

I'm not going to tell her, but that's definitely not a tour. I'm at home.

She was like, "Three nights, four shows. With Roy Carrier. He needs you to open up for him."

I had only been playing a year. But I knew a lot of French songs. I knew some John Delafose songs, a few little Cajun songs, some waltzes and two-steps. And I gave it everything I could. I played Thursday, Friday, Saturday. No, no, no. Friday, Saturday, Sunday. No it was four nights and four shows. Thursday, Friday, Saturday, and Sunday. And we played the Silver Slipper that Friday night, and the Big Easy that Sunday night. Those nights I remember very well. Because they didn't move me off the stage those nights.

Those are some great experiences. I was 13 years old, getting into clubs. You don't do that nowadays. And I'm only 25 now. Things have changed down here.

BF: It sounds like you really knew what you wanted to do.

RM: Definitely.

BF: I wonder about—when you were that age, what did your friends think? I mean did you feel a kind of self-consciousness about playing the accordion?

RM: I had about four friends on my block. And we kicked it hard. We were very close friends. And they knew me. They saw me grow up. Two of them played instruments. The other two were into something else, like committed. All of my other friends were 50-plus years old. All of them. These guys.

You know, it looked like the bar we're in now. All of them. Each and every one of them. That's my cousin over at the bar, Jerry. He'd go to my grandmother's bar. I mean, I wasn't in the bar but on Sundays, or

any other time, her close friends would be in the house. I was playing dominos or having drinks.

They'd be playing their instruments. And I'd be right there with them. I'd watch them. If there was something I needed to learn, I'd ask them. I was strumming the guitar, playing the drums, playing accordion, playing washboard, playing harmonica, playing every percussion instrument known to man. Oh my God. There were instruments all over my grandmother's house.

BF: Did she play anything?

RM: She played either piano or violin growing up. But she said her best instrument was the jukebox. She said she played that thing the best.

But when it comes to my friends, that was it. And it was strange, going to school when some of the cats would find out, you know, "Ruben ain't got no sleep because he was at the Big Easy until midnight." And seeing me on articles; seeing me on little small segments on TV or seeing me perform. Some of these cats were like, "Hey, I was at the Crawfish Festival in Spring, Texas. Was that you on stage?"

"Yeah. That was me."

So it was a little strange. My grandmother and my aunt, they would tell me, "You can't tell anybody what you do." I wouldn't go out flaunting it. They're like, "Can't tell anybody what you do. Because some people might have a problem with it." I was like, whatever that meant, "Okay."

BF: Because of your age?

RM: Because of my age. Because of some cats being jealous. I'd be bullied. Things like that you want to avoid. It made sense as I got older because I'd see how people reacted. When I went to middle school, I'd get interviewed in school, sometimes. There's always been a lot of stuff. But overall, it's been good experiences. I've faced some hard times, but it's been good overall. I love it. The kids, growing up in school, elementary, middle school, and high school, it's been fine. Not something I mention out loud. Usually it's just the cats that have seen me perform. They're like, "I know what you do."

"And I know you race cars. We'll both hush."

BF: I should have asked: did you grow up in an English-speaking household? Or was it Spanish?

RM: English.

BF: Do you speak Spanish?

RM: I don't speak Spanish. I understand Spanish. My grandmother spoke English. She spoke Spanish to some of her Spanish-speaking friends. If she didn't want us to know what was being said, she would, of course, speak Spanish. We'd hope we knew what she was talking about, but half the time we didn't.

BF: Talk about playing out with Leroy Thomas.

RM: That started around 8 years old. 9 years old. He played Pappadeaux's Seafood restaurant, Pe-Te's Barbecue House here in Houston,

a lot of different other venues and festivals around. He was really close to my aunts. My grandmother knew him. Leroy's a great guy. He's got friends all over the world. And he'll do anything for you.

So he called me, and my aunt would put it on speakerphone; he's like, "I got four shows this week." He'd give me the lineup, and he'd say, "Let me know which ones you can make it to." We'd be out there almost every single weekend. I'd be playing with Leroy.

Leroy taught me every single thing he possibly could. Everything. And has introduced me every possible way he could, in different cities, different states. I didn't start traveling with him until I was about 16. I started going to Louisiana. When I was 18, I toured the country with him. From 18 to 19. Then, in between that, I toured with C. J. Chenier for year, playing washboard—the youngest member of the Red Hot Louisiana Band.

Then, when I was 19, right before I turned 20, a friend from near Philly, she introduced Andre Thierry to me. She introduced my music to him, told him a little bit about me and what I do, playing washboard. And he gave me a call, from the East Coast, and said, "Hey, can you fly out here next week?"

I was like, "Yeah, sure." So that's when I started with Andre, when I was 19.

But from 8 to 19, I had been overall committed to playing with Leroy Thomas. And that dude opened up a whole lot of doors for me. Showed me all the ropes. He taught me every possible thing he could, and didn't hold back. Gave me my time to shine every night. Put an accordion in my hands—first time ever playing accordion in public, I was with Leroy. About 14 years old. I waited a while before I played that accordion. I'm a perfectionist and workaholic, and I'm extremely shy. If I pick up another instrument, I've got to be really comfortable, if I play it on stage. He gave me that shot, and I played accordion. I didn't put the accordion down. He taught me everything he could on that, too. Yeah.

BF: Is there a point at which you said to yourself, "I'm going professional" or "Hey, I must be professional"? Or something like that?

RM: I don't remember when I started considering myself professional. I do know when I knew that I wanted to do my own thing—I was probably around 18 years old. Yeah, I was 18. After playing with C. J. and going back with Leroy, and seeing not only the reaction of all the audiences across the country, but their feedback and their response. I played with it a little bit in Houston. Then I went to California. And Andre was like, "You need to do your own thing." He had taught me so much more for a year. Took another year to record my first album. Then I released that. I sold probably 5,000 copies the first year.

BF: That's great.

RM: That was impressive for myself. I wish I could have sold a million. But 5,000—I didn't think I'd sell one of those damn things. I probably thought I'd have to pay you to listen to it. The reviews were awesome. That album was so successful; the people loved those songs on that first album. And in 2012, from being in Cali from '09 to 2012, I came back to Houston. I guess I was considered a professional in 2009. I don't know. I always considered myself a professional. Being around the older generation of zydeco at that time. They taught me a lot, and I strove for the absolute best, you know. I made sure I stayed out of trouble, and I did everything they told me I should do—I should do things this way, and I shouldn't look at things that way, and I shouldn't pay attention to this, and I need to do this and learn that. I did it all.

BF: Give me an example of that kind of advice—something that you remember.

RM: No T-shirts on stage. Leroy Thomas: "You're going to wear slacks. They're going to be starched and ironed." You know, present yourself how you want to represent yourself. Don't embarrass yourself—if you have something to say or something to work on, you do it off the stage. I mean I can go on a 120 things of tips that these people have taught me. Overall, how to behave. How to carry yourself. Your decisions and your choices. Financial advice. Even telling me the trouble that I was going to get into—like how some people would try to throw speedbumps your way or make things difficult. There's people here in Houston, and other states—I mean there's an ugly side of the industry. I'm not going to sit here and talk about it all, but they got me prepared for that. "These are the obstacles you might face, you know; and hopefully you won't." There's some things I haven't had to face. There's some things I remember facing and saying I hope I never get into that situation, and I get into that situation. And I come out winning. You know, I figure that situation out and make the best choice, and everybody's okay.

It's difficult having my own band. It was really good for those many years always just playing washboard, and sitting in on a few songs. And then when they said, "Okay—you're the man now. You're the boss." Yeah. It's definitely a task.

BF: When did you take off with your own band?

RM: 2012.

BF: What was involved in putting the band together?

RM: Called a few guys up. I was saying, "Hey, are you open these days?" And, "Are you interested in booking us? We're finally starting."

And they said, "Hell, yeah."

Some of them said no.

But when I first started, I had at least one gig a week. Usually two to three gigs a week, every week. Every month. It hasn't slowed down. It's been four years now. And it has not slowed down. This year has been the busiest year.

Ruben Moreno being interviewed at the D&W Lounge, Houston, Texas, 2017

All I had to do was call the guys up. I knew so many musicians. I had cats from Louisiana and Texas at my shows, performing with me. Playing with all those artists, I had a big black book full of contact information. Who, what they played, and how to find them. So it wasn't too hard.

But it's hard locking guys in and growing together. There's always changes being made. You've got a lot of things to work out. Some people just don't work good with you. Some people you never would have thought work the best, work out the best. So that's pretty much what 2012 and '13 consisted of—trying to get comfortable, trying to figure it out, trying to get these routines down. And 2014 and '15 have been a whole lot better with, not finding my sound, but having a broader idea of what I want my sound to be like.

I'm not going to say I expected to find my sound that first year. Or the second year. Or the third year. Now going on the fourth year, I've gotten a lot more clarity with that. And I'm like, "All right, I'm moving forward here. I'm moving forward there. This I'm going to stop; I'm not interested in this anymore. This is overall what I want to do." Focusing on my image and what I want to represent. What I want to stand for. I've noticed that there's a lot more eyes on me than I thought. And I don't want to put any bad vibes out there or any bad ideas or images. I represent something very positive.

BF: I want to go in that direction. But first I want to ask, are you playing with the same guys pretty consistently?

RM: Yeah. This year, yeah.

BF: This year, okay. So, drums, bass, guitar; do you have keys? I don't remember if you had keys when I saw you.

RM: Off and on. I have two drummers that I work with. A young drummer by the nickname of Young Will. William Arrington. And then I have a drummer that I'm more consistent with, by the name of Sydney Pennie Jr. He's out of Houston. Sydney tours with a lot of big artists. I got him in contact with Andre. He's out in LA right now. He picked up something with Musiq Soulchild, a really big neo-soul artist. Another big R&B artist, I forget who that was, Mos Def, a hip-hop artist. And Andre Thierry. So he's out on West Coast, doing shows up and down from NoCal to SoCal. Then he gets back in October, and then he's in with me and a few other guys. So when he's out, Will's here. When Will's out, Sidney's in. So that's who I have on drums.

On bass guitar, Ray Carmouche. He's got twenty-five, thirty years of experience. He's only 30-something years old. And he most recently played with Brian Jack and then started working with me. For the past six months, I'd say.

On bass, also a local cat: we call him Bass Killer. I can't even tell you his name. I don't even know his last name. I call him Bass Killer. He's amazing. He's a schoolteacher. He's an educator. And God's gift

on bass. He's a freak. Plays so many different styles of music. So, it's Ray Carmouche and Bass Killer.

On guitar is Patrick Williams. He's been playing with me from 2012, off and on, until now. He's been hanging in there. He's really dedicated. He's the oldest in the band. The dude has a story. He's an amazing artist. He's around 55, 56 years old. He's been playing for so long. He's from Third Ward. That dude has history in blues and funk and soul. That guy's gone so many places and seen so many things, man. And to have him in the band, that sets the structure for so much season and experience. So that's Patrick Williams. They call him P-Dub. He played with Mel Waiters, who just recently passed away. He's a big soul artist from the South. He used to fill arenas everywhere, man. Up until he passed way a few months ago.

And on washboard; he's a rookie. He's been playing for probably about eleven months now. We call him Kid, Zydeco Kid. His name is Lenard Sweat. He's from Lufkin, Texas. That's cowboy country. He's a trailrider. So he's a Black cowboy. And he loves zydeco music, man. That young man must have tried every avenue to reach out to every zydeco artist in Houston, trying to get here. He moved here, didn't even have a job, wasn't even with a band. He found a job, and he was still contacting cats. And he contacted me; I thought he was still in Lufkin because I remember passing his message; I think it was in my Facebook or somewhere. Then I got an email from him. And I responded because he was looking to play washboard for somebody. And I said, "Do you have a washboard?"

He said, "Yeah, I got a washboard. I need a few lessons, I'm just starting."

I was like, "All right."

He'd been playing probably for year, in his home. I went over to his apartment, and I was surprised he lived in Houston. I asked where he lived; I thought he was still in Lufkin. He was in Houston. And I taught him a few things here and there. The dude learns fast. I hired him a few weeks later. And that's Zydeco Re-Evolution. That's who we consist of. We use a keyboard player from time to time. Sometimes we use J. Paul's keyboard player. Or another guy, who also plays sax.

BF: Do you ever use that?

RM: One time, here. Not this last time; the time before that. It was my birthday party. That dude brought that sax. Oh man; I wish he could do both. I don't use it often. There's some projects coming up where I'm going to use a horn section. And if I can bring that to a live experience, I'll definitely do that. So playing with C. J. and Leroy—they use horns from time to time.

BF: Didn't C. J. start out playing saxophone with his father?

RM: Yeah, he plays sax.

BF: I steered you away from something you started to say about what you wanted to accomplish—the purpose of your music; what you want to achieve. Why don't you talk about that?

RM: First my goal is to pretty much paint the world red—red hot, with zydeco. There's a few places zydeco hasn't been. Overall, zydeco has played everywhere. You know, zydeco music has been exposed to the world for years. But I want to continue that and move forward with exposing the rest of the world to the genre, to the culture.

So that's first. Second, I want to use my music as a tool to advocate and promote for positive things. To promote for social justice. To promote for nonviolence. To promote and support peace.

Right now I'm using my music as a tool to bring a voice to an issue, here in my community. We're going through what I consider forced gentrification. A lot of things against human rights. A lot of people in this community are being mistreated by billion-dollar developers that are coming in and trampling on us. There's poverty here in Houston. There's so many poor communities here that need help, tools, and resources. Some are there; some aren't. A lot of people aren't aware of the help they can get.

So I want to use my music as a tool to affect this community first. And this city and this town. And whoever else I can reach in doing that. That's a plus. I wish I could be used as a tool on a broader aspect, to do world events. I'd definitely do it. But pretty much I want to make a difference. And I want to leave a positive impact on the young generation. And I want to leave the older generation a feeling that people like me are still around, and we care. And we want to preserve and protect everything that you've left for us.

I love my ancestors. I love my roots and my culture and where I'm from. I mainly consist of North African, Moorish bloodline, and Native American—from North America down to South America. I'm passionate about that, and I'm passionate about my culture, and I'm passionate about youth. I have two children here, and I just want to leave them in a place that I know is going to be safe for them. And I want them to know Daddy made that happen. You know, Daddy was part of that collective group that tried their absolute best to make sure that we could continue that. Because there's so many people here, in the world, that work on positive influences. More specifically, what we're working on here—we have ideas of how we can use art as a tool, art across the board. All arts. As a tool to bring awareness to the issues of Second Ward in Houston, in the East End of Houston.

There's other people from this community, and other artists like local rappers and R&B acts and rock acts. Houston's full of music and full of art. And they all want to be on board. They all want to help.

We can help this community. And we can help the next. And we can help so many other communities across the nation who are being

bullied and being disrespected. And it's so many other issues that tie in with that. We can go on for days, talking about police brutality and so many other issues. But that's pretty much what I want to do. I want to use my music as a tool for this culture and for our culture. As in the people here in this country, besides the Creole culture, because it's another beautiful thing. That's pretty much what I want to do—those two things.

BF: That's admirable. How do you get a start at that? How do you get going doing those kinds of things?

RM: Networking. I've teamed up with Houston Coalition for Justice. It's a group that works very closely with the Black Lives Matter movement. And I work with Safe Second Ward organization. I work with a few other organizations that aren't named or titled, that work with grassroots and community things—Second Ward, Fifth Ward, Third Ward, First Ward. Houston consists of six wards, one through six. We've lost Sixth Ward, but it's considered, I think, a historic neighborhood. You probably can't move in unless you've got $300,000 for a house. We've lost Fourth Ward—it's now considered midtown. We've lost half of Third Ward, which Beyoncé is from. And I wish she could have helped. Artists like that need to come.

BF: She has some resources, too.

RM: They definitely have resources. And other than some of these artists from Houston that are charging a hundred dollars for parking; I wish they could use those proceeds. So I would pay a hundred dollars for parking if I know that's going to go toward the community. Because they're losing here. There's people out on the streets. There's children with no shoes, can't even make it to school on time. Six-year-olds, seven-year-olds, I see walking around, asking for food. This is Houston, Texas; this isn't part of India. This is Houston. Why is this going on in this country?

We start by organizing and using whatever tools we have. The only tool I have is my music. And I'm going to use it to the fullest, as much as I can. And I'm going to do it the hardest I can. It's making a difference. We have a network of thousands. And that's two people. People like my cousin, who's a lawyer, can reach out to thousands. And other artists of all sorts, performing artists, dancers, filmmakers, producers, poets, entrepreneurs, business owners. My aunt owns a beautiful cultural store, and she reaches out to hundreds of people, monthly. So it's people within the community that we organize.

We plan. We strategize. That's how it's effective. All I can bring to the table is my music. I wish I could bring more. Hopefully, my career will lead to me being rich in many ways—financially as well, I don't mind saying; so I can give back to my community. I want to start centers for the performing arts within Second Ward. Which we need. It's crazy. We have representatives here that represent us, that represent

another side of town. And it's like night and day. That side of town is wealthy, and their education is perfect. And their housing is perfect, and everything they have there is amazing. Versus this community—this community is hungry. We can't find jobs. And poor resources. We have all these issues that we need you to address and to attend to.

So it's a lot of things we can do, and it's the tools and resources that we have specifically. My friend is a videographer, and he has a camera, and he knows how to use it. I have a song. And I have a story to tell. We can all be used for things like that. In your community—wherever you're from. That's another thing I promote. That's another issue that's going to go on my website. I have a "causes" section. There's a Facebook page. I have an artist page, and I have another page called "Gentrification USA."

And I urge other people from all over the country to give me your story on how you're being treated in your community and how gentrification specifically has threatened and affected your community in a negative way. And in a positive way. Because I'm not against gentrification. I'm against forced gentrification. I'm against—when you take my humanity and you disrespect me. They're pushing out older people. Mr. Albert Martinez is dying of heart failure, and these developers are harassing him weekly. Have pushed him to being in the hospital. He just got released out of the hospital. The man almost had a damned heart attack. If he has a heart attack, he's going to die.

So these are stories that need to be said. I can offer my music as a tool to help my future generation, to help my kids and their generation. So that's pretty much what it's about here in Second Ward, Houston.

BF: That's very impressive.

RM: Thank you.

BF: So, if you have this commitment to the Second Ward, which you said is primarily Latino, is that a complication for you in the world of zydeco?

RM: Yeah.

BF: Does the whole identity thing get complicated you for?

RM: Oh, yeah.

BF: Can you speak about that?

RM: I have people who won't book me just because of my ethnicity. You've got to understand—before you make a judgment on somebody's ethnicity or race—you've got to understand the definition of that race and the history of that person. I say "Latino": I absolutely hate that term. Because my family are not from Italy. Nor do my family resemble Christopher Columbus in any way. That man came to this country and made it very difficult for many Indians. Made it very difficult for millions of natives. And people like him who came and colonized and conquered.

I'm not Latino. I'm not Hispanic. I am native. I am North African. I am a man of color. I am Moreno—that's what my name means. A

man of color. Or dark man. Or Moor. Some people have nicknames for me like "the wannabe" or "the little Spanish zydeco guy," or "You're Mexican, what do you know about zydeco?"

First off, understand that I'm not Mexican. I'm American. Understand that you don't know my roots. This has been such a struggle, where they have not booked me, or I've left a gig or got to a gig and had to hear horrible words and racial slurs from all types of people. Even what I what call my own people. We come in all shapes and colors. Latinos look like me, like you. Like these people there. So it's funny when people try to use my—*Latinidad* is a term I like to use—my Latin connection and roots, as if it's negative thing or as if I can't play zydeco music. You don't know my grandfather. Do I have to sit here and explain everything or defend my right to play this music? I've been defended one time by an elder in the community in front of other artists. What he said was amazing, and I was embarrassed but—he said, "This cat, whether he has Creole roots or not, has invested nineteen years of his life into this culture for you." And he pointed to these young men who don't speak French. Who can't play a waltz. Or can't tell you who the founders of zydeco music or the older generations are. You know, so—and I'm this cat who you think is some little Mexican boy who knows nothing of zydeco music, who can do all of the above. Because I've put my all into it, and I absolutely love every bit of it. I love my music; I love zydeco music; I love Creole culture.

I've spent my entire life trying to perfect this. And I will spend the remaining amount of my life trying to perfect my art and my passion. And my reason for being. I absolutely love it. And he defended me that day. And I have those times. And some people would never question; not many people ask me that. And I don't want to sound like, I don't want to play the victim role, but I want you to know those experiences that I've had. They're bad experiences. It gets bad, being at some of these events and some certain race would tell me, you know, "Put that accordion down; your people are not supposed to play that." Just horrible things. I'm like, "Dude! It's 2000-whatever. Get over it. My ancestors had to go through it. I'll be damned if I have to go through it." You know, I pay taxes. I'm just going to say it. I live here in America. I shouldn't have to hear your mouth; you shouldn't have to disrespect me. I don't have any negative way of viewing any people in this country. Because right now, the past fifty years, we've all worked just as hard to be where we're at, right now. Trying to keep our jobs. Trying to keep businesses flowing. Trying to keep gas in our tank. Trying to feed our family. We all try to do it.

We're not the elitists. We don't have billions of dollars in the bank. It's about respect and having compassion. So I got this tattoo on my arm; it's the word "compassion." Because that's what I ask for. So, that's mainly it.

BF: Thank you for speaking frankly.

RM: So you've heard half of my story.

BF: When I was here in June with my partner, we went to trailride in Cleveland.

RM: Oh, yes. Who played?

BF: Brian Jack, one night, and Leon Chavis the first night.

RM: That's awesome.

BF: It was good. It was a great event. We had a ball. People were wonderful to us, and we stayed in touch with a couple of people we met who were involved in organizing things with the King City Riders. I asked them whether they thought you'd be a good interview, just out of curiosity, and wondering about this dynamic. One said, "He's really good." Another said, "And he's got a really interesting story." So maybe that's the way some people respond, very positively. Ed Poullard told me I ought to talk to you, too.

RM: Oh, Ed has guided me. Ed and J. B. Adams from Les Amis Creole, the trio that they have. Those two have guided me behind the scenes since I was 11 or 12 years old. Behind the scenes. And knowing who Danny Poullard was and connecting that they're related. Danny taught his music to a lot of people in California. I didn't meet Danny in person, but I've heard so much about him. Hearing these voices and hearing these names. It was crazy that people like this would go behind the scenes and guide me. J. B. would call me; and I never met the man. J. B. and Ed would tell people to meet me and to put me here, at this time, and to take me here, expose me to this. It's like *The Matrix*. It's crazy. And I don't know if anyone else has that type of story. But I wouldn't be surprised because a lot of these guys don't pay attention like I pay attention. I'm an observer. I watch my back at the same time. I like to see all the moving parts and how they work.

An example of that is when I got my first accordion, I took it apart. Every instrument I get, if I can take it apart, I'm going to take it apart. Sometimes I might not be able to put it back together. Or I might break something, a few parts here and there. But it's all right. So, I'm an observer, and I love to know how things work.

It was really interesting growing up and becoming a teenager and finding out that people were assisting me without me having to ask. That gave me a sense of compassion. It gave me a sense of being so thankful for it. Not knowing what people were doing. Not even knowing this person and knowing that this person is going out of the way for you, specifically. That's an amazing feeling.

And there's other artists that have those people. They really have that support, and they would never know it. But the only key is to not give up. Keep going. Keep moving forward. Through all my obstacles, and being where I'm at right now, I'm really happy that I made it even this far. Because there's so many times when I wanted to give up, and

I didn't know those people had my back. And if I'd have given up, it would have been the stupidest choice of my life. So, it's been really interesting. And those people, and others, have played an important role in my career.

I wonder what older artists or cats helped J. B. and helped Ed Poullard back in those days. To be around Canray Fontenot and the Ardoins. Jesus! I just met Black Ardoin a few months ago, at a performance they did at Rothko Chapel here in Houston. You've got to go to the Rothko Chapel. It's a beautiful place.

BF: Was that with Ed? I know Ed was doing it. I didn't realize that Lawrence was doing it. I met Lawrence at a festival.

RM: J. B. was there, too. I just met Preston Frank, Keith's father, at Rhythm and Roots in Rhode Island with Ed Poullard and J. B. Adams. Like, "Man, you guys are everywhere." And Preston Frank heard about me; I was, it's like Elvis hearing about you. It's like, "What?! Are you serious?"

Spending time with him, spending time with the Cajun bandleader, Steve Riley. Steve Riley knowing me, asking me to get on stage with him. This was Rhythm and Roots 2015. I got to hang out with the Mavericks, and Los Lobos played the main stage. It was amazing. It was an amazing experience. What they got going on there they should never end.

BF: This is a festival in Rhode Island.

RM: Next year, I'll probably be there again. Y'all got to catch it.

BF: Just a couple of quick more. Have you had to work day jobs?

RM: Oh, yeah.

BF: Do you now?

RM: No. I worked a job—what time is it?

BF: It's about 5:30.

RM: Okay. I worked a job in my grandma's bar. But like a legit job. I always helped around the bar. But a legit job—my first job was at a restaurant—it's a cafeteria here in Houston called Luby's. I was sixteen years old. I got to the age where I could work legally, and I said, "I'm going to get a job." And then a year later my son was born. So I kept that job. And then I worked all types of random jobs throughout the city. Hard labor. Worked very hard. I dropped out of school three times—never went back and finished.

So when people tell me, "Ruben, you should come speak at my school, speak to the students there."

"You don't want me speaking. You don't want me to tell a thousand kids to graduate if I didn't graduate, and I made so much money in my life." It was crazy. I was young. I thought I was just living it up because my friends who had these jobs, minus the really successful friends who were making like six figures. But they were busting their ass. And I was like, "Dude, I quit." I quit; got on the road with C. J. And he took very

good care of me. I came home, and I was able to support my family. I bought vehicles. I lived in decent homes. I had running water. I grew up poor. I grew up dirt, stinking poor. I didn't have new shoes. They especially weren't name-brand, unless my dad got a gift from his job, and we'd finally be able to buy a pair of name-brand shoes. Didn't have television growing up, not until I was probably thirteen I had television in my room. Food was scarce. We ate, but I'd see cousins and friends who had these great dinners. And I settled for what we could get. We'd have go to the pantry and get free food sometimes. Get free clothes and school supplies. We lived hard. I didn't live in the streets. I didn't live dirty. But being able to have the things that I'd never had. And I didn't have to slave anymore. Because I was working a job. I was working a nine to five—blood, sweat, and tears, and not being able to live comfortably until I played music. And so much of my family were against it, "You can't do anything with that. You can't become anything. You can't go nowhere."

I became a local figure. I became a role model. I became a musician, an artist. I traveled the world. And I was supporting my lifestyle, which isn't much because I don't need much. But the lifestyle that I've always wanted. Doing exactly what some said I would never be able to do. It was like a big foot in the mouth, like, "Yeah. I won. Yes." And being an artist your career goes up and down. Sometimes it's June 26th, and I got a few days to make rent. And I'm like, "How am I going to come up with this $500 left that I need to come up with in a matter of days?" You know what I mean?

But also being an artist, as any good successful artist knows, it's a hustle. I don't mean as disrespectful hustle, but I mean it keeps you on your toes, and you got to think fast, and you got to make a move fast. You got three, four days to take care of this. You got to do what you got to do. He [friend] knows what I'm talking about. You got to do what you got to do to make it work. It's a struggle. Because this isn't a promised paycheck. You're doing what you love. And you only get out of it what you put into it. And I can say that's the truth. A lot of people cry, and they say, "I don't understand what's going on."

I say, "Well, how much do you invest in yourself?"

They don't invest anything into themselves. "Well, of course, you're not going to get anything out of it. Until you put in everything you've got, and you lose it all, and you put it into this. Then it starts taking care of you. Man, your business takes care of you." B.B. King says that—your business takes care of you as good as you take care of it. And the industry consists, again, a B.B. King quote, what he'd say? "Ninety percent business, ten percent music." And that's what I've learned. I thought it was all about music.

I wish I could sit and enjoy my music as much as I can. But I'm too busy running around the city of Houston, trying to get shows

lined up, and trying to get my image together. Trying to get these things together, and getting involved, and get this done, and appear here, and do this. You know, here, for example. Andre Thierry, does interviews and things like that—one thing I got to say, it's beside the point, but it shows the dedication and the love you have for it. Andre would be up at two o'clock in the morning trying to learn something that he hasn't got yet, gotten down yet. And some people would say, "Andre? He doesn't know everything yet?" Nobody knows everything yet. He'll be the first to tell you. You always learn. I'd live with him for years, and I'd come in from the mall or wherever the hell I was at, or coming out of my room, and he'd be working on something. And I'd hear what he'd try to do, and twelve noon would turn into five o'clock in the afternoon. Five o'clock in the afternoon would turn into nine o'clock at night. Nine o'clock at night, it would be midnight. And I'm in bed, and I'm listening to him doing the same damn thing. And I'm like, "What are you doing?"

And then he'd say, "All right, I got it." He'd click three or whatever that is on the keyboard in the studio, and he'd record it. And he'd go to sleep. Finally. And I'm like, "Dude, the dedication you have, you know, is not easy." And that's everything we do. That's all of our jobs. We call them jobs.

Yeah. That's it. That's what I got to say.

BF: Okay. Let me ask you one last question: Talk about being a zydeco musician in Houston as compared to being a zydeco musician in Louisiana. Is there a comparison to be made?

RM: As a Texas zydeco artist versus a Louisiana zydeco artist, the music's different. The feel. The feel is different. It's the same genre. But the feel is different. You've got artists here with a different background. And you have mainly, not all, but most of the zydeco artists in Louisiana come from people who in their family also played zydeco music or similar. Texas has a different feel, a different swing of things. Especially Houston being such a strong blues community. And a gospel community. You got a lot of these artists where their people didn't grow up playing zydeco music. They heard it. But they didn't play it. At all—that was on that side of the bayou. They live on this side of the bayou. They mainly played rock 'n' roll, rhythm and blues, blues, and that's mainly it. So, but the comparison, if I can—what are the differences? Other than the feel of the music, I can't say much. A lot of the zydeco artists here don't have close Creole roots. A lot of them don't speak Creole. A lot of them don't want to play traditional two-steps or waltzes. You ain't got no trouble with the blues around here; half the zydeco artists going to play blues. But I come up here, and I play an old style of a blues and a waltz. A lot of these cats don't understand that style.

LOUISIANA

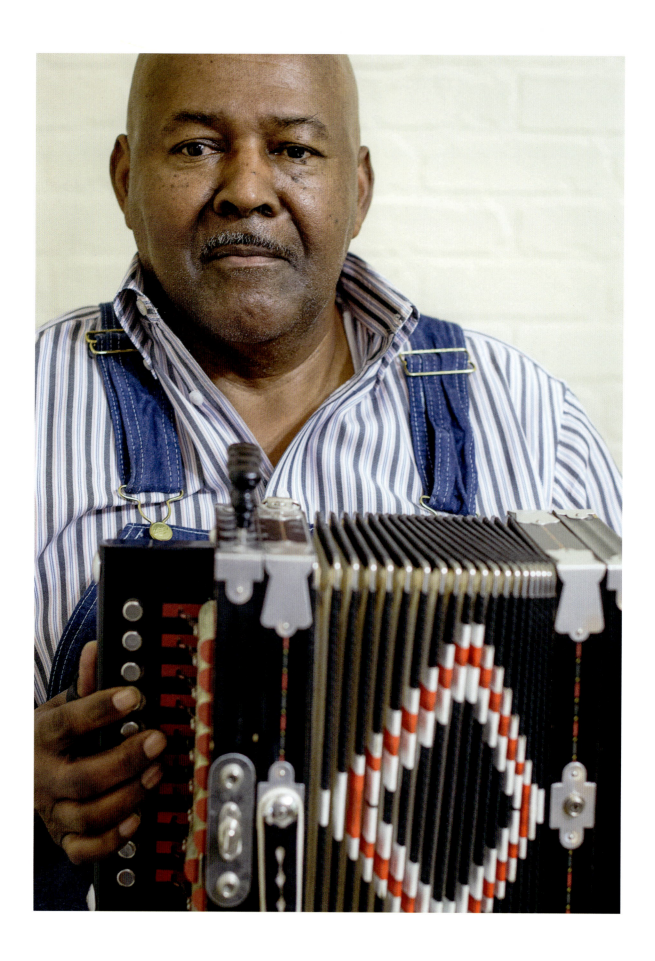

LAWRENCE "BLACK" ARDOIN

Lawrence "Black" Ardoin and His French Band

Ardoin is a big name in the world of Louisiana French music. In March 2018, the visitors center in Opelousas unveiled a statue of Amédé Ardoin (1898–1942). A Creole accordionist and vocalist, Amédé recorded thirty-four sides between 1929 and 1934, and those are among the earliest sound documents of French music from Louisiana. On some of the sides, Cajun fiddler Dennis McGee plays with Ardoin. Amédé's recordings are claimed by both Creole and Cajun musicians as part of their musical heritage. The records convey the sound of an era before musical terms such as Creole, zydeco, and Cajun had crystallized, and histories of the music of both Black and white cultural communities in southwest Louisiana cite Amédé as a foundational figure. That his music seems to transcend race is today an enormous irony; stories maintain that he died as a result of a horrific, racially motivated attack. Most of the accounts say that after a white woman at a dance where he was playing loaned him a handkerchief so that he could wipe his brow, a group of white men waylaid him, beat him severely, and ran over him with a car. He eventually ended up at Central Louisiana State Hospital in Pineville. He died there, and he was buried in an unmarked grave in a section where thousands of other Black patients were laid to rest. The statue of Amédé Ardoin is part of a project led by poet Darrell Bourque. An Opelousas *Daily World* article reports, "The event was one phase of an ongoing Bringing Amédé Home project, saluting Ardoin's musical legacy in addition to funding scholarships for young Louisiana musical artists who plan to study Louisiana zydeco and French music" (Ardoin 2018).

"I went twice to try to find where Amédé was buried. And all they could show me was a big old patch: 'Blacks are buried here; the Cajuns are buried over there.'"

Interviewed March 13, 2017, at home in Lake Charles, Louisiana. Jeannie Banks Thomas and Gary Samson also present.

Black Ardoin, Lake Charles, Louisiana, 2017

Amédé's younger relative, Alphonse "Bois Sec" Ardoin (1915–2007), Black's father, was a stalwart representative of the old French music, *la musique Creole* (Ancelet and Morgan 1984). Born in the community of L'Anse de Prien Noir, near Duralde, he began playing triangle with Amédé and Dennis McGee. By the 1940s, he was playing with fiddler Canray Fontenot. Their band, the Duralde Ramblers, played for local dancers, on the radio, and in clubs around home. In the mid-1960s, Ralph Rinzler, doing field research for the Newport Folk Festival, met them and invited them to play in Newport at the 1966 festival. Rinzler had invited Cajun fiddler and cultural advocate Dewey Balfa to the 1964 festival. Rinzler eventually moved to the Smithsonian Institution, where he was a powerful advocate for grassroots musical traditions, and his interest in Louisiana helped bring some masterful musicians to national attention. Following their appearance at Newport, Bois Sec and Canray made what is generally described as the first LP of Louisiana Creole music, for Arhoolie, and in 1986 the National Endowment for the Arts awarded the two National Heritage Fellowships. The year of their first Newport appearance, 1966, was also the year Clifton Chenier brought his deeply blues- and R&B-inflected Creole music to the Berkeley Blues Festival. Louisiana Creole music—in both its oldest and newest evocations—was busting out nationally.

Lawrence "Black" Ardoin, born in 1946, was one of Bois Sec and his wife Marcelene's fourteen children. In the sixties, Bois Sec brought three of his sons into what became the family band, along with Canray Fontenot: Black was on drums, Gustave played accordion, and Morris was the guitarist. Gustave died in a car accident in 1974, and Bois Sec, who had stopped playing in public, came back on the accordion. Black talks in this interview about the family band and about his taking up the accordion after Gus's death. The family band went through various iterations, holding on to the older Creole musical styles and repertoire while also modernizing its sound. Sons Sean and then Chris joined, Sean on drums and Chris on accordion. They were all Ardoins, very aware of their family's heritage and significance in the tradition. In Louisiana and Texas, the music was modernizing, in creative tension with Black popular music, and eventually a generation of musicians— Boozoo Chavis, Beau Jocque, and John Delafose among them—would move into the limelight. But it was the Ardoins who were invited to play Carnegie Hall, to represent the tradition.

Folklorist Alan Lomax, who had made field recordings in southwest Louisiana starting in the 1930s, shot film of Black and one of his bands at a club called the Crashpad in Eunice in 1983. You can view it on YouTube; it's also on the Lomax legacy site, the Association for Cultural Equity (culturalequity.org). The music is in transition. Instruments are amplified, including two electric guitars and bass. There's a drum kit, but the double-clutching bass drum pattern that is present

in most of today's zydeco isn't evident. Ed Poullard is on fiddle. They're singing "Joe Pitre a Deux Femmes," an old song that is still popular. The music doesn't have the stark sound of Bois Sec and Canray, where accordion, fiddle, and voice are perfect without other instrumental accompaniment. Here, Black is in the process of making a new sound that resonates with the music of Ardoins before him.

Today, Black Ardoin is mostly retired. Sean and Chris eventually took over the family band, naming it for that double-clutching move on the drums, which in itself is part of the move in modern zydeco to give heavy emphasis to the low end of a band's sound. Chris and Sean's music helped bring zydeco to broader audiences (Leibovitz 2003). Today, Chris, with his band, Zydeco Nustep, is one of the music's biggest attractions; Sean, who is interviewed elsewhere in this book, leads his band ZydeKool and is one of the creators of Creole United, a band featuring three generations of Creole musicians, including his father.

BF: Alright. You were just talking about the song "Joe Pitre a Deux Femmes."

LA: Yes. All of John Delafose's music—that he recorded on the first two, three, or four CDs—was basically Bois Sec and Canray Fontenot's music. He didn't play it like them. But he did it his style. The song "Joe Pitre a Deux Femmes"—Joe Pitre was my grandfather.

BF: Oh, really.

LA: Yeah. And he had two wives. But he didn't have two wives at the same time. But that was the image he wanted people to think. We recorded that back in '79, I think, at daddy's house. And we all got drunk that night. Chris Strachwitz had too much booze, so he had to come back and re-do some of it. Then John came over late in the eighties or whenever he recorded, said he wrote this song, which is not so.

BF: I didn't know that.

LA: Oh, Canray wanted to kill him. Have you ever met Canray back in the day?

BF: No.

LA: He was the fiddler that played with Daddy.

BF: I know who he was. He played your father with for years.

LA: His wife, he killed her so many times, but she lived. And the people he worked for; he killed them so many times. "I'm going to kill that . . ." That was Canray. We'd go to play; he'd come with me. I used to live in Kinder—that's where my wife is from. He'd get drunk, and then he'd fall asleep. So on the way back home he'd wake up probably about halfway, and he'd tell me a story. I wish I remembered everything that told me. Because one thing about him; he didn't lie. If he told you told you a story today, ten years from today he could tell you the same story word for word. He could tell it to you.

For not being educated, him and Daddy, I looked at them said, "This is something that's fantastic." Canray could read some and write; Daddy couldn't. He could sign his name. And they'd been all over the world playing music with a squeezebox and a fiddle. At no cost to them. We worked the fields. When I got big enough, I'd travel with Daddy. But Mama took care of everything when Daddy was gone. We were 14, and I'm number seven. I don't know why, but everybody's problems in the family ends up to me. They come to me for advice or whatever.

I went into the service in '66; I came out in '68. I was in Vietnam for a year. And she begged me, so we got married when I got back. She must not have heard. In 1974 we were the Ardoin Brothers. I was the drummer. My brother, Gustave, was the accordion player and the singer. Canray was on the fiddle. My oldest brother, Morris, was on guitar. I was the drummer. And later in the years before my brother got in an accident, Gustave, he trained my brother, Russell, the youngest one, to play the bass. Gustave got killed on September 29th—his birthday was going to be the 30th—in a car wreck.

So he was the accordion player, and I was the drummer. Daddy had retired. So then we had to get him out of retirement with the gigs we had booked, to keep on going. But my oldest brother could play the accordion some. But he didn't want to. We played a dance here in Lake Charles, at Sacred Heart Catholic Church. They hired the guy that used play accordion back in here, Raymond Latour. That kind of teed me off. I said, "Now, he's going to call a guy to come play and tell him that he's been retired—he was tired, to give him a break—and he could play." He didn't want to play, so I said, "I'm going to learn how to." That was in '75. I worked for Entergy. We went to Washington, DC, that July of '75, to play at—the Bicentennial was in '76, but this was in '75. When I came back from DC, Entergy was on strike. We stayed on strike six months. So when we was off, I picked up Daddy's accordion. I was still in Kinder. I started practicing a little bit.

Two weeks later we played at that same place; I played my first song. So then I started playing a little bit. I said when I learn good enough, I'm going to buy me an accordion. So I still hadn't learned good enough, but I bought one. And we started playing. Then my other brother was living here. He started playing drums. So we kept Daddy in the band. Daddy would play the first half; I'd play the second half. We got to where him and Canray were affecting our business because they'd be up there starting to play the same song over and over. Me and Canray had a little misunderstanding. I told him, I said, "It's best that and you Daddy continue what you're doing. We're going to pull to the side and do our own thing." Because he was dangerous with a knife. You had to watch him. Oh yeah, he'd get messed up, and he'd cut you in a second. Oh, yes. So, we didn't want that to happen.

So then we took over, and we started playing. Matter of fact, when we took over, for about, I guess, four or five years, we were the top Creole band in the area. We would play four or five times a week. And I had a job, and I'd work every day. It was hard, at times. But I used to enjoy doing it. My wife was sometimes pleased; sometimes she wouldn't be pleased.

We went to DC—she came with us for the first time. I had my daughter on scrubboard. Chris played the accordion; Sean played the drums. And had a guy from Lafayette playing drum. We played at the Monument. And the "Blue Suede Shoes"—Carl Perkins—he was there. He performed. Matter of fact, we had breakfast the next day. And Elvis Presley's guitar player, he had two—the old man, the tall one—we was having breakfast, and then Carl came in, and he sat with us. The old man said, "When we started playing with Elvis, my wife and I had a '57 Chevy, the station wagon type." And he said Elvis didn't have a car. By the later years, he said, "We were traveling in a jet." That's quite an accomplishment. But they were so nice. They were very, very nice. We had breakfast then, and I haven't seen him since. I guess the old man is probably dead now. I don't know about the other guitar player. But you get to meet a lot of important people, and some of them, just like Gatemouth Brown, oh, he wasn't too nice. Well, it depended on how he felt; if he had his stuff. If he didn't get it—they're all that way.

I went to Vietnam, was there for year, never even dreamed of touching the stuff. I never could stand smoking. So I guess that had a lot to do with it. Now, I did drink at the time. Sometimes I'd come home from playing a gig; next morning, I'd get up, go and look at my rig; whew—don't know which way I came home. But I never had no real bad accident. We had one. Not too far from here; truck hit us from the back. But nobody was injured from it. Tore up my equipment and stuff; I had to rebuy. And then I got the stuff stolen in New Orleans one day, at the Rock 'n' Bowl, in the parking lot. And I had a messed up shoulder at the time, and the owner knew about it; he didn't tell me until twelve o'clock. And this happened about 10:30 p.m. That was sad.

BF: Tell us more about your daddy.

LA: My old man was a farmer. He was a sharecropper. He'd build a fireplace; he was a carpenter. Build houses. And then worked on the farm, too. And played music. I used to play a fiddle back in the day, with him. I didn't want to, but I didn't have a choice. That's why I probably didn't continue. We'd go play at suppers and camps and things, and they would say, "Bois Sec; you know you not Black. You got a white heart." They'd always tell him that—that he was meant to be a white man, not a Black man.

BF: What did they mean by that?

LA: I don't know. Because we've gotten stopped by cops, and when they would see "Ardoin," "You're not related to Bois Sec?"

"Yeah, he's my dad."

"All right; slow down." That was a good thing in one respect. But in another one, it's not. Because the more advantages like that you get, the more chances you're going to take. And I told that to my son one day; I said, "Sean, I'm going to talk to him and tell him to stop fixing your tickets."

"Why?"

"Because I want to see you alive, not dead." Oh, he got teed off. But then he realized that I was telling him the truth.

But Daddy—the first time he went to Washington, DC—Ralph Rinzler came. He spent a whole week in Mamou. He'd come home every day. Because, see, he had heard of Bois Sec. And they had the Amédé story—that he had heard of. And they said that's the closest to Amédé. And it was. So Ralph wanted to bring him to the folklore festival in DC. Daddy said, "Ain't no way. We ain't flying in those birds." So he stayed the whole week, and they have this guy from Mamou named Revon Reed. He had the Cajun show on Saturday morning. At Fred's Lounge. So, finally, he came over one day; Mama would cook every day. They would bring the stuff for her to cook. And they'd eat. They would pig out. And he said, "Bois Sec," he said, "I just bought me a new Ford station wagon." He said, "I'm going to drive y'all over there."

And they said, "Maybe that way. But we ain't going to fly." That was in 1966. They went for the first time. And they went to Rhode Island, and then they recorded the first album. I was in the service when they were doing that. And they went that first year and every year from then until they got too old to travel. Then we started going with them, as a band. And there were so many people.

BF: Is this the Smithsonian Folklife Festival?

LA: Yeah. Ooh, that was big. The pond, you couldn't see the pond the Fourth of July because people was in all over the pond, all the way to the Monument, to the Lincoln Memorial. It was like flies. Oh Lordy. It was something.

So they started going, and then one year, Ralph called Daddy. He said, "Look, Bois Sec. I tell you what I'm going to do for you this year. I'm going to buy a ticket for your accordion so you can put it on the seat next to you." The tickets all came to me. So we left Lafayette and went to Houston. So when we got on the plane, I put the accordion on the seat, and I put the seatbelt around it. So a guy walked up; he wanted to sit there. I said, "No." He looked at me.

He said, "You ain't going to move it?"

I said, "No." So he went and got a stewardess. I was waiting. Boy, I was waiting.

So when she showed up, she says, "Sir, you have to put that box over here."

I said, "No, ma'am." Showed the ticket.

"Smithsonian?" She says to the guy, "Oh, you got to find you another seat."

BF: Man, I'd rather have an accordion next to me than a person.

LA: Oh yeah. I was waiting for that. I said, "I know somebody's going to come by and . . ." So, from then on, she came back and started questioning me and different things. I said, "Well, we're a bunch of farmers from Louisiana that's uneducated, that's going up there and doing a little bit of music." So, three or four of those stewardesses, they came—we played in New Orleans after we came back. So they came over; they really enjoyed it.

They even played for the inauguration of Richard Nixon. Not a very proud thing to say, but they played for the inauguration.

BF: "They" being your father?

LA: Yeah. And Canray. Yeah. They'd played before huge crowds by themselves. Just them two.

BF: And did that make a difference down here, knowing that you and your father and Canray were being asked to go to Washington?

LA: We did Carnegie Hall. Me, Daddy, Canray, and Morris went the first time. And then the second time we did a three-generation—my dad, me, and Chris, my youngest son. We did that in 1990. But most people, most of our African American people, said, "Carnegie Hall?" They don't know where that is. We played in Flint, Michigan, with Marcia Ball.

But my old man was somebody—he couldn't speak good English. But he could understand some, and people used to love to talk to him. When him and Canray was together, Canray would do most of the talking because he'd understand better what they was talking about. But when he'd understand, he would talk. He talked a lot.

He could dance, too. I see him on YouTube—he was younger back then—doing the little jig. One guy tried to do it, but he couldn't. Daddy was smooth. He could get right here, fold his leg, one inside the other one, and sit on the floor. And get up. I never could. I tried. Of course, I took on my mom's side, not the Ardoin. My mom's side. I'm a diabetic. Everyone on that side—diabetic. I'm bald-headed—I have never known an Ardoin that's bald-headed. No. I'm one, but I took on the opposite side.

BF: What was her name?

LA: Marceline Victorian. And she has one brother, and he's still living. Him and one of Mama's sisters are the only two living.

But I miss the barbershop gossip. Oh yeah, I miss that. I went, I think, twice last year. But it ain't like it used to be. The older people are dying. I'm 70 years old, going on 71, and it ain't too many older ones much older than I am. That's left. That's kind of scary.

But Daddy and them did a CD, well it's a LP, but this guy didn't do a CD. He went to Lafayette to record it—forgot the guy's name. He's

from London. But anyhow, he told Canray that his fiddle was out of tune. Oh my God. Canray packed it up; he went and sat outside. He said, "Anyone telling me that I'm out of tune . . ." So, that stopped the recording.

So he went to see Dewey Balfa. Dewey went with them, and they did it. That's a hell of a CD. Woo. Man, that thing, it is good! But most people that listens to it, they say, "They must have been playing together for a long time." Nope, never had.

BF: I'm wondering—would it have been common for a Creole musician and a Cajun musician to play together in those days?

LA: Oh yeah. If you play a song, one, two, three, one, two, three, any musician can follow you. But I can't tell you what key I'm playing in. That's the thing. We play by ear. Like Daddy and Canray—Canray could be drunk as he wanted. He'd play, and he wouldn't miss it. Like Nathan Abshire, a Cajun musician. He could be drunk; well, matter of fact, that DC trip I'm telling you about, he was drunk to where we had to pick him up and set him in a chair.

BF: But then he could play.

LA: Put that accordion in his hand. Woo. He was going to town. Oh, yes. I played the drums behind him. And he turned around, he said, "You helping me, too." He just took off with that thing. Oh, yeah. He was a good old man. I used to like to talk to him. He worked at the trash pile in Basile. He had half the trash pile at his house.

BF: He was trying to sell it?

LA: He'd just see stuff. He couldn't see it go there. He'd bring it home. Oh, man. Some people just can't let things go. He never had much money. And he always wore that red vest. Always had the same coat. But he could play. He definitely could play.

Daddy and Canray broke up during times. Canray got mad, and he'd stay away. I even played for about two or three years, the fiddle behind him. Similar to what Dennis was doing with Amédé. Dennis McGee would play. But they even took a trip to Canada. Dennis went with Daddy, my two brothers. And he told the people, he said, "Oh, they're Black, and I'm white." They looked at him; they said, "Well, we can't tell." It was in Canada. Oh yeah, he was okay. He could tell you some stories, though.

BF: So you knew him?

LA: Yeah. I had him and the old guy, Sady Courville from Eunice; they would play together. All the time. But I never met Dennis's son. He's a professional musician out here. Yeah. He got a son that's into music. So we played all over the place—Daddy, they've honored him. So I started playing in '75. And I didn't play zydeco; I just played traditional. And I still don't. When I do play, I play the old music.

BF: Did you have another name for it? Would you say la-la, or French music, or . . . ?

LA: Creole. Yeah. But it was Lawrence Ardoin and His French Zydeco Band. That's how I had named it. And *Lagniappe.* Because when Chris started playing he was four years old. So he would come along and take the show.

Now he's got two sons that's trying to do the same thing. I went by the house and brought him his award last night; he got the best CD of the year award at the Creole and Zydeco Music Awards. He posted it on the internet. Yeah, we played the last festival in Florida—what was the name of that festival? Florida used to have a zydeco festival every year until about maybe seven, eight years ago. We were the last band—the Ardoin Family—to play. I set him up; the guy said, well, we going to do it by age: your daddy, you, and Sean. No, Sean didn't play the accordion—yeah, he did—Sean; Chris; and then my nephew, Dexter. Whew, that boy can play! He learned from that. And he can play just like Pop. Oh, yes. But he don't have a band anymore. He don't want to do it. No. But he can play.

BF: Now, is Marcus Ardoin related to you, too?

LA: Yeah. His mom and I are first cousins.

BF: We heard him play a while ago in Houston.

LA: Yeah. He lives in Houston. His daddy and my daddy were two brothers. I mean his grandfather. And he used to live right by Daddy's house. But I'll tell you about Florida.

Daddy, he always did like to play my accordion. So, I told the stage guy, I said, "Now, he needs to hear himself. So they had two monitors on each side. I said, "Let's put one to where it's going to come right at him." So we fixed him up, and he started playing a little bit. I said to give him more. And then, let me tell you, it was the biggest tent that they had out there, and they was all over; they was standing on the tables and chairs, and they were hollering, and he was putting it on. Ooh. He really put it on. And that was, I'd say, the best moment on my life to see him. He was excited; he didn't want to stop. Oh, he played that song probably three songs long. But the audience loved it. Oh, yes, they really did. I never did try to compete with him. Because I knew it was useless. I told him, I said, "You play your way; I play my way. That's all I can do." And, oh, he was excited. And they had paid us real good for this festival, and I paid him.

He said, "For one song?"

I said, "If it wouldn't be for you, we wouldn't be getting that."

He was excited. Oh, Lord, yes.

Man, I gave him his flowers before he died. Because he'd go to Augusta Heritage in West Virginia every year, to that teaching thing they have. So when I was over there, they had one for Dewey before he died. Dewey was in the hospital. He really couldn't enjoy the thing; everybody wanted to jump in, put it together. I told Daddy, "I'm going to give you your flowers before you die. While you're still living."

So I talked to Margo Blevins; she was over the festivities over there. She said, "Well, why don't you do it the Thursday with Festival Acadiens in Lafayette, in September? I'm going to be over there that week." And she said, "Other people are going to be in town."

"Hmm," I said. "That's a good idea." So when I got back, I called Barry Ancelet, from Lafayette, and I asked him what he had going on that Thursday. He said, "Nothing." He said, "Why?" And I told him what I wanted to do. "Oh," he said. "That would be great." So I worked around, and Larry Miller worked with me, and we scheduled. I said, "I don't want people that's not playing Creole music, his music. I want people to come by, and the two-hour limit's going to have to be the program." So I asked him, I said, "Who do you want to play?" So, Steve Riley, and he had two guys playing him; it was three people mostly. And I got LeJeune, Iry's son. And some others. And we played, me and Poullard, and then my oldest brother and his group played, with Dexter. We all had like fifteen minutes to perform. And Christine Balfa and her husband. They played.

It turned out real well, and we gave him a new accordion. Matter of fact, I've got the accordion. And the case that the guy from Elton designed, with pictures and stuff on the wood—he carved it. He did a beautiful job. I'm going to show it to you in a bit. And we got some money they'd sent to the bank in Iota. So Larry Miller built the accordion. After it was over with we still had eight-hundred-some-odd dollars. Left over. So we got the money out, and I left there and I went to their house because I used to work four days a week—Monday through Thursday, ten hours a day—and on Fridays, unless we had an outage, we was off. So I took $250, and I gave it to Mama. The other part I gave it to him. I said, "Without her, you wouldn't be here today." Boy, they were happy.

They wanted to give me a share. I said, "No." It cost me twenty-two hundred dollars to put that on. I said, but I got it all back at two dollars a head. Yeah, because I rented the theater and the American Legion across the street because we had a jam session after we left that. And a friend of mine and his wife did a gumbo. You should have seen the people eat. They tore that gumbo up. And then we had some cake and punch. Steve Riley told me, he said, "You know, I used to go listen to y'all in Mamou, the festivals they had." And he said, "We'd look forward for that." But all his kinfolk from New Orleans and everywhere would come to Mamou and stay at their house. And he said, "This reminds me of that."

It was good. It was really, really good. But I told Daddy, I said, "You know, now you know how people feel about you. About your music and about what you've done in the past." It was packed. For me to get $4,200 at two dollars, you know we had to have some people. Yeah. My family supported it, but they didn't support it with the money. So,

Special accordion built for Bois Sec Ardoin, Lake Charles, Louisiana, 2017

I said, "That's okay." I wanted to do it. I said, "I'm glad I did it." Boy, he was happy. Oh yeah. He was very, very happy. It went well. It went well.

BF: Were they playing in clubs?

LA: Yeah. When I was small, when I was growing up, they had clubs in the area. Then he had a race track. A horse race track there, too. And he had a grocery store. So they always had something going. They started doing dances every Saturday night, same place. And on Sunday they had the horse race. And for several years, that was the place to go. Oh yeah. People were there. They'd bet on the races and stuff. And they were real good. And then my daddy's brother had a club in Soileau, off of 104. He played over there for a few years, and then he build his own club, off of 104, across the street from where we were living. He bought a house, an old house; he cut some logs and kind of chamfered them on the end. And then he tied them together, and then they picked up the house and put them logs under, and the parish supplied the Caterpillar, and they pulled it across the field. Set it over there, jacked it up, and put it together. I think he bought the whole house for $150. Back then, that was a good bit. But it wasn't that much, considering what he got. And then back then, people could help. People with the parish equipment. Not anymore. That's out now. You get caught doing that, you'd be out of a job.

But he built the club there. They started giving dances. It never was a real big, big dance, but it was enough where people would enjoy themselves. They'd come down Saturday night. Mama would do some weenies in barbecue sauce; put that on a bun. Oh, man; we used to hope she wouldn't sell them all so we could eat it. Just like in the cotton field. We'd wish for rain, and we'd know it was hurting us, but we wanted to get out of that field.

BF: So you were picking cotton?

LA: Whew. Was I! I'd plant it; I'd work it. And then had to help pick it.

BF: How old were you?

LA: When I started doing the planting, I was about twelve. But see, we didn't have but five boys—there was nine girls. So my oldest brother was gone, and then Gustave, when he was working out of the field, then I had to get on the tractor. I'd say, "Oh, man." We planted twenty-five, thirty acres at the end of the year. He'd promise us the world, but we wouldn't get a mountain. No, no, no. But it kept us out of trouble. We didn't go to school—school would start most of time in September—and we didn't get to go to school until late November. We had to pick up the cotton. They had cotton pickers, but it was so much a bale, and, no, he didn't want to hire them. He said, "I got some cotton-pickers."

Everybody in the area; that's what they were doing. They had big families, had to pick that cotton. But he'd work outside the family to

make extra money. Then he'd play music on the weekend, too. That cotton picking. Ooh Lordy. I hated it! I'm the one stopped him from planting. After I came back from Vietnam. I told him, "You just wasting your time and them kids' time." I said, "You aren't making no money doing it. So, you might as well quit." And them girls, ooh, they were so happy. When I told him that, he listened to me for some reason; I don't know why. And then he just quit planting. I went over there one day, I told him, "You might as well sell that tractor. You ain't going to plant nothing no more." Then I found a guy that wanted to buy it. He came over there, and the guy wrote him a check. I said, "You ought to do what you want with the money. It's your tractor."

I rebuilt the engine for him. It was smoking. He wrecked it. I took it and had it fixed. He charged me a reasonable price. I was always doing something to help him out. Even though I was in Vietnam, he spent all my money. So when I got back, a good thing she had saved up some money for us to get married. That's the way things go when you got a big family.

I used to like Sean to go—when they'd go to New York, and I couldn't go—Sean would go with them. They call him "Shine." It was S-E-A-N. But we would say, "Shine." He loved when Sean would go. Sean would talk, would talk on the mic. He was friendly. Sean never meets a stranger. When we was in Maine, we was in the breakfast room, eating breakfast. Sean was sitting right next to me, and a guy came walking right up there, "Oh, my God. Ooh, Sean Ardoin!"

"What the hell? Who the hell?" I said, "Where do you go where people don't know you?" Man.

They had met somewhere before. I don't know where. But he recognized him.

BF: Talk about how the music has changed a lot in the time that you've been watching it and playing it.

LA: Yes. We used to play, when we was the Ardoin Brothers we played all, but when the music started back in the day, it was an accordion and a triangle or a fiddle and an accordion. And then they come up with a washboard. That's zydeco, though. The la-la didn't have a washboard. Most people don't realize that. And we came in with drums instead of—but in 1974 we played the New Orleans Jazz Festival every year. And that particular year they put us—we came on at 3:00, and Cliff Chenier came on at 4:00. On the same stage. And my brother was playing back then, too. Daddy played; Daddy played about fifteen minutes. And then the other forty-five minutes, my brother picked up the accordion. And about 3:25—they had seven stages—everybody was at that one stage where we was. And then when we finished, Cliff came on. So for two hours, everybody stayed at the particular stage. So they wouldn't put us on the same stage anymore. Not one after the other, anyhow. And I remember Canray asked Cliff for some water; he

had a quart jug of ice water, but it had some Epsom salt. He told him, "No, it's Epsom salt." So he said, "You playing with the Ardoins today?"

He said, "Yeah."

He said, "We going to take New Orleans for us today."

And that just happened. For two hours straight, we had them all at the stage. They didn't want us to play drums; that year we did because Clifton's drummer sat in, and then I played drums instead of the triangle. So then they started missing what we were missing and what got people excited. But you play waltzes, two-steps—but now with that zydeco, you can't just stand up without moving when you play. It gets you going.

Now Cliff would do a different zydeco because he played the piano accordion. More bluesy. But John Delafose and Boozoo, when they came out with—John had that one-step, and he found two guys that would be able to follow him. So that's what got it going. That little hop thing. Then Boozoo came out with his no-timing set, but the band covered it up. And it got them youngsters involved. If it wouldn't be for that, it would have been dead a long time ago. But when they came up with that, and Boozoo had a guy who played bass guitar. He was a drug dealer. That's how he got the young people to follow him. Yeah. He always had a long coat on. And he'd go up there, and the young people started following. And they started dancing to Boozoo's music. And Boozoo became the number one man. Until Beau Jocque come along.

Now Beau Jocque is from the same area I'm from. And he came up with his heavy voice, but he came over here. I was working on a car back here. I was on the radio for twenty-three years; I did zydeco. He had a cassette that he had recorded. His name was Andrus, Andrus Espre, not Beau Jocque. But he came back with that name. He said, "Black." They called me Black for a nickname. Everybody back there; that's what they called me. He said, "I got a plan."

"Really?"

He said, "I been off" for maybe a year. He had got hurt at PPG. And he said, "I got a plan. I was watching BET and MTV." And he said, "I got a plan." So he bought them big old UF1 Peavey speakers that come two pieces together. He bought some of them. But he wasn't a sound man. He was having complications. He'd bust speakers every night. But he had some money because he had just got a settlement. And then he could buy. And then the drums; he had the drums booming. And when the youngsters starting dancing to it, I don't care how well you played. If they couldn't feel that drum, this is what they would do—they'd watch you; they wouldn't dance. So I started seeing his plan started working. And then he came out with that song, "Gimme Cornbread." That's what put him on the map.

See, Willis Prudhomme had recorded it first. But he didn't have the band. Now what Beau Jocque did, he hired the best musicians. If

you had a good musician, he'd mess around until he'd take him from you. Oh yeah. So he had all top musicians. And then he could bang. I read an article in the *New York Times*. It said if you can't find the big fellow, wind your window down and follow the vibrations. That's what it said. He played, and he packed the house.

But Boozoo used to pack it, too. But then, see, Beau Jocque used Boozoo to get to the people so they could hear him. Boozoo would play here every two weeks. Beau Jocque went to Boozoo's house. He said, "Look. I'm trying to start a little something. No offense to you." And he said, "If I set up my equipment, would you let me play at intermission?"

"Oh, yeah." Boozoo never had good equipment. It always would make sounds. So he did that. He set it up, and they got to intermission time. Boozoo liked to drink Budweiser. So he's sitting up there enjoying with other people, drinking his Budweiser. Beau Jocque gets up there, and he cranks it up. He did that two weeks. Well, he'd play every other week, so it was like one month. And after that he booked a dance in between Boozoo. Whoo. Boozoo got mad then. But it's too late. He had already got his foot in there. Matter of fact, I don't know if you've seen the film; they did it right here at the Habibi Temple.

BF: I've seen that film.

LA: I produced that show. And we had about 9,500 in that building. Boozoo's manager came up to me and he said, "Why?" This man's hadn't been playing but this amount of time, and Boozoo's been playing this amount of time. Why he has to open for him. I said, "Because I did your job." I said, "When Dopsie died, he was supposed to crown Boozoo as the prince. And he was going to be the king." Anyhow, they done that in Lafayette. So I called the woman, and I told her, I said, "Look, I got Boozoo booked here for this time." I said, "Whatever y'all doing over there, I'd appreciate if you could make it to where he could be here."

"Oh, yeah; no problem."

So we did that. Boozoo was okay with that. But then when they came, shooting him all this bull—and I told them, "Look, if he ain't up there in fifteen minutes, I'll tell you what's not going to happen. He ain't going to play." He was pissed off. But he played. Oh, he played.

When Boozoo finished his time, Beau Jocque got up there, and when they heard that accordion—you know in those big old ant piles, when you walk and you kick one, how the ants come out? That's what happened. If he had played first, and Boozoo would have played after-wards, nobody would have been dancing. No. So, I mean, I've been doing shows long enough, I've been around long enough, I know you have to do something, and people's going to come back when you do a show. And I never had a problem bringing people. No. When I got up there, and I told Scott Billington, from Rounder Records, I told him, "You see my reason."

He said, "Yes."

Yeah, then I did this chicken run, every year. I've been doing it for thirty-six years this year. Last year we had 1,900 people in that theater. All of this was plastered all over back over there, and the people that lived back here, the stage people wouldn't let them in. I knew that was the end of it. So I moved it to the civic center. And it's getting to be the same way over there. The civic center capacity is 7,000. And they shut us down last year and this year, the door.

BF: What's a chicken run?

LA: Mardi Gras festivities. We call it a chicken run. The people here, they don't want to dress in costume and all that stuff; they want to be seen. Well, we just do it. And every year it gets bigger and bigger. Every year. We had 700 four-wheelers. We had 175 horses. And we had ninety-eight floats. In the parade. And the floats were probably forty to eighty people per float. They were like flies on the float. Oh, they enjoy that. We rode seven miles. In town.

I had four roosters I bought, and I did it at the civic center. Oh, them kids love it. And I had some good roosters this year. They could run. Took off flying a little bit, but they didn't quit. They caught them all. Oh yes. But it's nice. And the weather was cooperating with us every year. Yeah, that's been good.

BF: So, would you say that the culture is still really strong here?

LA: Well. My cousin put something in the paper—one thing about people here, a new band don't stand a chance. Whoever is pretty well known, that's who's going to carry the crowd. So people—they'll talk it, but they don't support it. Some of the older folks say, "You need to start playing for us. We ain't got nobody to play for us anymore."

How are you going to go buy your equipment, make an investment, when they're not going to support me but every once in a blue moon? Ain't no way. And the older folks that used to go—I tell you, what killed the music here is the casinos. When they opened the casinos back in the nineties—because those that used to come to the dances, and back then they were charging five dollars to get in—they take that same five dollars and go to the casino and play a quarter every now and then, and get drunk, free. Free. Because they got free booze. Yeah. And then they get to talk to other people and walk around.

So that's when the music started—the dance halls—matter of fact around here, that's what affected the dances. Over here in town right now, the churches stopped giving dances at the church hall because no alcohol. And if a Coonass can't have alcohol, he ain't going dancing at your place. That's their enjoyment. They used to bring a briefcase; they used to bring mixed drinks, and they'd buy a setup from the place. They can't do that anymore. There's really no club—well, they got a few just club clubs—but no dance hall in the area. No. I'd say it's down.

BF: What about the trailrides?

LA: Trailrides. The Caucasian is trying to stop them from happening. What they do—of course, they have fights all the time. But they're going up on the prices, on the security prices. So it costs us to do this parade $11,000 for security. Yeah. So, I mean, they set up—there's too many places. They used to have Lacassine, Ville Platte, Opelousas, and different areas. The parishes clamped down; you can't have them anymore. Or they put a price on it to where they don't have to tell you. You know you ain't going to make no money, so you ain't going to do it. I don't know why because that's the entertainment that they've got. You know, that's a family-type thing that they do on the weekends. I don't know what's happening. But now if Keith Frank come to town, or if Chris come to town, they'll have a crowd. But it's all young people. The old people say, "We can't enjoy ourselves; they stand on the floor, in the middle of the floor, and all we looking at is butts."

When we were coming up, we would go to the dances with Daddy and them. But we'd sit down. And then they'd dance. And they had benches around the places back during them days. But today—now, like for the chicken run thing, we use the auditorium. So it has the bleachers. So all they had to do was go sit in the bleachers. You could see everything. And we had more that came for that. They sit for a while; then they want to get down where everything else is. Well, that's your problem.

The casinos are the one that started the downdraft. Then they started giving dances at the place. And it's free. But they don't get all of the good bands. Every now and then—they hired Chris a couple of Mardi Gras. They said, "Well, too many people." Hey—do it in the back there, in the auditorium. But in the auditorium—I don't think they sell beer in that particular area. It's mixed up.

But as far as for having dances, back then they used to be every weekend here in Lake Charles. The churches used to do it, and then they had some clubs that would do it. And people would go and enjoy themselves. But when the boat, the casino, came—well, the older folks went to the boat. And that's when the younger generation started going into—they didn't go to the boat then; they would go to the dances. But then when the older ones wanted to come back and go to the dances, then they said, "Well, I can't go there with all them young people that stay on the floor." So it just kind of spread out.

BF: So why have you stayed with the music and the culture as long as you have?

LA: Because of my kids. And to keep the Ardoin tradition thing going because the Ardoins have been over a century with this music. Amédé would have been 119 yesterday, if he had been living. His birthday was March the 12th. I never met him; he died before. . . .

BF: Right around the time you were born, maybe?

LA: Oh, no, way before. He would have been 119, and I'm only 70. Because he was born—I have a copy of his birth certificate.

BF: He died in the 1940s, right?

LA: Yeah. It was in '42, I think.

BF: When you were young and coming up, of course, with your dad . . .

LA: My oldest brother was born, for sure. But I wasn't born until '46. And he was already dead. I think it was '42.

BF: But were you always aware of him in this history, even coming up? It's not like you learned later on.

LA: Yeah. What they were saying back then, it was Amédé, played single. He didn't play a double. That's what the talk was. But I listened to the music, no—he played double.

BF: What do you mean by that? Double?

LA: One finger at a time. Like Canray's daddy was an accordion player, also. And his name was Adam Fontenot. But his daddy didn't sing. Canray said his daddy was a better accordion player than Amédé. But he didn't sing. So that singing, that's what got him to his death, really. Because the white guy said, "You ain't going make our white women cry." He didn't make them cry. He just sang it. So, I mean, I don't know—they ran over him several times, and they left him for dead. So they brought him to Pineville.

I went twice to try to find where Amédé was buried. And all they could show me was a big old patch: "Blacks are buried here; the Cajuns are buried over there." And during the time when he died, all it would have was a wooden cross. With a case number on it. And then back in—later after that, I think closer to the fifties—they started putting up concrete crosses with case numbers. I had a case number, but it don't do you no good. The cross is gone. So there's no way you can pinpoint where he's buried. No way.

JT: So I heard different versions of the story: one was that a white woman gave him her handkerchief during the . . .

LA: See, what happened there, the man he worked for—it was his daughter who gave him her handkerchief. And he was playing, and he was singing, and then she just wiped his sweat. Yeah, and them guys seeing that—so they waited for him up the road. After, he was finished. That was the case. But he stayed there in the barn. And he'd see that girl every day. She'd see him just like—yeah, Frugé, he was working for this guy, Frugé. There wasn't nothing going on between them. She was a young girl; he was an older man. He never was married. He didn't have no children.

He'd ride around in the neighborhood with his horse and play his accordion and make songs about what he'd see in the community. They had this woman from Tyrone, before you get into Eunice, off of 190. Her name was Louisa. And she was a Broussard. So he liked her,

Photo of Amédé Ardoin, Miller's Zydeco Hall of Fame, Lawtell, Louisiana, 2017

but her parents wouldn't let her talk to him because he was too dark. That's when he took off with his horse, and he went to New Orleans. I think it was in New Orleans he went to record that song. It's a waltz. And he said:

> *Oh, Madame Sostene, donnez-moi Alida*
> [Oh, Mrs. Sostene, give me Alida]

And he loved that woman, but nope, he didn't have a chance because he was too dark. Yeah.

That second time I went, they showed me, said, "What we're going to do is have some headstones. And if you want to go—I guess you'd have to pay so much." For a special area where they would do this. But they got a committee, matter of fact, I'm not on the committee. And they're trying to bring him back home. So it's going to be somewhere in St. Landry Parish. He was staying in St. Landry during that time. And they're going to have a headstone and stuff like that, that they're raising money for. So, Mr. Bourque calls me every so often to let me know what's going on. So I told him, I said, "That will be fine." But we'll see what they come up with. And I'll assist them whatever way I can, too. To do that.

Let me get that accordion case.

Black gets Bois Sec's accordion, and he plays and sings Amédé Ardoin's song "La Valse D'orphelin/The Orphan's Waltz," while Gary photographs him. Then the interview ends.

Later, on June 20, 2019, in response to follow-up questions from the editor of this book, Black expanded on the relationship between Amédé and Bois Sec. Bois Sec was in his late twenties when Amédé died.

LA: Bois Sec learned from and listened to Amédé; he was impressed by Amédé. He allowed Bois Sec to play with him at house dances. Bois Sec played the triangle behind Amédé. Most times Amédé played by himself, although he also played with Dennis McGee and some others. Amédé let Bois Sec play songs on the accordion.

You couldn't catch Amédé early: he'd play for the white dances first. Then he'd play late for the Creole dances, often starting around midnight.

Bois Sec was too young when his daddy died to know his daddy (Gustave) was an accordion player. Gustave was a good accordion player. When Bois Sec was little, he would take the accordion, and he would go in the loft of the barn and play it. He knew when his brothers would be walking home from work, so he'd put it up then, so they wouldn't know. But he didn't know that sound traveled. That sound traveled down the road, and his brothers heard him, and when they got home, they said, "Who's playing the accordion?"

Black Ardoin singing "La Valse D'orphelin" ("The Orphan's Waltz"), Lake Charles, Louisiana, 2017

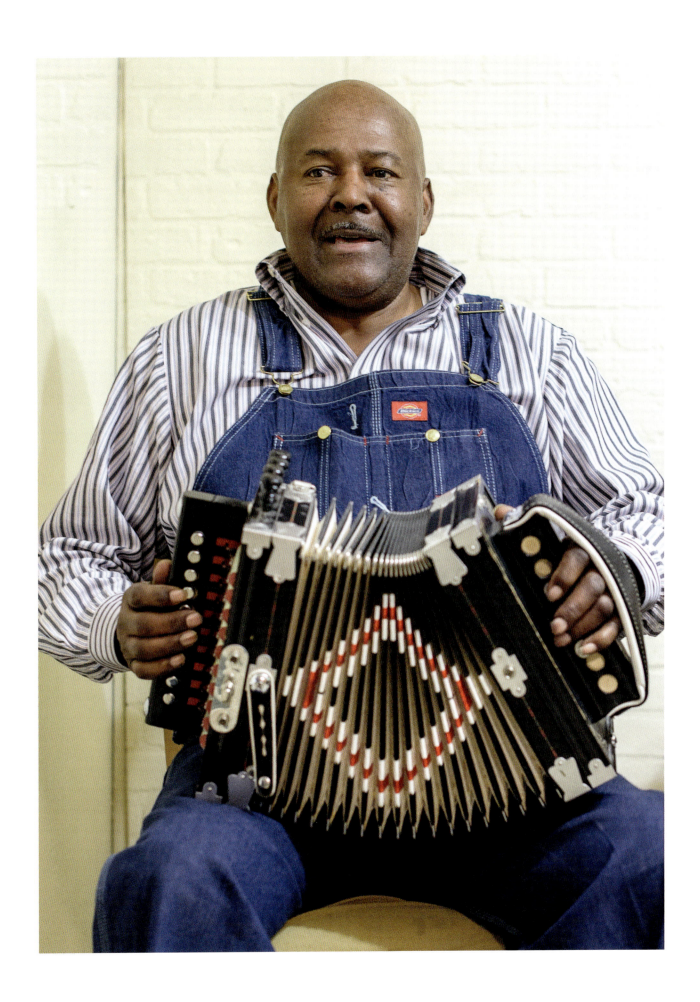

Canray's daddy (Adam Fontenot) was the one playing the accordion at a dance when Amédé arrived, and he switched over playing for him without stopping the song. Adam removed one hand at a time, and Amédé replaced them with his own. I would've liked to have seen that.

Amédé didn't have any instrumental songs. Anything he'd play, he'd sing. Everything he played, he wrote. He'd go around and make songs during the day about what he saw. People were jealous because he played music and didn't work. He might have survived the beating after the dance if they'd tended to him right then. He was staying in the barn, and they left him a while before tending to him.

LEROY THOMAS

Leroy Thomas and the Zydeco Roadrunners

Gary and I are driving from Houston, where we'd had good visits with Step Rideau and Jerome Batiste, to Baton Rouge. After a stop for coffee in Lake Charles, I propose that we get off of I-10 and look around. I am, of course, looking for zydeco on the landscape, hoping to see clubs or other indicators. Approaching Elton, on the flat two-lane, we stop to photograph a hulking rice drier, grey, silent, appearing not quite abandoned but close. On into Elton itself, where the main street is blockaded by police cruisers, light bars blazing. A homecoming parade is in progress, with dolled-up kids on flatbeds, hanging out of car windows, in convertibles.

We drive down Main Street. And there, on our right, is a small billboard or large business sign. "Leroy Thomas," it announces, "The Jewel of the Bayou." Leroy's photo occupies about half the sign. Underneath runs his website address, named for his band, zydecoroadrunners.com. It's at the entrance to a small compound, surrounded by a low wooden fence, the sort that might run in front of a house. Parked on a neatly graveled lot sit a couple of trailers, emblazoned with his legend, presumably to store and haul sound gear and instruments. There's a small, tidy building. Nearby, but not on the same lot, is his house. It all gives an appearance of order, of intentionality.

So does Leroy himself. Onstage, he wears well-pressed jeans, crisp shirts, a leather belt with metal decoration, polished boots, a cowboy hat. What might be his main accordion is bright green with yellow accents. What you see is a man with a strong sense of being a professional, confident in his ability, going about his business. Have a look at a YouTube video, where his father, Leo "The Bull" Thomas, joins Leroy onstage at Café des Amis, on East Bridge Street in Breaux Bridge, Louisiana. Leo is wearing a pink shirt, pink tie, pink Panama hat, and a rhinestone belt. He's singing, "Why Do You Want to Make

"The transmission had gone out of my Mom's car. So we would load the drums and everything in the trunk of that car and push it to the hog pen, and we would call it Richard's Club. And the other little building, we'd call it Slim's Y-Ki-Ki, and we would push the car to all the gigs and push it back. We had it hard."

Interviewed July 26, 2015, at the Lowell Folk Festival, in the University of Massachusetts–Lowell Conference Center and Hotel. Jeannie Banks Thomas also present.

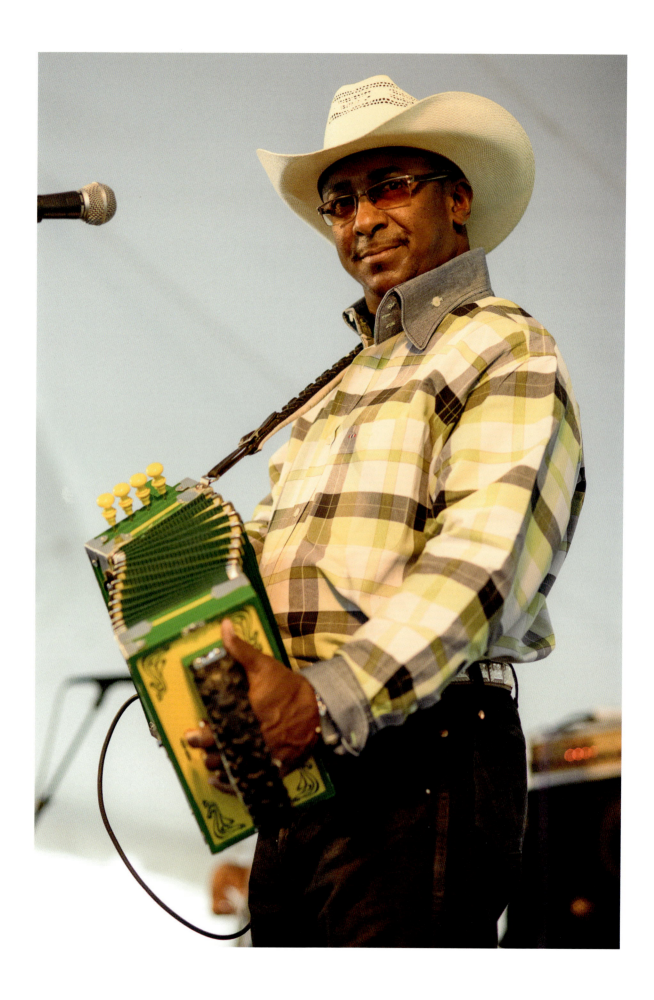

Me Cry?" a song attributed to Leo and Preston Frank, often described as the most popular zydeco song. In *The Kingdom of Zydeco*, Michael Tisserand points out that the song is an adaptation of Bois Sec Ardoin and Canray Fontenot's "Tit monde." So, not only is it a contemporary favorite but it also links the music to some of its royal antecedents. Leo, himself, began as an R&B musician, playing what his son describes as blues and soul music. Then he moved to zydeco.

Often described as the only drummer to front a zydeco band, Leo was a powerful influence on his sons. In this interview, Leroy describes how he and his brother improvised sets of drums, set them up in an outbuilding on the farm—a building they called "Richard's," after the famous club—and pounded away. He goes on to talk about moving to real drum kits, to acquiring his first accordion, and to moving into the music. The father was a model for the son, and that's true for many zydeco musicians. This son was especially into it, as you'll read here. And he came up at a time when the music was expanding; his influences include his father, Clifton Chenier, John and Geno Delafose, and Boozoo Chavis. Like many Creole people of his, and his father's, generations, at one point he moved to Houston. There he did skilled work in construction and established himself as one of a new generation of Houston-based zydeco musicians. The first version of the Zydeco Roadrunners, his band, dates to the Houston days. In Texas, he mentored the young Ruben Moreno, who talks about his influence elsewhere in this book.

Today, Leroy Thomas is one of a handful of zydeco leaders who make a living without having to venture far from home. By his tally, he plays fourteen to seventeen gigs a month, and he can drive home that same night. His audience is mostly white, and he plays a circuit of clubs and events that mostly serve those fans, a mix of locals and tourists. This means he played at the aforementioned Café des Amis when it was open. He plays Red Dog's Bar in Egan, Buck and Johnny's in Breaux Bridge, Wayne and Layne's Deli Nightclub in Sulphur, O'Darby's in Carencro, and Lakeview Park and Beach in Eunice. He plays local festivals, such as the Cajun Field Mardi Gras Festival in Lafayette. Sometimes he and the band go over to New Orleans, where they play Rock 'n' Bowl. He plays in the casinos that dot the South Louisiana landscape. And he sometimes travels to play roots music festivals and events across the country and abroad. In the world of Louisiana zydeco, a few others, including Geno Delafose, have created similar careers, playing mostly around home to avid audiences, occasionally leaving to play away from home. There is perhaps a more pronounced echo of commercial country music in his repertoire than in those of many other zydeco leaders, but like most of his contemporaries he ranges over and across genres. But his base is Elton; he's happy mostly to stay close.

Leroy Thomas, Lowell Folk Festival, Lowell, Massachusetts, 2015

BF: Start out by talking a little bit about where you're from, where you were born, and your family.

LT: I'm from Elton, Louisiana. I was born in Lake Charles. My dad was a drummer and lead vocalist of a band; he was the leader of the band from when he was like 16 years old. Had a one-piece band, playing guitar. Then he got a drummer, and they went on. And he started playing drums, ended up with a little blues band, and soul music. And then he started getting accordion players. Then he still was on drums and lead vocals.

And on my mom's side of the family, we got Preston Frank, Keith Frank—that's all my cousins. And to my dad, Geno Delafose—that's my dad's great nephew.

BF: I didn't realize that. So Geno is your father's . . .

LT: Geno's grandmother, his mama's mom, is my daddy's sister. And Keith Frank's grandfather, which is his daddy's dad, is my mama's brother.

BF: So it's in the blood.

LT: Oh yeah. No doubt.

BF: Did you grow up listening to zydeco?

LT: Oh yeah. On the radio, every Saturday, man. Back then it was just on Saturdays when you could hear zydeco music on the radio.

BF: Do you remember what program or what station?

LT: It was KEUN, I think.

BF: And how about your father? Were his people musical?

LT: No. They just played. Like my dad's dad, when they would all get together for Christmas, he'd sit on the sofa and play a couple of songs.

BF: On the accordion?

LT: Yes. But he never had a band.

BF: Yeah. I see. What year were you born?

LT: 1965.

BF: A youngster.

LT: Yeah.

BF: And your mother was not musical.

LT: No, no. All her brothers—her brothers played violin, accordion, you name it. Bass guitar, guitar.

BF: Do you remember hearing live zydeco music when you were young?

LT: Oh, yeah. My favorite was—my dad wasn't playing zydeco then, when I was really young. Then when they started, of course, he was my favorite. And we had John Delafose and, of course, Clifton Chenier. That was my three favorites, right there.

BF: So you used to hear Clifton.

LT: Oh yeah.

BF: Where would you hear him?

LT: I heard him once. I only saw Clifton once. It was at Richard's Club in Lawtell, Louisiana.

BF: Were you a kid then?

LT: I was 18.

BF: So you were legal.

LT: Yeah.

BF: What about Boozoo Chavis?

LT: Boozoo, I heard him many times, many times. Because then I was 21 and whatever. So we heard Boozoo a lot.

BF: And am I right to remember that you started playing drums?

LT: Yeah, when I was like 7 years old. We made drums, whatever. Actually, when I was 7, 8 years old, my brother and I just put magazines on a bed and got some forks and flipped them over and played them. And put my on daddy's eight-track tape, when we would record live at the gigs. And then when we turned like 13 we made some drums with some five-gallon buckets and screwed some things for the foot pedals sticking out, so we can both snap on to that. And we bolted the buckets, two buckets, to the other bottom five-gallon bucket. And we used the Christmas—when my mom would finish wrapping gifts, the cardboard tube. That was our microphone. We'd sing through that.

BF: So you were primed for this career.

LT: Oh yeah. The transmission had gone out of my Mom's car. So we would load the drums and everything in the trunk of that car and push it to the hog pen, and we would call it Richard's Club. And the other little building, we'd call it Slim's Y-Ki-Ki, and we would push the car to all the gigs and push it back. We had it hard.

BF: When you were that age, were you hearing much live music around?

LT: In Elton we would go to the church halls. My dad would just allow us to go to the church hall gigs, like in Basile and Elton, Eunice. He said we had to be 18 to go to Richard's. When I turned 18, he said I had to be 21. I said, "No, no. It's still 18." So he let us go when we turned 18. My brother was almost 17 then.

BF: People talk about zydeco being connected to Creole culture. Do you think of yourself as having Creole background, Creole heritage?

LT: Oh, yeah. The other place we would go, to the Ardoins'. Bois Sec Ardoin and them, they would have a house dance. It was a house, and they would turn the house into a club. Which it still was a house; they just knocked a couple of walls down, and they would give like a festival. So most of the kids would be like in and out; we'd play outside. We were like 15, 14. Then we would go inside, and that was the dance, where everybody was drinking and stuff. But it was a house. Didn't matter what age you were. And they would play the old, old Creole music, way back. I remember that.

BF: Was Canray . . . ?

LT: Yeah, Canray Fontenot was on the fiddle, drinking, drinking, drinking. Never missed a lick, though.

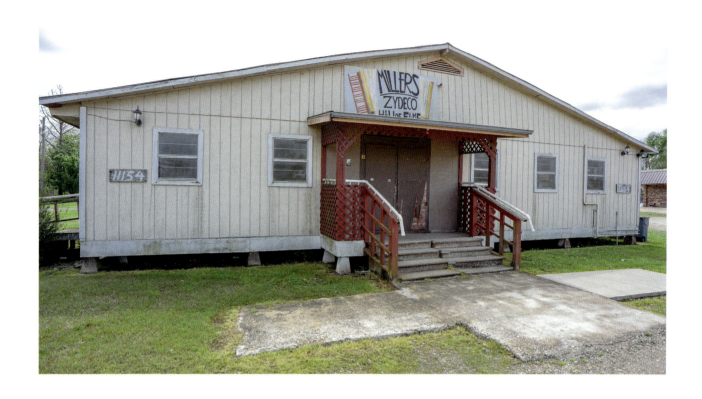

BF: And when did you put the buckets down and go for the accordion?

LT: After the buckets, we started unloading my dad's drums because he had a little trailer, a little small trailer, just that the drums were put in. And some nights he would go out to a supper somewhere, and we would take his drums out of his trailer without him knowing it. We'd put it in that little building, the Slim's Y-Ki-Ki building, and we would play all night. One night he came back because he was at the supper and he figured, "Let's jam." So he came to hook his trailer. And he hooked it. And I guess he felt it was a little light. So he opened it, and he was like, "Where are my drums?" We was inside, quiet. It was like, "Somebody got to go tell him."

So he asked my mama, "Where my drums at?"

And she said, "Well, Leo, I don't know."

And then we sent my cousin; me and my brother was too scared. So my cousin said, "We was practicing on your drums."

He fussed, but he got over it. He said, "Y'all don't touch my drums no more. Load them up!"

BF: You talk about the hog pen. Was this on a farm?

LT: Oh yeah. My dad was working on a rice farm.

BF: Working for someone else on the rice farm?

LT: Exactly. And then I worked on the rice farm. From there I did paint and bodywork. Then I moved to Houston, and I was a scaffold builder. From a scaffold builder to scaffold builder—the lead man. Then I went to another job in Houston. I was labor, and then two weeks later the guy asked me if I knew how to weld. I said, "Well, I welded in high school."

He said, "I'm going to teach you and pay you, pay you for your labor, which was seven something." He said, "I'm going to send you to the test in five days. If you pass the test, I'll give you $18.75 an hour." So I passed the test, and I went from $7.35 to $18.75 in four days. I didn't have to go to school because he let me practice on the job; he was the superintendent. But when I was the labor, he said, "Man, I don't have to tell you what to do; you're ahead of everybody."

BF: And were you playing music then, too?

LT: I was playing music in my dad's band. Accordion.

BF: Did you come to the accordion after the drums?

LT: When I turned 16 there was a guy in Elton had an accordion for sale. I said, "How much do you want for it?" He said either a certain amount of money—I forget what he said—or a cassette player, the little flat cassette player with the little button, you could rewind. My daddy had like five of them. So I took one—figured he wouldn't know. He still don't know today. So it was like two miles, gravel road; we walked all the way to town with the cassette player and went to that guy's house.

And we said, "We got a cassette."

(top) Miller's Zydeco Hall of Fame (former Richard's Club), Lawtell, Louisiana, 2017

(bottom) Sign from the now-closed Slim's Yi-Ki-Ki, Opelousas, Louisiana, 2015

He said, "Okay, y'all can have the accordion."

It was a little Hohner accordion, and my brother and his buddy were just playing the same two notes all the way back home. When I got home, they gave it to me. I sat on the step, and John Delafose was on the radio, "Joe Pitre a Deux Femmes." And I pretty much played it.

BF: And you were how old?

LT: I was 16. When I was 18 years old, I was already in my dad's band.

BF: And was he playing mostly around Elton?

LT: Mostly, Lake Charles, Lafayette, and all that area.

BF: And then when you ended up moving to Texas, did you stay with him?

LT: Oh yeah. Stayed with him fifteen years. We started touring California and everywhere.

BF: What was his band's name?

LT: Leo Thomas and His Louisiana Zydeco Band.

BF: Have you ever played other kinds of music?

LT: Not really, no. I mean I play it today. We do zydeco, swamp pop, country, Cajun.

BF: But it's zydeco style, right?

LT: Exactly. When I do the country, I put the accordion in with it.

BF: What is it about zydeco?

LT: I guess that's what I know. I'm raised up with it, man.

BF: You're self-taught on the accordion.

LT: Yeah. I taught myself.

BF: Is it always the button accordion? Do you ever play piano-key?

LT: I taught myself piano accordion, also.

BF: And are you a full-time musician now?

LT: Yeah. I quit working sixteen years ago. About 1999.

BF: And were you in Texas then?

LT: Yes. I was a certified combination pipe welder.

BF: And started playing mostly in Texas?

LT: No, coast to coast, in Texas, and overseas. Mostly Texas. And I say, "Well, when I move back to Louisiana, I need to try to play around here." Because I was watching these other guys, like, man they're making good money right here at home. The same money I was making on the road. So I said I got to change something. Because these are playing for the dance floors, packed. So I changed my style a little bit. Slowed it down, and played more dance music. And, of course, more slow songs. That's where I caught them, right there. And I never looked back. And that's what I keep doing.

BF: I don't even know. Are you based in Louisiana now or in Texas?

LT: In Louisiana.

BF: There are pictures of you, or at least one, in the Texas zydeco book. So you play mostly around home now.

LT: Oh yeah. Pretty much, fourteen to seventeen gigs a month, all in Louisiana.

BF: It's pretty amazing to me, with all the competition, that there could be that much work at home.

LT: Yeah. The furthest gig is like an hour and twenty-five minutes. Most of them are twenty, twenty-five minutes away from my house.

BF: What kind of gigs? What kind of events?

LT: Mostly clubs and festivals. Trailrides—they get kind of warm.

BF: It was warm when we went to one in Cleveland, Texas. And are most of the clubs pure zydeco clubs, or do they have a zydeco night?

LT: They got zydeco nights; they got country nights; they got swamp-pop nights. It's a variety of music. They don't have just zydeco there.

BF: Who's the zydeco audience in Louisiana? Who comes to the clubs?

LT: All the dancers. For sure all the dancers. And then you got the other people that just come to party, you know.

BF: We went to a couple of clubs in Houston, and we went to a trailride there; and it was mostly a Black audience.

LT: Yeah. Oh yeah, the trailrides, yeah.

BF: But what about the clubs in Louisiana?

LT: Where I play they're all pretty much 100 percent white. Yeah. Every blue moon you might have a couple of Blacks, but the trailrides is different.

BF: You've made a bunch of CDs?

LT: Probably a total of ten or eleven. Including a cassette with my daddy and three CDs with my dad.

BF: Are any of those recordings around? His recordings?

LT: Not really, man. I can't even really get them.

JT: What was it like playing this music back when you were in school? Were you part of a musical community with your peers, so playing this music didn't feel weird? Or did you feel like you had one identity at school and another at home?

LT: We didn't have a high school or junior high band at that time. So we would take regular drums, a drum set that we bought, and would just, like at the football game, we had like maybe two drums. We would play when they would make a good play. The cheerleaders would look at us and point at us, and we would just beat on that. Same beat all night. Same song.

And like I say, we were going to the dances where we could get in, at the church halls and stuff. I had no idea—like when I was in history the teacher would talk about New York and Germany and France, and I was like, "Man, I don't need to learn this. I ain't going nowhere. The farthest I'm going is Texas." And I didn't want to learn it. And I've been to France, Europe, forty-six states, I done performed thirty-three states over eighty times. Each state.

BF: And so it was a cool thing to be playing the accordion in high school?

LT: Oh yeah.

BF: Girls liked it?

LT: Oh yeah. Definitely. I didn't want—my brother and them would talk French at the dances, a little bit, not a lot, but one of my buddies, he can talk French all night. And I would tell them, "Man, quit talking French. We ain't going to get no girls to go home with us, talking French." Because, you know, it wasn't too cool back then, for young people. And I regret that today. I could talk French, but not a lot. And I understand most of it. I can sing it a lot, too.

BF: Do you think it's important to preserve the language?

LT: Oh, yeah, definitely. When I was on my tractor on the rice farm I had an eight-track tape on there. It didn't have no air conditioners, no windows. The dust was flying. And that Clifton Chenier eight-track was playing, and I would listen. You know, if you hear words over and over every day, it's all in French, pretty much, Clifton would sing. That's how I learned how to sing French. Then later on my buddy, that I was talking to y'all about, I would ask him what he's saying. So that's how I learned. I learned the French first, and then I learned what it was, what I was saying.

BF: In New England there are a lot of French people who came from Canada, came down here to work in the mills. A friend of mine claimed that she learned to speak by watching cable TV from Canada.

LT: Right. Oh man.

BF: Not too different. Talk about the zydeco scene in Louisiana. You know, how many bands and, you know—easy to get gigs, hard to get gigs?

LT: It's a bunch of bands in Louisiana. A lot of zydeco bands. But you know, it's only a handful that's popular. I would say maybe six bands. And I'm blessed to be one of them.

BF: Who else would you say now?

LT: Me, Keith Frank, Geno Delafose, Chris Ardoin, Lil' Nate, yeah.

BF: Is the music different in Louisiana from what you hear in Texas?

LT: No. The zydeco bands, it's the same. But in Texas they mostly going to play like Keith Frank or Lil' Nate style. Maybe Step Rideau keeps it traditional. But most of the other Texas bands kind of go towards the rap, hip-hop zydeco.

BF: So, more maybe than Louisiana bands do?

LT: Yeah. I think so. All youngsters in there.

BF: You would call yourself traditional or old school?

LT: Oh yeah, yeah. Because I could sell CDs for six years, doing that type of music. Because all my audience is 35 to 70. Where, if you're doing hip-hop, your audience pretty much is going to be 18 to

30, whatever. And a few older people. But most of them going to copy the CD. Maybe a hundred of them will buy it, and you'll get 2,000 copying them. Where my crowd, they don't want a copy. They want the real deal. Yeah.

BF: Do you do these recordings in studios in Louisiana?

LT: Yeah. We just got a new CD about two weeks ago. It's entitled *We Love You, Leroy*. And the fans gave me that name. Because every time we would play somewhere, everybody would scream, "We love you, Leroy." So I said that's what I'm going to name my next CD.

BF: Can you say more about how you would define "old school"?

LT: I would say, man, it's kind of like maybe a little blues and rock 'n' roll. And the hip-hop is more like—a lot of it is not a lot of accordion playing. Like when they're singing, they just stop playing the accordion and just sing. Like you probably seen J. Paul do that. Just letting the accordion hang, and singing and get into it. Which is good. It sounds good. Sounds great. And then the zydeco, like when I'm singing, I'm pretty much still playing the whole time.

BF: Are a lot of people building those accordions now in Louisiana? Are they hard to get?

LT: About the same amount of people for a few years now.

BF: And there's no difference between what you guys play and what Cajun players play, is there? The instrument itself, I mean.

LT: It's the same accordion. A lot of the Cajun guys put the microphone on the outside, what gives it that fine, thin sound. And the zydeco bands and Creole bands put it on the inside, which gives it that bass sound. Gives it a more full sound. Because you don't have the bass when you got it on the outside.

JT: I was just wondering—what things are the best things about being in the zydeco world? Like when you're at a festival like this, and you see all these different kinds of music.

LT: Well, it's real fun. Because they dance to all this music over here. Definitely, whatever different kind of dances they're doing. They dance to all of it. But with the accordion and the rhythm guitar holding that rhythm, and the drumbeat that we have, and the bass line, and the rubboard, they don't get that too often around here. So zydeco is, I think, a special kind of music. Like Louisiana is a special place, you know. The only way you're going to get the real zydeco music is in Louisiana. The only way you're going to get real soul food is in Louisiana. Or Cajun food, Louisiana.

JT: But not even Texas?

LT: It's not the same. I got a sister live in Texas, but they not going to have it like Louisiana, to be honest with you. Most of the people from Texas are from Louisiana. But when they left Louisiana, they quit cooking. When I go to my sister's house, we eat at 3:00. You come to

my house, we eating between 11:00 and 12:00. Everybody in Louisiana eats between 11:00 and 12:00. But when you go to somebody's house in Texas, it's ready about 3:00. It's a difference.

BF: Have you ever, in all your time playing zydeco music, have you ever had a sense that the music was, you know, not doing well? That there was a risk that there wouldn't be people playing it?

LT: Oh yeah. Yeah. Because when Clifton Chenier passed away, it was like, you know, John Delafose was still there and Boozoo. But when they died, it's like the older people, they stopped going. They quit going. So it was just youngsters going out, you know. Kids. When I say kids, I mean 18, 19, 20. And I'm glad that Keith Frank and J. Paul switched it that way because, you know, they're going to get older one day, and they're not going to want to go to the hip-hop. So we get them then.

BF: Do you think it's in good shape now—the music?

LT: Oh yeah. It's in good shape now. I'm mean we're doing thirteen to seventeen gigs a month for the last seventeen months, right there at home. And I'm doing the same thing, Geno, Keith Frank, Lil' Nate, all those guys playing thirteen, seventeen gigs a month.

BF: And I guess it pays well enough that you live on it.

LT: Oh yeah. Definitely.

BF: Is your band—do the guys play just with you, or do they work with other people?

LT: No, just with me.

BF: I feel like I've seen your bass player someplace else.

LT: He just joined the band like about five months ago. He was actually with Rosie Ledet; that's his ex-wife. And he was on bass.

BF: How do you decide what makes a good zydeco song?

LT: Well, when I kick off my first song, I know what to play the rest of the night. I judge the crowd. Well, I said the first song. Between the first and the third song, I know what to do. Because if I play that third song a country song, and it's, of course, a slow song, and they jumping up, I know I can throw in some faster country music later on. Some places they strictly zydeco, but when I put that country on them, they love it.

BF: When you say "strictly zydeco," how's that different from . . . ?

LT: Like just playing some two-steps and waltzes.

BF: So the older music and the older crowd.

LT: Exactly. Some places, that's what they want, you know. Very seldom—there's got to be, like everybody 65 to 70 or whatever.

BF: And there are those places, still?

LT: No. They're all mixed, from all ages now.

BF: And what are the big clubs now; what are the best gigs to have?

LT: Got Red Dog's in Egan, Cowboys in Lafayette, Cowboys in Lake Charles. You got the Camp Lounge in New Iberia. A few other places. We play a lot of those places monthly. The Coushatta Casino, we play

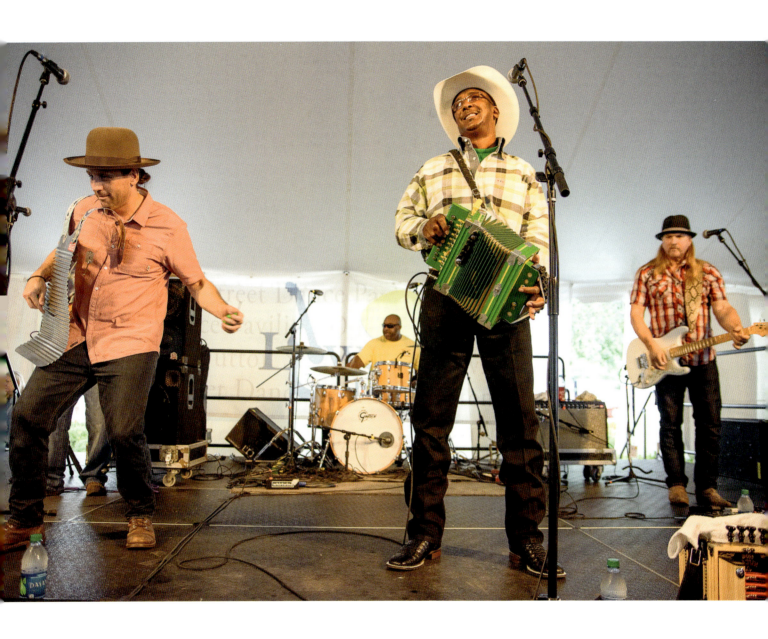

Leroy Thomas and the Zydeco Roadrunners: Storie Gonsolin, rubboard; Gerard St. Julien Jr., drums; Ronnie Rue, guitar; Lowell Folk Festival, Lowell, Massachusetts, 2015

there every month. And that's usually on a Thursday, and then they have a zydeco festival at Coushatta Casino once or twice a year. Yeah.

BF: What are the big festivals?

LT: A ton of them. Oh my God. Sometimes it's like five different festivals in the same weekend, fifty-mile radius.

BF: Do you ever get over to New Orleans?

LT: We play the Rock 'n' Bowl. We played it almost every month last year. Probably missed two months. And this year we probably only missed two months so far. We just played there last Thursday, not Thursday just passed, but the last—July 16.

BF: I've seen Jeffery Broussard there, I guess, and Corey Ledet. Kind of a funny place to play, with people bowling.

LT: Oh yeah. Rock 'n' Bowl. They rock and they bowl.

BF: This question of what makes a good zydeco song—when you hear a song and say, "I think I want to do it," what appeals to you about a song from outside the tradition, that you bring into it?

LT: Right. When I hear it like from another band? I'm going to feel it right away because I dance to zydeco music. So I'm going to feel it if it's a good dance beat. Then I'll start to play it. I might change it up, but it's going to still be there in that pocket, on that rhythm.

BF: Now I'll ask you a question about dance. Is there any such thing as a basic zydeco dance step or is it that people, they know how to dance within the tradition, but there's not one zydeco step?

LT: Everybody's different.

BF: If you look on YouTube, there are people who say, "Here's the basic zydeco step." But I don't think that's what I see in Texas and Louisiana.

LT: Even back in the day, man, you know everybody was pretty much doing the same thing. But everybody don't talk alike, so everybody don't dance alike.

BF: And you figure this is the career for the rest of your life?

LT: Oh yeah. Well, hopefully I'll retire with it and not have to play like a lot of them—like Boozoo and them, just play until you die. Because you have to. I don't want to have to do that.

JT: Is it hard because everybody is in the same area; is it competitive? Or is it friendly competitive?

LT: No, it's not friendly. I mean I don't have a problem with any zydeco band at all, but you got zydeco band leaders that tell club owners, "Don't book him," or throw my number away. And not just doing to me; doing it to like four other bands that I know. Which is not good, you know.

BF: What kind of music do you listen to when you're not listening to zydeco?

LT: To be very honest with you, I don't listen to music at all. I mean I could drive all day somewhere, I will not put the radio on. I don't

even have a radio in my house. I don't listen to music. If I'm going to my buddy's—every night I'm invited to a supper somewhere. Every night, during the week. They don't call me on the weekends because I have to play. But anyway, sometimes when I'm on my way there I might throw it on. Country western or KBON, which is playing zydeco and Cajun music, swamp pop, and a little country. So I'll put it on KBON 99 percent of the time. Every now and then I'll throw it on a country station. So it's either KBON or a country station when I do put it on. But I don't ever announce that, so—they want you to listen to the radio. One time I called 88.7, which comes on Saturdays from 8 to noon, and I said, good thing I didn't say, "Man, I'm listening to you all." Because I said, "I want y'all to announce something for me." And they said, "You know, we're not a radio station." They just got it on autopilot or whatever. They'd already picked all the music. Because usually I'll say, "Man, I got my ears on you; y'all sounding good." And they happened to be there.

BF: It was probably more local when you were a kid.

LT: Oh, yeah. When I was a kid, you couldn't take the music out of my vehicle. After that—my dad's the same way. He don't listen to music and drive. I will fall asleep listening to the music while I'm driving. Don't matter if it's in the daytime, tired or not tired.

BF: Was there much live music on the radio when you were younger? Were people playing on the radio?

LT: No, I don't think so. Back then, no. There's not much of that today. Not at all. Somebody might go in there with an accordion. Like when I go to the radio station, "You brought your accordion?"

"Nope."

I just like to go there and talk or whatever. I don't like to really play.

BF: Is there a main zydeco station?

LT: Well, KBON. It's a mixture, you know, Louisiana music. And then on Saturdays you got 88.7, and I think you got 106.9. And then 104.9 in Lake Charles.

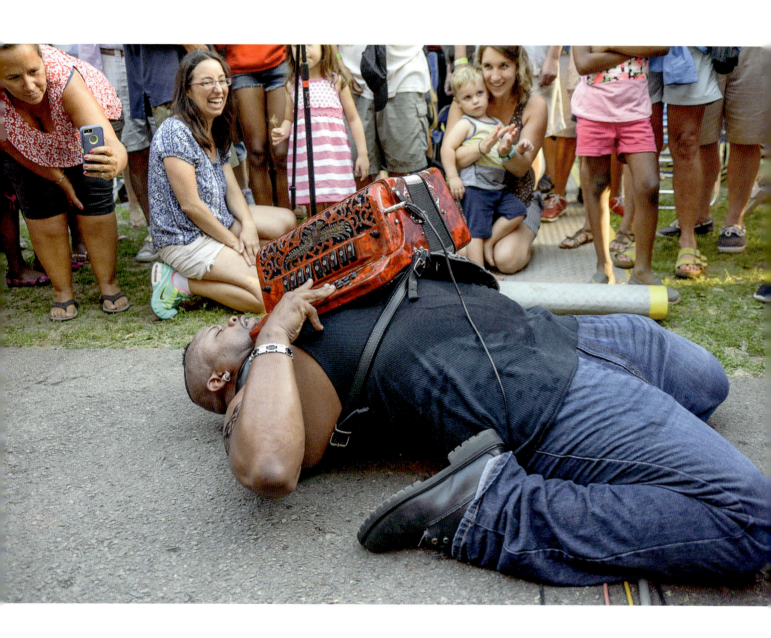

DWAYNE DOPSIE

Dwayne Dopsie and the Zydeco Hellraisers

If you've never seen someone play a large accordion on the ground, legs folded under the body, pretty much on his back, go see Dwayne Dopsie's show. He's an excellent accordion player and an exciting performer. His band, the Zydeco Hellraisers, earn their name. They travel around the country and abroad playing a hard-rocking music at festivals, private parties, and other events. They are well practiced at whipping a crowd into a frenzy. When I first contacted the 2018 Grammy nominee, via Facebook Messenger, about an interview, he responded that the music people call zydeco today isn't true to its roots: "It's more hip-hop, rap," he said. "My father was one of the pioneers of this music, and it's a disgrace when those folks tear down what they built and what I myself am traveling the world, not just local clubs, traveling the world doing so if u really wanna know I'll tell you." He's a man with a powerful presence on stage, impressive musical chops, and a set of experiences and opinions to match those. To him, the contemporary world of zydeco music in Louisiana and Texas has lost its way.

His model for the right way was his father, Alton Rubin (1932–1993), who performed as Rockin' Dopsie. A friend of Clifton Chenier and his family, Rockin' Dopsie was one of several musicians who continued Chenier's legacy, performing on piano accordion, bringing in liberal doses of popular music, breaking through to audiences beyond the local community. Dopsie senior played regularly at the Maple Leaf Bar, an enduring uptown New Orleans music club, and he recorded on Paul Simon's album *Graceland*. For Dwayne, born in 1979, the youngest of eight children, his father was both a pioneering figure for the genre and an inspiration. Three of Dwayne's brothers—David

"But what made zydeco music famous, that made everybody love it, was the way people played zydeco and put the blues into it."

Interviewed August 21, 2016, by Burt Feintuch at Northey Street House Bed and Breakfast, Salem, Massachusetts. Dwayne and the Zydeco Hellraisers were in town to perform at the Salem Jazz and Soul Festival. Jeannie Banks Thomas and Gary Samson also present, and Dwayne's bassist, Dion Pierre, was in the room. Brandon David, guitarist, was there at the start.

Dwayne Dopsie, performing at the Salem Jazz and Soul Festival, Salem, Massachusetts, 2016

(Rockin' Dopsie Jr.), Anthony, and Tiger—perform in Rockin' Dopsie Jr. and the Zydeco Twisters.

We met in Salem, Massachusetts, at the Witch City's annual Jazz and Soul Festival. It was the band's second year at the festival; they flew in that morning from a West Coast gig, picked up the van they travel in, checked into a bed and breakfast, and found some lunch. Some of the band members went to sleep; Dwayne sat for the interview and photos.

Dwayne and his band are one of several zydeco acts who are mostly on the road, not playing much in their home communities. After Clifton Chenier, the late Buckwheat Zydeco (1947–2016), Stanley Dural Jr., was probably the best known of those performers. C. J. Chenier and the Red Hot Louisiana Band (1957–) continue C. J.'s father's legacy; C. J. began his music career by joining his father's band in 1987. Terrance Simien (1965–) and the Zydeco Experience are another. These bands tend to exist more in the Clifton Chenier mold, playing some Louisiana standards with a mix of other songs, often with a notable blues inflection. They frequently employ the piano accordion. Their audiences are largely white; they play clubs, festivals, and private events. Back home, they may play New Orleans Jazz Fest or occasional other gigs, maybe Rock 'n' Bowl, a New Orleans bowling alley that books zydeco. Buckwheat used to do an annual benefit concert at his friend Sid Williams's club, El Sido's, in Lafayette. While most zydeco bands carry a guitar player, it's these bands that tend to feature rock-style guitar solos. By and large, the touring bands play a different repertoire for audiences to whom they represent a genre, audiences without access to the music in the context of its home communities. The bands tend to go for the grand gesture, working to excite their audiences in what we might describe as a *laissez les bon temps rouler* sort of effort.

In 1999 Dwayne, who'd grown up with his father's music and was establishing himself as a professional musician, won a national accordion competition. That titled him America's hottest accordion player and helped propel his career. On stage, his main instrument is a red triple-row Dino Baffetti, and he plays it hard. In a sleeveless black shirt and jeans, his muscular arms pumping the accordion, he has a powerful stage presence. Paul Lafleur, his scrubboard player, also performs with a lot of flash and drama, dancing around the stage. Back home, in Louisiana and Texas, bands tend to let their music speak for itself. On the road, Dwayne Dopsie and the Zydeco Hellraisers rip it up, with the energy and moves you recognize from rock music or blues shows. At the moment, the promotional video on Dwayne's website shows the band doing the Rolling Stones' "Beast of Burden." You're not likely to hear that song at a trailride. But at the Salem Jazz and Soul Festival, it's just right.

Dwayne's blues-inflected performances mix rock, blues, soul, with some references to Louisiana. Like many touring bands based

in Louisiana, the band makes a big deal of singing "Jambalaya." Hank Williams wrote and first released that song in 1952; the country music standard has become a cross-genre Louisiana anthem. The crowd recognizes the opening riffs and joins in on the chorus. In Salem, Dwayne came off the stage, at one point ending up on his back while playing, surrounded by enthusiastic audience members. A few people told me that he'd killed it the previous year; they were excited about his having been booked again. He closed out the festival, rocking it fiercely, and leaving the place jumping.

BF: I'll start out by asking you to talk some about how you would describe your music.

DD: The best way I would describe my music would be powerful. Aggressive. Right to the point.

BF: Do you describe yourself as a zydeco musician?

DD: I'm like a textbook zydeco musician. I'm just transformed into a 2016 zydeco musician. But I'm old school.

BF: I know you've got some strong feelings about what zydeco is. Talk about what zydeco means to you.

DD: Well, you know, it's not so much feelings; it's truth. Zydeco is blues music. It first started out as blues music, being sung in French. Back then they'd call it la-la music. And over time it developed into a band around an accordion player but a band also around a guy playing a washboard. Then a bass. Then a drum. And then they had house dances. And over the years, into the forties, fifties, sixties, seventies, up to I'd say mid-nineties, it pretty much stayed that way. With the guys pretty much being consistent, playing a certain style. Now after the '95 era, everything changed.

BF: Everything changed how?

DD: They started to add more funk into the music, more hip-hop. And now in 2016, fast-forward from '95 to 2016, a lot of the artists around Lafayette, Opelousas, Lake Charles, Houston, their style of zydeco music is all hip-hop. Nothing is giving people joy. The music's not happy to me. The music's very dark. It's not dance music. Well, it's dance music for a certain blend of people who only want to hear the same beat all night long. Poppa chunk, poppa chunk, all night long. That's all you hear. It's like you turn on the recorder, and that style of music brings a style of people that don't appreciate the musicians. They don't appreciate where the music comes from. They only just listening to a beat.

Well, zydeco is more than just a beat. It's a way of life. It's a culture. It's a feeling. It's how people pay their bills. It's how we grew up eating zydeco, you know, at my table. Eating the green beans. A lot of the guys coming up nowadays, they don't really know. In their minds, zydeco started in 2000. They don't know where it come from.

So that's why you have so many bands every year come out, and in three or four years, oh, what happened to this guy? Everybody else has a day job. I've been doing the same thing for sixteen years; I've never worked a day job. And I've traveled the world, more and more. I don't plan on working a day job. I don't like getting up early in the morning.

BF: I can appreciate that. Do you need someone to help out?

DD: There you go.

BF: Talk about your father's influence on your music.

DD: My father was my biggest influence. Growing up in a house that revolved around zydeco music from Monday to Monday, you know, from either him coming into town or going out of town. Or just watching him, sit down and talk about the fun that they had at the shows. Or having him clean his accordion and just kind of take it out and play a little bit. I was always in amazement of that, even as a little boy. I would stop what I was doing and just sit there and look and listen. That was my biggest inspiration, and I always knew from a young age, I wanted to be an accordion player.

BF: Where did he get his music? What inspired him to start?

DD: My grandfather played accordion. He wasn't a musician as far as playing out—dances. But he had an accordion at home because my father was from an area of Louisiana called Carencro. And they had like ten, twelve acres of land out there. So my grandfather was a farmer. And my father would help him. So when my grandfather would be out in the fields, my father would sneak over to the house, take his accordion out, and my father played the wrong side, so you have to turn the accordion upside down, play left-handed. And that's how he taught himself how to play. So that's where his influence of the music came from.

BF: Would your grandfather play the triple-row, too?

DD: He played a double-row. He played a two-row accordion.

BF: And what was his name?

DD: Walter.

BF: How did you father become "Dopsie"?

DD: Well, that name came about because there was a man out of Chicago that actually was, his real name was Dopsie. And when my father met my mother, they were young, so they'd go out dancing. The style of dance for zydeco music, really, is jitterbug dancing. So they used to do a lot of jitterbugging. The best jitterbugger at that time was a guy from Chicago named Dopsie. So my father would imitate him. So they called him "Little Dopsie." Then, when he started playing music, they called him "Rockin' Dopsie." So that's where the name comes from.

BF: I know you grew up in Lafayette and moved to Metairie; is that right?

DD: I moved to Metairie, and then I lived in Kenner a long time.

BF: So, in the Lafayette days, when you were younger, were you going out to zydecos or hearing the music much?

DD: No. I was hearing it, but I was young. Because when my father passed away I was fourteen. You know, if he'd leave, I would follow. If he'd stay, I would sit. So that's how it was. I listened to Clifton Chenier's music and Buckwheat's music. But everything revolved around my father. It's like the sun and moon set by his standards.

BF: How much was he out on the road?

DD: A good bit. I'd say out of like a year, maybe six, seven months out of the year. Traveling. And then he'd do a lot of shows around the home. But back then, it was very different. You could play more around Lafayette and the areas because you had more people going out to hear the music. Now the music scene there is not as strong as it used to be because the music isn't the same. A lot of those people don't go out because of the fights that the youngsters get into. So people that I grew up watching, they don't even go to zydecos no more. They just stay home and play their old records. And that's really killing our zydeco culture.

Cajun culture is fine because they stick to their tradition. But my culture is being cut in half because they feel like, "I can't make it playing zydeco. So let me add rap; let me put some lyrics; let me get a guest rapper."

BF: I know some people say the trailrides have hurt the club scene.

DD: The trailrides are just about banned in a certain area because of how people misuse those horses. They're trampling people's yards. There's always fights at the trailrides. Shootings. I could remember up until I was 18, I've never heard of people going to a trailride, a club, in Lafayette or whatever, and people will get in fights, shootings. It wasn't like that. Because the music was positive.

So that's why I really condemn a lot of the musicians that play that style of music. Because it's not zydeco. Zydeco isn't mean to hurt people. It's love. When people had house dances, and they had la-la music, they were celebrating because they had some green beans on the table, and everybody was ready to eat. So they played, having fun. That's what the love was. No, it's like they done took the love out.

BF: So, do you know any of the guys who are trying to play the old style?

DD: Yeah. I know them. But they don't know enough history to play the old stuff. They're only doing this—take the CD out, put the CD on, listen, and try to repeat it. No. Anybody could do that. If you know your instrumentation, anybody could do that. But what happens when you take the CD out? What can you play then?

That's one thing my father didn't ever do; he didn't show me how to play. I wanted to learn, and he told me, "Yeah—you could learn. I'll even give you an accordion. But when I'm not here, what you going to do? I want you to have your own style, but stay within the music." I'm happy it happened like that. Because I learned things that I probably

wouldn't have been able to because I probably would have been limited. So I didn't limit myself.

BF: When did you start playing?

DD: When I was seven.

BF: Playing the accordion? Did you play rubboard first?

DD: Yeah, I did. When I was four, for a few years, but I always played with the accordion. I guess I got serious with it when I was seven.

BF: Did I read that he took you on some of his shows when you were young?

DD: Yeah. I did a few shows with him, like the Dolly Parton show, when we did the recording we did then. There was a Community Coffee commercial; we did that in Louisiana. Super Bowl Saturday, when the Super Bowl was in New Orleans. I think Super Bowl XXII; it was Saturday night, and I was on TV with him. He would always take his accordion off and let me play. My biggest thing back then was I only knew two songs. So my other brothers would tease me and laugh at me. It would anger me. I didn't know much. But I was learning. And then I said, "One day, they're not going to laugh at me." Now, nobody's laughing at me.

BF: You have another brother who's a bandleader, too. And there were eight of you? Is that right?

DD: Yeah. I have three brothers and four sisters.

BF: Is anybody else musical?

DD: My other three brothers.

BF: In the zydeco tradition?

DD: Yeah.

BF: And do they play out?

DD: They do a lot of stuff around Louisiana. A lot of parties and stuff like that.

BF: That's great. It's incredible actually—what a big family heritage.

DD: Oh, yeah; exactly.

BF: Was your mother musical?

DD: No, my mother just put out the kids.

BF: That's plenty. So, you start playing when you're young, and you start playing out with your father a little bit. Other musical influences?

DD: I listened to Clifton's music. Watched him play. And my thing was I would never just listen. I would want to become the music. I would study his hands; there's things that I used to do that I know a lot of guys don't do now—that's why they don't play like that. I listened to Jimi Hendrix. I listened to B.B. King. Muddy Waters. Buddy Guy. Elvis Presley. Willie Nelson. Guns and Roses. I like people like that. I like Charley Pride. A lot of people.

BF: Would you say there's much of a country music influence in your music?

DD: There's one country song that I've always wanted to record. I just never did it yet.

BF: You were talking about zydeco being a culture. Did you grow up with French in the house?

DD: My mother and father both spoke French. So that's how I learned how to speak French, from listening to them. I failed it in school, but I passed it at home. It was more entertaining to listen to them talk than the teacher. So I picked it up from listening to them.

BF: And did you speak it at home?

DD: I would try and say a few words, and they would correct me and say, "No, you don't say it like that; you say it like this." When they was talking about me, they would speak in French.

BF: Thinking you didn't understand?

DD: Yeah. And so one day I said, "I know what y'all saying." And they kind of looked at each other, like, "Oh. He's picking it up."

BF: As you talk about the culture, I immediately think about the language, but are there other things about the culture that you remember from your childhood that are important to you?

DD: Oh yeah. The thing that I really remember about the culture is how much people put the work in wanting to be a part of the culture. The guys—back then, like in the '70s or '80s—that would never let the culture die. They would just sit on the front porch and play. And sing. They loved where it came from, what it was; I remember that.

Just going to a lot of my cousins' house, somebody had an old accordion. They'd take it out and play. They wanted to be involved in the culture because at that time zydeco wasn't big with the young people. But it was bigger with the older folks. And getting known around the world.

BF: What about things like the food?

DD: The food, yeah, definitely. Creole cooking—like gumbo, is an African word. A lot of people don't know that. "Oh, yeah, gumbo is from Louisiana." No.

It's a long history with that, like, the Creole cooking, we call it. You put your pork and your turkey necks and your okra and your crab, put it in a gumbo because, back then it was the poor man's food. But that's what Creole cooking was. Now it's like it's everybody's food.

BF: For some reason, that makes me wonder—what had your father done before he became a full-time musician?

DD: My father was an electrician. And he worked construction. He worked at a place in Lafayette. The men used to tell me my father could out-dig two men. He'd get a shovel, he'd say, "Man, let me show you how to dig."

BF: But he did go full-time, professional.

DD: He did. He did. Oh yeah. And even then, he'd work, and then he'd go play. And then I think after like in the thirties, him being in his late thirties, he just gave it up, and he stuck with music full time. Oh yeah.

BF: There weren't many other people getting known for their music in this tradition at that point, I guess.

DD: No. No. There was Clifton Chenier. There was my father. Buckwheat Zydeco. Marcel Dugas. And Fernest Arceneaux. That was the people that was really around. And Claude Faulk was another accordion player. It was people like that that were really keeping that music going on.

BF: What about people you sometimes read about, you know—Bois Sec Ardoin? Did you know him at all?

DD: I've heard of him; I never met him. Bois Sec Ardoin played more like the Cajun music.

BF: Yeah. Like the older la-la.

DD: Yeah. They say it's zydeco, but it's not. If you listen. It's good, but it's more on the Cajun side. And that's okay. But what made zydeco music famous, that made everybody love it, was the way people played zydeco and put the blues into it. Then it had a meaning. Then it had a feel. Then you really could connect with the music, like me—I could feel it. Not just chink-a-chink-a-chink. That's great. But there's only so many chink-a-chinks that I could hear. I would rather hear something that's got a good melody, and somebody that could play a guitar or accordion, or a washboard solo, and you could feel the love or just the intensity going into that.

BF: You carry a saxophone player, too, which you don't see in the other bands these days.

DD: Yeah, I'm kind of disappointed with the direction the music has taken. But there's still people that's keeping it afloat, like myself, C. J. Chenier, my brothers. You know, Terrance Simien. Chubby Carrier. That's still within that realm.

BF: Talk about your becoming professional and putting a band together.

DD: Yeah. Let's see. After my father passed away, I would go home and take the accordion out after school, and play, play, play, play. Then finally I met a guy—his name is Tony Delafose. He was looking for an accordion player. And I was looking to play. He said, "Yeah, you come in and play with us." I'd never been nowhere before. I was like 16, 17.

We drove all the way to California; I thought that was great. Until I realized how far it was. I said, "Man, I don't want to do this again." We went to Hood River, Oregon. We went to Seattle, Washington. We drove everywhere. But I felt like I needed to experience that. Hearing other guys play and what I was doing was like, "Oh, this is okay." It was like a whole different experience.

When I got to be 18, I decided, you know what? I could do this on my own. I felt like I had enough learning and enough teaching that I could do it on my own. So I went ahead and told him I was going to get my own band. And right when I got my own band there was an accordion

Dwayne Dopsie, Salem, Massachusetts, 2016

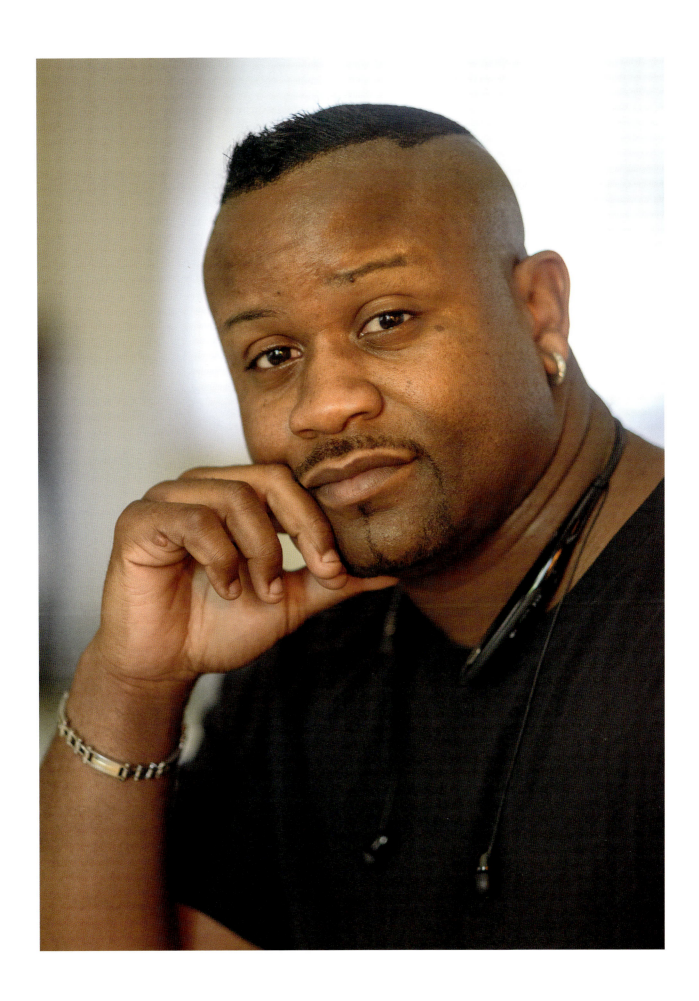

contest, the first-ever accordion contest ever held in America. It was a search for the hottest accordion player, to be like the next person to appeal to the MTV kind of crowd back then, in '99.

So we were playing the French Quarter with my band, and a lady named Faithe Deffner walked in. She said, "I love your playing. Here's my card. Send me a five-minute video of you playing, and we'll see if the people will put you in. There's a lot of submissions going in."

We went ahead and did that. About two weeks later she called me, and out of three thousand people they picked five finalists. And we were one of the five. They flew just the accordion players down to Branson, Missouri, at the Lawrence Welk Theater. There was one girl; she had a band to back her up. But everybody else was by themselves. But I was able to win.

BF: That's great. I read about this online.

DD: Yeah. I was able to win.

BF: What did you win?

DD: I won a big old trophy. Free studio time. I went on *Good Morning America*, *20/20*, *CBS This Morning*, and all that stuff.

BF: What did you play? Do you remember?

DD: I played a boogie-woogie by myself. I kind of knew that I had the crowd when everybody started moving their heads. I said, "Okay. I got you now." You know, just stuff like that. And I played the blues by myself. It's hard not having people back you up. That's the practice that I had did when I was living at my mom's house—just play, play, play, play. So that was normal for me. Yeah.

BF: So that's right about the time you're going out on your own?

DD: That was the biggest part to the start of who I am today. Because I was able to meet different people and they'd say, "We saw you on *Good Morning America*; come play our festival. Hey, we saw you on this. Play the festival. Oh yeah, we love you. Let's bring you to play in Maryland. Play here; play there." And then when I was on *Fox and Friends*, Fox News Network, and some people had seen us. They brought us up to Cape Cod. And we went to Cape Cod for ten years. Every summer. Then we started going in the winter, too, because it was so popular. So that was a big part of my coming up then.

BF: Also, weren't you playing a lot in New Orleans?

DD: Oh, yeah. I was doing some serious days in the French Quarter. I was doing like five days a week, eight hours a day. So that's where my workout comes from.

BF: Well, it beats the shovel, I think.

DD: Yes, it does. But I wouldn't trade those days for anything because that really created my skill, as far as playing. Because you play that long for that many hours, you develop a awesome style. You could think about the song, and you could repeat the song the next step, and just play it different. Say, "Okay, let me go see how I can do this."

And then while you're doing that, people just coming in, enjoying the music. Then next thing you know, you got a full house.

BF: Was it one club in particular, or did you move around?

DD: It was two. It was two but it was owned by the same person. One was called La Strada's—that was where I got my start. And the other place was the Krazy Korner. But they were owned by the same person, but they just moved the club.

BF: A New Orleans musician told me a story about how he used to play in a club that was owned by a big gangster, Mafia. They used to close the club, and they'd have the band just play for these guys, and they'd give them a huge tip.

DD: Yeah, there's a lot of Mafia in the French Quarter that a lot of people don't know. That runs the clubs. Yeah. Crazy.

BF: Are you still playing on Bourbon Street?

DD: No. We haven't done that almost like four years now. I've been fortunate enough where I just set out and said I'm just going traveling. Because there's so much work out there for what I'm doing. I mean, when I'm home, I just want to rest.

BF: Home is around New Orleans?

DD: No. Actually, I'm living back in Lafayette.

BF: How much traveling are you doing?

DD: I'd say total, in like a year, we have, I'd say, total about a month and a half off. Total. Because we always doing something; sometimes during the week, weekends, whenever.

BF: Who's your audience these days?

DD: My audience is from 20 to 90. It's a wide range. Even kids, babies, they'll come up to the front of the stage. Our audience is not like a lot of these certain musics is for a certain generation. It's like everybody.

BF: So you're here to play a festival. I imagine you play a lot of festivals?

DD: A lot of festivals, yeah. We're probably one of the bands out of Louisiana that play the most festivals.

BF: And clubs, too?

DD: No. No clubs.

BF: So, when you're traveling, it's mostly festivals.

DD: Festivals or like parties. Stuff like that. Special engagements we'll do. But mostly stuff like that.

BF: Some of the musicians we've talked to play mostly for African American audiences. Some play mostly for white audiences. Where's your music in those terms?

DD: Well, I play for both. But, to be quite honest, I get more hired by the white audience. Because my music is more happy. You know—it's nonviolent.

Because it's a shame that people like my father, and people before him worked so hard to build this music up, just to have it go away

because you want to make a quick hundred dollars or a quick two, three thousand dollars. That music doesn't have staying power.

BF: So, if your father heard you playing now, what do you think he would say?

DD: My father would probably say, "You could tell everybody else go home." Yeah. He would be very proud of me because I've stuck with what I believe in, and with all the good graces, it's been paying off.

BF: I read someplace that when you were young you used to cry when you played.

DD: I did. I was very shy. During Mardi Gras in Lafayette, there was a place called the Underpass in Lafayette, and everybody would come there after the parade and listen to my father play. It was a big old tall stage, and I was young. So my daddy would say, "Okay, I'm going to let my little boy play a song or two." So people would clap. You know, I was small, and I'd sit on his case. And I'd play, and I'd cry. I wanted to play, but I'd cry and I'd play. So he'd take his money out and throw it on the floor, and people start throwing money at me, and I kept crying, and I kept playing. Yeah, man. Yeah.

BF: You might want to keep that up.

DD: Yeah. I remember them days. I don't know why I used to do that; I was shy.

BF: How'd you get over it?

DD: I don't know. I think that my brothers had something to do with it. Because they'd say, "You're not going to cry today, huh?"

I'd say, "No, I'm not going to cry."

So that started to really piss me off. So I'd say, "All right, I need to nip this in the bud. Can't be crying all the time." So then actually, yeah, I actually thought about that a long time ago; I said, "Man, I don't know how I stopped doing that." But I just would cry and be shy. You know; I took the money.

BF: That would help.

DD: Yeah. Yeah.

BF: What was it like, as a kid, playing the accordion? Did friends in school think that was a cool thing, or were you self-conscious about it, or did they not know it?

DD: I was self-conscious. Because back then, zydeco music wasn't popular with my generation of kids. So it was like, "Oh, man; you playing that old people's music." They'd say stuff like that. Playing accordion for me was difficult. Because I didn't know nothing. I had to figure out, you know, where is this, where is that?

BF: Yeah, and your father played it upside down because he was left-handed.

DD: Yeah, he turned it around. I'd try to follow his hands. It was difficult. The whole time I lived in Lafayette, I was embarrassed to play around people my age because back then zydeco was popular

but not with 15-, 16-year-old kids. Now it is. Because of what they did to it. But back then it really wasn't. It was popular with their parents. And their grandparents or whatever. Those were the people that were supporting the music at that time.

BF: Talk about the accordion for a minute. Clifton played piano accordion. Your father played a triple-row. You play a triple-row. A lot of the other musicians today are playing the single-row. Were you ever tempted to play the single-row, or do you have strong feelings about which is the right instrument to play?

DD: I like something that's going to make my brain work. I'm not big on the whole toy thing. Some people consider the single-row traditional, and that's fine. Everybody has an opinion just like everybody's got two arms, but their tradition didn't make what we call zydeco famous. What made zydeco famous was what was being played by Clifton Chenier, Claude Fox, Marcel Dugas, my father, Buckwheat Zydeco. I can't tell you how many thousands of people I've entertained playing my style of music. I've never seen thousands of people going out to listen to a guy play eight buttons. There's only so much that you can do with that. I'm not knocking nobody. But the truth is the truth. Because one of those little accordions is only one key. It's F. So if you like to hear something in the key of F, okay you have it. Okay, I'd like to hear something in the key of D. I got to unplug it, I got to grab the other one, put it on. Oh, I'd like to hear something in E. I got to unplug—it's too much, when you can have something with all the notes. But that's why I say a lot of guys don't want to learn because they'd rather take the easy way out. They don't want to work and figure out the hand structure, to figure out, "Okay, when I go in, this is the F or the G. This is C." I mean it's a process. They just want to pick it up today and be a star tomorrow, and it doesn't work like that.

BF: When you moved to Metairie from Lafayette, did you feel like you left your culture behind or left the music behind, or was there interest in the music in the New Orleans area?

DD: Actually, I moved there because, at that time I was 18, and 18 in Lafayette you can't play every week. There were a few places—Grant Street, you could probably play Poet's in Lafayette, a few other places that closed by then. But it wasn't like New Orleans, where you could play every week. I needed to figure out how to have people know who I am, how to get my name out there. I couldn't get a booking agent because nobody knew me. They knew my father. They were like, "Okay, we knew your father, but we don't know you." So, X that one out.

I knew, okay, well, I need to get to the French Quarter, where all this music is taking place, and get me a band. And that's exactly what I did. From weekend to weekend to weekend, we had bigger crowds, more crowds—the word got out. And suddenly people started planning their trips to New Orleans around us, around our schedule. I was able to become one of the top one hundred things to do in Louisiana.

BF: Yeah—I know you're listed there.

DD: I'm number 29. I'm proud of that accomplishment.

BF: I don't know what you're going to do when they put a landmark plaque on your chest.

DD: I don't know. I don't know—something.

BF: Was there much other zydeco going on in Metairie and New Orleans in those days?

DD: No. I was really the only—there was a Cajun band playing in the French Quarter when I started, which was called Mamou. Which was my washboard player's father. His Cajun band from out of Eunice, well, out of Mamou. They were there, and we were there. Everything else in the French Quarter was—there was a lady called Mother Blues. They called her the queen of the blues. She was a great blues singer. There was another guy down there, Les Getrex. He was an accomplished guitar player. Everything else—blues, a few funk bands, Walter Wolfman Washington was down there. A lot of people like that. So that was my competition. I remember when I got my band, the lady say, "We really love you." And then she said, "If you can't keep a house, you can't keep the people in, you can't stay."

Because I said, "Okay. I got my band; can I sign a contract?"

She said, "We don't do contracts." She says, "It's by what you bring in. And if you make the cash register work."

And I didn't understand that. I said, "What you mean?"

She said, "Well, if you're playing and there's nobody here, then we're going to get somebody else."

So that put pressure on me. Because I didn't know nothing about entertaining a crowd. So immediately I snapped into it. The first day we played it was packed beyond capacity. I said, "Well, I think I found something."

BF: When did you start doing all the traveling, and when did you get a booking agent?

DD: I really started traveling after the accordion contest because people would call on me and say, "Hey—do you travel? Would you like to come here?" I remember the first job I ever got was in Maryland. I'd never been to Maryland before. So to pass by the Chesapeake Bay, I was like, "This is great." I remember that. That one and I think one of the first other ones I did was the Hot August Blues Festival in Annapolis, Maryland. Played there.

But I'd say like the majority of the festivals came around, we really started getting popular when I was about 24, 25. Started doing more and more, and more and more. Because we were always at like a jazz festival or a blues festival. And the only zydeco band. So people say, "Oh man; we're going to go listen to zydeco. We've heard zydeco before." And they come hear us. And they say, "Wow. I like what they do." And then the word got out, and more festivals, more this, and more that.

BF: Was the band always called the Zydeco Hellraisers?

DD: It was always the Zydeco Hellraisers. That came from a guy; when I played in the French Quarter, before I got my band. It was an old man, and he said, "Man. I love your music. Is this your band?"

I said "No, sir."

He said, "Get you a band and call it Dwayne Dopsie and the Zydeco Hellraisers."

I said "Hellraisers?"

He said, "Yeah—you raise hell, boy."

I said, "Yeah. I like that name."

And so, you know, I got that name, and immediately some people are like, "No, you don't want 'hell' in your name." One time we played in this place in Houston—we played at this, I think it was a church. Yeah, it was a Jewish church. So they took the "Hellraiser" out.

BF: "Heckraisers."

DD: Yeah. They just called it the Dwayne Dopsie Band.

BF: That's your G-rated gig.

DD: So the lady's like, "Well it's great to have you. You going to raise hell today?" It was pretty interesting.

BF: What do you like to do when you're not playing music?

DD: I like to cook. I like to do yardwork. I like to do physical stuff.

BF: Do you have a family at home?

DD: I have my girlfriend.

BF: I read, too, that your father did some programs in schools, sometimes with Dewey Balfa.

DD: Yeah.

BF: Did you ever do anything like that?

DD: I did something with some schools with a guy who's a fiddle player from out of New Orleans. He would go to school and teach the kids with the fiddle, with the Cajun music, and I'd talk about zydeco music. I did that a few times, down in Houma, Louisiana.

BF: Do you do any songs in French?

DD: I do. I do. If I was playing around Lafayette, I'd do more stuff in French. But on the road, I can, but—not to say it's not called for, but people, they would still relate to it, but it wouldn't have the same effect. Because they don't know what I'm singing. Or if I was in France or Canada it would be fine. Yeah.

BF: Do you have any interest in playing the older music? Do you play waltzes and two-steps?

DD: I do. I love to play the waltz, the two-steps. I love to play all that. With the show that we have, I play my own music. And when there's a call for it, I'll definitely play it. But I tell that to people all the time; I love the older music, but how do you think the older music got here? Because somebody recorded it, and you loved that. Well, you got to keep recording music. That's what music is—it's an ever-changing box. You know, you close it, open it up, you've got something else.

BF: Growing up were you at all aware of Boozoo Chavis and Beau Jocque?

DD: Oh yeah. Actually, my father was going to crown Boozoo the next king of zydeco—well, he was going to call him the prince. Because at that time there was just my father as the king after Clifton died. And he was going to crown Boozoo the prince, but he died before that happened. So they just made Boozoo the king.

BF: Where does their music fit in your view of zydeco?

DD: Well, to be quite honest with you, Boozoo came, and he was playing when my father and Clifton was playing. But people didn't go for his style of music. So he stopped playing for twenty years. And he started back in the late eighties. So from the sixties, seventies, he didn't play no more. Because people didn't like that style of music. They wanted to hear the blues. And he wasn't playing blues. If you listen to his music when he came back out, in the eighties, he did more blues. And more stuff with the triple-row accordion versus the single-row.

BF: How about Beau Jocque?

DD: Beau Jocque, I never really got into his music. He's got some good stuff that I could appreciate. I think that was when the era started to change. Because he added more things into the music and more of where the one beat came from.

BF: I hear a lot of funk in his music.

DD: Funk is good, but I want something that I could say, "Man, that boy can play." There's different fundamentals. I mean, he was a great musician. Don't get me wrong. But I think that's when the style of the music really changed to like '94, '95, '96, everything changed. And Boozoo would always be on the record saying, I remember him telling me, "These guys want to change my music. They want to put the rap and the this and that into my music, and that's not what it is." He said that a bunch of times at a festival over the mic. And people applauded, and they'd say, "That old man, he doesn't know what he's talking about." No, he does. He was there to see—when he was playing, and at that time he was playing his traditional music, but nobody wanted to hear it. So when he re-formed himself and came back out and did "Deacon Jones" and "Dog Hill" and everything, it was more with a little twist and flavor of blues. It had more of a kick to it.

BF: Is your band pretty consistent in terms of who's in it? Same guys travel with you? Change much?

DD: Pretty much. It's like McDonalds—you burn my burgers, I'm going to get rid of you.

BF: Really, what I'm asking is what it's like keeping a band together. My guess is that traveling and working as much as you do, you're not rehearsing a lot.

DD: No. Keeping a band together is tough. Because you got to deal with everybody's ego. Some people don't have them; some people do.

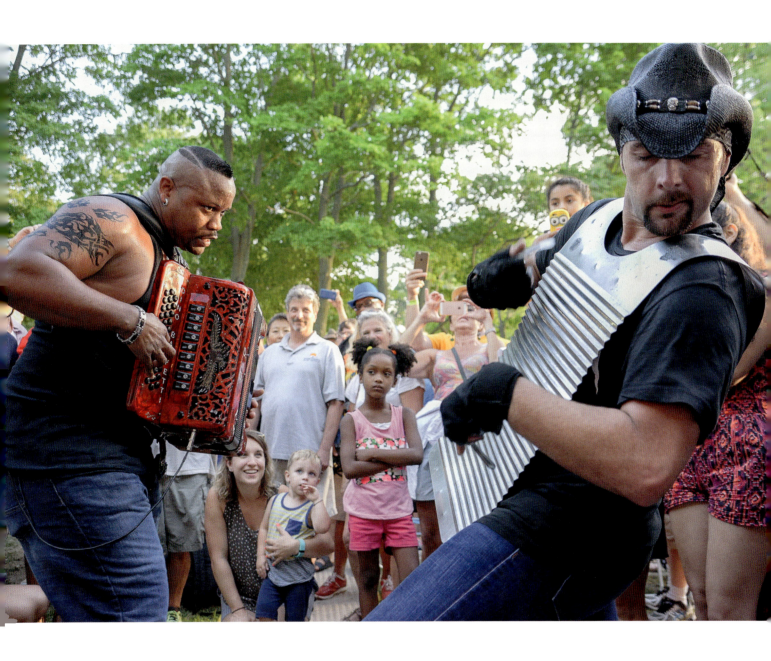

Dwayne Dopsie and Paul Lafleur, rubboard player for the Zydeco Hellraisers, Salem, Massachusetts, 2016

Some people have drinking problems; some people have drug problems. Some people just have personal problems. And they can't distinguish one from the other, and they just have them all the time. And then you got some people that just don't want to do right. And they don't show up on the gig. They're not reliable. They tell you, "Oh yeah, oh yeah. I'm going to be there." And nothing.

So having a band to keep a consistent sound is hard. But once you get that right chemistry and the right formula, it definitely works. You just got to find just the right people that's going to be willing to, A) want to travel, B) want to do the work, and C) able to play the work. Because not everybody that says, "Yeah, I could do that" can. I've had people like that, "Oh, yeah, I could do that." And you get there and it's like, wow—it's not even close. So, it's a challenge sometimes. But I've been able to make enough contacts over the years that if I need somebody I could get somebody. But right now everything's good.

JT: I'd like to hear you talk a little bit about the culture around the music. I was thinking about how you were brought up with your dad and all—have you thought about how you want to pass it on? Have you thought about that whole process, passing on what you've got to someone else?

DD: Yeah. I would love to have a son because I don't have a son right now. I'd like to have a little boy to carry my tradition, or what I'm doing. I think that would be important because I think it would be a shame that I wouldn't have a son and my legacy would kind of stop, like Jimi Hendrix's stopped because he didn't have a child. Or like a lot of the famous musicians like Prince didn't have a son; he could have carried the name. B.B. King has kids but nobody's carrying his legacy. So I want somebody to carry mine because—I think, definitely with this style of music it's important because you can let the tradition die. Because if it wasn't for zydeco music, I wouldn't be here. I don't know where I'd be.

BF: Which brings a question to my mind, too. Going back to the Lafayette area, the original homeplace of this music. Even with all the changes that you don't think are good for the music, do you think there's anything going on there that is good for the culture and that is helping the music?

DD: No.

BF: Even things like the murals on the walls in Opelousas about zydeco and the Zydeco Hall of Fame? Are any of those things helpful, do you think?

DD: It's nice. No, it's nice; it's very nice. But no. It don't mean nothing unless the people really follow it. I could put a splat on the wall and say it's art. But unless people really want to come see it, it's kind of pointless. I mean for somebody like me, I've been there to the Hall of Fame in Opelousas—it's great. There's a lot of history. A lot of people

that's playing music, these zydeco bands—they're not going to go over there. Because a lot of people don't even know who Clifton Chenier is. They don't know who Rockin' Dopsie is. They know Buckwheat. They heard of Beau Jocque because he plays funk in his music. And people like that. But they don't know about Marcel Dugas, Fernest Arceneaux, Sampy and the Bad Habits. I could go on and on. They don't know about people like that. I do. I was there to hear it and see it. Or the Sam Brothers Five. They don't know about people like that. It's nice, but it's like I said—it's great if somebody cooks, but if nobody eats it, it's pointless.

BF: Okay. Thanks. I really appreciate it. Is there anything you want to say, anything I should ask you about?

DD: Oh, you ask whatever. I'm a whole book of knowledge. I mean it's like the difference between me and a lot of guys, they're only talking what they heard. I can tell you things that I know, things that I've seen, been around, experienced. These guys that are just coming on the scene; I been on the crime scene.

BF: Do you ever wonder whether zydeco is limiting in the career you've made; whether if you'd become more of a straight blues musician or something else, that you'd have gone even farther? I don't know; I'm just wondering whether zydeco seems in some way to be a limiting factor. Not everybody knows what it is.

DD: I would say no. I would say it's a limitation for some people, but you can't be limited if you have good, pure, raw talent. Because no matter—if you're playing Cajun music, if you're a good violinist, it's going to play through. No matter what you're playing. Zydeco or classical, whatever. A lot of the other bands, they feel like they're limited, so that's why they have to add to it. Because their music is not aggressive; it's not forceful. What I'm seeing and what I'm getting in my head is that—that's why they're adding all these other elements, to make up for what they're not doing. That's fine, but just don't call it zydeco music. Just call it Louisiana rap or an extension of rap or whatever. But that's not zydeco music. Just because you have an accordion, but you're not playing nothing, that's not zydeco music. Because the first dominant instrument and the first aggressive instrument in that band is the accordion. So if you're standing there, just holding it and singing a bunch of stuff, that's not zydeco music. I think it limits them. It doesn't limit me. Because I could walk on anybody's stage—I've played on stage with the Blues Travelers. I've played on stage with different blues artists, different funk artists, with Cyril Neville; it does matter. Because I'm into music. So I could wrap my mind around whatever—I'll follow you. Yeah.

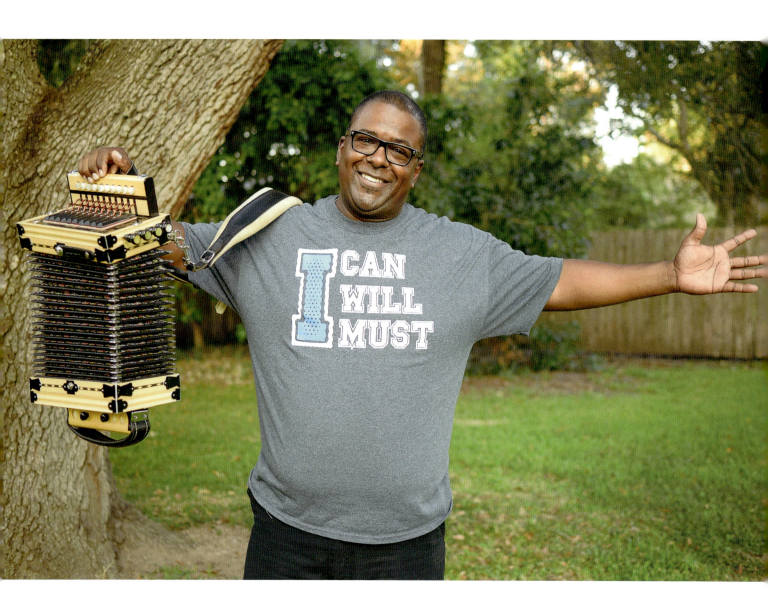

SEAN ARDOIN

Sean Ardoin and ZydeKool

Sean Ardoin is analytical about his musical and cultural heritage and also very creative and intentional about his career. I met him first in August 2015 when I was a stage presenter at the American Folk Festival in Bangor, Maine. He was with Creole United, a band he and his cousin, zydeco-player Andre Thierry, put together. Creole United is a set of musicians, many of them bandleaders, stretching across two or three generations of Creole music. Sean's father, Lawrence "Black" Ardoin, was with them on accordion and triangle. Ed Poullard played mostly fiddle, some accordion. Andre plays most of the instruments on stage—piano accordion, guitar, bass—and that's what he did. Rusty Metoyer was playing accordion and guitar. Sean held down the drums; he also did a couple of numbers on the accordion. The band itself is homage to the music, stretching from its early days to today, giving the audience a mix of classics and new material. Sean does most of the talking for the band, and at one point that afternoon he said the music was "wicked crunk." Downeast Maine met Creole Louisiana in that moment.

The Grammy nominee's lineage in zydeco is unassailable. He is Black Ardoin's son, Bois Sec's grandson, a descendant of Amédé. Like many of his generation, he began as a kind of apprentice in one of his father's bands, helping load equipment, playing the drums while the drummer took a break. He and his brother Chris, who today is a very big attraction in the zydeco world, were the heart of Chris Ardoin and Double-Clutchin'. The brothers brought a new generation—their generation of popular music—into their zydeco.

Sean has made the equivalent of several careers in music. Double Clutchin' was very popular, recording on at least one national label. Sean fronted many of the vocals. In 2001 Amazon designated *Pullin'*, his album with his band ZydeKool, as one of the top hundred albums of the year. Other albums followed, but around 2006 Sean decided to

"The Creole diaspora is big enough for everybody. But it's like you need to understand that it's everybody. And we all don't sound the same. It's like we all don't look alike."

Interviewed September 21, 2015, and November 1, 2015, at home in Lake Charles, Louisiana. Jeannie Banks Thomas and Gary Samson also present.

Sean Ardoin in his backyard, Lake Charles, Louisiana, 2015

take a break from the music. God spoke to him, telling him to shut it down. His restless creativity prevailed, and a few years later he was back with the first Christian zydeco album in the music's history. That project eased him back into performing music. When we did this interview, he was planning to leave his day job, concentrating on his music and building his other career as a motivational speaker. In our conversations, Sean talked about how he uses the term *alternative Creole* to describe his music, an idea he and Andre Thierry developed. Now he describes himself, at least on his website, as a Kreole rock and soul artist. He also has a very strong sense of the business of music on the regional scale of zydeco, and we talked at length about that—about the significance of radio and CD sales, the decline of clubs and the rise of trailrides as venues for zydeco, about the prospects for this regional music in national and international markets.

Sean had so much to say about music and his family that we did two interviews, sitting in his home studio in Lake Charles. What you're reading here is a synthesis of those two conversations. Since those visits, he has left his day job as a car salesman, reconstituted ZydeKool, was elected to the Memphis chapter of the Recording Academy, and continues expanding his business as a motivational speaker. As a speaker, he's an increasingly familiar figure at school programs in the region, helping students think about their visions of good lives: "See it! Say it! Get to work!" But Sean Ardoin's family roots and his Creole identity are at the heart of what he does and how he sees himself. In fact, with his father, he recently announced a Creole language initiative in Lake Charles, a project to preserve and protect the language of his forebears.

BF: Let me ask you first where would you say you fit in the world of zydeco music?

SA: I don't. How about that? I used to fit, and what I was doing back whenever me and Chris started—in '88—and then when I continued doing the ZydeKool was incorporating popular music into zydeco, which is nothing new. Because we've always done that. Every American music does that—borrows from other popular music. In my music it's really prominent and not just a flavor, but everybody's doing it now.

But what I want to do is not even in that vein anymore because zydeco has become a thing that the business world has deemed not financially viable. You also have the people who discover zydeco at whatever stage they discover it at, who want to keep it the way they discovered it. So zydeco makes people very passionate about it; they take ownership really quickly. And they want to keep it the way they discovered it. Which is a beautiful thing. But it's like cancer; the very thing that cures you is also the thing that can kill you. Well, those people who have loved it, and loved it really hard, want to keep it the way it is—they also put a stranglehold on it, so it doesn't grow. When

you're green you're growing, and when you're ripe you rot. And I don't want to have any part of rotting.

So be constantly on the move, acknowledge the past, live in the present, while looking towards the future. Right?

I don't fit in that neat little box of whatever somebody's idea of zydeco is. So my cousin Andre Thierry and I have created "alternative Creole." We fit in the alternative Creole box. But having "alternative" in the name implies it's not necessarily a box, anyway.

So there you go. That's the long-short answer.

BF: Say a little more about what alternative Creole is.

SA: Alternative Creole is a genre that we created because there is an issue with zydeco right now—the perception of zydeco in the world, and the fact that people want to limit it. So alternative Creole is whatever I, as a Creole artist, am feeling, whatever I create. It allows me to be free to be an artist. It allows me the ability to be free to do what it is that I was born to do, and that's create within the context of the Creole paradigm. There's an academic-sounding statement for you right there. Boy, I tell you!

It also ensures the safety of our genre because zydeco has been appropriated by a whole bunch of different people. They've appropriated it in their regions, and they, again, the thing that saves you kills you—so they expose zydeco to people in Minnesota and Chicago and DC and Japan or whatever. But at the same time they kill it because now people do it there for a tenth of the cost that it would cost to get us there. They found zydeco because we toured through those areas. Whenever they created a tribute band, they didn't do their research to know that a tribute band always turns into a gigging band, which then turns into a competitive band. So now you're competing against that which you say you love, and killing that which you say you love. Because they aren't the creators of the music; they can't even copy it accurately. So they're diluting it more than doing anything to nurture it. What it did—it stopped our ability to be able to go to those areas.

I went to the CD Baby conference this past weekend. My flag, my elevator speech was "Have you heard of zydeco? Well, I play alternative Creole."

"What's that?"

"Glad that you asked that question. It's a very funky version, a combination of zydeco, rap, funk, hip-hop, rock 'n' roll, reggae—everything that I as an artist have experienced in my life, I put it in there."

"I'd be interested in hearing that."

"Great."

They were talking about booking gigs, about money and booking, and so I asked a question. I said, "So, how do we get to negotiate?" Because it's my understanding it's been a negotiation, but the people who are booking don't negotiate. So it's like you have to lowball or you

don't get—you know, lowball, they have to know you and want you. But if you're in that middle ground, my question was, "How do I get to the negotiation part? Because whenever you send me an email back that says, 'Great, we want to have you. How much do you cost?' And if I'm getting $6,000 for these festivals, and I say $6,000, and then you don't respond back; how do we get to negotiating?" So everybody in the room is applauding.

And the guy says, "Sean, you play zydeco music." I let him talk, didn't stop him. "You play zydeco music." He says, "Fact of the matter is there's a local band that I can get on my event for $1,200. They're not as good as you. They don't hold a candle to you. But they'll fill my zydeco spot."

And I say, "See, that's why I don't play zydeco music anymore." Think about that.

Think about that. $1,200. In Chicago they filled a zydeco spot. So we don't even have a name; we're just a zydeco band. It don't take a genius to realize that if that's what you do, you're not going to really make it doing that.

Because there are so many; it's like saying, "Oh, we need a reggae band right here."

"Well, call Steel Pulse."

"No, we don't have that kind of money. There's a local band that plays. Get them."

BF: Maybe because I came up on the folk and roots music festival thing, where, at least in some of those contexts, there's interest in authenticity, whatever that means, I think it's maybe less the case there. At the festival in Bangor where I met you, you're not going to hear a Maine band that plays zydeco. The organizers are going to say there's some "real thing" idea or standard that motivates who they bring in.

SA: But even in Bangor, that whole "when I discovered zydeco and Creole music" thing is in effect. I always use an electronic track—we were going to do "Happy." Right? Because that's a good song to do, and it works. So I have a track. So we had in our contract rider and in our stage plot, it showed a thing for a track. So automatically they respond, "No, we're about authenticity." But then you go around and look at the stages, and people were doing all kinds of modern things. And I don't think they realize that we were going to actually be playing with the track. The track wasn't going to be supplying all the stuff; it was just going to be supplementing. But because in their mind that's not zydeco, you know, we can fight or we can . . .

BF: And they just don't get it. I mean I realize that as someone whose first exposure to zydeco was in those kinds of things. But coming here, reading more and listening more, and meeting people, you realize that . . .

SA: And the bands that you were exposed to up there, the biggest reason that we decide to change is, like I said, the compartmentalization of it. But if I would have gone to you before you met us, and say, "Zydeco music, name a band. What's the first band you'd name?"

BF: I'd have probably named Nathan and the Cha Chas.

SA: And then?

BF: Clifton.

SA: And then?

BF: I don't know. Maybe Jeffery Broussard.

SA: But you probably would have said Buckwheat at some point.

BF: Probably.

SA: The three people you said sound absolutely nothing like what modern zydeco sounds like.

BF: I know. Which is something that I've learned later than I should have.

SA: I mean, you learned it when you were supposed to. That's fine. The Creole diaspora is big enough for everybody. But it's like you need to understand that it's everybody. And we all don't sound the same. It's like we all don't look alike. And expecting us to be so is, you know . . .

BF: Is the accordion always going to be in alternative Creole?

SA: Accordion is going to be there 90 percent of the time. Because back in the day, when we were recording CDs, some musicians were talking about this; back in the day when we recorded the band, zydeco bands always had a slow song, waltz, maybe two slow songs, and a song that didn't have accordion at all, like a song they can do a shuffle on. Right? So we kept all the roots in there, and then at some point it became all accordion all the time, all zydeco all the time, no rhythm changes, no tempo changes. That to me just blows my mind. How you can have a whole CD at the same tempo. That would drive me crazy. But that's just me.

BF: What about the rubboard?

SA: Oh, we got a rubboard in there. Yeah. You keep the elements. The reason that you're able to keep it is A) I'm a Creole; B) I play accordion, and there will be a scrubboard in there. Even if scrubboard isn't in there, accordion will be. Even if I'm not in there, then the scrubboard's in there.

BF: What does being Creole mean to you?

SA: I'm an ethnic Creole from here in Louisiana. So basically my family's first language was French, Creole French. My dad didn't learn to speak English until he was 9 years old. So Creole to me is an ethnic derivation, not a racial type. It's our ethnic heritage. And that's a mix of everything that was in Louisiana from Louisiana's inception, which is Black, Indian, German, French, Spanish. It's all a hodgepodge, depending on which part of the country you come from. And that's the other thing with our music. Zydeco, we didn't come up playing zydeco. We

came up playing French music, la-la music. The diatonic accordion. Amédé Ardoin, he played the diatonic. So Cajun and Creole are the same; they come from the same root. Zydeco comes from a totally different root. Boozoo started it more. By the time Beau Jocque came along, everything with a Black man and an accordion became zydeco. Whether it was Clifton Chenier; whether it was C. J.; whether it was somebody with the big piano accordion or the triple-note, playing the boogie-woogie songs and the R&B songs on accordion; or whether it was us playing the small accordion—it all became zydeco. That's another reason why we don't have a problem separating ourselves from the zydeco genre because, now that zydeco, it almost, if you do the research, doesn't even speak to our experience because we're from the French music style, the la-la style.

BF: I'm not sure I understand that last thing you said. What doesn't speak to your experience?

SA: The zydeco genre, the zydeco name. The name "zydeco" doesn't speak to what we do because that originally was Clifton Chenier, piano accordion, triple-row accordion, playing blues, shuffle, you know, cha-chas. That's not what we do. Well, it's not what we did. We may do some of that now, but for the most part it doesn't. . . . Because all the zydeco players had to leave Louisiana to be successful. They had to hit the road.

BF: And why was that?

SA: Because this is king here in Louisiana; the diatonic accordion is king in Louisiana. The French music is king. Yeah. You can't make that percussive, melodic sound with the piano accordion. You just can't do it. Andre Thierry is the first one that I've ever seen do it.

BF: He's a great player.

SA: Yes. Yes, he is.

BF: I was hoping it would work out that we could catch him on this trip, but we're missing each other.

SA: Yeah. He's coming right after, I think. He's going to the East Coast this week, I think.

BF: In Baltimore, I think. So, you're talking about moving the music forward. But you're also in a position where you can look back because you have this distinguished ancestry, too.

SA: Yes.

BF: Can you say something about that?

SA: Well, that's why we did Creole United. Creole United was formed to create new Creole standards, and use both—because for the newer music we've lost the language. Because most people who love zydeco now don't speak French. So to put the French music in there in a heavy way would kind of alienate most of those people. So they only throw in a few French phrases every once in a while. So the idea was to have Creole bandleaders come together so that we bring all

of our crowds into this Creole United movement and play stuff in an old way with new influences, with a combination of everything about both musics, together. To create new Creole standards that will stand the test of time. Because we noticed that there were no Creole songs being made—no new ones. Only new zydeco songs. And what is now called zydeco. So nobody was reaching back and creating new. They were reaching back but just basically redoing old songs.

BF: By the way, I noticed—I'm sure you know this—but we were in Opelousas the other day, and there are two murals. One is a zydeco wall of fame, and there's one that's kind of focused on the origins of Cajuns. But Amédé is in both.

SA: Yep. But he had nothing to do with zydeco style.

BF: Sure. But people say . . .

SA: And that's cool.

BF: Say something about being a descendant of his.

SA: Technically, Amédé is my grandfather's, I think, first cousin. Bois Sec Ardoin's first cousin. And my dad found out recently that my grandfather's father actually played accordion, but he didn't actually play out. Amédé did help out my grandfather; you know, Amédé was my grandfather's inspiration, and he did allow my grandfather to play sometimes. So the family connection is there. My grandfather is Bois Sec Ardoin; my dad is Lawrence Ardoin, and he had the Ardoin Brothers. He played with his brothers, called it the Ardoin Brothers—like around '78, '79, became Lawrence Ardoin and His French Zydeco Band. And then Chris and I took over the band in '88. The first album was *Lawrence Ardoin and Lagniappe*, featuring 10-year-old Chris Ardoin. And then after that he said, "Well, do y'all want to take it over?"

We were like, "Sure."

So I named the band Chris Ardoin and Double Clutchin'. So then we were Chris Ardoin and Double Clutchin' from '89 to '99.

BF: Was your father a full-time musician?

SA: Oh my God; that's the other thing. When my dad was playing, the weekends were the weekends. He had a full-time job, but he got off at like 2:45 p.m. every day. So Friday, Saturday, Sunday, he can go play. And he had a lot of time off. But pretty much every weekend he played. So he was a full-time musician and a full-time job-job. So that was pretty cool. For some reason, he always wanted me to have a job. Chris didn't have to have a job, but I always had to have a job. Chris has never had a job, by the way. But I told him, I said, "Dad, you've got to realize something. The workplace doesn't make it as easy anymore to have a job and play music. Because now you work Saturdays and Sundays, and your days off are Tuesday, Wednesday. So you've got to be really careful about which jobs you get if you want to actually make a go at this music thing."

BF: What was he doing? What was his job?

SA: He worked at a plant, the power plant. He was a specialist, so he fixed everything. In Vietnam he learned how to be a mechanic. Well, he knew how to be a mechanic before. You know, fixed tanks and trucks and everything in Vietnam. Then he came back and got the job over there. And so that was his thing.

BF: And that was in Lake Charles? Did you grow up in Lake Charles?

SA: Yeah. First twelve years of my life in Kinder, Louisiana, where my mama is from. But that's like thirty minutes that way. But then he got a job here in 1980; in 1980 we moved to Lake Charles.

BF: And when were you born?

SA: 1969. Ten days before the lunar landing. So I tell people, you know, me and my friends realize, "We can say that we know everything. Because when we were born, we got to experience everything—from black and white TV all the way to cell phones." So, y'all have other stuff, but for the most part we caught the end of your generation and everything since then. Pretty cool. Think about it. Pretty scary, too. A lot of stuff.

BF: Was the accordion your first instrument?

SA: Drums. Singing was my first.

BF: Was there much music in the house?

SA: All the time. All the time. The music was a part of my everything. A part of my being. I loved listening to music. I can remember being 5, 6 years old at the Catholic church, going to church. I never wanted to hear what the priest was saying. I always wanted to know where that music was coming from. Because at the church we went to, up in the balcony, they had the music back there. Which, now that I think about it, that's a total acoustic nightmare. But that's the way they had it set up. Catholic churches are set up to be acoustic, so it didn't really matter where the music comes from. But I started, "Oh, it would be cool if they did this and da da da." And I'm singing harmonies and rearranging the songs. I remember that; that was pretty cool.

BF: And for whatever reason, you went to the drums first. How old were you?

SA: I started when I was 4, banging on the drums. It wasn't real. But let's say 8, 8 to 10 I actually started being able to get on the drums. Because I was always at the dances, and I would stand by my uncle and just watch. And when I got enough, and he had to go the bathroom, I got to sit in. And my dad would always say, "Play a waltz." But I knew that's not the song they play—because I knew the lineup. I knew, "That's not the song you're about to play right now." But he'd play a waltz until I got strong enough that then I would be able to just sit in, as long as I needed to. Or as long as he needed me to.

And then I stopped playing because I went from that to the accordion. And I was playing the accordion from about 12; I learned how to play at 11. So from 12 to 15 and a half, maybe, I played a lot. I was up

there playing probably a quarter to a half of the dance. I was playing a lot. And then I told my dad, "Can I get some change or something?"

He said, "You live here."

"Well, okay, cool; I can live here and eat and not do all this stuff I've been doing on weekends. So I think I'm going to do that."

So I stopped. And when I got to LSU, I realized that I was at LSU trying to find a career that I could live and take care of myself. And I looked, and I said, "I have a whole industry, a whole business, family business, at home. If I just take everything that I've learned and that I know, and put it into that. And we can be financially stable and successful and all that good stuff." So I went back and talked to my dad—well, my cousin was leaving. I went back and started playing scrubboard with them. And then my cousin was playing drums; he actually left the state. And then I got on the drums. And Chris came along, playing scrubboard, and he got into the accordion. He was always going to be good. Because he had a knack to want to play. He had desire, a hunger, for it. You know, starting to play the accordion at 4 versus starting at 12 was a big difference. And I was like, "If you can play the accordion, play it on the accordion." He had a work ethic. So I said, "Okay, whatever you can play on the accordion, play on the guitar, on the bass, play it on the keyboard. That's what you work on." So he would do that. He'd go out, shoot some basketball, eat some cookies, eat some cereal, go back in and do it again. He did that for years. And as a result now he can play all the instruments, which is a beautiful thing.

I, on the other hand, didn't prepare for rain. I was like, "Okay, so long as he can do that, I can write; I can do this, that, and the other, and we're going to be powerful." But then, whenever you split up, then you got to make some accommodations.

BF: Was it a cool thing to be playing this music as a teenager? You said you stopped for a while.

SA: Yeah, I stopped for a while, just for money. I was driving us to the dates or at least getting to the dates. If I didn't drive, I got there, I loaded up, I unloaded, I set up, I played, I broke it down, I loaded it up, and I probably drove home. And I didn't get any money. I needed money. Because, you know, if you're paying everybody else . . .

I wasn't asking for what everybody else was getting. It was just something.

Said "No."

"Okay, cool. I don't have to do that." But Creole music at the time, my dad was one of the only bands to be really, really successful in that period. They kept the music alive. The Ardoin Brothers, and then my dad, from the late sixties, seventies, up to eighties, whenever they started getting a resurgence. We were gigging every weekend: whenever Creole people got married, the parents insisted on having a Creole band, a la-la. So no matter what else was going on, they had

to have it. So that was a good thing. But it wasn't a popular thing. It was older people. As I say, older people, so now that I'm thinking back on it, everybody going to the la-las back when I was growing up was from 30 on up. It was older people.

And then Boozoo came along, and then it started to be 17, 18 on up. And then when Beau Jocque came along it was the babies all the way to the senile. You know, from birth to death, loving zydeco. All over the country; all over the world, loving zydeco.

BF: I'm jumping around now.

SA: It's all right. I'm following you.

BF: You are. Yeah. I'm not worried about that. Are we in a time of resurgence, I guess is what I'm asking. Have we been? Seems like a lot of young bands . . .

SA: Define *resurgence*.

BF: Yeah. I don't actually mean resurgence. I don't mean resurgence in the sense of taking an old form and doing more of it.

SA: No.

BF: It seems to me there's been a lot of change happening.

SA: Yeah.

BF: I guess what I want to say is in Louisiana and Texas, the area where the music is rooted, is the audience growing? Are there more bands playing?

SA: No. Just changed. It just changed. It went from being me and my peers to my brother and his peers, who is twelve years younger than me, to now, the high school people, high school and early twenties. They run it now. They're the major purchasers of the music. Yeah. We're the ones that's selling; they're buying. But they're the ones that are making the trailriding clubs sell it. So they're the major supporters of it financially and body-wise, you know, like promoting it and stuff like that. They ride with it in their cars, bumping.

BF: Were there trailrides when you were younger?

SA: Oh yeah; there's always been trailrides. They just haven't been as important as they are now. They're like Keno. Trailrides equal Keno.

BF: And how is that?

SA: The resurgence of which you speak is trailrides. That's why when you come here you notice it a lot. Because trailrides used to be a season. Now a trailride is every weekend. Everybody has it. There used to be only one association in Louisiana and Texas. Now there are like beaucoup associations with beacoup riding clubs. So every weekend there's at least one to three trailrides happening, if not more, between Louisiana and Texas. Every weekend. So there's an opportunity for zydeco bands to play every weekend. But here's the caveat: if you're not playing trailrides, there's nowhere for you to play. Because if you try to play a club, and there's a trailride going on.

BF: No one's coming . . .

SA: They're coming, but if you have enough of a name to bring people, yes, they're coming. But you're still not getting all the people you could because of their obligation to go to the trailride. The trailride works because everybody supports everybody else. Your weekend, we come, we spend money, we hang out, we party with you, help you make your thing live. When I have mine, you come to mine. So they have to come to the trailride as per their agreement as being part of the club and the association. So whereas we used to have Slim's, Richard's, Hamilton's, Sid's, you know, clubs in every city. Now the only club they have left that plays zydeco regularly is Richard's, which is now called the The Zydeco Hall of Fame. But there's not that many dances there because all the trailrides happen within a hundred-mile radius of that place. Some really close, some really far. But either way, if it's too far, they're all away; if it's close, then they're right there. You have to make something special for people to go. So it's a double-edged sword. It saved the music, but at the same time it's really, really put a stranglehold, a chokehold on it. Because it can't grow, and it can't get out of those places.

BF: What about radio?

SA: Radio—we lost a lot to the big radio, the homogenization back in the mid-nineties, whenever those corporations sucked up all the local stations. Then it became like every radio station was part of three radio stations. But when they come into the area, they don't honor the local programming. They try to change it, and say, "Well, this works in California, so it should work here." It doesn't. But they don't find that out—it takes a year or two, if they're losing money, for them to figure it out. Which helped KBON because they were able to blow up, even though they don't play zydeco-zydeco; they play old zydeco, and they won't play new zydeco.

BF: What is this now? K . . . ?

SA: KBON. K-B-O-N. Louisiana proud. I'm getting good. So, yeah, so we lost all kind of stations. On Saturday before the mid-nineties all week there were like two radio stations that played zydeco every day. And on the weekends there were at least, in Lafayette there were three shows; in Lake Charles there were like two shows; Beaumont there was a show; Houston there was like two or three shows. And on Sunday, on the major radio station they had zydeco. So you had an opportunity to be exposed to a whole bunch of people. And then the bottom fell out, and we had like two radio shows. KRVS and Herman's show, and over here in Lake Charles we had two shows. Our shows never stopped. But that was it.

And so how do you get exposure? Where do you get it? You don't. Whenever the bottom fell out, Keith Frank was on top, and Keith Frank was able to maintain that because the casual listener would come and say, "I want to go to the zydeco? Where do we go? We got

to go to Keith Frank. Because he's the hot guy." So they all wanted to go to Keith Frank. So Keith Frank was able to stay on top, being the hot man, for about fifteen years. Whereas usually the cycle would be you get hot for about two to five years, take that hotness—"I'm the best zydeco band in the world"—because you are because there are no zydeco bands anywhere else in the world, take that and bring it to the world. Come back every once in a while, go out and take it to the next level. And that's what everybody did until Keith Frank. Because he didn't have to leave because there were no challengers to the throne because there was no way for them to challenge him. There was no hill to climb and take the hill—couldn't do king of the hill because there was no hill. And then Chris took over; Chris was able to get it around 2001-ish, 2000, 2001. No, no, no—'05–'06. Whenever I stopped playing, about six months later the floodgates opened for him as a BAM! So since '06 he's been pretty much the man. And that was without radio stations, but it happened with the trailrides. Nathan Williams, trailrides. That's what made him hot.

BF: You know, I read the zydeco events website, and he's there every week, Lil' Nate.

SA: Club once every six months or something like that; other than that, it's trailrides. Or a festival. And the festivals are going by the wayside because they don't want to pay the people who draw. The zydeco festival is a victim of that; they didn't want to pay the people who were hot. It started with Beau Jocque.

BF: What about tourism, at least in Louisiana? There doesn't seem to be any tourism in the Texas zydeco scene.

SA: They don't promote it; the state doesn't promote.

BF: Here the state seems to promote it.

SA: They promote it here.

BF: Is it a significant factor?

SA: Tourism? In Texas?

BF: No, no; in Louisiana.

SA: For the festivals it is. But it's only for the festivals. And not even so much for the festivals because there are no more zydeco festivals. People used to always come. And that's also another thing, and I've got to figure out how to positively spin this. But the people who would come from around the country, read "Caucasian," who would come to zydeco, love zydeco music in Louisiana. But whenever it got too young, they still love it, but they don't want to do it with the young people. You see what I'm saying? So, since they don't want to do it with the young people, then they try to exert their influence over certain festivals to only book those people that they like. And if the festival doesn't have the people that they like, that fits what they—remember what I said about that love thing? If they discovered zydeco with Geno—if they discovered zydeco with these people—if they don't fit that, they

don't come. So now it used to be zydeco festival weekend, Labor Day weekend, there was an influx of thousands of people from around the country to come and zydeco that weekend. Not so much. Now they all come for Festival Acadien. Only. Now if we get new people who come in, they're fine. But the majority of people that used to come, that core group of people, thousands of people; they don't come any more.

BF: So, when Leroy Thomas tells me that he's really pleased that he doesn't have to travel much because he has enough gigs locally, but that he plays mostly for white audiences, where's he playing?

SA: He's playing the casinos. He's playing, well I don't know if he plays Whiskey River; he don't play Whiskey River—that's Geno's spot. A whole other story that I'm not going to get into. He plays here at Lake Charles at this club called Cowboys. He plays at Cowboys in Lafayette. But mostly casinos, parties, and clubs. He's gotten himself in a clique that likes what he does. He's found his niche, and he's good to go.

BF: Yeah. It's great; he seems very happy.

SA: Geno does the same thing. He came home and said he was going to start playing. And he did it at the right time. Because when the age of the average zydeco dancer dropped, and those people coming to zydeco didn't feel comfortable with those people, but loved coming to Louisiana to do it here, Geno said, "I'll stay home." And so they come and zydeco with them.

BF: It also sounds to me as if a lot of the innovation is not happening in front of those crowds.

SA: No. Those crowds. It's like the classics. Those crowds want the Temptations and the cover bands that play Motown. That's what they want. They don't want Drake. They don't want Drake and Nicki Minaj. They don't want that. They don't want anything new. They want old stuff.

BF: Do you ever worry that "new" can be too far from something?

SA: New can be too far if you don't include the essential elements. You got to keep the essential elements. The accordion and the scrubboard. You got that accordion and scrubboard—the other thing is the dance. You got to be able to zydeco to it for it to be considered that.

BF: And do you want people to be able to zydeco to alternative Creole?

SA: I will do most of them to where you can. But not all. I'll be able to teach people how to be able to do it. So the majority of my music you will be able to dance to. Yes. Zydeco dance to.

BF: What would you say to—there's a whole kind of infrastructure that grows up around the music, too, to some extent.

SA: Oh, totally.

BF: Ranging from local record labels to people teaching dance, teaching line dance.

SA: Exactly. And the line-dance thing happened because the young people never learned how to dance. And since they didn't learn how to

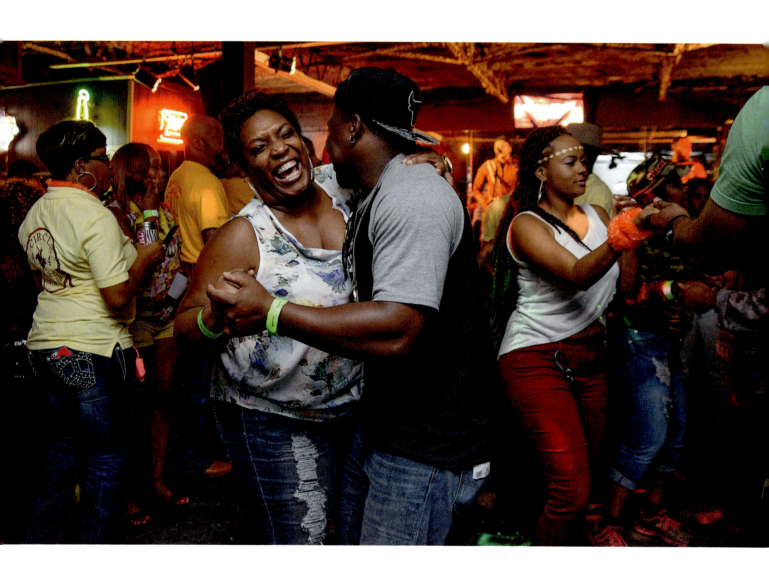

Zydecoing at Club ICU, Houston, Texas, 2015

dance, they came to it not knowing how to dance. So their thing was the visual. So the bands have accommodated the watchers, and that's why the older people don't like coming. Because they want to dance. They don't want to watch. They want to dance. Young people want to watch and dance in their spots and do what they do. So line dances help with that thing, so everybody would do it. Trailriding clubs, again, come up with their own line dances, stuff like that.

Now, Texas likes to dance. Texas still dances. They do the line dances, but they still all dance there. The dance is more important in Texas.

BF: Are there other differences between Texas and Louisiana?

SA: Oh, yes. The dance is different. The music is different. The whole vibe is different. Trailrides only happen on Friday and Saturday, not on Sunday. Whereas over here they go Friday, Saturday, and Sunday—Saturday and Sunday being the big days.

BF: How is the music different?

SA: Just like, being a grandfather in the music sucks, but being a statesman, an elder statesman in the music, I've had to really deal with myself and my hypocrisy, and my feelings about things. So I can't say that what Texas is doing is wrong because they're Creole artists as well. They're just not from Louisiana. So what happens is they see us doing one thing, and their interpretation of what they see is what they do. Right? It's always going to be different. It's always going to be different. So the Texas zydeco is just a little different because the drummers didn't grow up listening to it; the guitar players didn't grow up listening to it; the bass players didn't grow up listening to it. The accordion player is generally the only person who grew up listening to it. So anybody you get to play is going to be from the church or from the club. So they bring a whole different feel to the music. Yeah. So Louisiana music is more laidback, more fluid; Texas is a lot more rigid. But that's just me getting deep. You might not even be able to tell the difference between the two.

BF: A lot of it, too, seems—you're not dealing with thousands of bands, so a lot of it seems to connect to the leader and what he does.

SA: That's totally it. The leader is the one. And the thing is—I had to apprentice. You heard what I said earlier; what I played in the band earlier, before I got to be the guy in front. At some point, that wasn't even a part of the procedure. If you wanted a zydeco band, you'd buy an accordion, learn to play it, get the five guys, and go play. And when you do that, you're in a box, in a bubble, and you don't understand the music as a whole, the Creole culture—you don't understand the baby that you're trying to teach. Or better yet, the baby that you're trying to dress. You know? You just get in there and say, "Okay, I saw that they had baseball cap and jeans. So we're going to put baseball cap and jeans on them. And even though it's a hockey team." So it's almost right, but not exactly right.

BF: You know, it's wicked crunk, as you say.

SA: It's wicked crunk. See—when I say wicked crunk, people go "What?" I spin on what I saw. But it's okay, and it works—I said "Wicked." But when I put "crunk" with it, people are like, "Okay, you're not from here. I see you're trying to assimilate."

But they don't do it anymore—they don't apprentice anymore. So they don't learn it from the bottom up. It would like, you're an author—it would be like somebody who wrote a blog for a little while tell you they're an author. You go, "Oh, that's cute."

BF: I get it.

SA: You go, "Oh, that's cute. So where'd you go to school?"

"School? For what?"

"To be an author."

You know, they don't have to go anymore. The internet has made—this whole generation is, they're entitled. They don't want to work for anything. You know, which probably goes into why the music doesn't change. Because they don't to have to work to make their minds get accustomed to something different. If it's not (*Sean beats rhythm*) or (*he beats another rhythm*) or (*beats another*) or (*beats still another*). If it ain't that, then they don't really want to hear it. And for the most part of it ain't (*he beats two*), they don't want to hear it. You go past that, and they're lost. Because their dance doesn't go with anything else but those two things. You see what I'm saying? So putting a waltz in there, putting a slow song—young people don't slow dance. At all. White, Black, Hispanic—they don't slow dance.

BF: What about the French language in all this?

SA: French language, that's a part of it. Alternative Creole should have something in there with some French in it. We all generally have something in there that ties it in, something on a CD, somewhere. You know, if it's just a catchphrase or whatever.

First of all you've got to understand that none of people playing this music can really speak French.

BF: I wouldn't be surprised if there's somebody. . . .

SA: Geno speaks it. I don't know how well. But he grew up in the country, so he should. Leroy probably speaks a little bit. Not much. Because our parents—one of our parents didn't speak French. So we didn't have it in the home.

Keith Frank, I don't think Keith speaks French. Chris definitely doesn't speak French. J. Paul doesn't speak French. Brian Jack doesn't speak French. Lil' Nathan don't speak French. So. And then of those people I just named, the only people who really know the old style is me and Chris and Keith. And that's why I did Creole United—we're generational. We had four generations in the band the last go-around. This go-around we may have five. My dad and Ed Poullard, Sunpie Barnes. See Sunpie, he's a zydeco man. Didn't grow up here. He plays piano accordion, and you look at his gig, it doesn't look like zydeco music. But I can't say he isn't playing zydeco because Sunpie is getting zydeco exposure all over

the world. And that's one thing that I have to get off my high horse and be like, "You know what? Anything that promotes our culture and our music by one of us is acceptable. Acceptable and valid. End of story." Terrence Simien sounds nothing like us. He doesn't even really play zydeco at his gigs. But Terrence has two Grammys. He got our Cajun and zydeco category for the Grammys. Why would I not include him in my own idea of what is authentic and what is not? That's ludicrous.

I rationalize myself. If I'm able to do that, then somebody's able to do that to me. You don't want to get into that kind of game. So I just left it alone. So my dad and them is one generation. Sunpie Barnes is another generation. I'm another generation. Andre is at the end of my generation, and then there's little Caleb Ledet. He's a new guy; he does videos, he's a young guy. And Rusty Metoyer and Caleb. So Rusty's in the middle of Andre and Caleb. Rusty's one of the current young guys that's playing right now. So Rusty will be back in. So that's five, six generations of musicians. We're definitely from different generations, born in different years. So my dad was in the forties. Ed was in the fifties. I was in the sixties. Bruce is in the sixties. Andre was in the seventies. Rusty was in the eighties. Caleb was the nineties. So decades—we're seven decades, but generations—how much is a generation? Twenty years a generation? Ten, fifteen years, whatever. Whatever that is. So it covers the generations.

BF: You say *this version* of Creole United—for what? Doing some recording?

SA: Yeah, yeah. We're working on a new CD. Creole United is not just a band. It's a movement. Because we have to acknowledge our Creole heritage in all that we do. And because it's not necessarily financially viable to be a Creole band, then we've taken it on as a responsibility and a torch. Our torch song is to keep on doing the Creole thing. So we include everybody that we can. Everybody who wants to be included we include. So it will be different people. It won't be the same band every time.

BF: And you're working on a recording now?

SA: Yup. We've got the skeleton for the CD right now, *Tu Kekkchause a Korrek*. Chubby Carrier's going to be on. I forgot Chubby. Chubby's going to be on it. Nathan's supposed to be on it. Chris is supposed to be on it. Those two are wild cards. Never know if you're going to get that product back from them. We sent them songs. We'll see if we get them back this go-around. But Chubby, Step Rideau.

BF: Oh yeah—he mentioned that. We were at his house a couple nights ago.

SA: Chubby, Step Rideau, me, Rusty Metoyer, Andre, my dad, Ed Poullard, little Caleb Ledet, and we have his cousin, the little drummer, Classie Ballou's grandson.

BF: You're going to need a big bus.

SA: They won't all travel, but they'll be on the CD. And we might be able to get a little sit-in from Buckwheat or Terrence or somebody,

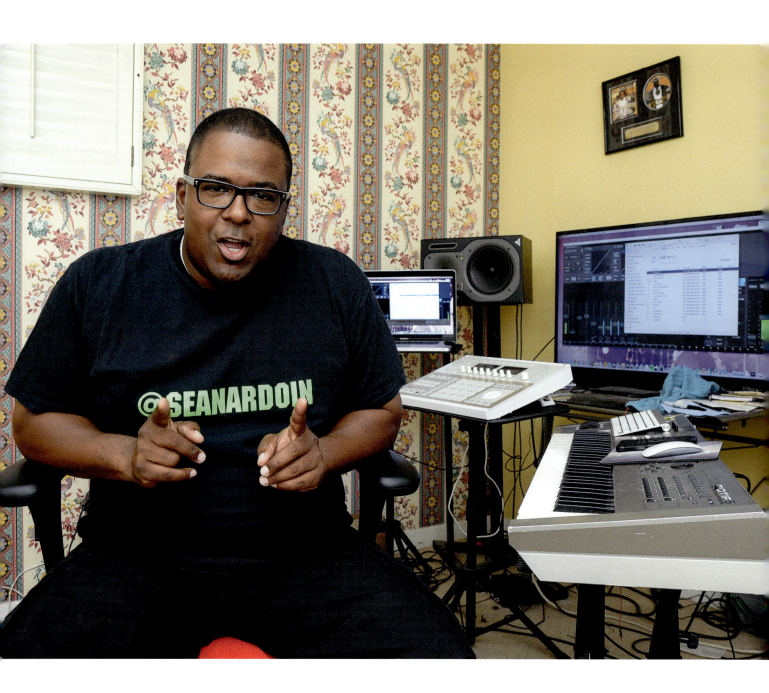

Sean Ardoin at home, Lake Charles, Louisiana, 2015

if there's no legal conflict we might be able to get them on a song or two. Want to make it all-inclusive, man. So that we get it rolling.

BF: Why do you think it's important?

SA: It's important because if you don't honor your past, you don't know what your future is. If you don't know what your past is, you're doomed to A) repeat all the mistakes, and B) you don't know where you're going. You have no basis of what you represent. You're just kind of meandering through. So we honor the past. We acknowledge the past. We learn from the past. We use that base of knowledge, and then we grow from that. It's roots. You can't have a strong tree with no roots.

BF: Is this roots aspect part of alternative Creole?

SA: Yeah. It's a part of everything I do. I grew up with that music. That was every weekend. That was all the time in my house and every part of me. So alternative Creole, if I want to do an all-old CD, I can do that. Because alternative Creole will allow me to do that. Because it's where I am. You know what I'm saying? I won't have to be bound by the zydeco gospel. "We can't dance to it because we don't know that dance. It's the wrong tempo. It's too fast." It's too whatever.

BF: I do want to talk about gospel zydeco.

SA: Okay.

BF: But first I want to go back. I guess not long after you stopped, after Double Clutchin' stopped, really, you had that album that had great critical success. *Pullin'*.

SA: When me and Chris broke up, the last date we played together was Zydeco Fest '99. I had my CD ready to go. *Sean Ardoin, ZydeKool*, self-titled. I had a booth at the festival, selling CDs. I had a gig that weekend. So everything was in place. Then that got me noticed by "Two Fingers in the Air," my song—Buckwheat Zydeco loved that song. He heard it on the radio, he said, "Stop, who was that?"

BF: I love that, too, by the way.

SA: Thanks.

And so he talked to my lawyer, and his guy called, so we did a meet and greet and whatever, and I was on Buckwheat's label for two CDs. Because I'm all about—if we can keep it in house, let's keep it in house. Because we've had major labels come through and plunder. Then they plundered it to the point where now they're like, "Well, you can't make money on it." Well, if you don't invest in the artist, if you just came to make money off of what I'm doing, then yeah, there's only so much money you'll ever get. If you invest in the artist and express to them that there's a big world out there; they don't have to change what they do, they just have to do it in front of more people. Some of them may be amiable to that. But the labels wasn't doing that; they were just coming in and working off what they had. Which was a lot at the time. But then when that dried up, when radio dried up, then they were like, "Well, you can't make money on zydeco." That's the official

statement from the industry. So, boom. Now what was your original question? I got off a little bit.

BF: About *Pullin'*.

SA: *Pullin'*. 2001. First CD with Buckwheat. Amazon dot com top 100 CDs of 2001. But to back up. The thing that kind of, I believe, threw it off and stopped me from really being able to push, is it came out on 9-11. I was like, man, can I get a break? I mean because I had this great CD. I was like, "Oh my God, this is going to be the one." And it comes out, no fanfare. It was, of course, how many months after 9-11? Still? I mean, so I wasn't able to really capitalize, initially, and get that big buzz. But 2001, top 100 CDs for Amazon, I was an *Ebony Magazine* most noteworthy. So I was in the magazine. My music was on *Real Road, Road Rules, Fraternity Life, Sorority Life*, and I think that's it. We performed live on BET's *Comic View*. And most of the major newspapers in the country, a lot of major magazines, gave reviews. So I was everywhere. Why didn't it happen? Didn't have a publicist. Didn't have someone to take all that and grow it. I know that now. But the label is supposed to have that popping, and it just didn't happen, for whatever reason. I don't cry over spilt milk. I just learn from it. So that will never happen again. Never happen to me again. I don't care if I get a little blip—blow it up, blow it up.

But it was great. I toured the world. It got me everywhere. I can still use that information as promo. So it was great. I enjoyed it.

BF: Was the gospel CD the next one?

SA: No. No, no, no, no. That was 2001. Then I released another one in 2003, which I think might have been 2004 when it came out. Then I had another one that I did in 2004, started in 2004, finished in '05, and in '05 is when I decided to stop. That's when I had the thing where God said, "Shut it down." July of '05. Cancelled all my noncontracted gigs. December 31st into January 1 of 2006, last gig, in the Bahamas for a friend of mine's corporate party. And then I was out. 2009 released the Christian zydeco CD. Yeah. 2009. And then 2014 *Return of the Kool* came out. I was able to release that. Creole United came out the same year, as well, 2013, September of 2013.

So now I'm working on a new Creole United and new ZydeKool CD, and also I'm releasing a single Christian zydeco song. One of my friends that does Christian artists, he was like, "Hey man, I want you to do a zydeco of this song." I was like, "All right, cool." I like the song, so we're going to knock it out.

BF: What happens with a single? I've never understood. You do a single, but . . .

SA: Well the industry is single-based now. It's not CDs anymore. The fact that I'm even contemplating doing a CD, it almost goes against everything I know to be prosperous and good. But I'm still the old school model. I want to have a CD. That's what I want. You've got

to sell CDs; you can't really sell singles at a live show. But singles are what the industry is—now they'll put a single out, and single will tell you what direction to go in. So record labels and people who do stuff release singles on a regular basis.

BF: Release them to who? To what?

SA: To the world. The World Wide Web—www.

BF: But people don't buy the singles.

SA: Yeah.

BF: Oh, they do?

SA: Yeah. Put them on iTunes. They buy singles—digital singles. You're thinking hard copy. That's an antiquated model. That is no longer the standard.

BF: Well, that's me, an antiquated model.

SA: Right. They're no longer the standard. I mean I get it; trust me, I get it. But that's no longer the standard, unfortunately. But you know, you adapt. Now you're green; you're growing. So that's the industry. Theoretically I could release a single, you know, every month, every other month, every two months or whatever. And never release a CD. And be fine.

BF: And never deal with manufacturing.

SA: Right. Or if I got fifteen CD singles released, put them all on a CD and sell them at the gig as an album. I still prefer the album. Because I'm always growing. And I want what I'm doing now I want to have a representative marker of that part of my life and my artistry. You know? I want to have that. That's just me.

BF: Okay. Well, I'm thinking, as in the last time we talked, there's a lot of talk here about innovation and creativity, which is great to hear. And I think is really, in some ways, a story of a lot of zydeco these days, too. But you're thinking differently from what I hear from a lot of other people, which is great.

You do solo gigs, for instance, right? How does that work? We always think of a band.

SA: See, when you said I think differently because—and I preach this on every stump that I can get with my artist friends—you have to study that which you say you are, so you can be the best in that field. Well, the music industry, the performance industry, is totally track-based right now. If you want to get one of these artists you hear on the radio, you're going to get them as a solo artist with a track. You might have one other person on stage or some background singers or whatever, but you're getting them with their tracks. And somebody to run the tracks. You know what I'm saying? So I was like, well, why don't I operate my business like a twenty-first-century business instead of a twentieth-century business? You know? If you're trying to drive a Model T on I-10, you're going to get pulled over for driving too slow.

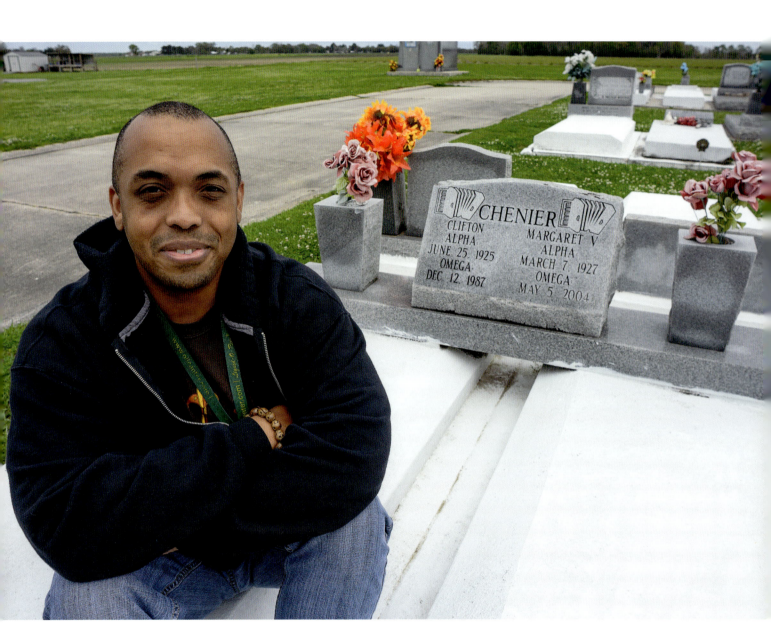

COREY LEDET

Corey Ledet and His Zydeco Band

Corey took us a few miles from his home in Loreauville to visit the grave of Clifton Chenier. Clifton lies next to his wife, Margaret. The formerly unmarked grave now has a granite marker. Two accordions grace the stone, carved into the upper corners. The cemetery is a few miles from the capacious, occasionally open, Clifton Chenier Club, which dates to the mid-1980s. The metal building stands, a little forlorn, surrounded by sugar cane fields. Corey loves Clifton's music, and he loves this part of the world.

Until a schedule change led to complications, Corey had originally wanted to do the interview and photo shoot near some family property in Parks. His family has some land there, about fifteen miles from his current home. He was a city kid, born and raised in Houston. But summers in Parks started his enduring romance with Creole Louisiana. As soon as he could, he left Houston and moved to Louisiana, wanting to immerse himself in a Creole world.

We had been in Parks the day before. At the intersection of Resweber Highway (Rt. 347) and Promised Land Drive, we photographed an old club, PB Dee's Classic Club Valentine, a former grocery store, now open occasionally. As we were out with our cameras, a car stopped, and a young African American woman asked what we were doing. We explained; she invited us to drive down the road afterward to visit her family. We took her up on this, and there followed a very sweet interlude, which I describe in the introduction to this book. Corey and his band have played in that club, and the band had played for a family event the young woman's mother attended. "He's funky," she said.

He is funky, and he's a virtuoso player on any kind of accordion a zydeco musician might want to employ—piano-note, single-row, triple-row. Growing up in Houston, where many Louisiana Creole people had gone for better economic times, he closed the loop, moving to Louisiana for music and culture. His father, who had come to

"Boozoo just got two fingers cut off, drove three hours, played four— and drove another three back."

Interviewed March 12, 2017, at home in Loreauville, Louisiana. Jeannie Banks Thomas, Gary Samson, and Kelly Lagan also present.

Corey Ledet at Clifton and Margaret Chenier's graves, 2017

Houston from Parks, was a zydeco fan. Corey's grandfather was Clifton Chenier's drummer for a time. Corey started on the drums, but around age 10 he began the accordion. The family lived on the south side of Houston, but they were often in Frenchtown, visiting relatives, going to church zydecos, and otherwise participating in Houston's Creole scene. It was enough of a scene to draw top-tier bands from Louisiana. From his childhood, Corey remembers John Delafose, Terrance Simien, Roy Carrier, Boozoo Chavis, Beau Jocque, and others playing in Houston. Corey saw Boozoo play the memorable night he performed following the freak accident he had while building a barbecue pit. He never saw Clifton Chenier perform, but it's Clifton's influence that has been dominant. He prefers the piano accordion, which Clifton had mastered. It's a more flexible instrument, more adaptable to other styles, Corey says, and while his mastery of button accordions is clear, generally speaking, it's the piano accordion that he'd pick up first. Most zydeco musicians of his generation play single-note button accordions; the piano accordion seems to be in decline. A few—Corey Ledet, Andre Thierry, and Dwayne Dopsie among them—can make those boxes do anything.

I've seen assertions, online, that Corey can play just like Clifton Chenier, replicating his licks. But his musical interests and influences range widely, from old Creole sounds to Clifton's music to contemporary popular music. He's a musical collaborator, too, and if you want a sense of his range, check out the CD he did with Creole music traditionalist and innovator Cedric Watson. It's both rooted in place and all over the place. You hear strong echoes of the master Creole fiddler Canray Fontenot. There's some Creole French and a lot of English. And the blues. The recording has a rawness and an energy that makes it compelling. Corey's collaborations include a group called Soul Creole, which brings in the passionate fiddling of Cajun player Louis Michot and the triangle-playing of Ashlee Michot. Both Michots sing with Corey, and this music, in a sense, might sound as Amédé Ardoin would have, had he been born thirty years ago. It's clearly French while it's also somewhere in between, not quite zydeco, not quite Cajun. But whatever it is, it has passion, and it gets down to it. In 2013, an album, *Nothin' But the Best*, featured collaborators Corey Ledet, Dwayne Dopsie, Andre Thierry, and Anthony Dopsie. It was nominated for a Grammy. It almost seems that, in Houston, zydeco players collaborate with rappers, whereas in south Louisiana they collaborate with other zydeco players and with Cajun musicians.

It's a crowded scene in south Louisiana, with French music—zydeco and Cajun—featured in clubs, at festivals, at trailrides, on television and radio. The national zydeco scene, though, isn't all that jammed up. And, according to Corey, the local scene is limited in what it embraces. When we did this interview, he had recently signed with FLi Artists, a

New York and Los Angeles agency specializing in roots music. Founded in 1957 as Folklore Productions, FLi lists a large number of performers from around the world. If you're looking for Houston-born Corey Ledet and His Zydeco Band, look under "Louisiana."

BF: You say *Le-dett*, right?

CL: Ledet, yeah.

BF: Does anyone ever say *Le-day*?

CL: Actually, the French term is *Le-day*. Because the *et* in French is usually pronounced ay. So, they'll say *Le-day*. The last name *Ledet* is an interesting name, and I'm trying to figure out the origin of it. Because some people say *Le-day*, and they spell it *L-A-D-A-Y*, some of them. And some spell it *L-E-D-E-E*. It's all just different spellings. So, it's one of those mysterious last names. But I have *L-E-D-E-T*.

BF: And we're at your house. Do you say *Lor-eau-ville*?

CL: Lor-a-ville.

BF: Naturally, I get it wrong.

CL: The French spellings are kind of confusing. When you look at it spelled out, it doesn't look like it would say *Lor-a-ville*. It's one of those Louisiana things, I guess.

BF: I want to start by asking, why zydeco? You're a young guy; you grew up listening to all kinds of music, presumably. Why zydeco?

CL: There's something about it that just attracts me to it. But like you say, being from Houston, I was around several different kind of cultures and styles of music. Houston is a major city, so you got all kind of stuff there. And being from Houston, I like a lot of other stuff. But zydeco is the one thing—it's from Creoles. And with my dad being from here, and we being Creoles, it's like a special—it's our music. You know what I mean? It's the one style of music that's for us.

So that's mostly why I choose to do zydeco. But then I like to mix it up, too. Because I like other stuff. Music for me is—it's a blessing, but it could be a curse. Because I could turn the radio on, and it's hard to find something I don't like. But I always come back to zydeco. That's always the core. And it's because it's the music of the Black Creoles, and that's our music.

BF: Your father was from here?

CL: Yeah. From a small town called Parks, which is about thirty minutes from here.

BF: What took him to Houston?

CL: In that time, a lot of people from Louisiana left Louisiana for work because there was not a lot of work here. A lot of Creoles went to Houston, and a lot went to the Bay Area in California. So there's a huge Creole community in the Bay Area. I think some went to Atlanta; some went to Boston. So, a lot of people left Louisiana looking for work. Because there just wasn't any work. To live.

BF: Did he find work when he moved?

CL: Oh yeah. I think at first he was a security guard at a school, and then he got a job at a chemical plant. He stayed there for years.

BF: Did he speak French?

CL: Yeah. Oh yeah—fluent.

BF: And how about your mother?

CL: She was from Houston. So he met her after he moved.

BF: Was Frenchtown still going in Houston in those days?

CL: Oh yeah. Oh yeah.

BF: Did you grow up in Frenchtown?

CL: No. I grew up on the south side of Houston. Kind of like around Sugar Land; I'm not sure if you're familiar with the area. That's where I grew up. But we would always go to Frenchtown because he had two older brothers that lived around there—my Uncle Harris and my Uncle Nolan. We'd go over there and visit, and then even when they'd have church dances, that was all over there. So we'd go over there.

BF: What was your father's name?

CL: C. J. Ledet.

BF: What was your mother's name?

CL: Phyllis Ledet.

BF: And when were you born?

CL: I was born in 1981.

BF: What's your first memory of hearing Creole music?

CL: Well, my dad told me when I was being born he had zydeco playing. So that's the story. I don't remember that, but that's the story. And then after I was born he would—I could cry a lot, they said. The only thing that would stop me from crying, he would pick me up and dance, would put some zydeco on, and that would shut me up. I remember, me and my brother were listening to something, some kind of rap song or something. And so my dad comes in, he had a Clifton Chenier cassette. And he said, "Put this on, and listen to that." And I've been listening to it ever since. I must have been about five or six. But I've been listening to it ever since.

BF: Did you ever get to see him?

CL: Clifton Chenier? No. I never did. I wish I could have.

BF: When I read about you online, everything says that Clifton was a big influence on you.

CL: Yeah. Yeah. He was. My grandfather actually was his original drummer. This would like back in the thirties and early forties. Then, when Clifton starting taking the road, my grandfather was more of a family man. So he stayed home, and then that's when Robert Peter came. All the family has nothing but Clifton Chenier stories—how he used to play in Parks all the time. My cousins had a bunch of clubs in Parks, and Clifton would always play over there, and stuff like that. So, I heard the stories.

BF: I guess now there's a Clifton Chenier Club around here someplace.

CL: Yeah. That's his club. He built that before he died. I think he played one time in there; I think it was his birthday. And it was packed. At least that's what I heard. I wasn't there, either.

BF: But someone else owns it now and opens it occasionally?

CL: His nephew.

BF: What else do you remember about music in Houston?

CL: Let's see. The church dances. The church dances were big. I mean they had club dates; people would go play in clubs. But I couldn't get in. Sometimes I could, if my dad knew the club owner, and they knew that I was just there to watch the music—then they would let us come in. But a lot of time, with the clubs' liquor licenses, kids couldn't come in. That's just how it was. So, the church dances was the next best thing. Because kids could come in. So the church dances. Some restaurants were big in Houston; they had a place called Pe-Te's Cajun BBQ House, and they would do zydeco every Saturday from 2:00 to 6:00 p.m. Kids could go there because it was a restaurant. I remember going there. So, just the church halls, the restaurants, and, of course, festivals. I could go there. And the older I got, I could get into the clubs.

BF: Who do you remember hearing when you were younger?

CL: They had a lot of Houston-based bands that didn't get too much recognition outside of Houston. But it was guys like Wilfred Chevis and His Texas Zydeco Band. There was Little Willie Davis. There was L. C. Donatto. Who else? There was Wilbert Thibodeaux—the guy that gave me my first drum job. So I was playing drums with him for about six or seven years. So it was him, there was another guy named Bon Ton Mickey. Who else? There was a bunch of them. The Zydeco Dots was another one. Pierre Blanchard was another guy, and another guy was Willie Tee. There was a bunch of people. And they were all Houston-based.

BF: And in those days, I wonder if it was more separate. Now a lot of the Houston guys come to Louisiana and play, you guys go there and play, and so forth.

CL: Well, it was the same back then as well. The bigger guys would come; I remember Roy Carrier would come a lot. Terrence Simien would come for festivals. Zydeco Force would come a little bit. John Delafose would come a lot. Beau Jocque would come a lot, and Boozoo would come a lot. And then Keith Frank started coming after a while. That's what I remember.

BF: And what about the Texas guys? Would they come here? Come to Louisiana?

CL: Not so much. Not so much. Step Rideau—that was more around the nineties. So Step Rideau would come to Louisiana and do some stuff.

BF: He told me it was a big deal for him to come here and to feel that he was accepted.

CL: Yeah. Yeah. Because he had the Houston sound. Basically, the best way to explain the Houston sound at that time was, Houston, of course, is a big city, and has plenty musicians, all kind of musicians. They come out of the church; they come out of jazz bands, so they start putting their little elements into it. That gave it more of a, well, it gave a different sound instead of the rural sound of over here. So there was a little difference. And a lot of people were not used to that sound at first, but then they started coming around. Now it's cool to put different elements in there; it just keeps it fresh.

BF: So you're ten years old, and you're playing drums. How much were you doing that?

CL: We did that—Mr. Thibodeaux played every Friday, Saturday, and Sunday.

BF: Did you have a problem getting into some of venues because of your age?

CL: As long as my dad was there, it was all right. I had to stay on the stage. So, if I wanted something to drink, they'd have to go get it for me. So I would go straight to the stage and stay there until it was over and then go straight off.

BF: Did you take drum lessons, or did you just pick it up?

CL: Just picked it up. Because it was in the family. My grandfather did it. My dad plays drums, and my uncle plays drums. And I had another cousin that was Ike and Tina Turner's drummer. His name was Peanie Potier. We got all kind of weird names, nicknames, around here.

BF: When did you move over to the accordion?

CL: I moved to accordion when I was about maybe ten. I don't know what it was about it. I always did like drums, and I still like drums, but the accordion, it just was calling me. I got fascinated with it. I used to have a shoebox—you know the kind that opens from the top? I would sit there and open and close it, like I was playing an accordion. And I had my uncle's harmonica, and I'd put it on top of the box, and blow in it.

BF: You ought to do that now; that would be good on stage. I can just picture it.

CL: I don't know if that would work . . .

BF: What was your first real accordion?

CL: Well, the first real accordion, it was a toy, but it was like a little piano accordion. So I started to pick up a few notes, and then my dad got me the bigger piano accordion. I didn't like it at first; it was kind of tricky to learn. So then I went to the single-row, and then I started picking that up a little quicker. And then I went back to the piano-row, and now the piano is my favorite one. Because it's basically a piano, and you can play all kinds of stuff on that. And a piano is like guitar—the music you can get out of there is just unlimited.

BF: Do you play a single-row and triple-row on stage, too?

CL: Yeah. I haven't played the three-row in a while, on stage. But I still have them all.

BF: You made an instruction video about the triple-row.

CL: Yeah.

BF: I'm jumping around here. In Houston we see a lot more single-row; here we see a lot more piano accordion. Is that accurate, or is it just what we've run into?

CL: A lot of people tend to go to the single-row first because, number one, it's a little bit easier to learn. And then the bigger guys that play piano accordion are pretty much—they've died off, like Clifton Chenier, Buckwheat just died, Rockin' Sidney. So you just don't see it that much anymore. And it's just not on the brain to think about playing a piano accordion. I think that's where we are.

BF: Yeah. But here you see Chubby Carrier playing it, and Nathan Sr. plays.

CL: Yeah. Nathan still plays piano. But he does a lot of out-of-town stuff, so the young generation doesn't get a chance to see him do that. So it's not on their minds to say, "Hey, let me try that." People tend to want to do what they see the most and what's popular. So with the fact that they don't see the piano-row that much, they just don't think about it. It would be cool if they would because, like I say, it's just a piano, and you can really be creative with it, do all kind of stuff. You could really do a lot of stuff on the three-row, too. But it's a little tricky. It's a little trickier.

BF: After you graduated from the shoebox, you got a full-size piano accordion. How old were you then? Do you remember?

CL: Between 10 and 12; somewhere up in there.

BF: And then, as I understand it, you went to high school in Houston and then moved over here eventually?

CL: Yeah. After I graduated high school in 2000, I moved here. So I've been here ever since.

BF: What made you move?

CL: I wanted to be more around the Creole zydeco culture. I mean they still have that in Houston; it's just not as strong as over here. Over here, you could put the TV on, and you might see a band playing or the radio and hear zydeco. In the newspapers and magazines out here; it's just not like that in Houston. You kind of have to go look for it in Houston, when here it's everywhere. You could be sitting outside, and somebody might be driving by, blasting some zydeco. I wanted to soak all that up more than what I was getting in Houston. So that's why I moved here.

BF: And how did it work out—I mean in terms of getting more into the culture and the music?

CL: So far, it's working out pretty good. Pretty good.

BF: You're talking about the music, but you also say the culture. Do have the language?

CL: I'm not fluent. But I do know some. And that's another reason why I wanted to be here because, like I say, they still have it in Houston, but it's just not strong. It's just not strong, over there, like it is over here. So I just wanted to come here and just drown myself as much as I could in the culture.

BF: Why, do you think?

CL: Well, it's a part of me, for one. It's a part of me. Louisiana almost seems like it's a different country. But it's still American. Zydeco is still American music. Creole is still American music. But it seems like it's from somewhere else. And I think that is special. That's real special. And it's something that, it's just in me. And I just have to have it.

BF: Do you think that identity is still as strong in this area as it was in the past?

CL: I don't think it's as strong as it was. I think some things have kind of interrupted that a little bit. With a lot of the artists coming out now, they're kind of going away from the traditional side and trying to do different things. Nothing is wrong with doing stuff different, as long as you bring along the culture. As long as you keep the culture.

I give people examples all the time. It's like the conjunto, the Tex-Mex style. They'll do modern stuff, but they'll still sing in their native language; they'll still play the old, ancient—I call it ancient—their songs, the old songs from way back. They'll still tie that in to whatever they change it to, or whatever they're trying; they'll bring it along with them.

Nowadays people are kind of pushing the older stuff aside; pushing the language aside, and trying to turn it into something else. They're kind of sabotaging it when they're doing that, in my opinion. But I don't mind people trying different stuff, as long as they bring along the culture. Because Clifton Chenier did that. If we listen to his music—I mean he still was doing the old stuff, way, way back. Clifton was born in 1925, so he was playing stuff from back then and even further back. At the time, he was doing Louis Jordan stuff, Etta James—stuff from that time. All kind of stuff like that. B.B. King. And he was tying all that together. That's the recipe that I want to follow.

Buckwheat Zydeco did that, too. He would do the older zydeco stuff, speak the language, everything. But then he would do Rolling Stones music. He would play with Bob Dylan and do stuff like that, of that time. So that's the recipe that I want to do. And I think that if other people would follow that, it would be good. Instead of just pushing the culture away. Because it's kind of dying, in a way. I hope that other artists, artists that are still out now, will bring it back in. Just bring it back in a little bit. We're not saying that they should play just traditional stuff. But bring it along with you. Just keep it a part of what you do.

BF: And when you say "the culture," what do you mean besides the music? What are you including?

CL: The language. The old two-steps. The old standard songs. And there's millions of them. We could still play them. I mean, why not? That's a part of the culture. The language and the old songs, the music, the sound of the music, the sound, the style. All that stuff. Because without that, we wouldn't be doing this. If that hadn't started hundreds of years ago, we wouldn't be sitting here talking about what we're talking about today. So we can't forget about that.

BF: How much is the language spoken these days?

CL: Not that much. The older generation—some young generation, but mostly it's not, and that's why I was saying it's kind of dying. Actually me and another guy was talking about it Friday. There are even older words that, like, my dad doesn't even know—the French words, like way back in the 1800s. Even those words are lost now. I mean my dad's fluent, but even a hundred years before him, you know, the language was even stronger. There was no English. It's kind of dwindled down since then, and it's even worse today. I'm trying to finish learning, myself. But I think it's important for them to put it in schools, and make it a point to learn it. At least to a certain extent. Maybe not fluent, but at least to a certain extent.

BF: I know there was a time that the Cajun French was in the schools.

CL: Yeah. Yeah.

BF: But not the Creole, right?

CL: No, not the Creole. I think that's sad, but I hope that it changes. I hope that they bring it back. But they do have French immersions. They do have stuff like that. With French immersion like the one in, is it Quebec? It's called St. Anne's. Have you heard of that one? It's the French immersion school; I know it's in Canada somewhere.

BF: I wonder if it's the one in Nova Scotia.

CL: I think that's it. So there's that. And that helps out a lot. But the thing about that is you have to go there, and you have to be there for like three months. So it's kind of hard for a working musician to leave for three months and not work for three months. With people's lifestyles, it's kind of hard to just drop everything and leave for three months. But if they could do something like that here, where people can still go to work and do what they have to do and still do that. I think they're working on something like that here. If they are, I'm going to probably be a part of that. But I think that would help. That definitely would help. But start with Louisiana Creole style first and then expand from there.

BF: I guess your father must have grown up speaking it in the house.

CL: Yeah. He had to learn English.

BF: But he probably didn't speak it in the house that much while you were growing up if your mother didn't speak it.

CL: No. She didn't speak it. So, for me growing up, the only time I would hear it is if he would talk to somebody on the phone or somebody would come over or we'd go to a church dance, and he'd

fall into it. That's the only time I would hear it. Or coming over here; I would hear it.

BF: Are there programs here that bring the Creole culture into the schools? Music, or . . .

CL: Not that I know of. There might be, but not that I know of. I think it would be cool if they did, though.

BF: To back up: You graduated from high school; you moved here with the idea of getting going as a musician?

CL: Oh yeah. I mean around 12, that's when I knew I wanted to a musician. I didn't want to be anything else. I tried several different kind of jobs, and I got fired from all of them. That wasn't for me. Being a musician was definitely for me.

BF: How did you get started here?

CL: Just going around to the jam sessions and meeting different people, meeting musicians. Mitch Reed, a fiddle player, he took me around to different places and let me sit in with his band, that he was playing—the Lafayette Rhythm Devils—at the time. Meeting the Savoys—just going around and meeting everybody is kind of how it started coming around.

BF: Yeah. It seems to me one big difference, too, between here and Houston is you've got the whole Cajun scene here and some of the zydeco musicians, like you, have built alliances there, too, with those people. That's a different sort of situation.

CL: Yeah. In Houston I had a bunch of documentary videos, and I'd watch them all the time. So by the time I came over here and was meeting all the people that I saw in the documentaries, it was like I was meeting these superstars. For me. It was like I was meeting Elvis Presley, or something like that. I mean for me. So I thought that was cool.

BF: Who made an especially big impression on you?

CL: All of them. It wasn't just one specific person. It was the fact that I was meeting everyone. The fact that I was actually shaking these people's hands and sitting down and talking with them. And hanging out with them. It was everybody. Everybody.

BF: When did you put together a band, your first band?

CL: About a year after I moved here. I just got some guys together that I knew already and just kind of went on from there, taking little gigs, and trying to make the rounds, and establishing myself.

BF: There's somebody at the door.

JT: There's somebody peeking in.

Kelly Lagan enters.

CL: This is Kelly.

BF: Hi, Kelly. I'm Burt.

KL: Oh, hi. It's nice to meet you.

BF: Thanks for making this possible.

KL: Well, thanks for coming. Sorry I interrupted.

Brief conversation ensues.

CL: Y'all want some boudin?

BF: I'd love some boudin.

KL: All right, then. I'll see y'all a little later.

BF: So we were talking about putting together your first band.

CL: Yeah. I put a bunch of guys together—my cousin was on the rubboard, his name is Greg, Greg Potier. He knew a lot of people, so through him I met a lot of people, too. We started getting little jobs around. Then I had to put a CD together to push it out even more. So that came out. And then it just started growing from there. Just got bigger and bigger. And here we are.

BF: I guess you were coming here summers, too. Did you go to the jams and things like that then?

CL: Trailrides at the time, on Sundays. We'd go over there, and wherever I could get in at the time—if I could get in, we would go.

BF: Are trailrides still big here?

CL: They are, but it's changed from when I was growing up. When I was growing up, it was more family oriented. Now it's a bad scene right now. It's not like it was. Everything is changed. And that's because the element that a lot of bands are bringing in, they're bringing in the bad elements. And pushing out the good elements. So it's kind of changed a lot.

BF: I saw something about some police officers got assaulted at one recently.

CL: Yeah. It's not the same.

BF: Everybody was great and welcoming when we there.

CL: Yeah. I mean maybe not every trailride will be bad. But you just never know when you go to a trailride, is this the one? Where something could happen? Twenty years ago, you didn't have to worry about nothing. You could bring your grandma, your grandpa, the kids can run around. No problem. But now it's not that.

BF: So you have a band together, you've moved here, you do the first CD. Where are you playing in those days?

CL: Playing at Randol's restaurant in Lafayette. Playing at the Blue Moon Saloon in Lafayette, Vermilionville in Lafayette, Café des Amis in Breaux Bridge. Playing little gigs like that. Of course, the festivals, like Crawfish Festival, International, Jazz Fest, mixing in with private parties and weddings, and just kind of doing stuff like that. So those are like the first kind of gigs coming up.

BF: Who were your audiences in those days?

CL: Actually, it was a lot of different people because I was like the new kid in town. Everybody was kind of interested in seeing the new

Corey Ledet memorabilia at his home in
Loreauville, Louisiana, 2017

kid in town. So I had all kind of people there, from young to old. Black, white. All kind of stuff. That was cool. Yeah.

BF: I should know this, but I don't. I mean now there are a lot of young players. Were there many young players when you were at that . . . ?

CL: Not as many as today. I mean they had some, but not as many as today. Every time you look up, there's another young person playing. Which is good. Which is good. That means there's an interest. But I just wish they would be more interested in—when they're doing their learning, to go to the beginning, and work their way back. They just want to pick up to what's happening right now. And they're missing all this stuff, this other cool, great stuff.

BF: So, besides Clifton, what would be the beginning to you?

CL: Amédé Ardoin, of course. We could start there. But there are even some other musicians before that. You know, you probably can't even find any kind of music from them or anything like that. So you'd have to talk to the older people to learn that. But I mean, basically, they could start from Amédé and then work their way up to today. When you think about it, it's a lot to process—to go back to, just say, the 1920s. It goes back further than that. But if we just start from the 1920s to 2017, that's a lot to cover. That's a lot to cover. So it might be a little overwhelming, but it's definitively worth it.

If you're a Creole or a Cajun, it's definitely worth learning who you are and where your family and where your culture came from, and how it's evolved through the years. You have to know who you are in order to decide what you want to do next. I can't see how they can want to keep going and change stuff without knowing how it started. It's like knowing your alphabet; you can't read a paragraph if you don't know the alphabet.

BF: We're going to go interview Lawrence Ardoin tomorrow. We've spent some time with Sean, too—so we have a sense of that historical connection.

CL: Yeah—that's a great example right there. You have to know where everything started from in order to take it wherever you want to take it. That's learning your alphabet. It's the best way to put it, I think.

BF: This is much more recent, but where do you see Boozoo and Beau Jocque in terms of their influence on the scene and how important they were?

CL: Well, let's see. Boozoo's influence was the music of his time. Like the la-la stuff. And just having that punch. Like almost a drive; it would hypnotize you. When it kicked off, that was it. As long as his music was going, you were going. Soon as his music stopped, then you stopped. If it was going, you was going with it. And if he'd stop one and start another one, you'd turn around and go right back. Grab somebody else, and get right back on the dance floor. He had that power, to do that.

Beau Jocque brought in the sound as far as like having equipment and stuff like that. Before that people would have just two speakers and like a little head and kind of do stuff like that. And then Beau Jocque came with the big sound in the clubs, and then he had the powerhouse band doing all their funky riffs. He was like the Parliament of zydeco. He was doing all kind of funky riffs and effects, and throwing all that stuff in there, which—that wasn't before Beau Jocque. So he brought all that in, and it just kind of picked it up. But at the same time, if you listen to his records, he's still playing the old traditional songs, even if it's just one or two. He'll throw that in there, he'll sing in French, and he'll bring that new element in. So that's the influence with that.

BF: I listen to Boozoo and Beau Jocque, and I listen to Clifton, and I think there are two really different lines of development, musically.

CL: Right.

BF: Clifton with the much more kind of R&B influence eventually, the horns . . .

CL: Yeah. And that's because Clifton was on the piano accordion. So he could do more stuff. He could do the big band sounds. And like I said, he would mix music from his time in with what he was doing. And he did it on the piano accordion. So you can get more out of it. I mean there was so much more stuff you could do on a piano than you can with a single accordion. Because a single accordion is kind of limited. Not that it's a bad thing; it's not bad thing. But there's only so much you literally can do. So, when Clifton picked up the piano accordion, there was nothing he couldn't do.

BF: These days, you see these guys on stage with a row of single-row accordions.

CL: Yeah. I remember seeing Beau Jocque one time—I think I counted fourteen, all across the stage. It looks cool; don't get me wrong. It looks cool.

BF: It's a big investment.

CL: Yeah, yeah. Had like fourteen of those and like three triple-rows and all that stuff. And then Cliff, which I never did see, but seeing a lot of his videos, he would only have one accordion. All night long. All the keys are there. You can just switch your key right there.

BF: You would have seen Boozoo, I guess.

CL: Yeah. I've seen him a couple of times. One time, I remember that was when he just got his fingers cut off. But he cut his fingers off that day, went to the emergency room before—and this was in Houston—went to the emergency room, got it bandaged up, drove to Houston, and played four straight hours. Like it wasn't nothing. And then the blood was dripping on the stage, and he was just pumping, pumping, pumping.

BF: Amazing.

CL: Oh, yeah. We was talking about that—my cousin and I—the other day. They don't make them like that no more because nowadays if a musician has a headache, "Oh, man. Cancel the gig. I can't play." Boozoo just got two fingers cut off, drove three hours, played four—and drove another three back.

They don't make them tough like that no more.

BF: You've done a lot of interesting collaborations, too, like Soul Creole and things like that. How usual is it for zydeco and Cajun guys to play together and to do those kinds of collaborations that you've done?

CL: It happens a couple of times. In my opinion, that's cool because music doesn't have to be just one thing. You can do different things with different artists, and just collaborate, and just create. I think that's the cool part about music. You can create and build anything. Pretty much everything will probably work if you get two artists that are good at what they do, and they just kind of meet in the middle. I think that's what brings even better music instead—there's nothing wrong with each band just being separate as themselves. But every now and then if you can get a couple of guys together and create something outside of what they're already doing, it's cool. That's pretty common out here.

BF: Is it?

CL: Yeah.

BF: I've seen some YouTube videos of Soul Creole. It's just great stuff.

CL: Oh, yeah; oh, yeah. Louis Michot, he's a hell of fiddle player, and guitarist and bassist, and stuff like that. Oh, yeah.

BF: And have you played with any Creole fiddle players?

CL: Yeah. Ed Poullard.

BF: Ed's going to be in this book, too.

CL: Yeah, Ed. He's the man. His brother, Danny Poullard, yeah, I learned a lot of accordion stuff from him because we took some accordion classes at Augusta.

BF: No kidding.

CL: So he taught us a lot of stuff on that, too. D'Jalma Garnier, of course. And I think I played a couple times with Jeffery Broussard since he started playing the fiddle. So, yeah.

BF: Was Canray Fontenot around at all?

CL: No, I think by the time I had moved here, I think, if I'm not mistaken, he might have passed already. But I never got a chance to meet him either. I did meet Bois Sec, and I had a chance to jam with him at Augusta. And I actually got video of it, too.

BF: Are you doing any of these kinds of collaborations now?

CL: Actually, yeah. Me and Louis Michot are getting together and doing some more work together.

BF: You know, by coincidence, we're calling this book *Creole Soul*. So it's turned around your name.

CL: Okay. So me and Louis are getting together and doing some more collaborating. Actually, we were jamming a couple of weeks ago. He does a lot of Creole and Cajun stuff on the fiddle, and I do the same on the accordion. So I'm like, "We know we've done that. Let's try something else. Let's see if we can play some R&B and some funk with the accordion and fiddle. Put that together—the way you do it, and the way I do it, and let's mix it together." That sounds pretty cool. When he starts doing R&B and soul on a fiddle, it really isn't typically that would see that kind of music being played on that kind of an instrument. That's pretty cool. You should see it.

BF: And are you playing mostly around here these days, or are you traveling much?

CL: Mostly traveling. I mean the local festivals, I'll probably do them, a couple of dates. But most of the time it's out of town.

BF: Did a lot of other people kind of have it sewn up locally?

CL: Pretty much, pretty much. Yeah. For the style of music that they play. To play here is almost like—in my opinion, to play here you have to almost be like an iPad or something like that. You have to be programmed to play one kind of style of music. And once they are used to hearing whatever you're doing, that's all they want. They don't want you to get out of that bracket at all. You're stuck right there. If you try anything different, then they'll leave and go see somebody else play. So you're kind of stuck doing that.

But when you're in different town every night, you've got that freedom. If you feel like doing more Creole stuff tonight because I'm in California, you can. Next night, you're in Seattle, you want to do more funky stuff. You could do it. You got that freedom. I like that. It gives me a chance to play everything that I want to play, instead of just being stuck like that.

BF: So the local scene is more kind of traditional—I don't mean traditional. Well, people know what they want here.

CL: Yeah. Yeah. They know what they want, and then that's it. They kind of look at things like this, and that's it.

BF: Who is big in the scene around here?

CL: You have Chris Ardoin, who does well. You have Lil' Nate; he does real well, Nathan Williams's son. Keith Frank does well. I think J. Paul does well. And Geno Delafose. Those five guys, they do really well. And you have to commend them for that.

On a musical standpoint, I want to be able to do other things whenever I feel it. It's hard to do that here. Because once they get used to a band playing the way that they play, you have to play like that. And that's it.

BF: And you've recently gotten a new agent?

CL: Yeah. With FLi Artists. From California. That's the first agent I've ever worked with. So I was kind of excited about that. Because it's

Corey Ledet at his home in Loreauville, Louisiana, 2017

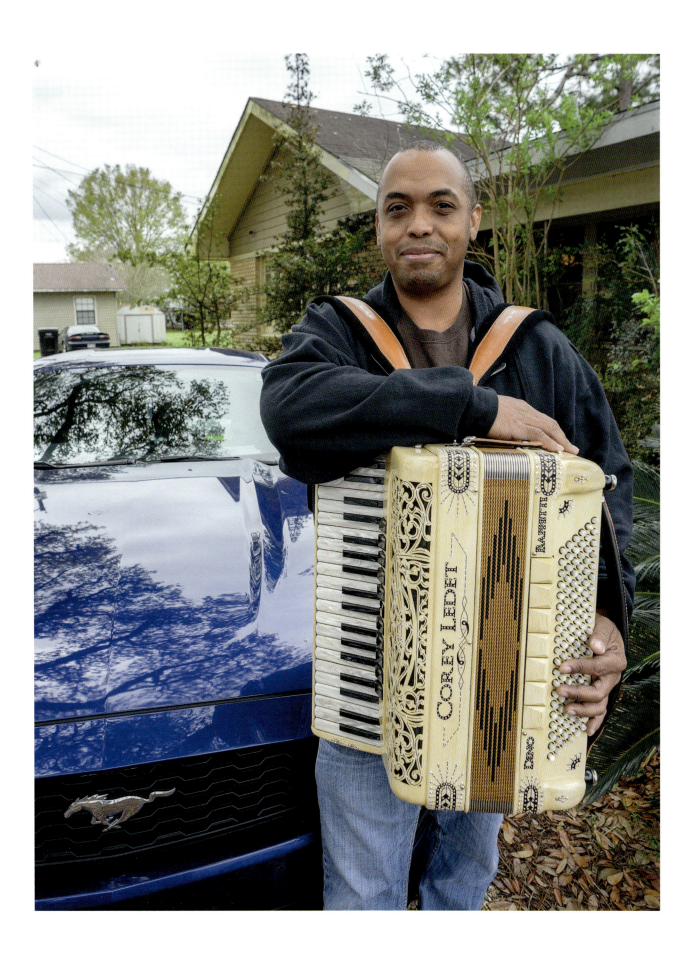

kind of hard to get signed on to an agency. That's hard right there. And it's also hard to book your own shows and get big gigs, get big jobs, without that. Especially when you're basing your livelihood on it. It makes it hard. But if you have backing like that, it helps out.

BF: So that's great.

CL: Oh yeah.

BF: You'll have a new Mustang next time I see you.

CL: I'm a Jaguar kind of person.

BF: How much are you traveling these days?

CL: Well, like I say, I just got signed onto them, so I'm new to their roster. So they're just now starting to get me rolling. Got a few dates coming up, and with the new record coming out, that helps some. Got some reviews coming in. So that's helping them. So I see it picking up between this summer and the fall. Kind of picking up. Yeah.

BF: It's good. Great. Yeah. Meanwhile are you playing locally at all, or . . . ?

CL: Yeah, yeah. I'm still doing local shows, local festivals, like Jazz Fest, Crawfish Fest, the festival last night in Crosby. So I'm still doing some stuff right now.

BF: How healthy is the local scene, even if it's kind of in a rut? That is, are there still lots of places to play if you're a local person wanting to play?

CL: Actually, recently it's kind of shrinking a little bit because the clubs are closing. It's like the people aren't coming out like it used to be. So the clubs are hurting, which is making the bands hurt because now it's getting harder and harder to find places to play.

Now you have to almost play at places that you would normally never play at because other places are closing. And the trailride circuit doing what it's doing—that's making it kind of hard, too. Because a lot of people are not wanting trailrides in their town or on their property because of the way it turns out. So they're shutting stuff down. So the trailride scene is getting weird, too. And if it keeps going like that, I think it's going to probably have to go back to how it used to be, to where bands are going to have to hit the road. Because there won't be anything here.

BF: And is there much of a national market for the music, do you think?

CL: It can be. And I think that there is because Terrance Simien is still highly successful. Buckwheat Zydeco, highly successful. But to be at that level you have to be more open-minded, as an artist and as a musician. Because everyone may or may not understand or like zydeco. So you have to have something else to offer. With your zydeco. Like if you're doing just zydeco, they might say, "I don't understand that." But if you come with something they know, they're like, "Oh, that's cool. And they did it on the accordion. That's cool." Now you got

their attention. So now you got something to work with. There's an opportunity for national. But you got to do it in the ways of Buckwheat, Clifton, Terrance Simien, and those guys like that.

BF: And each of them really had their own sound.

CL: Terrance has a lot of reggae influence with what he does. And he likes Sam Cooke. If you listen to some of this songs, he could sing just like Sam Cooke. He could sing like Aaron Neville. So he's highly successful with that.

BF: You say the scene is changing here. Is it changing enough that there's reason to be worried?

CL: It depends on the person you ask that question to. For me, yes. Maybe to somebody else that just got into it maybe about five or six years ago, probably no. Because they don't know how it used to be. They don't know where it came from. They're just kind of picking up from today and going on with whatever direction it goes. I worry about it because I know how it used to be. I mean I was born in '81, so from '81 to now I've seen a huge change. And just from '81 to now there was a lot more fun back then. I'm sure it was even more fun in my dad's era. And even more fun in my grandfather's era. So, I'm kind of worried about it.

BF: There must be a lot more competition as part of it, too.

CL: Yeah. They didn't have as many groups back then.

JT: You talk about kids getting into the music. Any girls? Is the gender line just going to remain? Do you want to talk a little bit about gender?

CL: Actually there's a student of mine named Gracie and her sister, Julie. Their last name is Babineaux, and they're coming out, and they're doing their own thing. They're called the Babineaux Sisters. And they're doing a lot of stuff.

But not too many females I see get into it. I think it's kind of always been like that. I mean you might see a female pop up every now and then. There was Queen Ida and then Miss Ann Goodly, and then Rosie Ledet, and then Donna Angelle, then another one, her name was Dora—she was from Houston. But just like in the past thirty years, only like maybe four or five females have popped up.

JT: Why do you think?

CL: I have no idea. I have no idea why.

BF: You're related to Rosie Ledet. Is that right?

CL: Yeah. Just cousins.

BF: Did you play drums for her?

CL: No. That was another Corey Ledet. There's two of us walking around.

BF: And when you say "students"—you're teaching at the university?

CL: Yeah, I taught at the university, some accordion lessons, and I've taught at kids' camps.

BF: Kids' camps in this area?

CL: Yeah. For the accordion and stuff like that.

BF: Are there a lot of people who play the music at home, for their own enjoyment—people who aren't professionals?

CL: Oh, yeah. There's a lot of people that just do it for a hobby. At home. And that's it. There's still a lot of musicians that do that. In the Creole and the Cajun culture. But some people want to do it for a living. That's why we have so many musicians around here. Some do it for living; some just do it for a hobby.

BF: So, if Alan Lomax came back, would he find people singing really old songs in French?

CL: Only a handful. Only a handful. He wouldn't find too many people doing the older stuff. Just a certain batch of them.

BF: How available is the music on the radio here?

CL: It's pretty available. Especially on the weekends. Saturday mornings is zydeco. Sunday mornings is zydeco, and I think during the daytime, Monday through Friday, between three and four there's zydeco. There's also Cajun music on Sunday mornings, Saturday mornings, during the week on KBON, and I think there's another AM channel. So that's part of the reason why I wanted to move here. To catch that. Every day. You couldn't catch that in Houston like that. But now you can with internet radio. So at that time there was no internet radio. So now in Houston they can just log on to whatever and get it.

KRVS is one. KBON is another. In Houston, 90.1 FM, KPFT. On Sundays I think is Majic 102. In Houston. But I'm pretty sure nowadays you can catch all the radio stations online now.

Matter of fact, when I was in Houston, remember I was telling you we would go to Pe Te's on Saturday mornings? He still has his Cajun show on Saturday mornings. It's on KPFT, 90.1, and it's called Pe-Te's Cajun Bandstand. But it comes on like at six in the morning. So from six to nine, every Saturday morning. That's been on for about thirty years.

JT: I have one more question. I was wondering, can you describe for me those moments when you're like, "Oh, yeah; this is perfect. This is why I'm here." Where everything is just going really right. Where are you, and what's happening to make it feel so good at that moment? You know what I'm talking about?

CL: Yeah, that would have to be—it can happen anytime. That would have to be probably if I'm playing somewhere and there's a lot of people there, and the vibe is going. See I'm a musician to where I feed off energy. So, if there's a lot of energy in the room, that's like my fuel. And if the band is right on, and the sound is good, I could hear everything, and the energy is there, and I could feel it—that's when it's like, "Yeah. That's right."

NATHAN WILLIAMS JR.

Lil' Nathan and the Zydeco Big Timers

At one point in this interview, Nate—Nathan Williams Jr.—says that he thinks he is one of a small number of artists who made zydeco appeal to young people. You can see the results of that at his shows. I've seen him at a zydeco extravaganza at a rural exposition center, a trailride, and a Halloween gig at his uncle's club, El Sido's. He does turn out the younger demographic, and even if he's now in his thirties, he seems not far removed from it himself. See him on stage, surrounded by a large band—often two keyboards, two rubboards, guitar, bass, and drums—sporting some gold and ripped jeans, listen to his rich baritone, and you can see why young people come out to hear him. He has a distinguished family history in the world of zydeco, but his sound makes fewer references to the tradition than many of his peers do. It's as if the blues, a strong element in zydeco, is gone, replaced by neo soul, a smoother sound with the edges buffed. And while western hats are still in vogue among some zydeco bandleaders, you're not likely to find Nate Jr. under one, other than in a few promotional photos. He's developed a more urban image.

That family matters in zydeco is especially evident in Nate's case. His father, Nathan Williams, leads the nationally touring band Nathan and the Zydeco Cha Chas. Born in 1963, Nathan Sr. grew up in a Creole-speaking home in St. Martinville, about seventeen miles southeast of Lafayette. Deeply influenced by Clifton Chenier, and surviving the loss of his father when he was 7 and a serious childhood illness, he was eventually raised in Lafayette by his older brother, Sid. Sid went on to found one of the most important clubs on the circuit, El Sido's, where we saw Lil' Nate perform in costume on Halloween 2015. Sid and Nathan Sr.'s brother, Dennis Paul Williams, plays rhythm guitar in

"I picked up writing, transcribing: a lot of Charlie Parker tunes, a lot of Monk tunes. That really just opened my brain. Like, 'Man, this is some crunchy stuff.' You know, and that's all I thought of, 'It's crunchy. It's crunchy. It's not what I'm used to. But I like it. I want to do this. Let's do this.'"

Interviewed November 1, 2015, in his studio at his father's house, Lafayette, Louisiana. Gary Samson also present at interview.

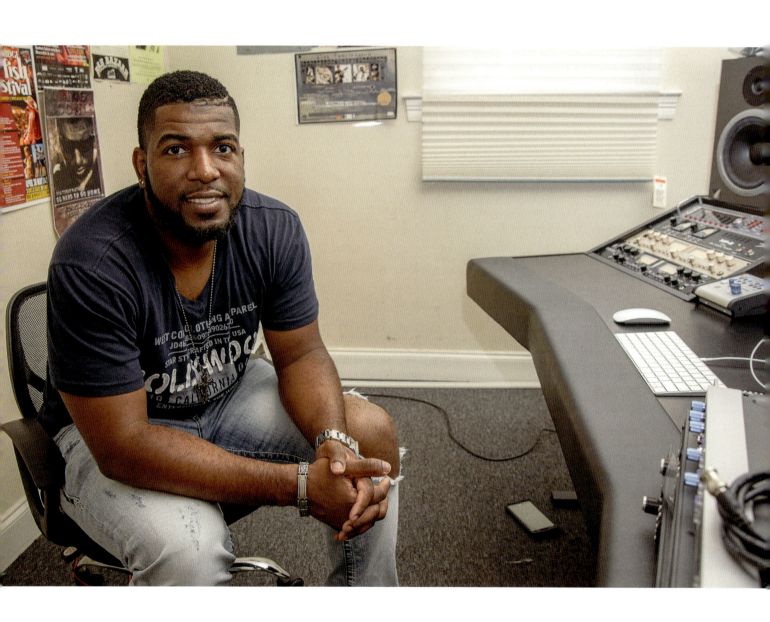

Nathan Williams Jr. in studio at his father's house, Lafayette, Louisiana, 2015

the Cha Chas and is a well-known painter and local politician around St. Martinville. It's a close family, and Nathan Jr. went through what was essentially a musical apprenticeship in his father's band, starting on rubboard. He studied jazz at the University of Louisiana Lafayette, where he now teaches zydeco accordion. Uncle Sid is an impresario. His club keeps going in an age where others, especially those who catered primarily to Creole audiences and performers, have been closing. He was very good friends with the late Buckwheat Zydeco—Stanley Dural Jr. (1947–2016)—who did an annual charity gig at the club. Sid owns a convenience market around the corner from the club, and between his property and business holdings and his role in the local music scene, he's the unofficial mayor of his part of Lafayette, a generous man very connected to his family and his neighborhood.

Nathan Jr. grew up in this environment. His father was then on Rounder Records, a national label, touring, helping fill the vacuum Clifton Chenier left. Lil' Nate was part of many of his father's shows, especially locally. As he matured, his musical tastes moved with him. The blues and older R&B models must have seemed more connected to his dad's generation. Lil' Nate moved toward the distinctive sound he has today, a richer, smoother, less demonstrative mode of musicality. He held on to the family values—whenever you see him on stage, his band includes other members of the extended Williams fraternity. Whatever it is that he does, younger people love it, and they turn out for him. He may play more trailrides than any other zydeco musician. His father, it seems, plays mostly out of the region; Nathan Jr. is one of a younger generation that has revitalized, and re-created, an audience that stretches from south Louisiana to east Texas.

BF: Let's start by talking about how your music fits in the contemporary world of zydeco.

NW: I feel like my music is in its own world. Zydeco for me has deep roots—Clifton Chenier, guys like Rockin' Dopsie and Fernest Arceneaux and the Thunders, and, of course, my dad, Nathan and the Zydeco Cha Chas. But I feel like my music is headed toward more of a newer sound. I fuse a lot of different genres of music with what we call zydeco to give it a somewhat urban, nouveau sound. That direction is geared toward trying to preserve the history but also to be moving forward and making progress with the younger audience as well.

BF: And what are the qualities of the urban sound that you bring into it?

NW: Well, of course, zydeco music was geared toward the accordion and the washboard. I mean everyone knows that's the central area of where this music has evolved from. It moved over to having amplification, guitars were popular, bass guitars, and then guys like Clifton Chenier added saxophones and organs. And that was the start

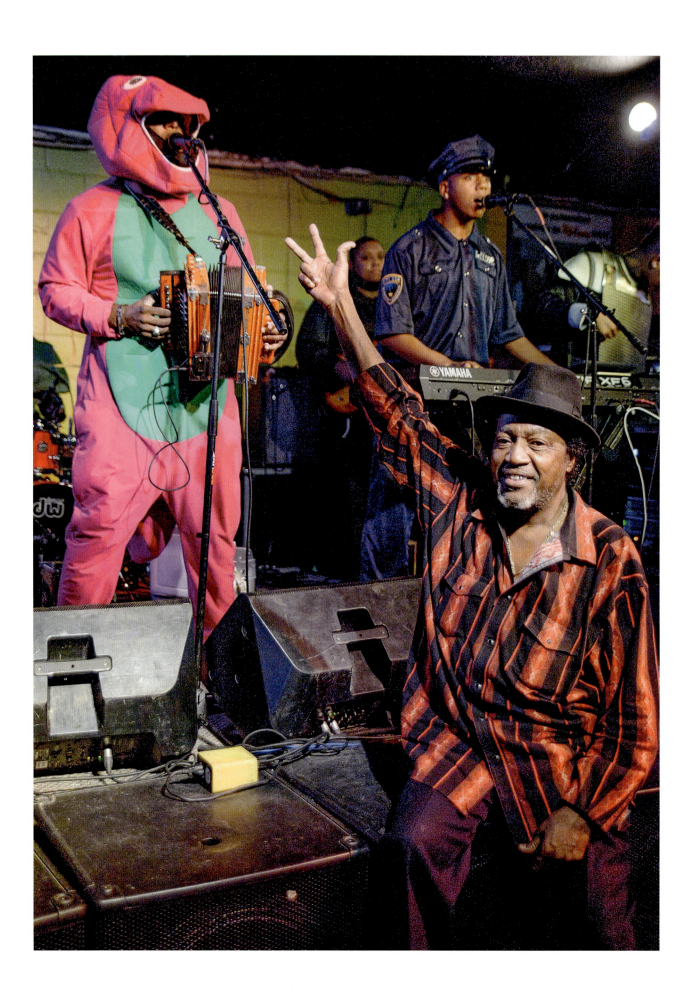

of it—the organ, with my style of music. Now with so many unique set sounds and lead sounds and keyboard, digital, we're geared to more of a neo soul-type feel, R&B-type feel, with a lot of lead synths. So we're adding a lot of keyboard flavors into the music.

But, as I say, every time I explain this whole situation, I go back to this theory of mine. Some folks say, "Well, man, you're changing it too much. It's not zydeco." My question, and I understand it's not good to answer a question with a question, but when someone asks me, "Why you doing that? What are you trying to do, as far as zydeco?" I say, "What is zydeco?" Because if we talk about Clifton Chenier, you know we can ask what was he doing with zydeco? He was fusing it, also. So I think the keyboards are helping me to venture off into that style of neo soul, R&B. But as I said, the accordion is still pretty much prominent; the washboard is still pretty much prominent in the music and the drums.

BF: You seem unusual to me in zydeco in that you've got two keyboards and two rubboards.

NW: Yeah.

BF: Was that to go after a certain sound?

NW: No. It just evolved with family members in the organization. My group started off with me and my cousin Isaiah Williams on rubboard. My little brother ventured into the band on keyboards. And I have another cousin who's playing rubboard. He's just a family member that's getting into the music. If I see one of the kids want to do it, I'll allow him to come do it.

And the two-keyboard situation is because we have so much into our studio recordings as far as keyboards, and in order to replicate that on stage we need to have at least two keyboards. We really can use three. But we're traveling excessively during the week; now I'm down to two keyboards. We used to have two guitars, but one is doing pretty good.

BF: Talk about growing up in a family with a father who is a well-known musician in the tradition.

NW: That was a good experience for me. I felt like I had a lot of years of experience by just being a kid whose father played music, if that makes any sense to you.

BF: Sure.

NW: Just being around my dad, at his concerts, and, of course, festivals, as a kid, I felt like I was young and naïve. But I was absorbing everything—the whole process of how you get on stage. How you play. How you enjoy an audience. How you make an audience enjoy you. The whole process of recording. My dad took me through all these processes. And I think it's still instilled in me right now, and I feel like I have an advantage. It was great being around my dad, playing music, and my uncle Dennis being an artist, and my uncle Sid being a club owner. So the whole process was just there as a kid.

Lil' Nathan dressed as a dinosaur for Halloween with his Uncle Sid Williams (foreground), El Sido's, Lafayette, Louisiana, 2015

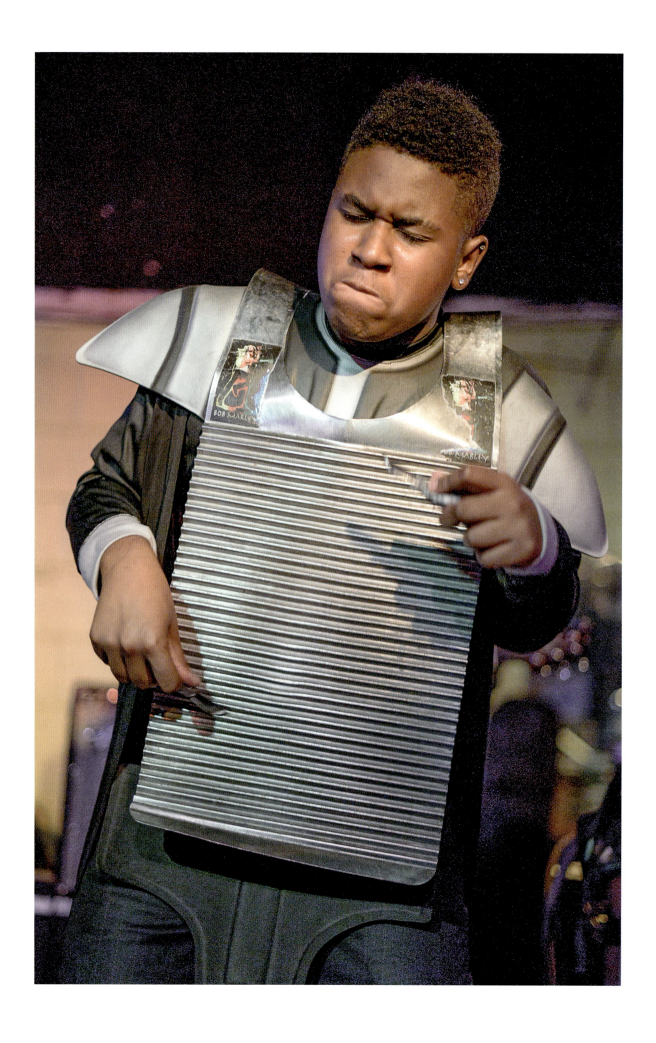

BF: When were you born?

NW: 1986.

BF: What were your first memories of music?

NW: A cowboy hat, man. That was my first—I hated a cowboy hat. My dad used to put me on stage with some shorts on, and—matter of fact, I think I have some pictures here. Used to stick me on stage; I had a little rubboard, this big, and I never wanted to wear a cowboy hat. You know, they'd stick a hat on my head. So that was my memories—just having fun. I know I was having fun because I was around family, and I was around my dad. I was doing what I loved to do. And he did it, which turned out to be really what I loved to do.

BF: How old were you when you first got on stage?

NW: I have some videotapes. Two years old; three years old.

BF: Playing rubboard.

NW: Yes. That's pretty much where it started from. I've been a musician, I guess you can say, ever since then.

BF: Was it a cool thing for a young guy to be playing zydeco? Or was it something that made you self-conscious?

NW: In middle school I was very self-conscious about it. My teachers and faculty members always embraced the fact that I was into zydeco. But the students didn't embrace it as much as the faculty did. When I got to high school, it was more self-conscious. But you have a few students that really knew what zydeco was. They made it like it was a joke, but, "It's cool, man, playing zydeco." When I started doing well, started adding a little more urban music into it and doing some features with guys like Juvenile, and Kevin Gates, and Cupid, people really respected. When I went to college it was a cool thing; zydeco became cool for people in that 18-to-24 group. I feel like we as young artists, myself and a couple other artists, made zydeco cool to the younger generation. And I feel good about it because it's going to grow. And hopefully these young kids and students—high school, college students—are going to continue to support zydeco throughout the years and teach their kids to support zydeco. So we can keep the genre going.

BF: And do you think that's happening now?

NW: I think it is.

BF: Is it better known now, more popular than it was when you were younger?

NW: Locally, I think it's better known. I also think that—and this is weird because I feel like I'm getting old—a lot of these young people that used to follow me are having kids. So their kids are coming to the zydecos. Man, it's weird; I'm getting old. We're affecting generations; you know, they're getting their kids into the zydeco, too. Going to trailrides and festivals. So there are these high school students that were eighteen at the time when they started supporting me, and I was

Rubboard player Michael Dugas Jr., El Sido's, Lafayette, Louisiana, 2015

eighteen. And now they're in their thirties, and they have kids now. So the kids are coming. It's cool. To know that you can bridge that gap.

BF: How much does the Creole heritage part matter to you? And how much does that have to do with why people are involved in the music and interested in music?

NW: I've never really been involved with the Creole history aspect of it. I've been around some Creoles, and I've heard stories of how they preserved what was called la-la music at the time. Don't get me wrong; I have much respect for a lot of Creole musicians and what they've done. But I just wasn't influenced with that style of the music as much as I was with the Rockin' Dopsies, Sampy and the Bad Habits, Clifton Chenier, and Buckwheat Zydeco. That's my influence of it. Don't get me wrong—we all, as musicians, tend to borrow. And I can honestly say I borrowed the single-row accordion from this area because none of my family members played a single-row accordion before I picked it up. But my dad and Boozoo was real good friends. I knew Boozoo as kid. I knew Beau Jocque as a kid. My dad and Beau Jocque were real good friends. Seeing them playing those squeezeboxes influenced me to want to play those squeezeboxes. Because when my dad would do shows with Boozoo, I would see him playing: Man, that's pretty cool.

But my dad always had piano accordions. So that I started with that. So, you know, me mixing and matching with Boozoo and Beau Jocque, and going to Rock 'n' Bowl with those guys, seeing that made me like that style of zydeco.

BF: So, when I ask you about the Creole thing, would you say you're Creole?

NW: My ancestors, from what my grandmother explained to me, were from Haiti and Dominica. Around that area. Creole French-speaking people. My dad actually went to Dominica and realized that there's a lot of Williams in Dominica, a lot of Hypolites. My grandmother was a Hypolite from that area, of course, Harry Hypolite. They speak the same Creole French as they speak in St. Martinville and Breaux Bridge. It's safe to say that that's my ancestors on my dad's side. And they play accordion.

BF: Yeah, a lot of accordions. So you started with the piano accordion.

NW: Yes.

BF: How old were you?

NW: I was 8 years old. It actually goes back—let's start from the beginning. I started on rubboard. Between the ages of 7 and 8, I was on drums. I went to Catholic school, and we had Mass every Friday, and I would always see the drums, and nobody was on the drums. The piano player was plucking away. One day I just went up there, and I started messing around. And they said, "What you doing, man? What you doing?" People were unsure why I just started messing around.

The piano player was like, "Let's have some rehearsals, man. I want to see what you can do." I could barely reach the kick pedal. They had to lower everything down to the lowest turn.

But we started rehearsing, and I started playing at Mass every Friday. I ended up starting doing some church events. And the piano guy took me to all these little gospel extravaganzas and stuff. At that time my dad was buying a lot of accordions. He would leave a lot at home. And I would mess with them.

He'd always be freaking about me picking up those accordions because they were very expensive. But I started learning. Every time he'd come back from a trip I'd show him what I learned, and he realized that I could actually play a little something. I started on that piano accordion. He finally introduced me to the world at 8 years old, at the Plaisance festival. It's actually on video. I played "Josephine Is Not My Woman/Josephine C'est Pas Ma Femme." Clifton Chenier recorded that.

That was the start of it. I ended up winning the zydeco extravaganza concert at the Blackham Coliseum in Lafayette a year or so after, and I realized that I wanted to play accordion.

BF: When did you make the move to the button accordion?

NW: My dad bought me a button accordion for my fourteenth birthday. That was my first diatonic, single-note accordion. And I still have that. I started playing a lot of Boozoo songs. My dad would let me open up with two, three songs, and I'd play a lot of Boozoo, Beau Jocque stuff. Because being that my dad was playing a lot of piano-note, it made the show diverse by me playing the diatonic, single-note. It became that every time I was at a festival, I would open up for my dad, when I was there. With his band.

I started having one of my cousins, who's still with me, playing rubboard; he would start traveling with us at the local stuff. And my other cousin was a drummer. We'd been together, beating on pots and pans. And they would start coming, and we would just replace the drummer and the rubboard. So that was my little group.

We would open up for my dad. That's pretty much how it got started. I moved to the diatonic triple-note when my dad got one in Rhode Island and realized that he didn't know how to play the triple-note accordion. So he gave it to me. And quite naturally, playing the diatonic single note, I would just fiddle around with one row until I could start crossing over and playing different styles, as I'd practice.

BF: When did you become a leader?

NW: 2001, 2002—the millennium. Started playing more gigs, like Café des Amis in Breaux Bridge. We started doing the Blue Moon Saloon. Little pickup gigs, Vermilionville. Every once in a while El Sido would let us play in his club. So that was pretty cool. And we got around to doing the kids tent at Jazz Fest, kids' tent at Festival International, kids' tent at Breaux Bridge festival. We started doing a lot of kid things—of

course it was Lil' Nate. And that was the start, man—just playing Café des Amis once a month. It was basically getting some rehearsal time in front of an audience, playing Blue Moon once a month. Playing El Sido's once a month. We at least had four or five gigs a month, which for a young guy, 13 or 14, that was pretty cool. So that's where it started.

And ever since then—I can say from 2000 to 2015, we've been rolling ever since.

BF: With mostly family members in the band?

NW: We have maybe 30 percent family members in the band. A couple of my musicians come out of the church. One or two of them come out of zydeco families like the Broussard family—Zydeco Force—and the Chambers family—they're in my organization, too. A lot of our musicians have some kind of background in music, as far as church or zydeco background. It's all rooted in their ancestors.

BF: Is it hard to be a musician playing zydeco Friday night and playing church on Sunday? Would there be tension about that?

NW: Some of them, they actually do. My keyboard player is in church on Sundays. I did that for years, when I was donating my time to the church as a drummer, I still played zydeco.

BF: So you started around 2000 on your own, and the name Lil' Nate—that's the band name. Talk about how you build a career in this music.

NW: First it started off with dedication. Before there any financial revenues involved with this music, I just loved to play the music. When I started realizing that I could actually make money in this organization, dealing with the trailrides, I really decided that I was going to make this a business.

Going to university and taking business classes and studio classes and realizing, man, this could actually be something that can make a living, I started being about business. Started realizing that sometimes you have to know what you're worth. It's a tough thing to do, when you're expecting zydeco music to be your full-time income. But I was always blessed with some family members that—of course, my dad was always into the music, and he always did give me business tips. So, I took what I thought I was worth and didn't take what I didn't think I was worth. And it's still like that, to this day.

Going into the university, that was a great experience as far as learning how to run a business, learning tax brackets and how you invest in your business and make it work for you. Invest in different things; don't put all your eggs in one basket, like the old folks say. But I've always had a business mindset. I used to work at my uncle Sid's grocery store, Sid's One Stop. I used to watch him—how he handled his business. And a lot of that rubbed off on me. How to be professional: when you present the name, Lil' Nathan, how to be as professional as possible. You know, when I present my band, we try to be as tight as possible.

BF: What about the jazz studies part of going to University of Louisiana at Lafayette?

NW: That goes along with the whole style, fusion, jazz. As we all know, zydeco music back in the day was, you know, you played 1, 4, 5. Any musicians that read chord symbols can play anything in zydeco. I wanted to be different than that. I have a lot of chord progressions that still deal with those generic, I would say historic, chord progressions. Where you can jam on the one, you know you're good.

But I wanted more than that. I wanted it to grow. So, of course, going to UL with jazz studies background, learning all these different chord progressions and scales and modes, it really helped me to take some ideas and, you know, still have the accordion and the rubboard prominent, and the drums, but with the keyboards, make zydeco be something of a totally different style. You can hear all these chord progressions going on but still have an accordion in the mix.

That was a game-changing experience for me. I learned so much. I was always an ear-trained musician. I hadn't had any background in piano before I went to UL. But I had a good ear, and my professors realized that. You know, "He can play some stuff; he don't know what he's playing, but he knows it sounds good." And they respected my ear. I really appreciate the University of Louisiana–Lafayette for giving me a chance at this wonderful experience.

I started reading music; I picked up writing, transcribing: a lot of Charlie Parker tunes, a lot of Monk tunes. That really just opened my brain. Like, "Man, this is some crunchy stuff." You know, and that's all I thought of, "It's crunchy. It's crunchy. It's not what I'm used to. But I like it. I want to do this. Let's do this." When I came out with my second project in 2007, you can kind of hear a lot of jazz progressions with some minor ninths and major seventh chords. And it just started turning it around.

BF: And somehow you were able to make the single-row diatonic accordion fit into that.

NW: Yeah. Exactly. Of course, you know I won't get any major sevenths out of a diatonic accordion. But with the keyboards being in the mix, it all fuses. One band, one song.

BF: Is it a fair question for me to ask you to compare your music to your father's music or talk about how it differs?

NW: As far as music goes, it's really no comparison, man. My dad was ahead of his time. You know, a lot of my dad's music that he played in the eighties and the nineties, like I could take one of his songs right now and it would end up being relevant to the urban music. My dad was ahead of his time. I feel like we're ahead of our time. But the only thing I can compare is I feel like my dad's voice and my voice are pretty similar. Speaking voice and some songs that we sing, some keys that we play in; people couldn't tell us apart. I feel like my dad's music was

structured, you know, bridge, chorus, A and B, he actually put forth an effort into making it a form, with his music. And I feel like I do that. So that's a comparison. I mean that's basically all I could compare it to—the structure of the music, our voices. We always had a pretty good band behind us, on top of our skills playing accordion. Always did have a decent sound, PA. Business-minded. Yeah.

BF: Great. I should know this, but I don't. Have you recorded or performed anything in French?

NW: I have. Creole French, not traditional French, but Creole French. Every album that I have, I try to dedicate at least 5 to 10 percent of it to old-school music, zydeco music, and within that section of the album I'll have a song where I'll put some Creole French in it. If not 100 percent, 50 percent, we'll do a verse in French. Because when I sing in French, I want to make sure that the younger audience can understand what I'm saying. So I'll sing that same verse in English.

BF: Was French spoken in your home when you were growing up?

NW: Oh yeah. My mom is a Breaux Bridge native, man; her mom, that's all they spoke was French, Creole French. And my mom is very fluent in Creole French. My dad, he's pretty fluent, too. Because his mom and grandmother; that's all they spoke was Creole French. I'm not fluent in it. But I could kind of get the picture. I took French in high school, and I could kind of see where I was going. That's in my plans, too—take some French classes at the university and get more into it. So if my career takes me to one of those venues where I need to be able to do 100 percent French, I can.

BF: So who's your audience?

NW: Man. I've had little kids come up to me. Like what I'm doing. And I've been in nursing homes. But the weekend-to-weekend basis, I would say it's from 18 to about 40, 45.

BF: So, younger.

NW: Yeah. I'm blessed, man. But being that my dad influenced me so much with the older style of music, and me learning how to somewhat speak in Creole, it helped me bridge that gap. And I could do the youngsters; I could do the mid-age; I could do the older folks. And everybody'd respect me. So it's all a great fusion.

BF: Is it mostly a Black audience that you play for?

NW: Yeah, prominently Black. It depends on the venue. It depends on the venue. We play a lot of venues where it's interracial. And pretty cool because you know a lot of Caucasian people, they're getting more and more into zydeco. And they can dance, man. At one time, it was like they really didn't understand—you know, they got a lot of people doing zydeco dance lessons on the East Coast and West Coast, Gulf Coast, and a lot of Caucasian people, man. We're getting a lot of Mexicans, too. And they can dance now. They can dance, and I'm really appreciative. Because all these ethnicities, man, they have so much that

they have in their own land, and they give us their respect, as African Americans and Haitians and Dominicans. You know, to respect our music. And that's cool when you can cross racial barriers. I'm real proud of that, when Caucasian people and Mexicans can come up to me and say, "We like 'Bass in Yo' Face,' man." So it's pretty cool that I can do something like that. It's only God's gift of music, of course, you know, that we can have an audience with so many people of different ethnic groups, and them be all of one accord, dancing to one style of music. I really appreciate that.

BF: Talk about playing trailrides. You seem to do a lot of trailrides.

NW: Trailrides are 80 percent of my work. And it is 80 percent of my work because I choose to make it 80 percent of my work. I play local Gulf Coast from Mississippi to Dallas, Texas. And fifty-two weeks of the year, I'm working every weekend. Between those three states. I get offers to go out of state—we've been to California, we've done shows in Jersey, Michigan, with my group, Florida. But like I say, trailrides—that's a culture in itself. Because it's been going on for so long, and guys like Boozoo made it famous in the early eighties to do trailrides. With him being involved in horses and all. Zydeco Force was a big trailride band at that point in time. When Boozoo was in the eighties, man, is when trailrides first got started, he was the trailride man. And that's always been something where they support each other. You know, trailriders, every Sunday, man. Loyal. They're on their horses riding around, and the dance is the dance. It's just a tradition. You go through that whole process every weekend. And it spread to southeast Texas, and it spread back over to Mississippi. Sibley, Mississippi, has one of the biggest trailrides now in Mississippi. There's a trailride way up by Austin area. Dallas. So it's getting up there. Then it goes back down to Galveston. So it's getting around. Louisiana—so much all over.

They got about ten to twelve trailrides scheduled between Mississippi and Texas. And go figure, do the math. I'm only one band. That's a lot of work out there. Trailrides create a lot of work for some of these bands that want to play music full time. And it's great. These guys can work, myself included. And do what we love to do—spread zydeco. And we can also make revenue so we can support our families, too. So it's pretty cool.

BF: You have a wife?

NW: I have a wife. She's still into her studies. I'm still into my studies. I'm also teaching at the university. There's a traditional music program at UL Lafayette, which consists of subgenres of bluegrass, Cajun, and zydeco. I'm with the zydeco aspect of it, where I teach private lessons on piano-note accordion, triple-note accordion, and single-note accordion. And I also was teaching classes on the accordion, Lil' Pop took over one of those classes—Corey Ledet. He came on, and he took one of those classes. I still do accordion lessons, and

I do the zydeco ensemble. A couple of zydeco musicians are involved with that program, which is pretty cool.

And in the fall of next year I'm going to be starting with an arts academy in St. Martin Parish where I'll be teaching the history of zydeco, an appreciation class, teaching class accordion and also zydeco ensemble to some elementary students at St. Martinville. So my teaching background is getting some good work.

My wife is getting her masters in December. And I have a couple of state tests that I have to take before I go back and get my masters. I want to get my masters in theory and composition. Either theory and composition or some sort of studio engineering. But I think theory comp is the one I'll go into, if not performance. But I'm still juggling three curriculums that I want to get into. So we're still into the education side. I'm so busy; she's so busy.

BF: Sometime, though, you're going to need someone to help haul those heavy speaker cabinets around.

NW: You're right. You're right.

BF: I wanted to ask about that. You've got some of the biggest band PA I've seen on the zydeco circuit. You've got those big bass cabinets, subs, or whatever they are.

NW: Man, you know who got to thank for that? I remember Boozoo used to go out there with two fifteens and a horn. SP2s, Peavey. And that was enough. You know, Beau Jocque came out with all those speakers, started putting a lot of thump in the kick drum, with Rounder Records and Scott Billington, their producer, of course. And that became the thing, man. When Beau Jocque came out, they wanted a lot of kick drum. And then, of course, Keith Frank, where when he played there was just so much low end, so much subs, and that became the face of zydeco. If you don't have a big PA and have the kick drum thumping—you know, that's what they want to hear. And these trailrides are so big right now, with thousands of people coming out, you have to have PA for two, three thousand people. If you want to be heard. I bought more PA than I needed, obviously. But of course you've got maintenance, man, so I have enough PA to where if things break down, I could just substitute them and not have to go to the shop over the weekend. Because I play three, four, or five gigs a week. So that helps, having spares. But, yeah, we got a lot of PA there.

BF: You do. You feel it when you're in the audience.

NW: Like I said, you got guys like Keith Frank, was really a guy that created a lot this thump, man. Oh, my God, like stop-your-heartbeat-type low end. I like that. That really gets me excited.

BF: Do you guys worry about your hearing at all?

NW: Not really. I soundcheck from a distance, and when I get on stage, my monitors are not as loud. I don't play with too much in the

monitors. If at all; some gigs I don't even put monitors on. I put earplugs in, and I can hear myself singing. But it really doesn't bother me.

BF: Changing the subject: I was surprised when I started this project to realize there's as much happening around Houston as there is here in Louisiana. Because everybody who came to zydeco the way I did thinks of Louisiana. Can you say anything about the Texas scene and the Louisiana scene; how they're related or how they're different?

NW: I'm not going to lie, man. Texas is neck-in-neck with Louisiana right now in the zydeco scene. There's a lot of people supporting zydeco in Houston. And it's always been a market for zydeco in Texas. My dad and Clifton used to do a lot of church dances. That's where it really started, in Texas, was with the church dances. Then, of course, you have a lot of trailriders, too. But trailrides, to me, took over. There's still some church hall dances, and there's still some nightclubs in Houston. But trailrides; that's where it's at. That's where a lot of the zydeco lovers are, at trailrides. The older folks still go to church dances. I do them, too. So, Texas is really supporting zydeco.

It's a big thing, though, weird. Majic 102 FM, one of the biggest urban stations in the Texas area, is playing zydeco. They're playing my music. It's unheard of for a lot of these rap stations and R&B stations to play zydeco. But they are now. Even in the Lafayette area, Baton Rouge, New Orleans. You know, a lot of these big corporate companies are now actually supporting zydeco. That's cool. That's cool.

BF: So just a couple more questions. With all your experience in studying jazz, with your interest in bringing a more urban sound into the music, why have you stayed with zydeco at the center when you could be doing other genres of music?

NW: Yeah. Of course that's a question that I've asked myself a lot because I've had opportunities to do R&B and gospel, and I mean you never know. That's all I can say; you never know where my career is going to go. There's always those options out there. I think there's a mystery as to where I'm going to take this music in the future. But zydeco is what I was born into. And it's a good career. You know, it's not—I don't have no big record deal, getting big movie roles, or playing BET awards, but I play for an audience that appreciates my music. And if the opportunity came where I could present this to the world on that level as far as R&B and neo-soul-type music, I would want to make sure that they know that this is where I started from. There's a lot of musicians out there that get record deals, and they don't play the accordion anymore. But to each his own. I feel like if they can't accept me for who I am, then what's the point? I may as well do what I've been doing.

BF: It's great to see that you can be successful in this music and do reasonably well, too. We were at a Houston zydeco musician's house the other night; it's a very nice house. He seems to do well. Your father

seems to have a nice house. So it's great to see that it's possible to make a life in this music.

NW: It all depends on what you want in life, man. Some musicians—I say this because it can happen to any one of us. Some musicians get caught up in the party life, man, and, as in any type of entertainment career, they get caught up in the party life, and that could really destroy them. Because first of all, being a full-time musician, you have to take care of your health, man. This is a lot of work on the body, traveling at all these times at night, and not getting the rest that you need. And on top of that to be involved in alcohol and all kind of other drugs and stuff like that—that could destroy you.

I'm not a preacher, and I'm not to judge anyone. But I've seen a lot of my relatives get destroyed by choosing a certain path in life and not focusing on what their goals were. So I tell it to any musicians, man—try not to get caught up in that, man. Because you can really make a living with this, if you live responsible with your finances.

There's a lot of respect for musicians right now. If you don't respect yourself, it don't matter how much money you make if you spend it all—it's still defeating the purpose. But all these guys you mention are business-minded people. You know, Step Rideau, Brian Jack, my dad, Keith Frank—those guys focus on presenting this music on the highest level as far as recording and performing live. So that's why they sound like they sound. That's why they have what they have. Because they invest in their business. And, of course, I'm in that same boat, too. Which is what you see right here. Hey, I could choose to not do this and spend my money elsewhere. But this is what I do. So if I take pride in what I do, I'm going to take those leaps of faith into buying audio recording gear and making sure things are on point. So then when I present this music to the world, it's at the highest quality. I've always been like that. Every album I produce, I try to make sure is at the highest quality, and it compares to a Beyoncé record as far as sound engineering—not the music, but just sound engineering. The master volume is as loud as Beyoncé's record or Michael Jackson. We listen to all kinds of stuff, man, when we're mixing and mastering. We take pride in that.

BF: Okay, great. Is there any last thing I should ask you? Am I leaving something out that's important to you?

NW: I think we talked about a lot of stuff. I didn't mention that my family played a big part in me staying grounded and staying on top of everything. It's one thing to start up something. But just to keep it going, maintain it, it's tough. And you're going to have people pushing you, giving you courage, like my dad does. My dad gave me a lot of courage. And my mom was always there. I played football in high school and one semester in college. And my mom was always there supporting me, giving me courage in my athletics and also my music.

Trailriders, Opelousas, Louisiana, 2017

My dad pushed me to get my undergrad. I had no intention of going to college. My dad literally picked me up and said, "We're going to the university." I said, "Well, Daddy, my scores, my ACTs and SATs . . ." He said, "We're going to find a way to get you in." And we found a way.

I thank him for that, to push me to go to college, get my four-year degree. It just opened up a lot of doors. I thank El Sido's for having his doors open for a lot of the zydeco musicians to go play in Lafayette, Louisiana. Because there's not too many historic zydeco clubs in Lafayette, Louisiana. You got some clubs that host zydeco music, but it's not a zydeco club. So I always make it a point to make it a priority to play to that club. Because that club started a lot of zydeco bands. And we can't forget that. You know, I understand we need to branch out and play different venues. But Slim's Y-Ki-Ki, El Sido's, even the old Richard's Club—the Zydeco Hall of Fame—that's some historic places that need to be having zydeco. Their doors need to stay open. So I thank those people out there. The trailriders. And the disc jockeys that do all music. And guys like you guys who come out here, travel, not expecting revenue or anything, just to preserve the culture and publicize—it's very appreciated. I thank y'all so much for doing this.

First, a warm thank you to the musicians featured between these covers and also to those with whom Burt, Gary, and I interacted while doing the fieldwork, photography, writing, and editing of this book. They and their families shared their music, thoughts, experiences, homes, studios, dining recommendations, boudin, and venison sausage (I'm looking at you, Kelly and Cheri!). Thanks also to the anonymous reviewers for the University Press of Mississippi for their suggestions and deep knowledge of the region and culture.

ACKNOWLEDGMENTS

Then the trailriders. We had nothing but good experiences on the road and in the arena with them. It was Texas-plus-Louisiana-sized hospitality with the welcome addition of *lagniappe* and a little moonshine. The trailrides were remarkable to witness; I've tried to figure out why they were so striking. My photographs of people's faces during the rides' rest breaks helped me settle on what it was that made it so engaging: I'd simply not seen that many people of all ages so deeply relaxed and having a good time together. I think much of that vibe was due to the influence of the physical exertion, the interaction with animals—the horses deserve a shoutout here—that, plus the music, of course, always the music. All of that mixed together makes for an excellent homebrew.

Cedrena Tillis, Teresa Tisdell-Reed, Patrika Reescano-Ellis, Pat Cel, Malex Wilson, Nathaniel Wilson, and Kenneth all took the time to show us many kindnesses and generously shared their knowledge of the trailrides and all things zydeco. Cedrena merits a special thanks; she is good at fielding questions and also at "keeping the party jumping."

A big thanks also goes to Tressa on the Tri-City party wagon. Once I lost my balance; she caught me and said, "I got you; don't worry," quietly into my ear. I learned then that it was much easier to stay balanced in the moving party wagon by dancing to the zydeco music coming from DJ Pooh's speakers rather than standing still. Soon, Burt and I were actually hanging off the sides of the party wagon while still moving with the beat. Movement, rhythm, balance: a life lesson there.

Thinking about generosity calls up Kelly Lagan's warmth and also that of Sid and Susanna Williams. I wear my El Sido's shirt with pride and remember what Dennis Paul Williams told me about the importance of acts of mercy. Also, Nathan Williams Jr. was indispensable in helping me identify musicians. After we met the Williamses, we found Clifton Chenier's Club; a storm was charging the air. We could hear a rooster crowing and church bells ringing in the distance as we stood there. Our indefatigable fellow traveler, Gary Samson, had started the day by remarking on the hospitality we had experienced on the trip. With humorous hyperbole, he said, "And, today, we'll meet someone, and they'll invite us to their house for dinner." Soon after the Chenier Club, we were standing on the Promised Land Road photographing what is now known as the Valentine Dance Hall, when Tramaine

Payne stopped by and said, "What y'all doing?" She then invited us to her family's crawfish boil on the Bayou Teche. Thanks are also due to her mother, Mary ("Be open to God's work; it's everywhere you look") and her family for sharing their food with us and letting us pass some time in their company.

Back in Utah, Wade Nicholas helped me with some Louisiana genealogy. Ken Anderson, Katie Umans, Carol Nicholas, Annie Strickland, Sara Johns, Angela Richter, Tristan Petersen, and Alex Jensen all helped me direct and properly channel my Mac-user instincts into finding all the needed files for this book on Burt's PC. Then they helped me make backups and hard copies of what I found. They kept me sane through at least two rough patches when I couldn't find all the files I needed to complete this book. Fortunately—and with welcome mercy coming from somewhere—I ultimately retrieved all the files. The words about this music want to be shared.

Finally, there are those dear souls who were there for Burt when he became ill and the worst happened. This shining group includes his beloved daughters Sophie Feintuch and Hannah Feintuch; his siblings Betty Weinkle and Robert Feintuch; his sister-in-law Rona Pondick and niece Sidney Weinkle; and his friends Sara Hydorn and Pete Armstrong. Heather Trobe and Jake Mattleman lifted us all. Also, Nancy Banks, John Banks, Dorothy Banks, Madison Thomas, Rio Thomas, and Pat Gantt helped me help Burt. To this fine roster we also add those who cared for Burt at the end or brought some tunes to him. They include Karen Andersen, Richard Peele, Kim Stanton, Perry Blass, Liliana Ouimet, Anita Baldwin, Rick McAulty, Emery and Kit Hutchins, John and Judy Carew, Bill Zecker, Sara Mason, Steve Panish, Peter Yarensky, and Emeline Dehn-Reynolds. Some words from a traditional song that Burt knew well and that the above group left him with at our last gathering are also appropriate here:

> But since it falls unto my lot
> That I should rise and you should not
> I'll gently rise and I'll softly call
> Good night and joy be with you all

WORKS CITED

Ancelet, Barry Jean. 1988. "Zydeco/Zarico: Beans, Blues and Beyond." *Black Music Research Journal* 8: 33–49.

Ancelet, Barry Jean. 1996. "Zydeco/Zarico: The Term and the Tradition." In James Dorman, ed., *Creoles of Color in the Gulf South*, 126–43. Knoxville: University of Tennessee Press.

Ancelet, Barry Jean, and Elemore Morgan. 1984. *Cajun and Creole Music-Makes: Musiciens cadiens et creoles*, 2nd ed. Jackson: University Press of Mississippi.

Ardoin, Bobby. 2018. "Amédé Ardoin's Legacy Marked by Statue, Lemon Trees." March 13. https://www.dailyworld.com/story/news/2018/03/12/lemon-trees-go-up-state-capitol-honor-amede-ardoin/416411002/.

Ariaz, Jeremiah. 2018. *Louisiana Trail Riders*. Lafayette: University of Louisiana at Lafayette Press.

Bernard, Shane K. 1996. *Swamp Pop: Cajun and Creole Rhythm and Blues*. Jackson: University Press of Mississippi.

Brasseaux, Carl. 2005. *French, Cajun, Creole, Houma: A Primer on Francophone Louisiana*. Baton Rouge: Louisiana State University Press.

Dewan, Shaila. 2011. "Louisiana's Zydeco Trail." April 22. https://www.nytimes.com/2011/04/24/travel/24zydeco.html

DeWitt, Mark F. 2008. *Cajun and Zydeco Dance Music in Northern California: Modern Pleasures in a Postmodern World*. Jackson: University Press of Mississippi.

Dorman, James. 1996. *Creoles of Color in the Gulf South*. Knoxville: University of Tennessee Press.

Fuselier, Herman. 2016. *Ghosts of Good Times: Louisiana Dance Halls Past and Present*. Photographs by Philip Gould. Lafayette: University of Louisiana at Lafayette Press.

Giancarlo, Alexandra. 2016. "Democracy and Public Space in Louisiana's Creole Trail Rides." *Southeastern Geographer* 56: 223–44.

Giancarlo, Alexandra. 2018. "Louisiana's Black Trial Riders: A Living History. In J. Ariaz, ed., *Louisiana Trail Riders*. Lafayette: University of Louisiana at Lafayette Press.

Istre, Elista. 2018. *Creoles of South Louisiana: Three Centuries Strong*. Lafayette: University of Louisiana at Lafayette Press.

KQED Arts. 2020. *Zydeco Dance in Houston*. July 14. www.kqed.org/arts/13883253/if-cities-could-dance-houston-zydeco.

Leibovitz, Annie. 2003. *American Music*. New York: Random House.

Le Menestrel, Sara. 2015. *Negotiating Difference in French Louisiana Music: Categories, Stereotypes, and Identifications*. Jackson: University Press of Mississippi.

Minton, John. 1995. "Creole Community and 'Mass' Communication: Houston Zydeco as a Mediated Tradition." *Journal of Folklore Research* 32: 1–19.

Minton, John. 1996. "Houston Creoles and Zydeco: The Emergence of an African American Urban Popular Style." *American Music* 14: 480–526.

Mouton, Todd. 2015. *Way Down in Louisiana: Clifton Chenier, Cajun, Zydeco, and Swamp Pop Music*. Lafayette: University of Louisiana at Lafayette Press.

Owens, Maida. 1997. "Louisiana Traditional Cultures: An Overview." In *Swapping Stories: Folktales from Louisiana*. Jackson: University Press of Mississippi, xxix–xlvii.

Sandmel, Ben. 1999. *Zydeco!* Photographs by Rick Oliver. Jackson: University Press of Mississippi.

Savoy, Ann. 1984. *Cajun Music: A Reflection of a People*. St. Louis: Bluebird.

Sexton, Rocky L. 2000. "Zydeco Music and Race Relations in French Louisiana." In P. Kivisto and G. Rundblad, eds., *Multiculturalism in the United States*, 175–84. Thousand Oaks, CA: Pine Forge Press.

Spitzer, Nicholas R. 1986. *Zydeco and Mardi Gras: Creole Identity and Performance Genres in Rural French Louisiana*. Diss., University of Texas at Austin.

Spitzer, Nicholas R. 2003. "Monde Creole: The Cultural World of French Louisiana Creoles and the Creolization of World Cultures." *Journal of American Folklore* 116: 57–72.

Steptoe, Tyina L. 2015. *Houston Bound: Culture and Color in a Jim Crow City*. Berkeley and Los Angeles: University of California Press.

Tisserand, Michael. 1998. *The Kingdom of Zydeco*. New York: Avon Books.

Wood, Roger. 2006. *Texas Zydeco*. Photography by James Fraher. Austin: University of Texas Press.

Wood, Roger. 1999. "Zydeco Rap?" October 14. www.houstonpress.com/music/zydeco-rap-6566427.

INDEX

A

Adams, J. B., 51, 136, 137
American Folk Festival, 31, 201
Ancelet, Barry, vii, 4, 7, 16, 144, 153
Angelle, Donna, vii, 241
Arceneaux, Fernest, 188, 199, 245
Ardoin, Alphonse "Bois Sec," 32, 144, 167, 188, 207
Ardoin, Amédé, 21, 31, 32, 51–52, 143, 162, 206, 224
Ardoin, Chris, 42, 94, 95, 98, 174, 207, 238
Ardoin, Gustave, 44
Ardoin, Lawrence "Black," 45, 47, 51, 137, 143–64, 201, 207, 225
Ardoin, Sean, 21, 31, 155, 201–21
Arhoolie Records, 14, 16, 45, 144
Ariaz, Jeremiah, x
Arrington, William, 130
Augusta Heritage Center, 32, 47

B

Balfa, Dewey, 32, 44, 45–46, 144, 150, 195
Batiste, Jerome, 78–79, 101–15, 165
Beaumont, Texas, 31–32, 36, 37, 39, 49, 58, 64, 211
Billington, Scott, 156, 157
Bland, Bobby, 69
Bourque, Darrell, 143, 162
Brasseaux, Carl, 3, 4
Breaux Bridge, Louisiana, 165, 167, 233, 250, 251, 254
Brian Jack and the Zydeco Gamblers, 6, 77–100
Broussard, Jeffery, 111, 178, 205, 237
Broussard, Koray, 106–7

C

Caillier, J. J., 108
Carmouche, Ray, 130–31
Carnegie Hall, 32, 144, 149
Carrier, Chubby, 21, 26, 188, 217, 229
Carrier, Roy, 125, 224, 227
Carriére, Calvin, 32, 44
Celestine, Welton, 61
Charcoal Club, 26
Chavis, Boozoo, 7, 14, 26, 27, 55, 59, 61, 67, 74, 78, 80, 83, 86, 97, 107, 108, 111, 144, 156–57, 167, 169, 176, 178, 196, 206, 210, 223, 224, 228, 235, 236–37, 250, 255, 256

Chavis, Leon, 7, 136
Chenier, C. J., 127, 182, 188
Chenier, Cleveland, 14
Chenier, Clifton, 14, 16, 23–24, 26–27, 32, 41, 59–60, 61, 72, 88, 105, 144, 156, 167, 168–69, 174, 176, 181, 182, 185, 188, 193, 199, 206, 223–24, 226–27, 229, 230, 243, 245, 247, 250, 251, 262
Chenier, Gerard, 105
Chenier, Walter, 105
Chubby Carrier and the Bayou Swamp Band, 21, 27
Clifton Chenier Club, 23, 223, 227
Club ICU, 17, 19, 20, 63, 214
Cormier, Andrew, 38
Cormier, Toby, 51
Courville, Sady, 150
Coushatta Casino, 176–78
Creole and Zydeco Music Awards, 151
Creole United, 31–52, 145, 201, 206–7, 216, 217, 220
Crosby, Texas, 11, 62, 101, 240

D

D&W Lounge, 117, 118, 122, 128
Davis, Tyrone, 6
Davis and Elkins College, 32
Deffner, Faithe, 190
Delafose, Geno, 105, 167, 168, 174, 238
Delafose, John, 61, 74, 107, 125, 144, 145, 156, 168, 172, 176, 224, 227
Delafose, Tony, 123, 124, 188
Donatto, L. C., 227
Dopsie, Dwayne, 27, 67, 74, 98, 105, 108, 123, 157, 181–200, 224, 245
Dugas, Marcel, 188, 193, 199, 249
Duralde, Louisiana, 144
Duralde Ramblers, 14, 144

E

El Sido's, viii, 21, 23, 182, 243, 247, 249, 252, 260, 261
Elton, Louisiana, 78, 81, 153, 165, 167–68, 169
Espree, Andrus, 14
Eunice, Louisiana, 32, 35, 36, 144, 150, 160, 167, 169, 194

F

Faulk, Claude, 188
Feed and Seed, 21–23, 26

Festival Acadiens, 153
Festival International, 95, 233, 251
FLi Artists, 224–25, 238
Fontenot, Adam, 160, 164
Fontenot, Canray, 23, 32, 43, 45–46, 137,
 144, 145–46, 149–50, 155, 160, 164,
 167, 169, 224, 237
Frank, Keith, 32, 66, 95, 97, 98, 111, 159,
 168, 174, 176, 211–12, 216, 227, 238,
 256, 258
Frank, Preston, 32, 47, 51, 137, 167, 168
Frenchtown, 4, 14–16, 124–25, 224, 226
Frugé, Jeremy, 160

G
Garnier, D'Jalma, 46, 237
Ghosts of Good Times (Gould and
 Fuselier), 23
Giancarlo, Alexandra, viii–x
Goodly, Miss Ann, vii, 241
Guillory, Harold, 50–51, 111

H
Habibi Temple, 157
Hendrix, Jimi, 62, 122, 186, 198
Hooker, John Lee, 26
Houston, Texas, 11, 13–16, 17, 19, 44, 51,
 53, 55–58, 61, 66, 67, 68, 71, 72, 77,
 89, 91, 101–3, 109, 112, 114, 117–23,
 125–34, 137, 138–39, 148, 151, 165,
 171, 183, 195, 211, 223–30, 232, 236,
 241, 257; Fifth Ward, 4, 14, 16, 118,
 120, 124–25; Second Ward, 117, 118,
 120, 124, 132, 133–34
*Houston Bound: Culture and Color in a
 Jim Crow City* (Steptoe), 16
Houston Coalition for Justice, 133
Houston Margarita Festival, 56, 67
Howlin' Wolf, 69

I
Istre, Elisa, vii, viii, 3, 4

J
J. Paul Jr. and the Zydeco NuBreeds, 17,
 21, 77
Jack, Brian, 13, 109, 111, 112, 130, 136,
 216, 258
Jax Grill, 17, 34, 88, 91, 112
Jeremy Frugé and the Zydeco Hotboyz,
 21
Jocque, Beau, 14, 27

Jolivette, Jean-Paul, 53, 61–62, 109
Jones, Clarence, 108
Jones, Larry, 71

K
KBON, 179, 211, 242
King, B.B., 26, 138, 186, 198, 230
King City Trailriders, 6
Kingdom of Zydeco, The (Tisserand),
 167
Kravitz, Lenny, 83

L
Lafayette, Louisiana, 21–23, 24, 25, 26,
 47, 58, 61, 147, 148, 149, 153, 157, 167,
 172, 176, 182, 183, 184–85, 191–93,
 195, 198, 211, 213, 232, 233, 243–45,
 247, 249, 251, 253, 255, 260
Lafleur, Paul, 50, 182, 197
"la-la," x, 4, 14, 29, 42, 79, 150–51, 155,
 183, 185, 188, 206, 209–10, 235, 250
Latour, Raymond, 146
Lebeau, Louisiana, 55, 57, 60, 61, 78, 80,
 81, 82
Ledet, Caleb, 217
Ledet, Corey, 24, 26, 42, 97, 98, 178,
 223–42, 255
Ledet, Rosie, vii, 5, 176
Leo Thomas and His Louisiana Zydeco
 Band, 172
Leon Chavis and the Zydeco Flames, 6
Les Amis Creole, 136
Lil' Nathan and the Zydeco Big Timers,
 19, 78, 243
Lil' Wayne, 107, 111
Little Brian Terry and the Zydeco
 Travelers, 62
Little Willie Davis and His Zydeco
 Hitchhikers, 60
Lomax, Alan, 144, 242
Lowell Folk Festival, viii, 46, 165, 167,
 177

M
Mamou, Louisiana, 47, 148, 153, 194
Mardi Gras, 67, 158, 159, 167, 192
Marksville, Louisiana, 107, 108
McCormick, Mack, 14, 16
McGee, Dennis, 31, 36, 143, 144, 150, 162
Metairie, Louisiana, 184, 193, 194
Metoyer, Rusty, 201, 217
Michot, Louis, 51, 224, 237

Mickey, Bon Ton, 105, 227
Miller, Dustin, 21, 26
Miller, Larry, 47, 50–51, 153
Moreno, Ruben, 99, 117–39
Musiq Soulchild, 130

N
Nathan and the Zydeco Cha Chas, 23, 24, 243, 245
National Zydeco Foundation, 72
New Orleans Jazz Festival, 155
Newport Folk Festival, 32, 144

O
Opelousas, Louisiana, 14, 21, 23, 45, 60–61, 143, 159, 183, 198, 207
Owens, Maida, 3

P
Parton, Dolly, 122, 186
Payne, Tramaine, 24, 262
PB Dee's Classic Club Valentine, 24, 223
Pennie, Sydney, Jr., 130
Poullard, Ed, 27, 31–52, 136, 137, 145, 153, 201, 216, 217, 237
Prospect Park, 17
Prudhomme, Willis, 80, 86, 156–57

Q
Queen Ida, vii, 40, 241

R
Rawhide, 108
Rebirth Brass Band, 19
Red Hot Louisiana Band, 27, 127, 182
Reed, Mitch, 232
Reed, Revon, 148
Richard's Club, 21, 26, 60, 64, 165, 168, 169, 171, 260
Rideau, Step, 53–75, 77, 101, 105, 106, 109, 111, 165, 174, 217, 227, 258
Riley, Steve, 137, 153
Rinzler, Ralph, 144, 148
Rockin' Dopsie, 27, 74, 181, 184, 199, 245, 255
Rockin' Sidney, 26, 61, 64, 79, 80, 229

S
Salem Jazz and Soul Festival, 181, 182
Samson, Gary, 5, 6, 53, 77, 101, 117, 143, 181, 201, 223, 243, 262
Sandmel, Ben, 3, 4, 5

Savoy, Ashton, 108
Savoy, Marc, 47, 50, 82
Simien, John, 40
Simien, Nolton, 44
Simien, Terrence, 122, 182, 188, 217, 224, 227, 240, 241
Slim's Y-Ki-Ki, 165, 169, 171, 260
Smithsonian Folklife Festival, 148
Step N Strut Ride, 68
Steptoe, Tyina L., 16
Stoot, Pierre, 82, 105
Strachwitz, Chris, 14, 16, 45, 145
Sweat, Lenard, 131

T
Texas Zydeco (Wood), viii, 6, 78, 101–3
Thierry, Andre, 31, 35, 42, 97, 127, 130, 139, 201, 202, 203, 206, 224
Thomas, Leo, 123, 165, 167
Thomas, Leroy, 46, 50, 89, 95–96, 117, 123, 126, 127, 128, 131, 165–80, 213, 216
Thomas, Mary, 72, 105, 125
Tillis, Cendrena, x, 261
Tri-City Riders, 17

V
Victorian, Marceline, 149
Vidrine, John, 47

W
Walker's Recreation Center, 45
Watson, Cedric, 32, 224
Williams, Nathan, Jr., 42, 212, 243–60, 261
Williams, Dennis Paul, 23–24, 34, 261
Williams, Patrick, 131
Williams, Sid, 23, 182, 261
Wilson, Malex, 17, 19, 261
Wilson, Nathanial, 17, 19
Womack, Bobby, 69
Wood, Roger, viii, 3, 4, 6, 55, 78, 101–3

Z
Zydeco, Buckwheat, 23, 26, 66, 182, 185, 188, 193, 199, 205, 217–19, 220, 230, 240–41, 245, 250
Zydeco Dots, 92–93, 227
Zydeco Force, 227, 252, 255
Zydeco Hall of Fame, 21, 64, 160, 171, 199, 211, 260
Zydeco Nustep, 145
ZydeKool, 145, 202, 219, 220

BURT FEINTUCH (1949–2018) wrote several books and numerous articles about roots music, regional cultures, and music revivals in North America and abroad starting in the 1970s, along with producing documentary sound recordings. An academic and musician, he also directed the Center for the Humanities and was a professor of folklore for many years at the University of New Hampshire.

ABOUT THE AUTHOR

JEANNIE BANKS THOMAS is a fellow of the American Folklore Society and a professor in the Department of English and Folklore Program at Utah State University. She is the author of many articles on contemporary folklore as well as several books, two of which won international awards.

ABOUT THE EDITOR

GARY SAMSON is an accomplished fine arts photographer and New Hampshire Artist Laureate whose work has been exhibited internationally. He chaired the Photography Department at the New Hampshire Institute of Art. He is Professor Emeritus of Photography at the Institute of Art and Design at New England College. Together, Feintuch and Samson published *Talking New Orleans Music: Crescent City Musicians Talk about Their Lives, Their Music, and Their City* with the University Press of Mississippi.

ABOUT THE PHOTOGRAPHER